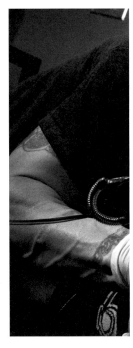
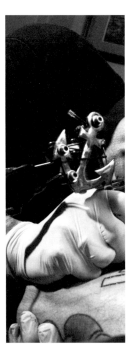
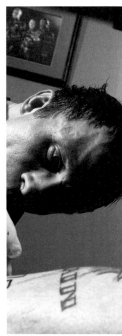

Barred for Life: How Black Flag's Iconic Logo became Punk Rock's Secret Handshake
by Stewart Dean Ebersole

© Renegade Art Front 2013
This edition © PM Press 2013
All rights reserved. No part of this book may be transmitted by any means without permission in writing from the publisher.

ISBN: 978-1-60486-394-9
Library of Congress Control Number: 2012913625

Cover design by Matthew Smith and Richard Demler

10 9 8 7 6 5 4 3 2 1

PM Press
PO Box 23912
Oakland, CA 94623
www.pmpress.org

Printed in the USA on recycled paper, by the Employee Owners of Thomson-Shore in Dexter, Michigan.
www.thomsonshore.com

BARRED FOR LIFE

Words
Stewart Dean Ebersole

Photography
Jared Castaldi
Stewart Dean Ebersole

Layout
Richard Demler

Design
Matthew Smith

Editor
David Ensminger

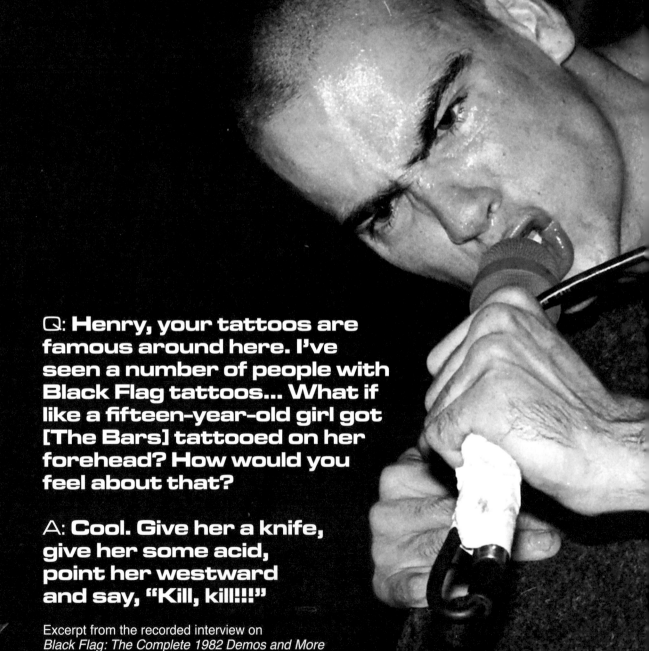

Q: Henry, your tattoos are famous around here. I've seen a number of people with Black Flag tattoos... What if like a fifteen-year-old girl got [The Bars] tattooed on her forehead? How would you feel about that?

A: Cool. Give her a knife, give her some acid, point her westward and say, "Kill, kill!!!"

Excerpt from the recorded interview on
Black Flag: The Complete 1982 Demos and More

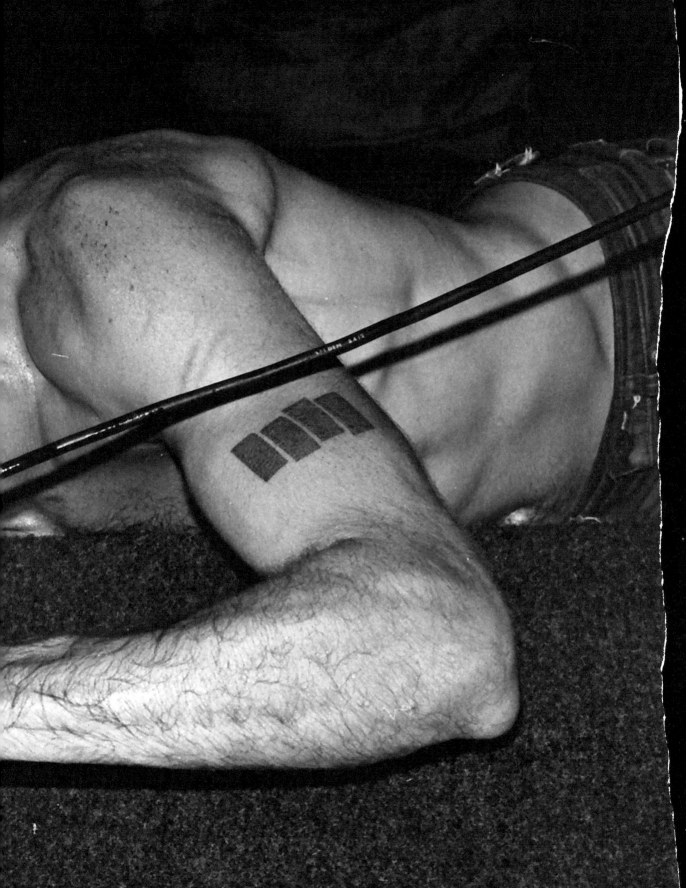

Photo by Edward Colver

ACKNOWLEDGMENTS

I CHASED MY FIRST COLLEGE DEGREE for nearly five years, which is actually less time than *Barred for Life* took to grow from simply an idea into a completed volume. If one can say that a university education is a life-changing event, then I contend that being given the opportunity to create this book, the act itself, the amazing people that helped me, and all of the people that I met along the way, was probably the most important event in my own life so far. Love the book or hate the book, it does not change the fact that the product is a combined effort of hundreds of people, thousands of hours, and was a total test of everybody's patience who had a vested interest in completing the project.

Let me start off by saying that *Barred for Life* began its life as a joke among four friends at a suburban Columbus, Ohio, tattoo studio. Besides me, at the christening were Naomi Fuller, Keith "KEEF" Elliot, and Matt Marsh, who all questioned why I decided to move forward with the project roughly one full year after that fated, rainy, dreary, and gray day when I dropped into the shop to show off my new tattoo work, and to grab a quick nap on the shop couch. For the entirety of the project I always tried to keep in mind the "joke" element that emerged at Thrill Vulture Studios that day so that the "project" element didn't become too serious and heavy. Sadly, sometimes I forgot the original spirit of the project. Sometimes things got *real* dark and *real* heavy, but that is now all water under the bridge. *Barred for Life* is finished. The joke is over.

Working side-by-side with the original crew of Jared Castaldi, Matt Smith, and Mr. Todd Barmann across the broad timeline of research and production of *Barred for Life* was as amazing an opportunity as it was truly humbling. These three men, so perfectly suited for this tightly-niched task, and their roles as Photographer, Layout Designer, and Editor respectively, freed me up to do what I do best, which constantly changed and wasn't always an easy role to define. Their collective patience as the book took on its final form, and as I morphed between the many roles necessary to bring the stories and photos together, was super-human at times.

Picking up the camera and following in the footsteps of Jared sent nervous lightning down my spine for the first few days of *Barred for Life*'s 2009 tour. His emotionally textured portraits set the style-bar high right from the beginning of the project. Jared proved a serious professional during every phase of the

project. Not only did he teach me how to use my digital equipment, but he served as a great mentor to me as I took over his photographer's role for the tour. I came to realize from Jared's first shot of Matt Marsh in Columbus, Ohio, that no guidance was necessary. Jared seemed to understand exactly what look I had in mind for the visual end of *Barred for Life*, and every shot fell onto the pages perfectly.

Matt never let me forget that this book is rooted in the most DIY of Punk Rock traditions, so whenever I felt like caving in and taking an easier path he supplied me with the inspiration and strength to continuously ask myself, "Would I have done things this way when I was a broke-as-shit Punk Rocker working on my own fanzine way back when?" Equally as important, Matt gets full credit for the title. In a flash of inspiration on a cold Saturday morning in a small, crowded, and very noisy coffee shop on the Lower East Side of Manhattan, Matt blurted out, "How about *Barred for Life*?" Everybody present at our table turned, looked, smiled, and shook our heads in unison. It was a feeling of "near completion" just giving a finished title to the project, and from that day the name never once changed. It is/was perfect.

Mr. Barmann, the consummate editorial force that he is, urged me to dig deep and write words that speak to a wider audience that may not share our twenty-five-year Punk Rock perspective. The many days sitting and writing at various Philadelphia coffee shops found me asking the question, "Will Todd like what I wrote?" Knowing that I can write a "perfect" paragraph, and that Todd would somehow always make it better, forced me to keep my style streamlined and linear, and to make my words count. A new editor took over in Todd's stead early in 2010, but even while sitting and finishing the writing in my friend's flat in Italy I always wrote to an audience of Todd; his guidance was as Yoda-like as a Jersey City Jewish mystic could muster.

On the publishing end, a massively sincere THANK YOU is offered to Craig O'Hara and his mighty PM Press. Craig approached me right after the 2009 tour and offered to release *Barred for Life*, but I was hesitant. No, for some reason I was stubborn and wanted to self-publish, but over the course of next year and a half I slowly migrated back to Craig, asked him to publish, and he welcomed the project without hesitation. Craig, a friend of nearly twenty-five years, offered me the powerful editorial assistance of David Ensminger, who rapidly sharpened my narrative meanderings and lengthy interviews into what you are soon about to read. Craig encouraged me to plug away diligently toward the light at the end of the tunnel even when I was ready to give up and focus on my new career.

And lastly, on the production end of the spectrum at least, I offer a sincere YOU ROCK SO HARD to my layout guru, Richard Demler, who at the last minute picked up the final design portion of the project. Stepping in to fill the shoes of Mr. Smith, who defined the look of the book back in 2008, Richard took on the task with a fury, remained focused on continuing the existing visual flow, and managed to add his unique creative vibe to each and every page. A friend of the Cadena family for more than a few decades, Richard was a pivotal resource in helping me score the very first *BFL* interview with Dez Cadena at his home in Newark, New Jersey, almost three years ago. Before that interview I had no intentions to increase the scope of *Barred for Life* beyond interviews with people wearing The Bars on their skin. Thanks to Richard, an important documentary facet entered into the book, and one that led me to an score an interview with one of my teen-aged Punk Rock heroes, Mr. Ron Reyes.

As for the tour, I will never be able to thank enough my loyal travel companion, Stefan Bauschmid. Two broke, unemployed, and hungry-for-adventure mid-lifers, we found everything that we could have

wished for and then some on this tour. A few arguments and disagreements, and more than ten thousand miles shared in our cramped Hyundai Sonata sedan, and magically never a punch thrown! Almost always Stefan would give me the better bed, choose to do the gnarliest stretch of driving, and always on the mark when it came time to break down our portable studio and get rolling, he was the *ultimate* traveling companion. Seeing nearly thirty states he had not seen prior, my friend, a native of Austria, at times seemed to be having twice the fun that I was. Happily, I didn't mind at all.

And where Stefan was absent from the vehicle, I was accompanied by Jorge Brito (Toronto, Ottawa, and Montreal), Noe Bunnell (East Coast of North America), and Audrey Dwyer (now Audrey Traum) (UK and continental Europe), who all wanted to make the tour happen as much as I did, and to see parts of the world they'd never seen before. Jorge nearly wrecked a Canadian wedding, Noe scored us nearly all of our East Coast couches and beds, and Audrey kicked into full gear and took the reins of the entire European excursion so that I could just focus on completing the tour without falling apart. Before the tour all were my friends, but during and afterward they assumed a new dimension in my world that amounted to super-hero status. To all three of you, I am lucky to count you among my continuing friendships.

On the tour side, there are just too many people that gave us food, gave us lodging, gave us a home, gave us friendship, and organized shows and photo shoots, to mention here. Standouts in my mind are Amy Chaos (Boston; who doesn't have The Bars tattooed anywhere on her, but set up a shoot anyway), Nate 9000 (Bozeman, MT; who broke up our 2,000-mile drive to the West Coast from Minneapolis, and showed us an amazing three days in the wild west of Montana), Phillip Alcala (L.A., CA, who supplied us a home-base, and probably one of the best show/shoots of the entire tour), Wayne Glass (London, UK; who kept us safe and warm on the freezing leg of our winter journey in London), Patrick Pechado (Paris, France; who scoured France for Black Flag–related tattoos), and Mayo Maggiore (Milano, Italia; who, graciously, along with his wife, took care of me when I was so sick that I thought I was going to die of fever). I'd like to call particular attention to one Mr. Phillip Torriero, who not only put together an amazing shoot in Manchester, UK, but went on to became my go-to guy when I needed a fire lit under my ass. Phillip loved the *Barred for Life* mission so much that he asked to manage my promotions in the UK, came with me to California in a failed attempt to interview the elusive Raymond Pettibon, and, ultimately, became a very good friend along the way. And finally, a huge debt of gratitude goes out to Steven "88" Wade for making my trip to Europe not only affordable but also manageable. While Steve and I are not "family," per se, his generous contribution made *Barred for Life* an international effort.

The tour would never have happened without fundraising efforts on the project's behalf. Friend and the Philadelphia cycling community's favorite attorney, Stuart Leon, started the ball rolling by cutting *BFL* a check to get the tour efforts moving forward. Starting with the BFL Alleycat bike race, so aggressively put together by Ms. Rachel Fletcher and Sharkfin Bicycle Club, moving through the Black Flag Karaoke throw-down that featured the Danzig Brick and Chubb Rock, and his mighty Snack Flag, and finishing with Doug Achtert's monumental all-ages show at Exit Skateshop (featuring Aneurysm Rats, Autolyzed, Cop Out, and Backwoods Payback), I was just totally blown away by your respective efforts. While a huge portion of the tour was financed by my own personal savings, the contributions of these fundraisers kept me from bankrupting myself on behalf of making this story a universal one, as opposed to just a local one. A big thank you goes out to Phillip and the Sailor Jerry Brand for offering a barrage of support, their downtown Philadelphia storefront, and mass of prizes to the fundraising effort. Richard and Chubb Rock, lending me the second floor at Tattooed Mom's to host more than a few

photo shoots, it all really started there with your generosity: Philadelphia IS Tattooed Mom's in my eyes. Inside this inner chamber are so many other folks that contributed heavily to the success of the tour, and you are too numerous to include by name, sadly. To those members of Black Flag that look back at their band's history and see an amazing thing, and who were willing to tell me all about it, I offer up my sincerest gratitude. To photographers Edward Colver and Glen E. Friedman, two men who definitely helped galvanize the visual image of Black Flag back in their day, the same. And to Rick Spellman, tattooist extraordinaire, it was a pleasure to listen to your stories and that you offered your talent and services on London May's arm, from which the best images that I ever captured emerged. I am so thankful and honored to have met all of you.

My sincerest personal thank you goes out to the Famiglia Gambino (Iolanda, Giuseppina Gigliotti, Silvia, and Sandro) in Cecina, Italia. My "other" family for more than a decade, Iolanda's couch was not only my last stop on the 2009 tour (where I was sitting when I found out I had been identity thieved, thus having to come home early from my trip), but was where I returned in the Spring of 2011 in order to clear my head, share an Easter holiday, and finish writing the book that I began writing from that exact same couch. I love all of you more and more each year, and rarely do I consider my trips to Italy simply vacations, but see them as family reunions with my "altra famiglia."

Of course I am continuously in the debt of my "for real" family, my mother Lois and my father Stewart Sr., for just about everything else. I know that it wasn't easy for you to understand, or to deal with my conversion to Punk Rock back in the early 1980s. You accepted my bizarre choices, encouraged my reckless travels, and allowed me to express just who I felt that I was at the time with little more than a confused look. Sure, there were arguments, as well as long periods of silence, but never once did you tell me to stop doing what I was doing. I don't think that you liked the funny hair, the leather jacket, the ripped jeans, the skateboarding, or the furious music cranking out of my bedroom, but I do believe deep down that you at least found it somewhat interesting. You collectively brought me into the world, and I hope that I made yours fun and exciting in some way. I love you guys just too fucking much.

As for the rest of you (you definitely know who you are), I am just sorry that I don't have the room to individually pen your names into this volume. I will try to make it up to you at some point, but for now please just know that your contribution helped make the tour and this book possible. Many of you barely knew me when you made your contribution, and many of your contributions were beyond awesome and helpful. So to all of you that helped, I hope that by offering your services, friendship, food, legal help, and glasses of white wine while I was busy conducting interviews, you realize that you are remembered because *Barred for Life* is now a real "thing," and not just some odd concept that I try to describe to people who want to know what I do with my spare time, why I am not married, and why a 41-year-old man would quit a career and travel around the world taking pictures of the tattoos of strangers representing a band that maybe 1% of the people on this planet even know. To everybody that played any part, large or small, I thank you from the depths of my soul.

Stewart.Dean.Ebersole.2

Photo on pages 4-5 by Edward Colver; pages 17-83 by Jared Castaldi; pages 84-322 by Stewart Dean Ebersole; page 323 by Jaime Robinson.

CONTENTS

MY DISCLAIMER

The story that follows is how I might have responded to any question regarding the meaning behind the Black Flag "Bars" tattooed on my ankle, had anybody cared to ask and stay around long enough to listen to my grandstanding on everything Punk Rock. Heaven knows, I can tell a story, but at my advanced age I might feel the need to exaggerate an instance or make some radical assumptions to connect widely separated thoughts at varied points of the story. As I see it, in the proper telling of any good story there will be the need to suspend disbelief, so suspend it.

All ideas and text, except the larger interviews and photograph captions, are my interpretations of a myth about a band called Black Flag and a thing called Punk Rock, which both conspired to completely change my world. Yes, over the past three decades, Black Flag changed a lot of people's worlds, but from this point forward I mostly speak from my own personal history.

No two people viewed, or continue to view, this groundbreaking band's contributions to the Punk Rock subculture in the same light. Each person's Black Flag experience can be best summed up by various elements, including a favorite song, album, lineup, era, concert, and interview. Not every person's experience was a positive one, and negative commentaries thread into the lore, especially relating to the post–*My War* period, when Black Flag lashed out at fans instead of lashing out at messy aspects of the outside world. That noted, I chose to pull and use mostly positive commentary and experiences from the hundreds of interviews that my crew and I conducted over the past half of a decade.

To add variety to this volume, I decided to include extensive interviews with Black Flag veterans and others inside the SST camp. Meeting and interviewing Ron Reyes about his experience in Black Flag was one of the most profound experiences of my adult life, and the resulting interview could have certainly become a book itself. Interviews with Greg Ginn and Henry Rollins are absent. Both were both invited, and declined an interview. Though missing contributions from two of Black Flag's most prominent and keystone players, *Barred for Life* (which started out as a joke among a few of my friends and me, mind you) does contain an in-depth, close-to-the-ground, and well-rounded approach to the topic.

So, yes, this is my blanket warning: the following text is a biased account of events pertaining to me over the past twenty-five years. With luck, you will relate to my opinions, but your interpretations of the myths, differing ever-so-slightly, are at least as good as mine and equally interesting. I do not aim for the whole truth; I simply offer my own story juxtaposed to the insight and anecdotes of Black Flag's members and close friends. Furthermore, the photographs and quotations embody fans' personal sacrifices to become part of the permanent record. If you have a problem with the expressed views, or you feel that your story was maliciously excluded, then do the Punk Rock thing: write your own book, blog, zine, or make your own documentary film. After participating in Punk Rock's more active aspects, I learned one very important lesson: Punks are quick to criticize and slow to produce, so produce or keep your trap closed and read on. ■

SCENE NUMBER ONE
REMEMBRANCES ON A CULTURE OF YOUTH REBELLION

"Black Flag pursued a politics of action. Thus they earned a solid reputation as being the real deal—truly Hardcore."

THE HUMBLE PERSPECTIVE OF ONE JADED OLD MAN

This is not a treatise on Black Flag, so if you desire a treatise, rush out and buy *Get in the Van* or *Spray Paint the Walls*, or any other books sketching the heart of the Black Flag experience. Do whatever you need to do, please, but don't read *Barred for Life* and expect high drama and juicy details about a single band amid thousands shaping the culture of youth rebellion appropriately named Punk Rock. While Black Flag was important, I refuse to write off other amazing bands that helped build the scene.

While I will not claim to be an authority on Black Flag matters, I do understand Punk Rock because it impacted my life for years. In my opinion, if Black Flag quit right after releasing the *Damaged* LP in 1981, I would be satisfied with their long list of previous achievements. Instead, Black Flag proceeded to release a lot of records, a few of which I bought and still enjoy. That is the extent of my Black Flag fandom: I am not an admirer of their entire career.

Middle-aged by now, I grew up in the throes of the early 1980s American Hardcore culture, when Black Flag's status as innovators and leaders was not doubted. Not only did they play a generation-defining aggressive style of music, but by all accounts they lived aggressive lives too. By doing so, they generated a template even modern Punk Rockers accept and emulate. In simple matters, such as honestly making an effort to stand up against authority systems and figures, which is now easy to discuss over coffee and cigarettes, Black Flag actually pursued a politics of action. Thus they earned a solid reputation as being the real deal—truly Hardcore.

They didn't just offer tough talk; they walked hard too, and they caused an epic amount of drama along the way. As an authentic real-deal, they unapologetically sought the

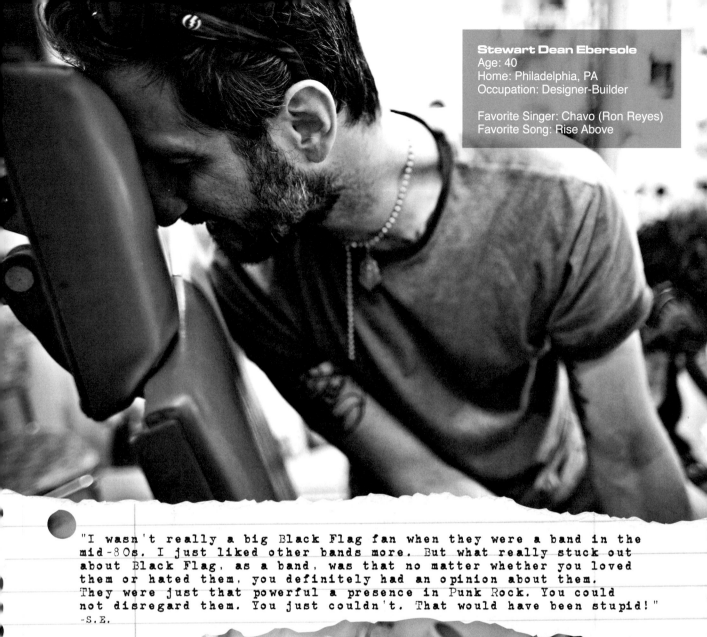

Stewart Dean Ebersole
Age: 40
Home: Philadelphia, PA
Occupation: Designer-Builder

Favorite Singer: Chavo (Ron Reyes)
Favorite Song: Rise Above

"I wasn't really a big Black Flag fan when they were a band in the
mid-80s. I just liked other bands more. But what really stuck out
about Black Flag, as a band, was that no matter whether you loved
them or hated them, you definitely had an opinion about them.
They were just that powerful a presence in Punk Rock. You could
not disregard them. You just couldn't. That would have been stupid!"
-S.E.

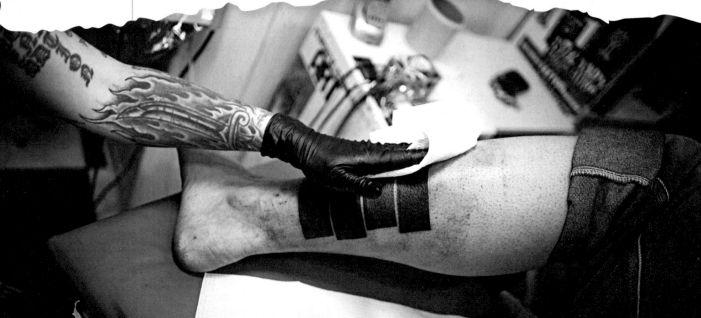

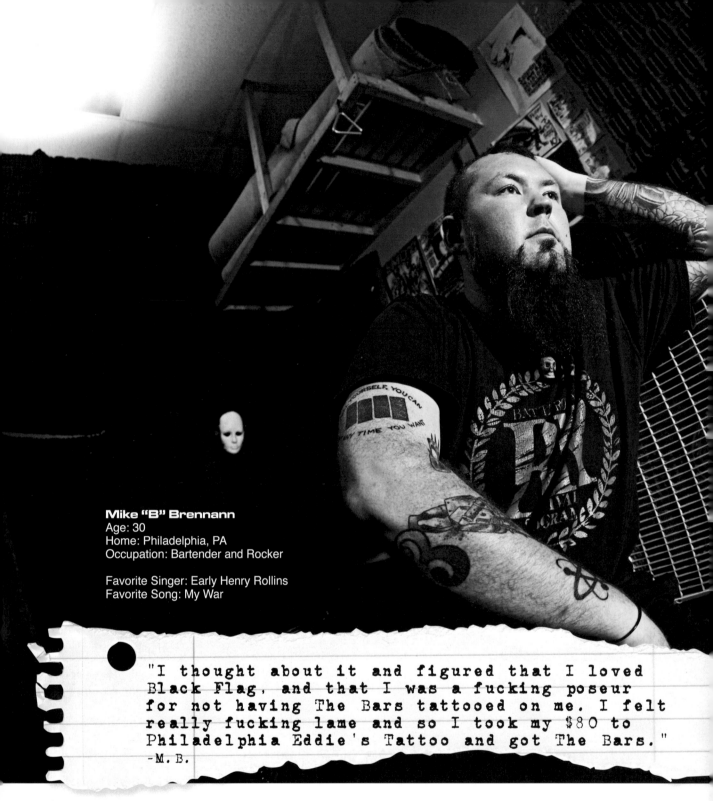

Mike "B" Brennann
Age: 30
Home: Philadelphia, PA
Occupation: Bartender and Rocker

Favorite Singer: Early Henry Rollins
Favorite Song: My War

"I thought about it and figured that I loved Black Flag, and that I was a fucking poseur for not having The Bars tattooed on me. I felt really fucking lame and so I took my $80 to Philadelphia Eddie's Tattoo and got The Bars."
-M.B.

complete and total attention of the LAPD—no small feat for a musical group to accomplish—by squaring up against them at nearly every show, big or small, they played in the Los Angeles area from the late 1970s to the early 1980s. While most bands steered clear of police intervention, Black Flag seemed to encourage the wrath of the LAPD, which created a dark, permanent cloud around them. Like the bad press issued to the Sex Pistols on their first-and-only American tour back in 1978, Black Flag easily won the hatred of parents and the praise of pissed-off kids across the country by

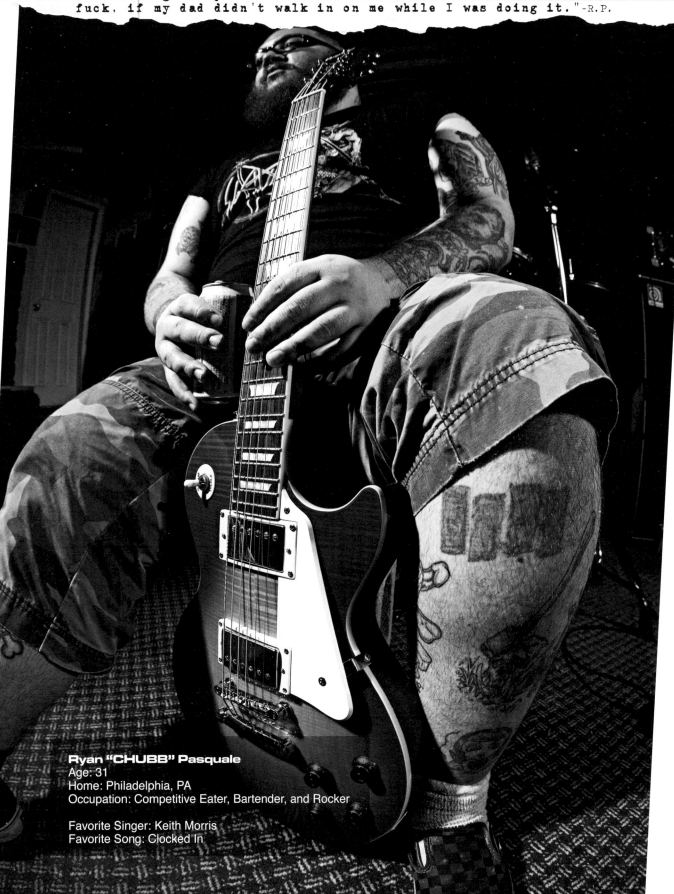

"I was like fifteen or sixteen, and I made a tattoo machine out of a toothbrush, pieces of a Bic pen, a race car motor, and a pencil eraser. I gave myself The Bars while I was in the bathtub and, fuck, if my dad didn't walk in on me while I was doing it." -R.P.

Ryan "CHUBB" Pasquale
Age: 31
Home: Philadelphia, PA
Occupation: Competitive Eater, Bartender, and Rocker

Favorite Singer: Keith Morris
Favorite Song: Clocked In

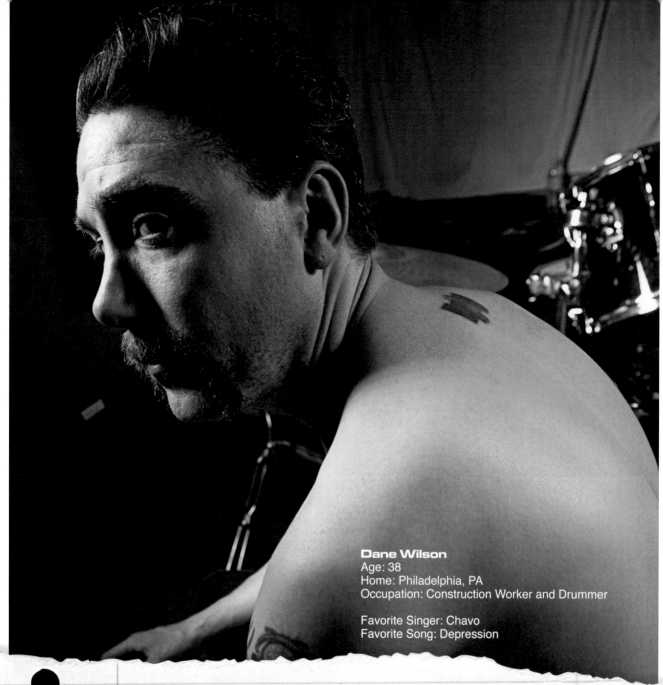

Dane Wilson
Age: 38
Home: Philadelphia, PA
Occupation: Construction Worker and Drummer

Favorite Singer: Chavo
Favorite Song: Depression

"Black Flag definitely nailed angst. A lot of bands handled angst in their music but there was something deeply personal and pissed off about how Black Flag did it. It was about being alone and pissed off, and I still am, except for now I have a wife, so I am not actually alone anymore."-D.W.

simply taking on the cops, the most identifiable example of questionable authority. Few bands dealt with police the same way then, or since.

I was lucky to have been a Punk Rocker when Rollins led the band after the riots. In awe, I read how the band lashed out and confronted fans and enemies alike. As for me, I was hugely inspired by the courage of both Black Flag and their fans at that time. But *My War*, while a powerful release, changed everything for me. Photographs of the band, and even their attitude in interviews, not only bore little resemblance to the

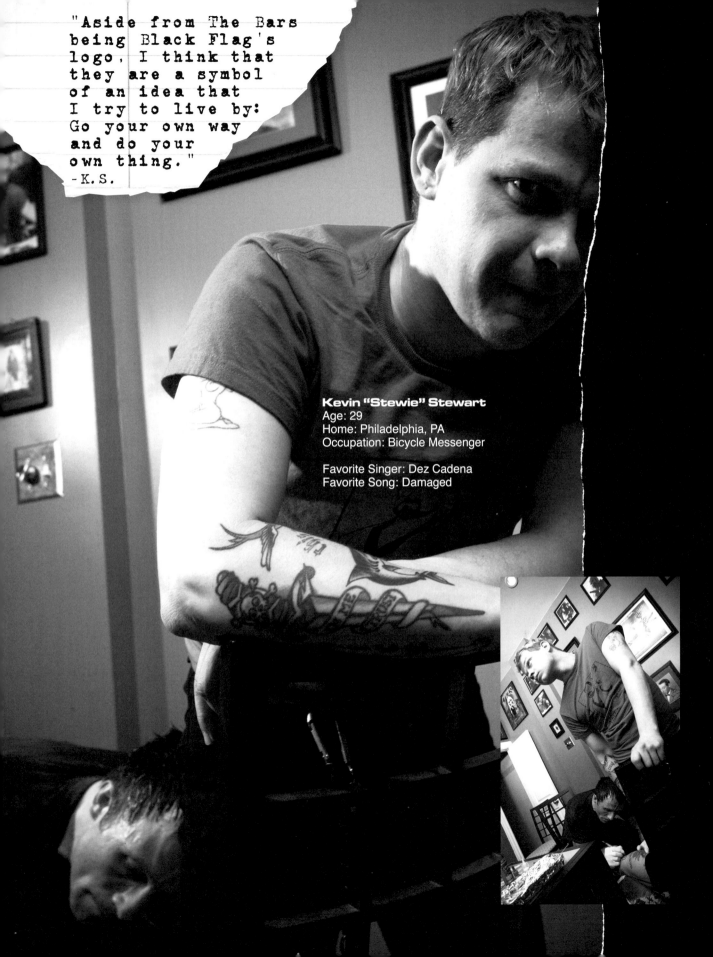

"Aside from The Bars being Black Flag's logo, I think that they are a symbol of an idea that I try to live by: Go your own way and do your own thing."
-K.S.

Kevin "Stewie" Stewart
Age: 29
Home: Philadelphia, PA
Occupation: Bicycle Messenger

Favorite Singer: Dez Cadena
Favorite Song: Damaged

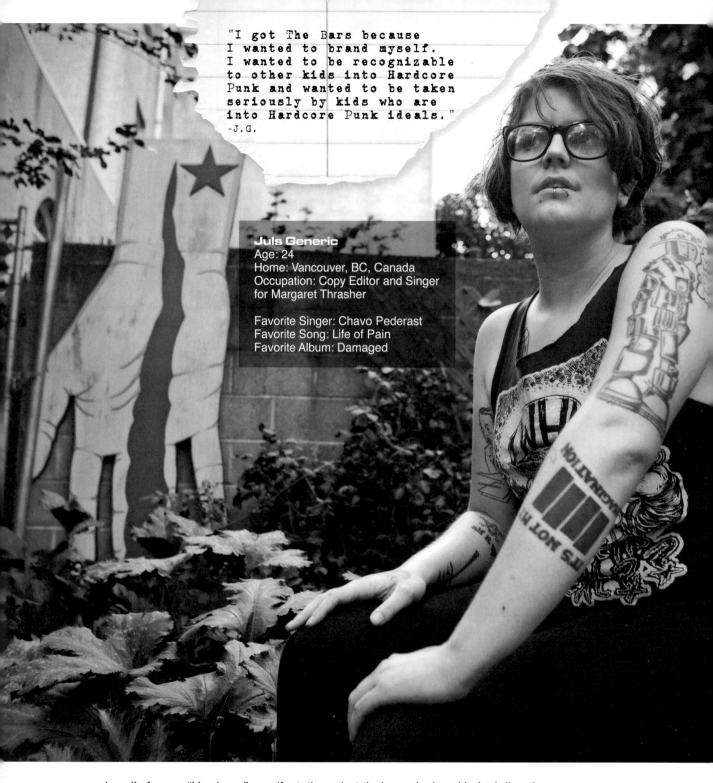

"I got The Bars because
I wanted to brand myself.
I wanted to be recognizable
to other kids into Hardcore
Punk and wanted to be taken
seriously by kids who are
into Hardcore Punk ideals."
-J.G.

Juls Generic
Age: 24
Home: Vancouver, BC, Canada
Occupation: Copy Editor and Singer
for Margaret Thrasher

Favorite Singer: Chavo Pederast
Favorite Song: Life of Pain
Favorite Album: Damaged

band's former "Hardcore" manifestations, but their musical and lyrical direction was an unacceptable 180-degree departure from their formative years. For that period of time, Black Flag took a lot of abuse from their fans, mostly because Punk Rock, as an angry genre and identity, was still active and vital. While probably not the best way to describe Black Flag's evolutionary quickstep, the words "SELL OUT" frequently found their way into conversations regarding the band at this time, mine included. Looking back, with one of the keystone bands of the generation righteously lashing out at fans (and the entire Punk Rock culture), those were some strange times to be involved in Punk Rock.

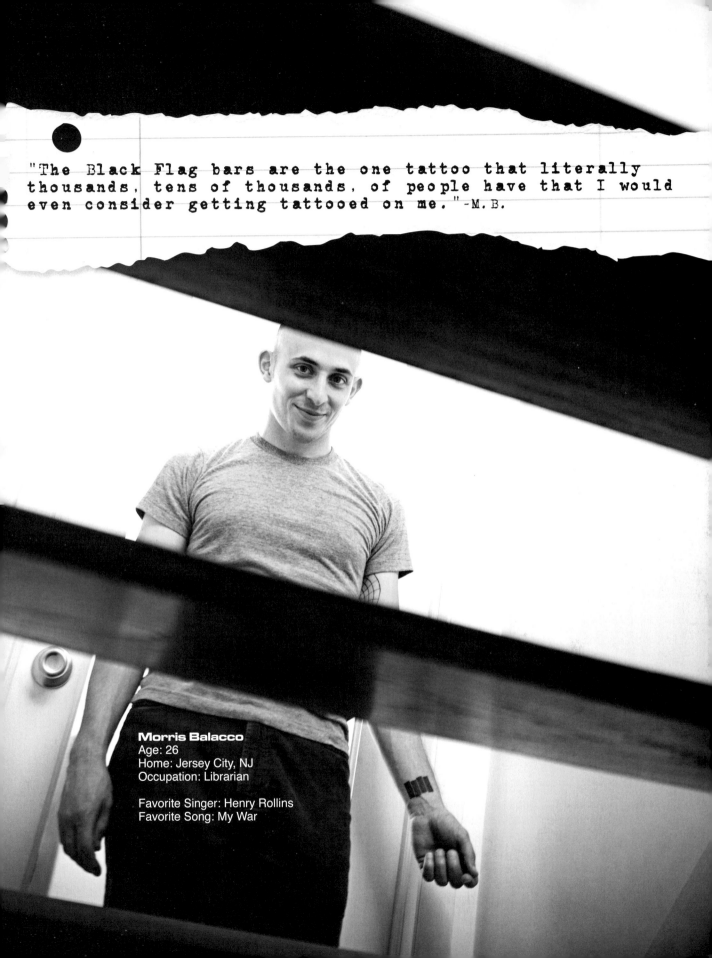

"The Black Flag bars are the one tattoo that literally thousands, tens of thousands, of people have that I would even consider getting tattooed on me."-M.B.

Morris Balacco
Age: 26
Home: Jersey City, NJ
Occupation: Librarian

Favorite Singer: Henry Rollins
Favorite Song: My War

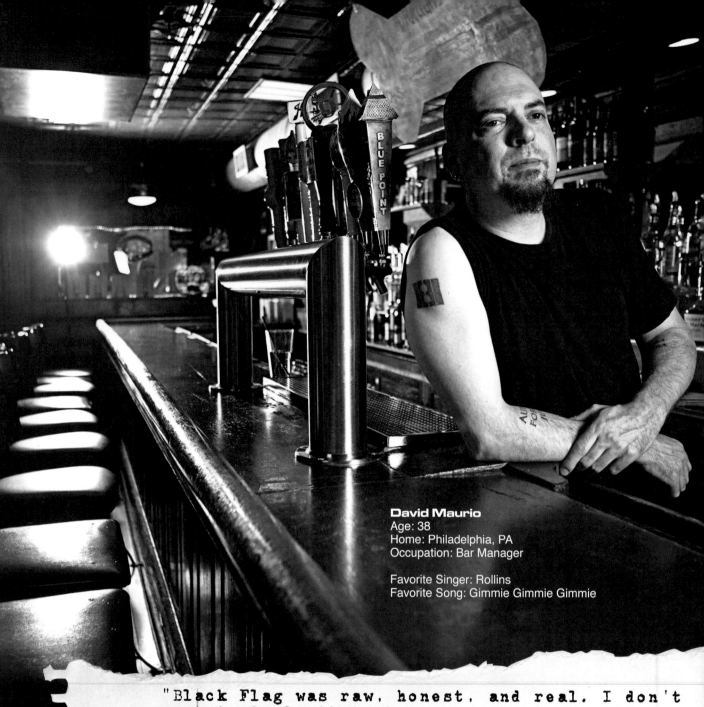

David Maurio
Age: 38
Home: Philadelphia, PA
Occupation: Bar Manager

Favorite Singer: Rollins
Favorite Song: Gimmie Gimmie Gimmie

"Black Flag was raw, honest, and real. I don't want to imply that they were fearless, but their lyrics were what everyone was feeling at the time but were too afraid to say." -D.M.

My personal approach toward the post–*My War* Black Flag format was to purposefully ignore the changes, continue listening to the old stuff, and hope that their next record would be a little more Punk Rock and a little less "cheese" Metal. Where there was once this near-continuous flow of antiauthoritarian anthems, many later Black Flag releases scarcely contained one, or possibly two, memorable songs for me. And for a band that once boasted four amazing singers, later releases seemed to indiscriminately alter musical lineups more in the lineage of Jazz recordings than of Punk Rock records. At some point, I just had to stop paying attention.

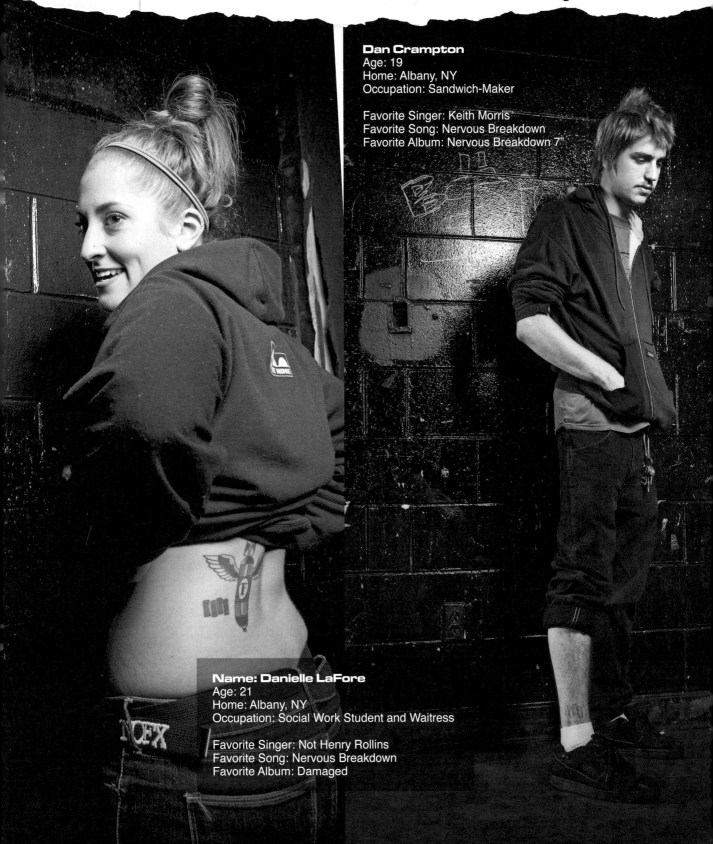

"If I saw somebody on the street, a total stranger, I would be inclined to talk to them if they had a tattoo of The Bars." -D.L.

"I don't think Punk's dead. If I didn't have that, who knows what I'd be doing?" -D.C.

Dan Crampton
Age: 19
Home: Albany, NY
Occupation: Sandwich-Maker

Favorite Singer: Keith Morris
Favorite Song: Nervous Breakdown
Favorite Album: Nervous Breakdown 7"

Name: Danielle LaFore
Age: 21
Home: Albany, NY
Occupation: Social Work Student and Waitress

Favorite Singer: Not Henry Rollins
Favorite Song: Nervous Breakdown
Favorite Album: Damaged

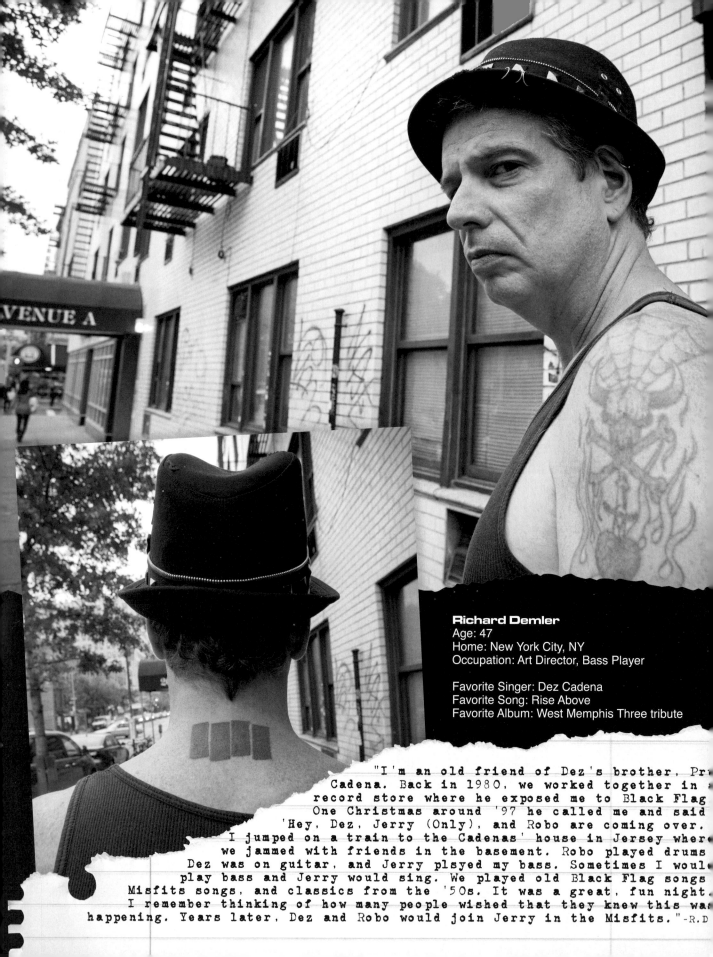

AVENUE A

Richard Demler
Age: 47
Home: New York City, NY
Occupation: Art Director, Bass Player

Favorite Singer: Dez Cadena
Favorite Song: Rise Above
Favorite Album: West Memphis Three tribute

"I'm an old friend of Dez's brother, Pr
Cadena. Back in 1980, we worked together in
record store where he exposed me to Black Flag
One Christmas around '97 he called me and said
'Hey, Dez, Jerry (Only), and Robo are coming over.
I jumped on a train to the Cadenas' house in Jersey where
we jammed with friends in the basement. Robo played drums
Dez was on guitar, and Jerry plsyed my bass. Sometimes I woul
play bass and Jerry would sing. We played old Black Flag songs
Misfits songs, and classics from the '50s. It was a great, fun night.
I remember thinking of how many people wished that they knew this wa
happening. Years later, Dez and Robo would join Jerry in the Misfits."-R.D

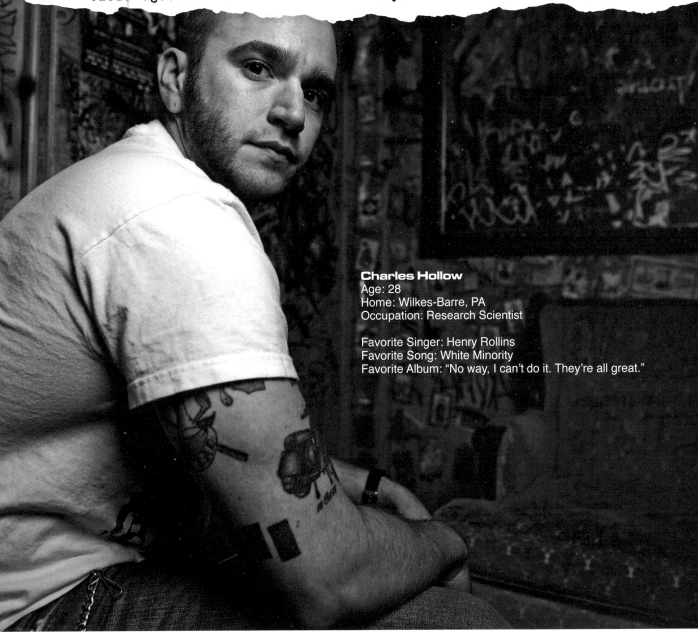

"My boss asked what it was and I said, 'It's an underground political movement.' It kind of is, but it's not anything that he'd know. I just found out my wife's pregnant; I want to make sure to raise my kids with this stuff. I want to show them what dad did at their age. I'd love to hear them say, 'Damn! That was cool!'"-C.H.

Charles Hollow
Age: 28
Home: Wilkes-Barre, PA
Occupation: Research Scientist

Favorite Singer: Henry Rollins
Favorite Song: White Minority
Favorite Album: "No way, I can't do it. They're all great."

A bit immaturely, I didn't want to deal with yet another iconic Punk Rock band turning its back on the scene that once enabled it to thrive and grow. While I once believed their changed attitude and style were a direct assault on that scene, now I actually know they were assaulting the scene. They stopped lashing out at parent, teacher, and cop "authority" and began lashing out at their former Punk fan base, all the time not noticing that kids around the world stopped caring about them! Between the years of 1984 and 1986, they actively distanced themselves from Punk Rock, placed all-SST bands on Black Flag gigs, and gave interviews suggesting Punk Rockers were a bunch of closed-minded idiots. Hence, spending hard earned cash on, say, *Family Man* or *Annihilate This Week*, or giving it to a band that didn't hate me, became an issue of moral importance.

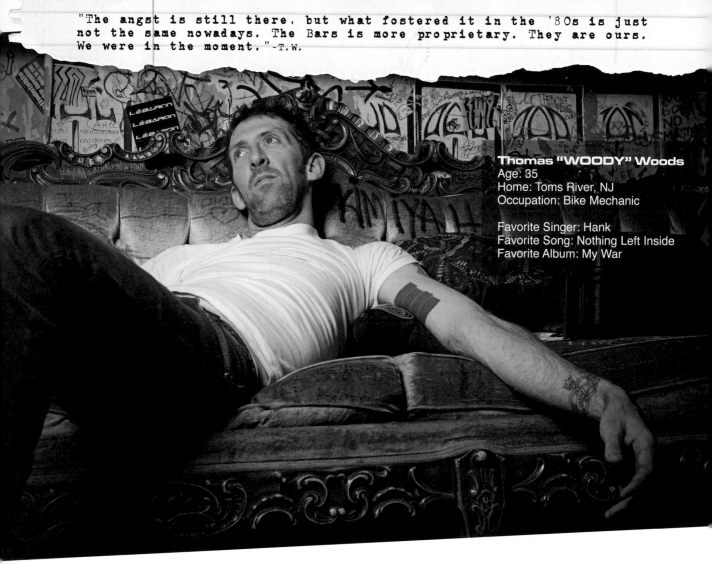

"The angst is still there, but what fostered it in the '80s is just not the same nowadays. The Bars is more proprietary. They are ours. We were in the moment." -T.W.

Thomas "WOODY" Woods
Age: 35
Home: Toms River, NJ
Occupation: Bike Mechanic

Favorite Singer: Hank
Favorite Song: Nothing Left Inside
Favorite Album: My War

Calling it quits in 1986, I recall Black Flag accepting rather lukewarm condolences from the Punk Rock community. Most of the members, and many people close to the band, seemed traumatized, as roadie Joe Cole's book *Planet Joe* helps picture. Their accumulated mythos and ethos, including their contributions to the Punk Rock ethos, as well as a years-long assault against the Punk Rock establishment, would remain honored in Punk Rock history books, though many years passed before the scene really made peace with them.

Apparently, both the quantity and quality of rivalries were an essential part of the Black Flag experience, first made public by Rollins's epic tell-all *Get in the Van*. Though only an account of one dramatic man, it suggests the trauma experienced in Black Flag resembled being a foot soldier in a war where everybody was a potential enemy. Punk Planet's book, *We Owe You Nothing*, featuring interviews with former members nearly fifteen years after the band's demise, depicts how the more pressing rivalries between frontman Henry Rollins and founding member and guitarist Greg Ginn never died. In fact, if anything, the spirit of angst espoused by them in those pages showed a very real and evil-spirited rivalry toward one another that made the entirety of my teen angst pale in comparison.

The Black Flag traumas, while masked to some degree and often passive-aggressive, live on via print and social networks, still aflame nearly thirty years after the band's

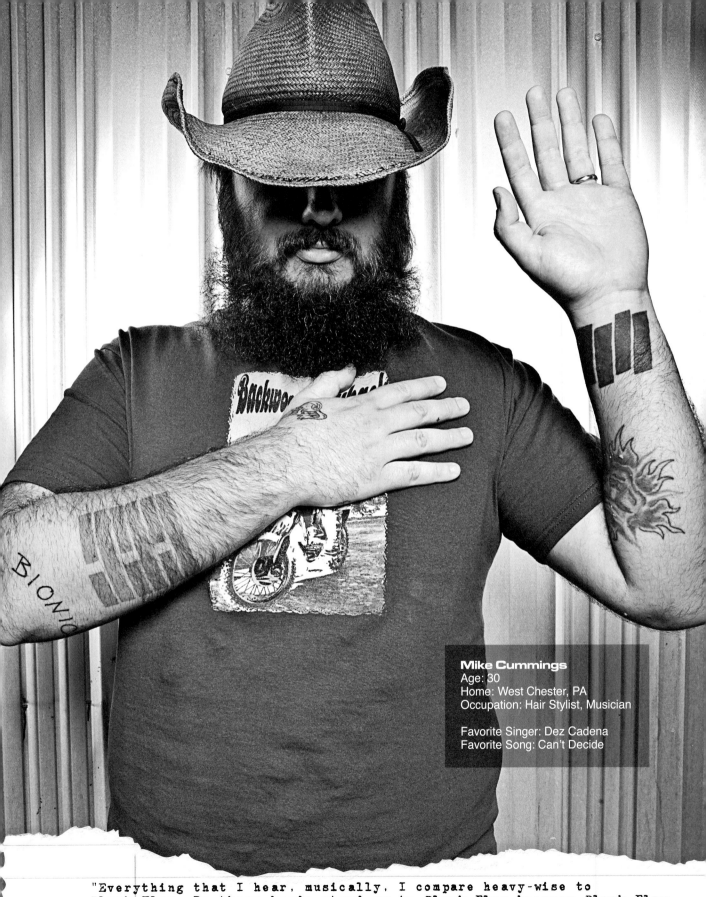

Mike Cummings
Age: 30
Home: West Chester, PA
Occupation: Hair Stylist, Musician

Favorite Singer: Dez Cadena
Favorite Song: Can't Decide

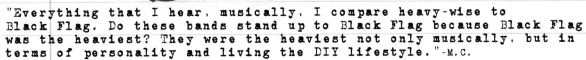

"Everything that I hear, musically, I compare heavy-wise to Black Flag. Do these bands stand up to Black Flag because Black Flag was the heaviest? They were the heaviest not only musically, but in terms of personality and living the DIY lifestyle."-M.C.

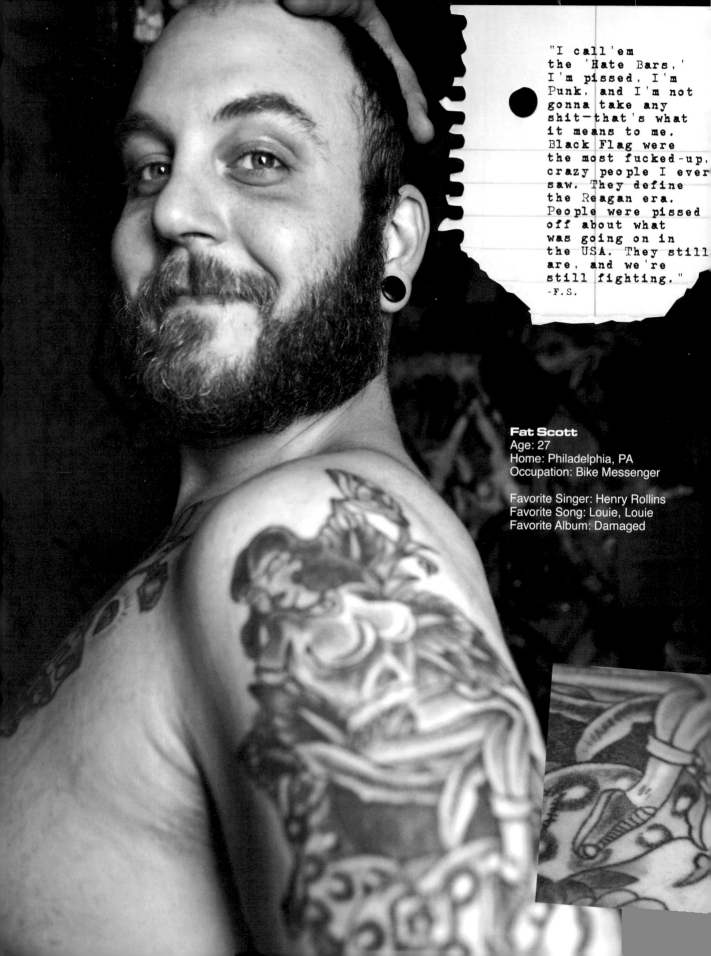

"I call'em
the 'Hate Bars,'
I'm pissed, I'm
Punk, and I'm not
gonna take any
shit—that's what
it means to me.
Black Flag were
the most fucked-up,
crazy people I ever
saw. They define
the Reagan era.
People were pissed
off about what
was going on in
the USA. They still
are, and we're
still fighting."
-F.S.

Fat Scott
Age: 27
Home: Philadelphia, PA
Occupation: Bike Messenger

Favorite Singer: Henry Rollins
Favorite Song: Louie, Louie
Favorite Album: Damaged

"The Bars say 'I'm not one of them,' and it also lets the right people know that I am one of them." -K.P.

"Black Flag is the one band that covers such a wide musical spectrum that I can listen to any of their albums based on the mood that I am in. I totally love the later, weirder stuff like Process of Weeding Out. It isn't that aggressive, but maybe it is my old age where I can just listen to it and get into it. If I listen to the old stuff like Rise Above, which is a great song, I might want to punch somebody out." -J.M.

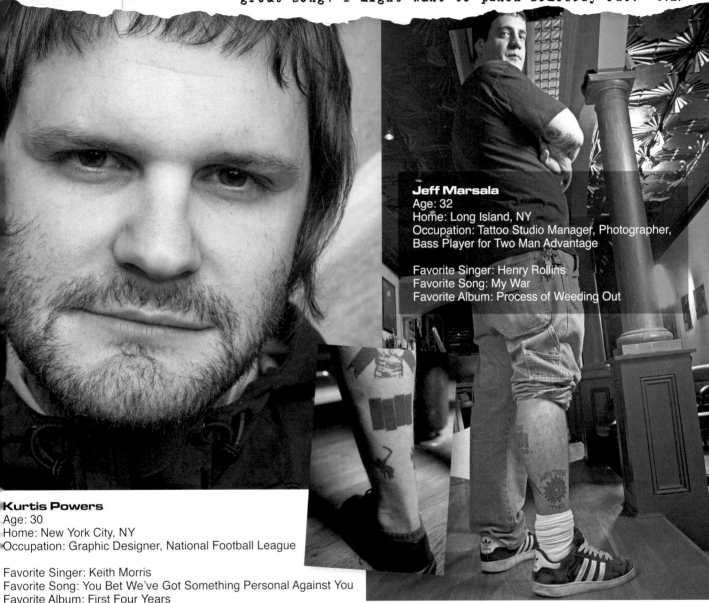

Jeff Marsala
Age: 32
Home: Long Island, NY
Occupation: Tattoo Studio Manager, Photographer, Bass Player for Two Man Advantage

Favorite Singer: Henry Rollins
Favorite Song: My War
Favorite Album: Process of Weeding Out

Kurtis Powers
Age: 30
Home: New York City, NY
Occupation: Graphic Designer, National Football League

Favorite Singer: Keith Morris
Favorite Song: You Bet We've Got Something Personal Against You
Favorite Album: First Four Years

demise. Since starting this project, much has changed concerning my perception of the band's evolution. I've come to accept some aspects that I wasn't prepared to accept back when I saw things only in black and white. I've grown to completely appreciate the path that Black Flag, and its numerous members, cleared so that Punk Rockers like me could walk with a degree of freedom not available beforehand. With four singers, three bass players, and drummers too numerous to count, Black Flag plowed through a decade commando-style. And, sadly, when comrades fell, well, there just wasn't time to stop and pick them up.

None of the band members, or even those closely associated with the SST dynasty, walked away from their experiences without some curious emotional scarring. Needless

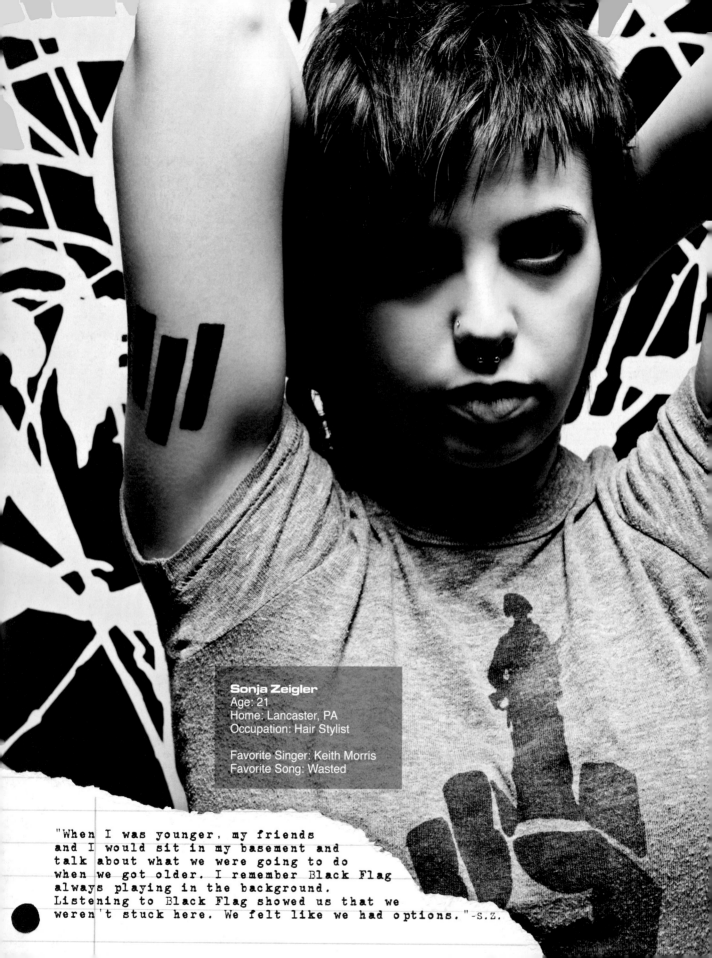

Sonja Zeigler
Age: 21
Home: Lancaster, PA
Occupation: Hair Stylist

Favorite Singer: Keith Morris
Favorite Song: Wasted

"When I was younger, my friends
and I would sit in my basement and
talk about what we were going to do
when we got older. I remember Black Flag
always playing in the background.
Listening to Black Flag showed us that we
weren't stuck here. We felt like we had options."-S.Z.

"I think The Bars represent a sort of ability to think the same way about some things. I see The Bars and I smile, even if it's a kid wearing a weird get-up who's obviously getting into Punk a little too late. I think that then and now, Black Flag was so real, as opposed to all the blow-n-cuts out there. That reality was so compelling." -K.H.

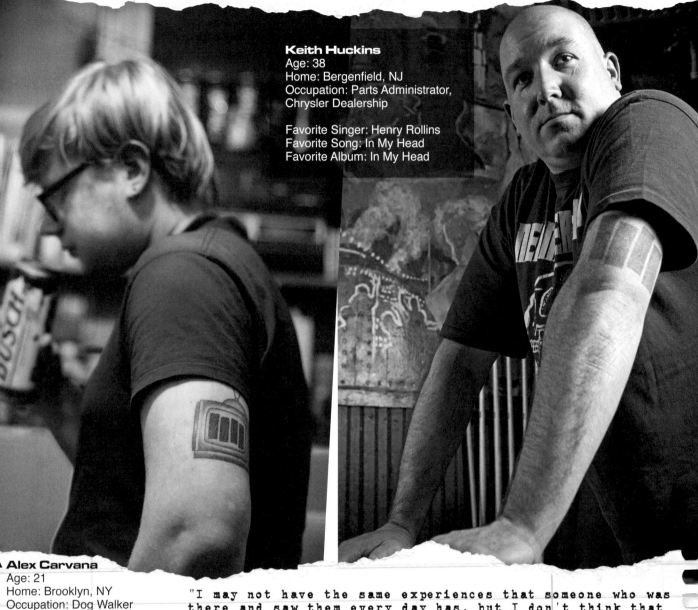

Keith Huckins
Age: 38
Home: Bergenfield, NJ
Occupation: Parts Administrator, Chrysler Dealership

Favorite Singer: Henry Rollins
Favorite Song: In My Head
Favorite Album: In My Head

Alex Carvana
Age: 21
Home: Brooklyn, NY
Occupation: Dog Walker

Favorite Singer: Henry Rollins
Favorite Song: TV Party
Favorite Album: Damaged

"I may not have the same experiences that someone who was there and saw them every day has, but I don't think that takes away from how important Black Flag are to me." -A.C.

to say, I welcomed the opportunity to learn more about life inside the Black Flag camp from these pioneers. Just as I expected, they properly schooled me, showing me how the cloth of former Black Flag players was just made tougher than most. Partially due to this, many people across the globe cannot get enough of Black Flag lore, music, and biography. Every person that is, or ever was, a Punk Rocker seems to offer an opinion, often deeply emotional, of Black Flag, this most iconic of underground bands.

I am no different. As a teenager, I was a mess. Had I not found Punk Rock, maybe I would be dead by my own hand, or I would be a family man or a businessman.

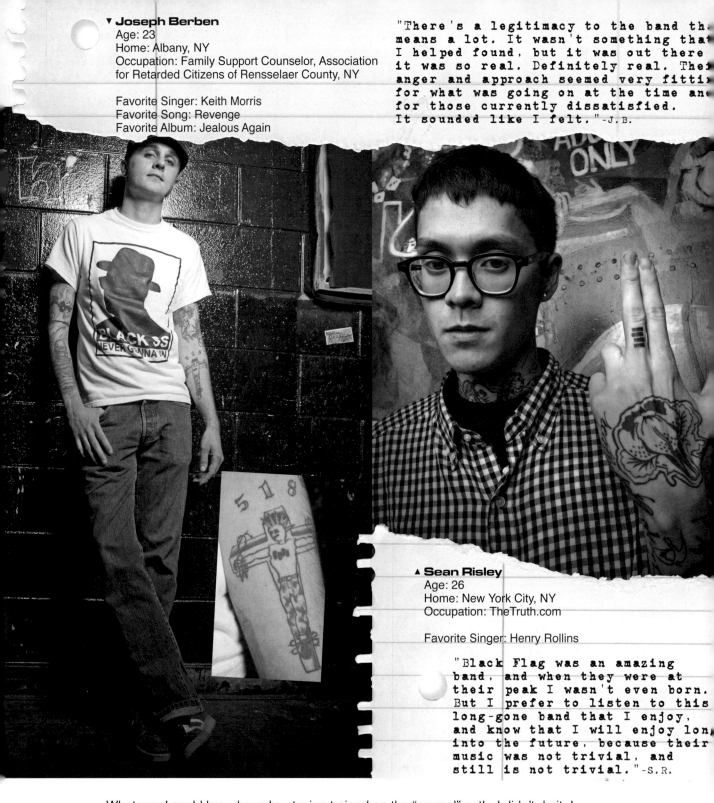

▼ **Joseph Berben**
Age: 23
Home: Albany, NY
Occupation: Family Support Counselor, Association for Retarded Citizens of Rensselaer County, NY

Favorite Singer: Keith Morris
Favorite Song: Revenge
Favorite Album: Jealous Again

"There's a legitimacy to the band th⸱
means a lot. It wasn't something that
I helped found, but it was out there⸱
it was so real. Definitely real. The⸱
anger and approach seemed very fitti⸱
for what was going on at the time an⸱
for those currently dissatisfied.
It sounded like I felt."-J.B.

▲ **Sean Risley**
Age: 26
Home: New York City, NY
Occupation: TheTruth.com

Favorite Singer: Henry Rollins

"Black Flag was an amazing
band, and when they were at
their peak I wasn't even born.
But I prefer to listen to this
long-gone band that I enjoy,
and know that I will enjoy lon⸱
into the future, because their
music was not trivial, and
still is not trivial."-S.R.

Whatever I could have been by staying trained on the "normal" path, I didn't do it. I became something else. I rebelled against the world, and then I traveled the world and discovered myself. I give the lion's share of the credit for my crazy achievements to being a Punk Rocker, and just a bit more to being a Black Flag sort of Punk Rocker. My cloth isn't exactly Black Flag cloth, but it is similar. While Punk Rock may have wounded some people, I believe it helped more lives than it hurt, which is why it thrives as an alternative culture even now in this new millennium.

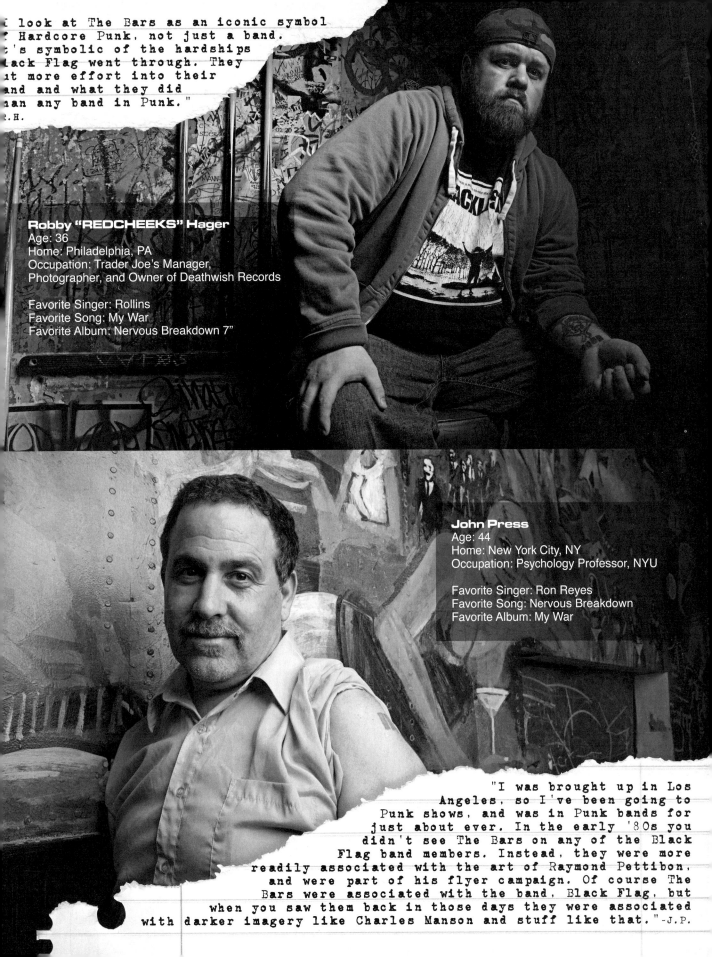

"I look at The Bars as an iconic symbol
of Hardcore Punk, not just a band.
It's symbolic of the hardships
Black Flag went through. They
put more effort into their
band and what they did
than any band in Punk."
-R.H.

Robby "REDCHEEKS" Hager
Age: 36
Home: Philadelphia, PA
Occupation: Trader Joe's Manager,
Photographer, and Owner of Deathwish Records

Favorite Singer: Rollins
Favorite Song: My War
Favorite Album: Nervous Breakdown 7"

John Press
Age: 44
Home: New York City, NY
Occupation: Psychology Professor, NYU

Favorite Singer: Ron Reyes
Favorite Song: Nervous Breakdown
Favorite Album: My War

"I was brought up in Los
Angeles, so I've been going to
Punk shows, and was in Punk bands for
just about ever. In the early '80s you
didn't see The Bars on any of the Black
Flag band members. Instead, they were more
readily associated with the art of Raymond Pettibon,
and were part of his flyer campaign. Of course The
Bars were associated with the band, Black Flag, but
when you saw them back in those days they were associated
with darker imagery like Charles Manson and stuff like that."-J.P.

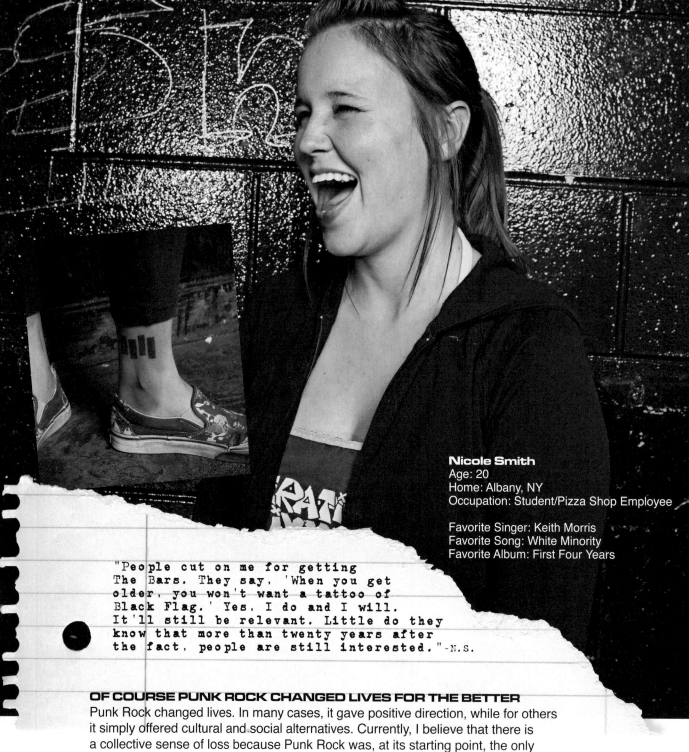

Nicole Smith
Age: 20
Home: Albany, NY
Occupation: Student/Pizza Shop Employee

Favorite Singer: Keith Morris
Favorite Song: White Minority
Favorite Album: First Four Years

"People cut on me for getting
The Bars. They say, 'When you get
older, you won't want a tattoo of
Black Flag.' Yes, I do and I will.
It'll still be relevant. Little do they
know that more than twenty years after
the fact, people are still interested." -N.S.

OF COURSE PUNK ROCK CHANGED LIVES FOR THE BETTER

Punk Rock changed lives. In many cases, it gave positive direction, while for others
it simply offered cultural and social alternatives. Currently, I believe that there is
a collective sense of loss because Punk Rock was, at its starting point, the only
alternative for geeked-out, rebellious kids to lash out against Reagan-era (or Bush-era)
conservatism. In many ways, Punk Rock responded fiercely to shady elements of
popular culture by forcibly rising above it, but in the end squandered ideals by focusing
so much energy internally on "scene" politics and too little externally on local, national,
and global politics. That gap between talk and action is still felt.

For me, Punk Rock, despite many faults, felt like a positive-directed culture. Yet, the
published rants of prominent members of Black Flag seem to suggest the whole

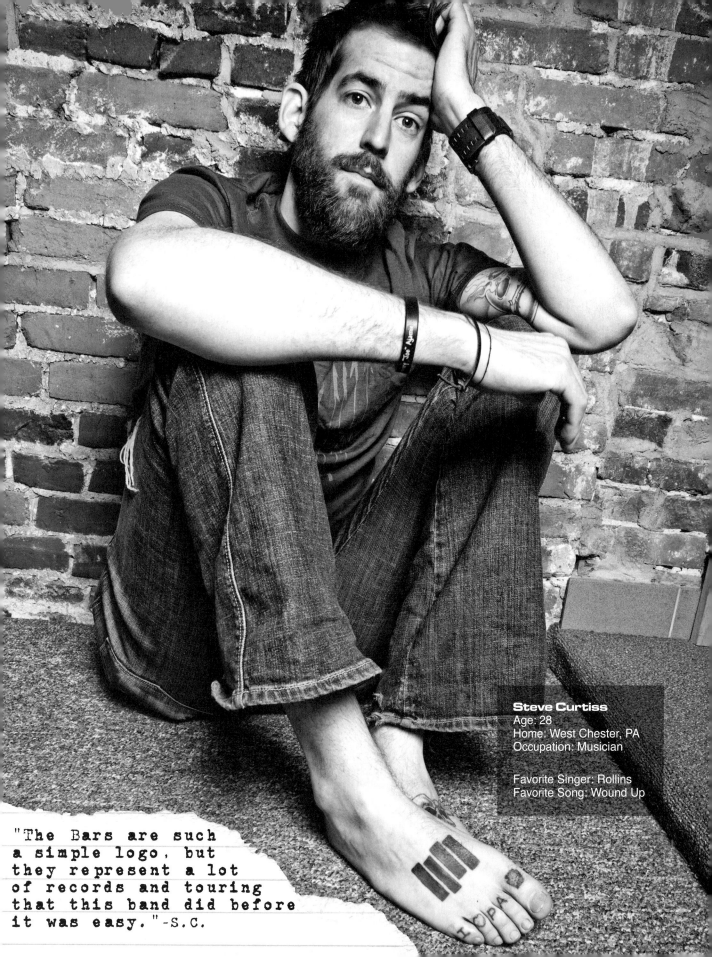

Steve Curtiss
Age: 28
Home: West Chester, PA
Occupation: Musician

Favorite Singer: Rollins
Favorite Song: Wound Up

"The Bars are such a simple logo, but they represent a lot of records and touring that this band did before it was easy."-S.C.

"I enjoy the fact that The Bars say
a lot with very little. They speak
volumes to those who see them:
just four rectangles next to
each other, but far more
significant than that.
These four rectangles
represent Punk at a time
when it wasn't cool
or safe."-R.S.

Ron Segarra ▶
Age: 27
Home: Albany, NY
Occupation: Pizza Delivery/Amateur Tattooist

Favorite Singer: Chavo
Favorite Song: White Minority
Favorite Album: Decline of Western Civilization (soundtrack)

"After reading about Black Flag, it
kinda became a bigger picture about ho
the people in the band lived their own
individual lives. They lived active
lives versus reactive lives, and they
inspired me to keep off of my ass and
keep moving forward."
-K.C.

◀ Kyle Chard
Age: 23
Home: Albany, NY
Occupation: Construction Worker

Favorite Singer: Henry Rollins
Favorite Song: Gimmie Gimmie Gimmie
Favorite Album: Damaged

movement was a huge waste of time and energy. That disappoints me. In a frustrating, maddening world, for scene-architects to look back at a movement that attempted to challenge that madness, and then deem it a waste, is a grand disservice to the people on the ground level. So, I decided to focus my attention on people that look back and see merit where others see waste. I am too old and stoked to focus my energies on trauma and negativity. Personally, I try to celebrate Punk Rock, including the people

"Black Flag represented a sort of universal American Punk Rock icon.
No matter where you saw the name or the logo, you felt like you were
a part of a movement. They (Black Flag) were just that aggressive
about projecting their image and message."-S.F.

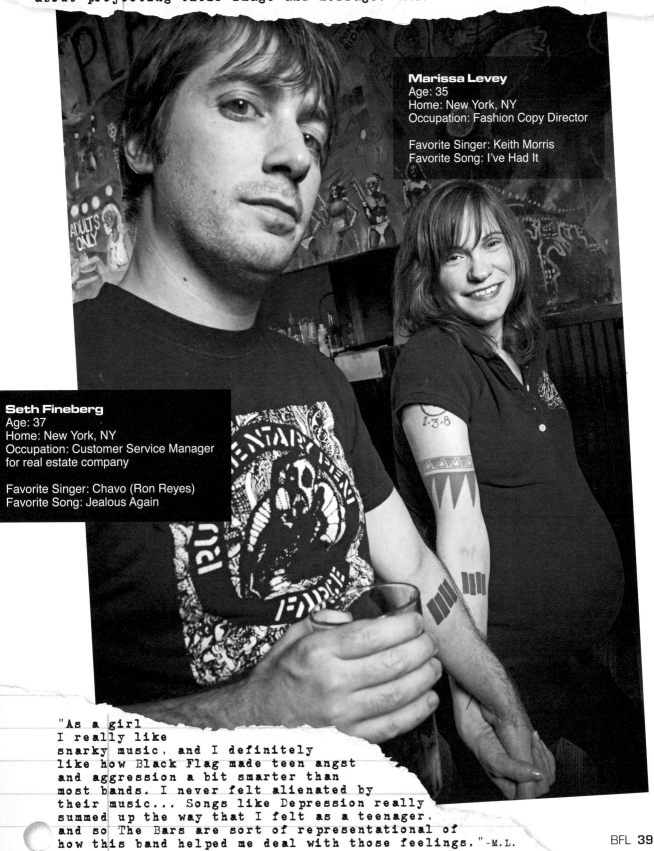

Marissa Levey
Age: 35
Home: New York, NY
Occupation: Fashion Copy Director

Favorite Singer: Keith Morris
Favorite Song: I've Had It

Seth Fineberg
Age: 37
Home: New York, NY
Occupation: Customer Service Manager
for real estate company

Favorite Singer: Chavo (Ron Reyes)
Favorite Song: Jealous Again

"As a girl
I really like
snarky music, and I definitely
like how Black Flag made teen angst
and aggression a bit smarter than
most bands. I never felt alienated by
their music... Songs like Depression really
summed up the way that I felt as a teenager,
and so The Bars are sort of representational of
how this band helped me deal with those feelings."-M.L.

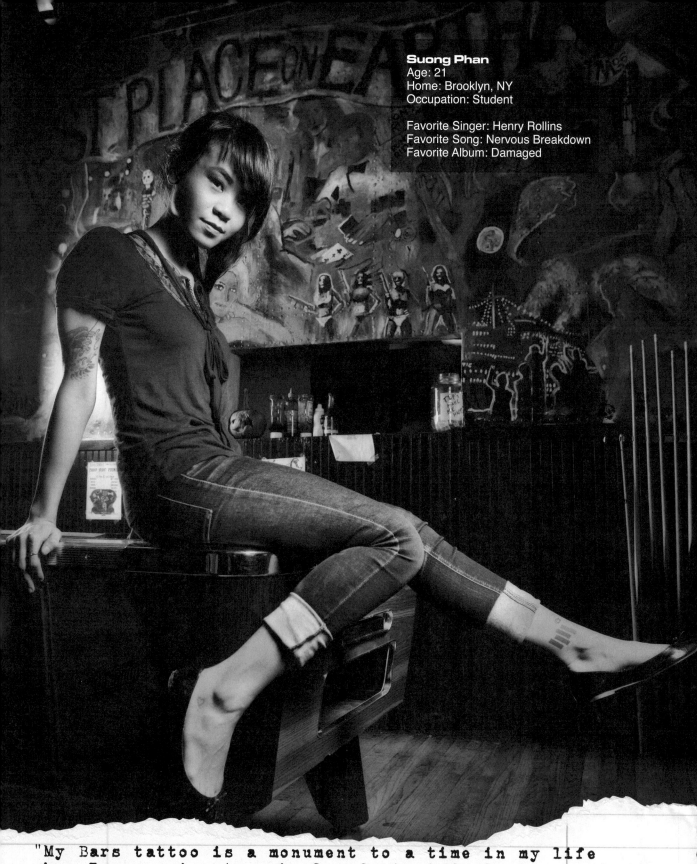

Suong Phan
Age: 21
Home: Brooklyn, NY
Occupation: Student

Favorite Singer: Henry Rollins
Favorite Song: Nervous Breakdown
Favorite Album: Damaged

"My Bars tattoo is a monument to a time in my life when I was going to school and started playing music seriously. It was a point in my life where I knew where and what I wanted to be. I had figured myself out."-S.P.

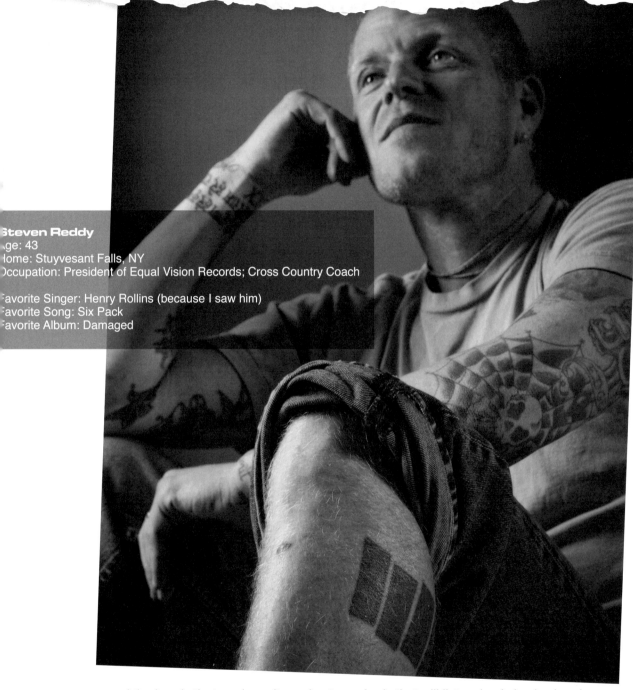

Steven Reddy
Age: 43
Home: Stuyvesant Falls, NY
Occupation: President of Equal Vision Records; Cross Country Coach

Favorite Singer: Henry Rollins (because I saw him)
Favorite Song: Six Pack
Favorite Album: Damaged

and the bands that made up its ranks, to anybody that will listen. I only bash when I deem it completely necessary, or, because I am only human, when it is fun to do so.

AND WHERE DO THE BARS FIGURE INTO THIS RANT?

As I see it, The Bars, the most iconic of Punk band logos, seem to outshine their role as merely representing the band Black Flag. After all, Black Flag died long ago, but The Bars do not just reflect a dead musical entity. Somewhere along the way, a cult of The Bars emerged and became an important cultural phenomenon unto itself. Once, The

"The Bars represented everything that I felt about teenage rebellion;
they were so much more than just an anarchy symbol... I would never
cover up my Bars. If somebody wants to cover up a tattoo I recommend
that they cover it up with The Bars. And, if they are thinking about
covering up The Bars I recommend that they cover them with bigger
Bars."-M.M.

Matt Marsh ▶
Age: 34
Home: Sunbury, OH
Occupation: Air Pressure Technician for AT&T

Favorite Singer: Henry Rollins
Favorite Song: TV Party

◀ Frank Bucalo
Age: 26
Home: Brooklyn, NY
Occupation: Dog Walker

Favorite Singer: Henry Rollins
Favorite Song: Six Pack
Favorite Album: Jealous Again

"I don't always feel an instant connection
with others who have The Bars tattoo.
Not everybody with The Bars is a person that I want
to be friends with, nor do I think that they are all
the best people. We might have the same view on some things,
but not everybody is cool. Some people just suck."-F.B.

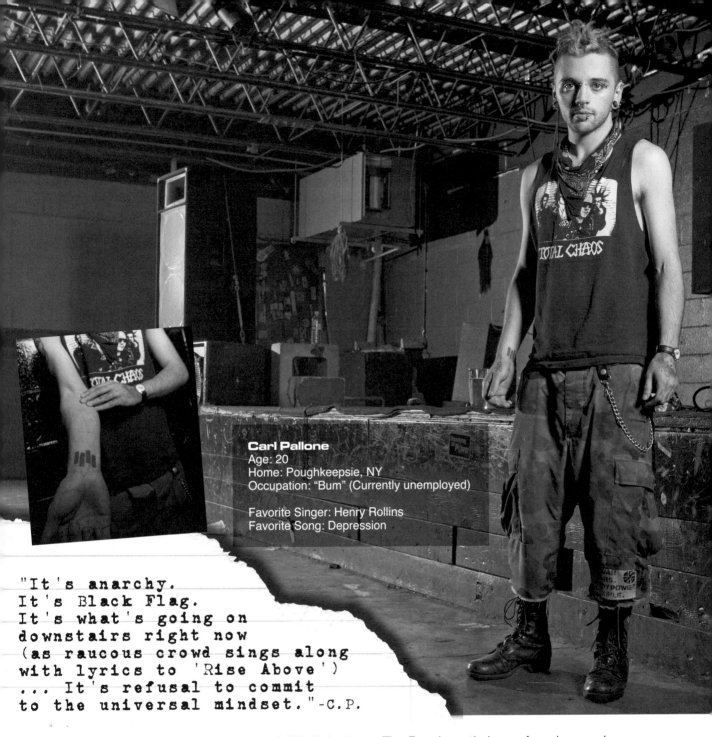

Carl Pallone
Age: 20
Home: Poughkeepsie, NY
Occupation: "Bum" (Currently unemployed)

Favorite Singer: Henry Rollins
Favorite Song: Depression

"It's anarchy.
It's Black Flag.
It's what's going on
downstairs right now
(as raucous crowd sings along
with lyrics to 'Rise Above')
... It's refusal to commit
to the universal mindset." -C.P.

Bars and Black Flag were indelibly linked; now The Bars have their own fans, lore, and impact. The Bars didn't die with the band. They can be found from mundane places to bizarre locales. Look around where you are right now and you might see The Bars. From the guy behind the coffee counter wearing a Black Flag shirt or Hank Williams III reconfiguring them to use for his own public image, The Bars have snuck into dominant culture, yet they still speak to subverting-the-system rather than selling-us-product. Pretty cool, right?

My whole point may be best summarized by a Black Flag parody T-shirt. The entire front of the shirt, one of seemingly millions of such shirts flooding the Internet marketplace, was dominated by a multitude of Bars. However, instead of the text

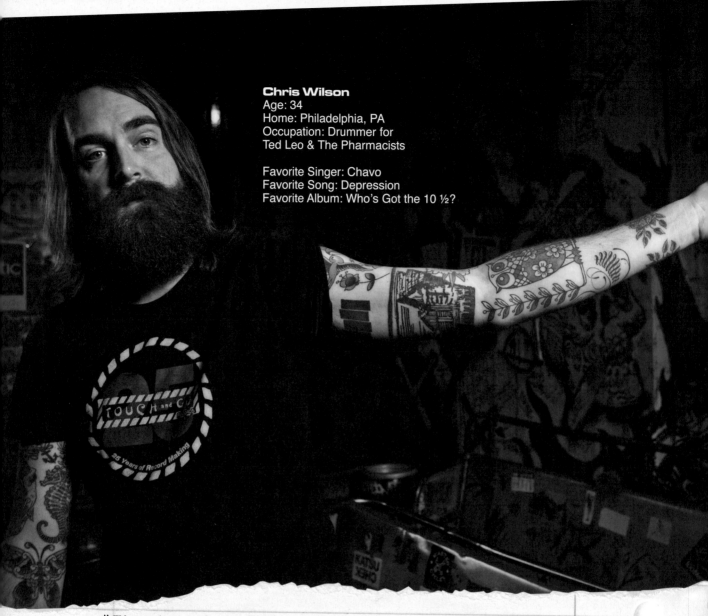

Chris Wilson
Age: 34
Home: Philadelphia, PA
Occupation: Drummer for
Ted Leo & The Pharmacists

Favorite Singer: Chavo
Favorite Song: Depression
Favorite Album: Who's Got the 10 ½?

"The touring I do now wouldn't have been
possible without Black Flag having done it
first. They proved it was possible being a
Punk band in the middle of nowhere and being
successful with it."-C.W.

reading "Black Flag," as one would typically expect, it read, "You don't actually like Black Flag, you just think the logo's cool." That statement bares some modern truths. Yes, Black Flag was a singular, powerful band. But, yes, The Bars really have become an unbound symbol, like a virus that just spreads and spreads irrespective of its body of origin. Look closely at those four rectangles, and you can see a cute little waving black flag representing anarchy, the stateless state, and DIY politics. The Bars proclaim, "No Gods and No Masters," and proclaim it loudly!

Now, some three decades later, the entire spirit of Punk Rock seems to be wrapped in The Bars; a symbol that mutated from simply representing one of the fiercest bands on

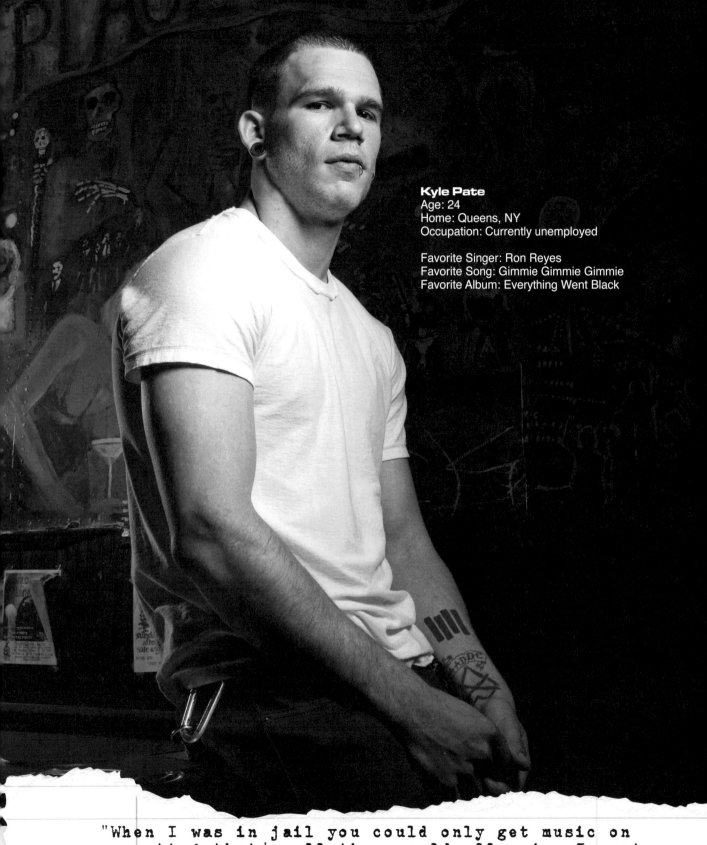

Kyle Pate
Age: 24
Home: Queens, NY
Occupation: Currently unemployed

Favorite Singer: Ron Reyes
Favorite Song: Gimmie Gimmie Gimmie
Favorite Album: Everything Went Black

"When I was in jail you could only get music on cassette; that's all they would allow in. I wrote to SST and ordered Bad Brains and Everything Went Black. They sent those plus all the Flag EPs. That's all I listened to while I was in jail."-K.P.

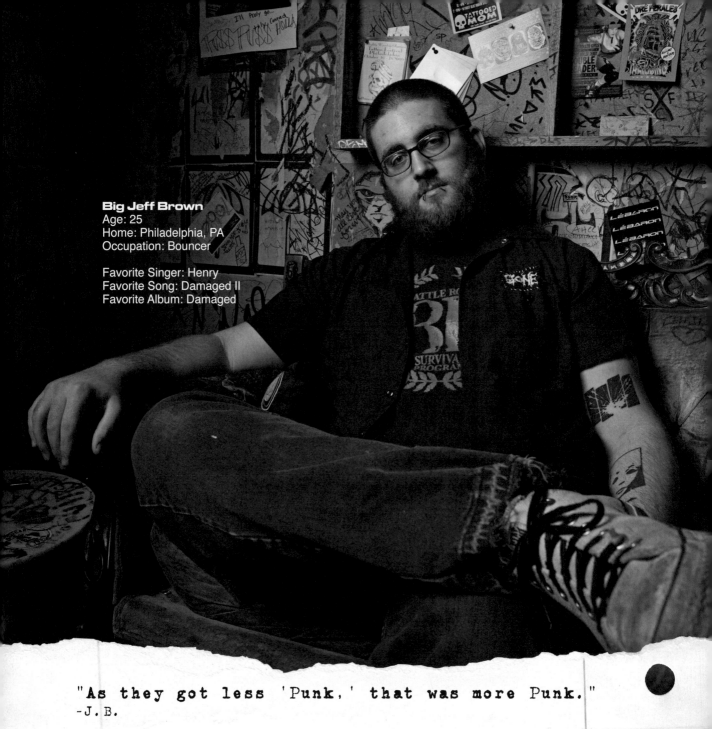

Big Jeff Brown
Age: 25
Home: Philadelphia, PA
Occupation: Bouncer

Favorite Singer: Henry
Favorite Song: Damaged II
Favorite Album: Damaged

"As they got less 'Punk,' that was more Punk."
-J.B.

the cultural landscape to becoming an international symbol of Punk Rock unity. Obviously, I think this is something worth celebrating!

The Bars have officially risen above their former station. They have their own halo and their own wings. The Bars have outgrown their initial purpose. In fact, Black Flag has become a bit of a slave to The Bars, much like the Misfits owe much of their modern fame to the Crimson Ghost image so loved by Punk Rockers across eras. While Black Flag's legacy is now being rediscovered by a whole new era of pissed-off kids eager to see Off!, a Keith Morris offshoot that emulates Black Flag, The Bars never really went away at all. To their credit, they made sure Black Flag didn't disappear either. I certainly view my Bars more as a testament to my involvement in Punk Rock culture than as

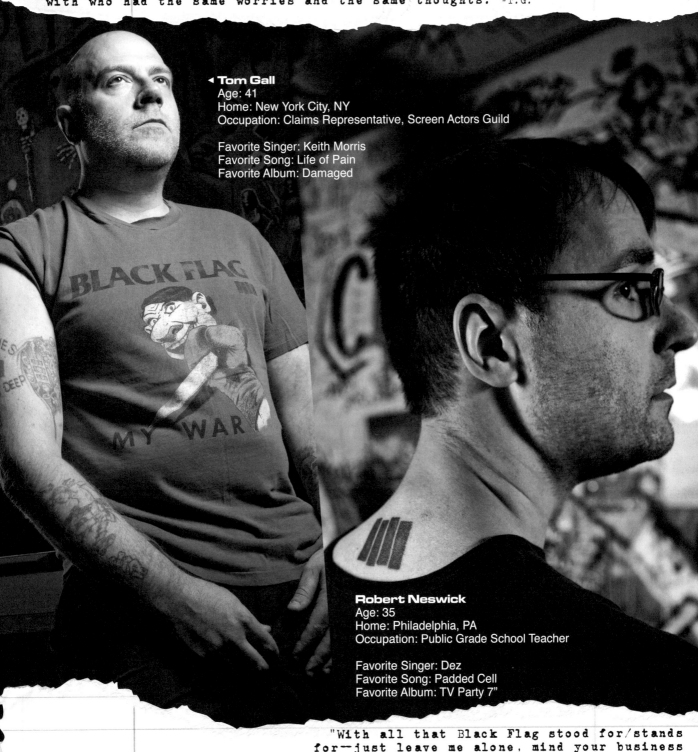

"I knew I was part of 'it' and 'it' was part of me, and I knew I had to do something to show that. Black Flag was speaking my language when no one else was. I was kind of a misfit kid, and they were the only ones telling me there were other misfits out there to hang out with who had the same worries and the same thoughts." -T.G.

◄ **Tom Gall**
Age: 41
Home: New York City, NY
Occupation: Claims Representative, Screen Actors Guild

Favorite Singer: Keith Morris
Favorite Song: Life of Pain
Favorite Album: Damaged

Robert Neswick
Age: 35
Home: Philadelphia, PA
Occupation: Public Grade School Teacher

Favorite Singer: Dez
Favorite Song: Padded Cell
Favorite Album: TV Party 7"

"With all that Black Flag stood for/stands for—just leave me alone, mind your business and let me do what I need to do—it still resonates with me as a 35 year-old as much as it did when I was a kid. Those who know what it means get it, and those who don't get it, that's fine by me. We all know where we're coming from." -R.N.

"Giving up on 'normal' and finding something new and better is the Punk Rock path. Luckily, most of us lived to tell about it."

a reference to the idol worship of Black Flag. I would never lump the entire history of Black Flag into one easily digestible visual pill and then to have that pill tattooed onto me. No, The Bars, Black Flag, my association to the Punk Rock culture, and my continued disdain for traditional forms of authority are far more complicated than can be summed up with just an image; a tattoo, but it is a start.

So, then, *Barred for Life* is not so much a documentary about Black Flag or a chronicle of early 1980s Hardcore Punk Rock culture, but represents a recollection of my thoughts, recent photos, and missives told by people most frequently missing from the official record: the anonymous faces in the crowd that have long been the life's blood of the scene across its lifespan and those that still believe that participating in the Punk Rock underground amounts to meaningful, worthwhile, and life-changing opportunities.

More importantly, this volume represents nearly five years' worth of research, photography, and interviews conducted during numerous road trips and one international tour, all completed via a few fundraisers for the cause, and without the aid of moneyed sponsors. *Barred for Life* is as DIY as the road paved by early Punk Rock pioneers. At every step, we experienced unexpected surprises and many, many missed opportunities. With little capital and essentially no advertising budget, we traveled halfway around the world to document a formerly localized image that, while few were paying attention, became a universal phenomenon, as recognizable in some circles as some multinational corporate images.

To end, I feel this compilation of words and images speaks to, and for, people that are, were, or ever will find their way from the mainstream into the Punk Rock underground (or any politically and socially radical subculture). Giving up on "normal" and finding something new and better is the Punk Rock path. Luckily, most of us lived to tell about it. As for me, it all started something like this . . . ■

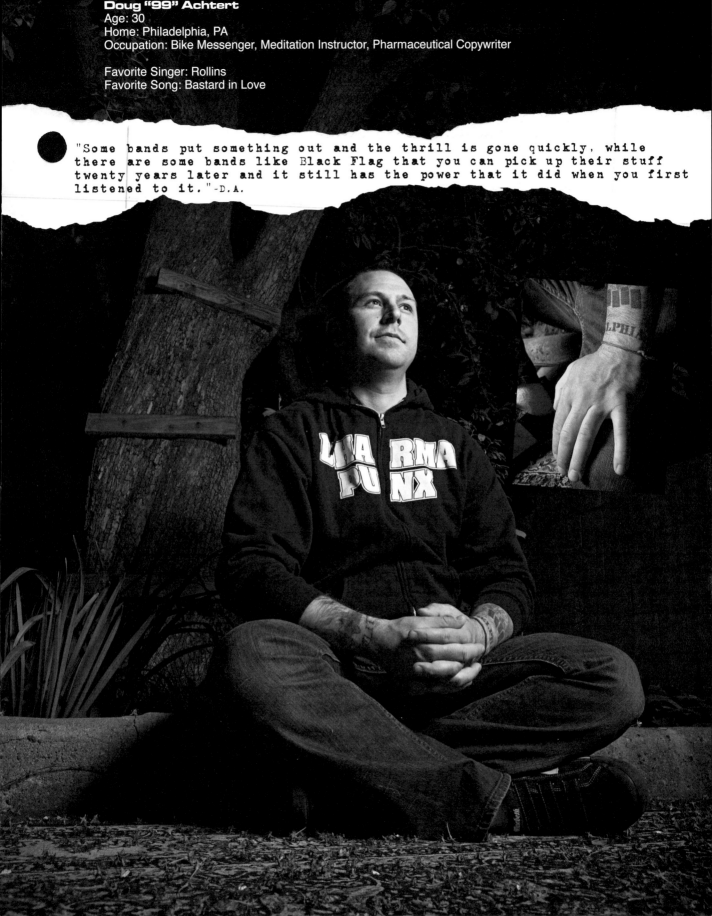

Doug "99" Achtert
Age: 30
Home: Philadelphia, PA
Occupation: Bike Messenger, Meditation Instructor, Pharmaceutical Copywriter

Favorite Singer: Rollins
Favorite Song: Bastard in Love

"Some bands put something out and the thrill is gone quickly, while there are some bands like Black Flag that you can pick up their stuff twenty years later and it still has the power that it did when you first listened to it."-D.A.

INTERVIEW

WE ARE BLACK FLAG. WE ARE GOING TO DO THINGS OUR WAY.

DEZ CADENA

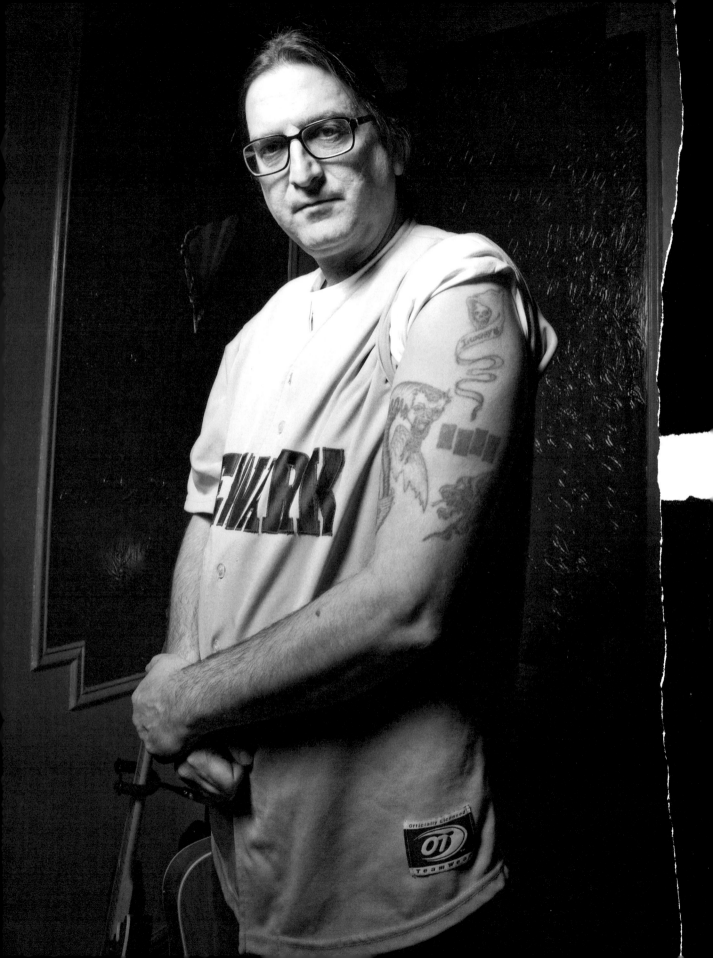

> **"We all moved in together into the same space, sort of like a commune. In a way, it was like giving away all of your worldly possessions and joining the Manson Family or the Hare Krishnas. It was like, 'If you're going to be in this band, you really cannot afford to have a job.'"**

DEZ

IN THE NAME OF THE JAZZ FATHER

I grew up in Newark, NJ. When I was thirteen, my entire family moved to California. After my father left the service after World War II, he developed a career in music in the late 1940s and early '50s. First, he was a bass player, but when he married in 1950, he didn't want to live the lifestyle of the musician and decided to put that part of his life away. He moved more into the production end of music. So, he got married and settled down but was still involved in music.

In the 1950s, he worked for Savoy Records, a very popular Jazz label. We stayed in Newark through the 1960s as riots happened in New York and New Jersey. New York City was pretty much bankrupt under Mayor Lindsey. Since my father went to California a few times in his life for the military and music, and produced records for Fantasy Records, he knew about this famous Jazz club called the Lighthouse, a club in Hermosa Beach. He fell in love with the town and decided to move us there in 1972.

My mom thought my dad was crazy. She was like, "I've lived in the same house for thirty-seven years with my mom in the basement, my older sister down on the second floor, and we're on the third floor. Now, you're taking me where?" Thirty years later, as my dad was getting older, he would say, "Maybe we should just move back to Jersey." He never lost his affection for New York and New Jersey. When he suggested moving back to New Jersey, my mom said, "After thirty years here, now you want to move back?" I ended up doing it, but she's still in Hermosa Beach with my sister at the Lighthouse, keeping his music going and booking Jazz talent.

CALIFORNIA DREAMING

I remember that California was very golden when I first moved there, always very sunny. In terms of style, people seemed backwards and slow, not that it mattered that much to me. I could tell such a thing when I was ten or eleven years old. On the

East Coast, we'd already gotten past the hippie thing, and by that time people were already dressing like *Saturday Night Fever* four years before the movie—guys in wife-beater shirts, greased back hair, jewelry, the medal of St. Christopher, or the little pepper that Italians wore. The hippie thing was gone.

When I moved to California in 1974, everybody looked like hippies. It left a weird impression on me.

When I was in the eighth grade, I went to a Catholic school called the Our Lady of Guadalupe out in Hermosa Beach. Kids were supposed to be well-behaved because they go to a Catholic school, and their parents paid money for them to go to school, but it was like a walking Cheech and Chong movie.

The kids weren't going to church like they were supposed to. All the kids in my class would come back from a holiday weekend and were like, "Yeah, I went to go visit my dad this weekend." Not that in NJ we didn't have any divorces, but when we did, everybody knew about it because everybody on the block was talking. But every kid in my class in California was spending the weekends with dad or mom. I thought it was strange, like, "You're going to visit your mom. Isn't she just in the next room?" California was more like a free and easy lifestyle. The area was very docile, a party area. A lot of people go, "How did Black Flag come from a place like this?" Sometimes the best things come from an area where the environment isn't so violent, isn't so crazy, or isn't like New York or Newark, New Jersey, and somebody just wants to stand out in some way, shape, or form.

[It seemed] to me, people would jump right into the California lifestyle or be repelled by it. In some ways, I just accepted it, but I didn't jump into the lifestyle. I stuck with the music. The music was my thing. Everybody was riding skateboards and surfing, had blonde hair and tans, and ate granola. I was still eating burritos and hotdogs. I always knew

I was an individual. I just stuck to the things that I liked to do, which was to play the guitar.

LOS ANGELES: THE GREAT ROCK'N'ROLL MELTING POT

By the time I was in high school in 1975, Punk Rock wasn't called Punk Rock yet, but those kinds of bands were starting to form in NYC, like the Ramones. My older brother was into the rock thing, but due to my father I had Jazz, Blues, R&B, and Gospel, and Americana too. I started guitar lessons in California and ended up gravitating to a group of maybe four or five people in the whole school into bands like Led Zeppelin, or maybe into a little bit of Glitter-Rock like T-Rex and David Bowie, maybe Brian Eno.

I remember going to a thrift drug store and finding the first New York Dolls album and the Velvet Underground record with the banana on the cover. Sometimes we would just buy the records for the cover. It was crazy. A record with a banana on the cover? The Velvet Underground? These records would be cut outs, so they would be two dollars instead of four dollars, and sometimes even a dollar.

By the time I was a sophomore and junior, my friends and I sought out alternative music magazines, like *Rock Scene*, that had the Ramones and Patti Smith. We'd be like, "Oh, this is the Ramones. They look pretty funny." Then the album came out, there were no guitar solos, and they all had pageboy haircuts—long hair with bangs—and the magazines started calling this "Punk."

DJ Rodney Bingenheimer on KROQ 106.7 FM in L.A. was a scenester guy who knew every band from Sonny and Cher to the Germs. Rock stars used to go to his English Disco, where Rod Stewart would hang out with riff-raff, or maybe David Johansen and Lou Reed, and party together in Hollywood.

[At the time] his radio show, whether it played the Bay City Rollers or the Germs, was very important. He would get acetates, test pressings of

"Black Flag played two songs, Ron's girlfriend was in the audience, somebody hit her, he jumped off stage and grabbed her, and then he quit the band."

a single before the actual record came out. It was like, "Here is the new single by . . ." and he could never pronounce the title right. I remember he said, "Antarctic in the UK" and played the acetate two weeks before it was even out in England.

I was always into searching out music. As 1976 and '77 came rolling around, we started noticing these bands from New York and London, and we got hooked up with this place in Hollywood called The Masque, which was the first underground club in Los Angeles. Los Angeles bands were Johnny-come-lately bands, but there were tons of them. You didn't have to like all of them because they were all different, but they would all play The Masque. The Whiskey had Johnny Thunders, the Damned, Television, and other people from that era. I saw Cheap Trick there after their first album came out, and Judas Priest before anybody knew them. We'd see the album covers, then say, "These guys are playing at the Whiskey. We should go see them."

DEZ

L.A.'S YARD-SALE CULTURE YIELDS A CONSPICUOUS FRIENDSHIP

I waited until I was like seventeen or eighteen when I played my first show with Red Cross (later known as Redd Kross). I had already met Black Flag and Red Cross, and people from the South Bay scene, which was a separate little L.A. contingency down at the beach where we lived. Ron Reyes, the person who sang in Black Flag before me, and I lived on the same block.

Garage sales are a big thing in California. Ron came to one of my dad's Saturday yard sales. My dad put me in charge of it because he had something to do, so I opened the garage door and put things out. I saw this kid walk by with a ripped white jean jacket. He was Spanish-looking, and his jacket had buttons on it. I had clothes with buttons on them, and some clothes where I had written "The Weirdos" on them. He heard the music I was playing and was like, "You like this kind of music?" At the time, I was listening to some of the Punk Rock stuff I had, maybe some Bowie, and a little Zeppelin.

After a few garage sales, Ron comes over and says, "Hey, do you want to go down to this old church converted into an arts and crafts center, where this band called Panic practices tomorrow?" Both of us read all of these magazines from all over the world and knew there was a Punk Rock band called Panick from England, but they spelled their name with a "K" at the end. I asked him if it was the Panick from England, and he assured me it wasn't the English. "I think they are changing their name to Black Flag," he said. I was like, "Sure. Whatever. Let's go!" The next day, I go down there and meet Chuck, Greg, and Robo.

Around age five, I figured out I was gonna play music for a living. For me, when I finally joined Black Flag, it was easy because they needed a singer. I wasn't a singer, but they asked me, and they were, at the time, my favorite band. I had tried to write a few stupid Punk Rock songs and played with Saccharine Trust and Red Cross. There were a

lot of cover bands in L.A.—even Van Halen started out as one. I didn't want to do that. So, the beauty of Punk Rock was it really helped me learn to play with people, which, as it turns out, was important.

DRAWING THE LINE IN THE SAND: US VERSUS THEM

In our little part of town, only a handful of people knew about this music. All the other people were living in Hollywood or going to The Masque. Surfers, who would eventually get totally into Punk Rock and Hardcore, would go, "I am gonna kick your ass, Devo fag!" They would challenge friends of mine. They didn't even know the word Punk Rock yet. The kids with the skateboards, they weren't us. The song "Wasted" was a parody of people who got wasted every day at the beach. "I had a skateboard. I was a hippie. I was so heavy man I lived on the Strand," was making fun of all of these people we had to deal with while growing up.

Black Flag played their first gig at the Moose Lodge in Redondo Beach on Pacific Coastal Highway two blocks from my house. They threw the show themselves because they couldn't get gigs in Hollywood since they weren't from Hollywood. The bands in that scene were kind of like, "One guy still has long hair. He must be a poseur. I don't know about them." The bill included Black Flag, a band called Rhino 39 from Long Beach, and a band called the Alley Cats, who played every gig with everybody. Even though Greg rented the place himself, they decided to play first.

The space was a Moose Lodge serving twenty-five-cent beers, but everybody bought their liquor at the liquor store on the corner and drank in the parking lot, so they didn't go inside to drink. There were like five old men and one hundred Punkers. Rodney Bingenheimer was there, and he brought Stiv Bators of the Dead Boys. When Black Flag came on, Keith already had a few beers, and at the beginning of the set he grabbed an American Flag and swung it around. I forget what song it was, and the owner goes, "That's it. You guys aren't

allowed to play here ever again. Get out! The rest of the bands can play but you guys gotta get out!"

So, the Alley Cats and Rhino 39 played. After that, Greg put a hippie wig on Keith, and Black Flag got back on stage as another band. They made up a name, and they just played their twenty-minute set only with Keith in a wig. The guys from the Lodge didn't even know. They played the same songs because they didn't have any more than maybe twelve songs. If they needed more time, they would do this long, long, long extended version of "Louie Louie." That was it. Their set was about thirty minutes.

[Not too long after that gig], in late 1979, Keith left the band.

ENTER/EXIT RON REYES

Ron and I were hanging out with Black Flag, and they picked up Ron right away. He lived with them and rented a closet space at "The Church." Robo was also sleeping in there too. He had built a bunk in the closet: Ron slept on top and Robo on the bottom in a sort of party room with graffiti all over the walls. Remember, this was the basement of a church.

Ron was playing in Red Cross at the time, and I hadn't even started in Red Cross yet. All this progression happened to each person very quickly. Ron played with them for about six months, while I kind of followed in his shadow. He ended up singing in Black Flag just by renting a room there. We were kind of a pair, and he tried out singing for them, and they said yes. He ended up singing for just about six months, which they filmed in *The Decline of Western Civilization*, so it is well documented.

Six months later, he quits on stage at another gig at the Fleetwood. Black Flag played two songs, Ron's girlfriend was in the audience, somebody hit her, he jumped off stage and grabbed her, and then he quit the band. After that, Black Flag invited the whole crowd up on stage to sing this fifty-minute version

"Certainly, nobody in the band had them. I got them in 1980, the second time I had gone to San Francisco. I don't remember the name of the shop, but Mabuhay Gardens was on Broadway right near Chinatown, next to strip clubs and x-rated places. Right across the street were two tattoo shops. I went to the smaller mom-and-pop one because I felt sorry for them since the other one was a popular place where everybody would go."

DEZ

of "Louie Louie." I watched from this balcony. The Fleetwood was an old theater, and it had this old booth where they showed the spotlight. A friend and I snuck up there. We didn't have to deal with people, so it was great. People were singing and screaming and pulling down their pants.

ENTERING THE RANKS OF BLACK FLAG AND THE EMERGENCE OF "HARDCORE"

Ron moved to Vancouver with his girlfriend. I was in Red Cross at the time, but we weren't doing much.

I went down to the Church one day. Chuck had this old beat-up Impala with Bondo all over it. He was like Fonzie. He would hit the trunk, and the trunk opened. He reaches in there and has this beer everybody was drinking, Burgermeister—Bergies. They only came in sixteen-ounce cans. It was midday in July, and he offers me one. It must have been as hot as a cup of coffee. I was like, "Yeah, sure," because we would drink anything in those days. He says, "We leave next week for Vancouver, and we're doing this little tour to San Francisco, Portland, Seattle, and then Vancouver." I asked who was singing, and he said, "That is what I wanted to ask you. Do you want to try?"

"I play guitar, I am not a singer." Chuck was like, "Yeah, we know you play guitar, but we've known you a long time, and we know that you know all of our lyrics." I told him I didn't know every exact line, but I would try. They were like, "Fine, you want to go?" I said, jokingly, "Let me check my calendar. Nope, nothing going on." I joined the band at that moment.

In 1980, they went six months without a singer. At the beginning of summer, we noticed a contingent from Orange County. The music started to change. The Germs might have been detrimental due to their manic music, and Black Flag too, but it started becoming faster. It wasn't just Punk Rock anymore. People started calling it Hardcore, or Hardcore Punk.

The fans were bored white gangs from down in Orange County, where mostly Republicans live in this concentrated area. Other than surfing and skateboarding, the kids have a very boring lifestyle. Because it is between L.A. and San Diego there are a lot of military brats with nothing to do but form gangs. When this music, which is a lot of fun to skateboard to in somebody's pool, came along, these kids got into it. They cut their hair. Suddenly, it was no more "Devo fag." It was like, "Hey man, you're hardcore," with the bandanas and the whole way of dressing. Suicidal Tendencies? They were white kids that took the whole idea of bandanas and wife-beater shirts from the Mexican cholos. That whole style of dress, and the intimidating look, wasn't Punk Rock, it was Hardcore.

We had this mailing list, and about three quarters of it was from Orange County. Greg had been battling the city of Hermosa Beach for many, many years, as long as they were rehearsing there. Even during his high school years, he used to hang out at this place that used to be called the Würm Hole, which was this old bathhouse down by the beach where everybody sold weed before I moved to California in the early 1970s.

The police knew the people at the Würm Hole. There might have been ten policemen in Hermosa Beach at the time. They would always give them a hard time for rehearsing and the noise and give them tickets. Greg always wanted to get back at the city. Things had gotten to a boiling point. Greg decided he was gonna throw the final party at the alter of the famed Church. We didn't really have a PA, so we would just plug in a guitar amp and sing. We would get as much beer as we could to supply the people to start getting them drunk, like throwing Christians to the lions. It was like that. It was the whole plan.

The night before we were supposed to leave for the tour, we throw this party. All these people come down from Orange County. We're talking about three hundred people on our mailing list showing up from Orange County versus maybe ten police in

Hermosa Beach. Hermosa is a town that is about one-mile by about one-mile. The fans broke all the big stained glass windows and even windows across the street. We played, got in the van, and took off. The whole plan was to leave and never come back. Greg had already rented a place out in Torrance. Everything got destroyed, so the local free paper wrote an article stating, "Hermosa Beach police kicked Black Flag out of the beach area because of Punk Rock violence." It is not true. Black Flag left Hermosa. We were not kicked out.

THE BIRTH OF THE BARS TATTOO AS THE PUNK ROCK HANDSHAKE

I didn't know anybody that had Black Flag bars before I got them, but somebody could have. Certainly, nobody in the band had them. I got them in 1980, the second time I had gone to San Francisco. I don't remember the name of the shop, but Mabuhay Gardens was on Broadway right near Chinatown, next to strip clubs and x-rated places. Right across the street were two tattoo shops. I went to the smaller mom-and-pop one because I felt sorry for them since the other one was a popular place where everybody would go.

There were people in Punk Rock with tattoos, but they were mostly like broken hearts with arrows through them, or guns, but they were mostly traditional types of tattoos. You didn't see a lot of people out there with, say, a Sex Pistols tattoo. I'd seen a Germs tattoo, a blue circle, that evolved from cigarette burns those guys used to give to each other called the "germs circle," but never Black Flag. I thought getting a tattoo of a favorite band would be cool, but I never did. Being in Black Flag, I figured, "Here I am. It's a pretty cool, fucked-up situation, so I can do anything I want." I didn't mention it to anybody in the band, so while we were waiting for sound check I decided to do it.

I asked Greg for a copy of the single and told him I wanted to give a copy to one of my friends. The single had The Bars on it. The Bars are such an easy thing, and I probably could have described them to the guy, but I wanted to go to the tattoo artist with

a picture. I think that it cost me twenty-five dollars. It was just The Bars. It didn't say Black Flag or anything. I had this bandage over it, went back into the club, and sat beside Chuck, who sees the bandage and asks, "Did you hurt yourself? What happened?" I was like, "Yeah, I hurt myself" and pulled the bandage off. Chuck was blown away. He was like, "Wow." Most tattoos were of mermaids or ships, but I had this tattoo of a band they started, and they were blown away.

TAKING CARE OF HARDCORE BUSINESS: SST EMERGES

We would go shopping around Hollywood with our demo, but we weren't going to William and Morris, the music lawyers, asking how music law was done. As for our work ethic, we knew we couldn't rely on anybody else; nobody wanted to even look at us as far as record companies were concerned. We were against the whole corporate rock thing, and that is cool, but it may have hurt SST down the road since they didn't know how things run and how musicians should take care of their publishing—all the basic things a musician needs to know just to take care of himself. So, it was a very underground, anti-industry thing. *Damaged* might be gold right now, but I don't think Greg ever checks. The basic attitude was, "We are Black Flag. We've got nothing to do with that. We are going to do things our way." It may have hurt them.

A rehearsal was a five-hour ordeal every day. We'd rehearse for two hours, go and eat, and then come back later and practice for another two hours, and then the other guys would go and work in the office. I was more like, "You guys are doing just fine. Get Raymond's artwork and do whatever it is that you are going to do." I was not a desk person. They were more into that. They were into running the record company besides being in the band. For me, I was just happy to get to play. It took discipline and was a fairly long, regimented day. Sometimes, you had two practices, sometimes three, to the point of being mindless. You just did it. You didn't think about it anymore.

We all moved in together into the same space, sort of like a commune. It was like offices, and we put curtains over these desks made out of two-by-fours. Underneath we'd put a mattress, and that is where we slept. This went on the entire time I was in the band, maybe two and a half years. They did it afterwards, with Kira and other people in the band. Wherever they had their office and practice spot, they lived there. In a way, it was like giving away all of your worldly possessions and joining the Manson Family or the Hare Krishnas. It was like, "If you're going to be in this band, you really cannot afford to have a job."

You couldn't run a separate business on the Internet while sitting at the SST desk. Before Black Flag, I put O-rings in regulators in scuba gear. We had just come back from a Public Image Ltd. show where we had all taken LSD the night before. I came in at seven in the morning, and I was putting O-rings into the regulators meant to regulate the amount of air a diver would breath underwater so he or she wouldn't explode. Still going from the night before, I was thinking, "I might be murdering a bunch of scuba divers." But once I joined the band, I couldn't afford to have a job.

NAVIGATING THE BYWAYS OF THE AMERICAN UNDERGROUND

Black Flag was influenced early on by the Ramones, who never stopped touring with a van. They never had a big tour bus. By the time they broke up, a couple of them had a few bucks tucked away. They had a work ethic. You could credit Black Flag for the "Hardcore Work Ethic," but I know that Greg saw the Ramones pile out of a van. We were like, "They must be big. They have two albums. They are on a record label." Yet, they had this van, and a lot of times they had a crew in there with them, and they had a trailer.

We saw the Ramones in 1976. It was kind of like being in a Cheech and Chong movie. We were expecting a big tour bus. The door opened and smoke rolled out of a beat-up 1969 Econoline van.

DEZ

Dee Dee fell out onto the concrete. Greg said it in interviews, and said it to me, that he understood that was "the way to go." Black Flag toured like that. Black Flag went to a hardware store and built a loft-like bunk where everybody slept like sardines in a can and underneath we put amps. That is how we traveled. If we had rolled the van at any time, we wouldn't be having this conversation right now.

You have to book a tour, but you cannot afford a gigantic phone bill, so you buy a stolen phone card number from a guy on a corner that looks like he should be selling crack or something. You have a big notebook of numbers from around the country of clubs and promoters. You use this card at a payphone so that the stolen credit card number cannot be traced to your home phone. Booking whole tours illegally takes discipline too. You cannot use your own phone because you'd have this phone bill of hundreds of dollars a month.

Greg's label SST put out the first Black Flag single, "Nervous Breakdown," then put out the Minutemen's "Paranoid Time" single. Early tours included bands they liked to play with, like DOA and Subhumans from Vancouver and the Mutants from San Francisco. But when they started touring with me, every town had a band called Toxic Shock, garage-like and similar to each other. These people didn't know that only fifty miles away there was another band called Toxic Shock that sounded like them and dressed the same way. There is nothing wrong with that. There was no Internet. People communicated with just flyers. We got tired of going to small clubs with shitty PAs and getting hopes up to see a new band that turned out to be less than what you expected. After I left Black Flag, they brought a whole PA company with them and SST bands. My band DC3 toured with Black Flag. In other words, why should we have to deal with having an inferior show? The tour wasn't just about Black Flag, it was the entire SST package.

Once and a while, you played with bands like the Big Boys and the Dicks down in Texas. We loved them. Then there were the Effigies from Chicago, but there were just a handful. We were always looking for stuff with originality, not just loud and fast. We created our own little community of bands. Once I was in the band, they really started getting serious about traveling: first, all around the country several times, and by the time I switched over to guitar and we had Henry singing, we made it to England.

BLACK FLAG D-DAY: THE BRIT-PUNK FIASCO

Other bands had gone before us. X and the Dead Kennedys had gone to England. Nobody did it like we did, though. We suffered. We decided to take on a tour that was probably ten or twelve shows in England with the Exploited. After 1980, Punk Rock in the UK had become bands like the Exploited and Discharge, and here in America we were always

"Chuck was blown away.

He was like, 'Wow.' Most tattoos were of mermaids or ships, but I had this tattoo of a band they started, and they were blown away."

"It is a mission for musicians to play what they want to play. Black Flag's mission was a little different from that because they wanted to do everything their own way."

acting out against that by growing our hair and beards because we believed that Punk Rock meant no rules, yet these bands were giving us rules. Before, other people gave out the rules, and now Punk guys were giving us rules. We didn't have mohawks or spiked hair, we didn't wear chains, have a tattoo of a swastika on our heads, wear spikes and leather, and didn't dress Punk.

When we showed up in England, we looked like a bunch of trolls living under a bridge. I had a beard and kind of long hair. You tell people we were the most notorious Punk band in America, and we show up looking like homeless people. Basically, the Exploited didn't sell enough tickets for the entire tour package. They ended up playing a couple of shows with us before the singer faked a broken leg. We played one show with them, and then we had another show a few days later in London, and he came out using a cane. It was in the papers that the Exploited wouldn't be able to do the tour, except one last show at the Rainbow in London.

The Exploited start playing, Wattie starts dancing and throws the cane out into the audience, and he was laughing. Black Flag was a support act. We are in England, we play two shows in London, and all of a sudden the rest of our tour is gone. We were like, "What are we gonna do?" It was the middle of December, and we were staying with two American girls in Shepherd's Bush. Luckily, two American girls put us up because nobody in England was going to even look at us. We didn't behave like Sid, you know what I mean? We looked like the Allman Brothers Band. We didn't have mohawks or spiky hair. But we did it. We had flights for two weeks later, so what were we supposed to do? We could have changed the flights, which would have cost us a lot of money, and we didn't have any more money. We called all of the clubs and the agency we were dealing with and told them that we were going to play all over England.

The people that we met helping us with our tour were very nice and friendly. But the crowds were very drunk and belligerent. I think when you're labeled "the most notorious Punk Rock band in America," people challenge you on the street, or wherever. They will do something. The skinheads wanted to see how we'd react. You might whack the guy over the head with your guitar because you are so mad, but that would have killed somebody, and that could have been a big problem. We could have ended up in a "London Dungeon," right?

[To make the point,] we were playing at the Marquee Club in London, with Henry singing, and I am stage left. Chuck is right beside me. A bunch of skinheads show up. One of them turns around, pisses in his cup, and since they were throwing beer on us anyway, I didn't really notice, but this guy hits Chuck square in the face with the cup. I didn't know it was piss, and I was right next to him. If you've ever noticed, a cup of beer looks an awful lot like a cup of piss. I started to smell something, and when I looked over at Chuck, I could see his face turn blue. He was out behind his amp getting sick, and other than somebody getting physically hurt, I've never felt so bad for somebody. They might have been aiming for me because I had longer hair. That was the type of reaction that we were getting.

[To make things worse,] we lost Robo at the end of that trip. He didn't want to go [in the first place]. By then, for some reason or another, he wasn't happy with the band even before we had made plans to go

DEZ

to England, but Chuck convinced him to go. Now, Robo is Colombian, and he probably had to get a certain type of visa for the trip, and he couldn't get it in time. At that time, people would look at anybody with a Colombian passport a bit differently than they would look at me because of all of the political stuff that goes on in Colombia. He has nothing to do with that, obviously, because he is just a musician. They wouldn't let him board the plane with us to come back, and they wouldn't let him stay there. So, I guess that his only other option was to go back to Colombia.

BACK TO AMERICA, IN A STATE OF FLUX

When we got back, we had shows lined up in New York and Chicago, and some here and there on the way home, maybe about eight shows [in total]. The only person we thought could fill in for Robo was Bill Stevenson, since he was such a big Robo fan. Bill Stevenson didn't end up joining the band at that time. He just filled in for the rest of the tour. He already had his band, the Descendents, and we just didn't know where Robo was going. They didn't tell us anything.

We landed in New York and had a gig at the Mudd Club, a pretty important New York show. We sent for Bill, got a couple of rehearsals, and he was cursing us. He was a hyperactive kid. The entire time he was like, "Where is Robo? I hate you guys. What the fuck, this is New York and there are giant rats. Dezo, stay near me, there are giant rats. This is New York!" Remember, Bill hadn't left Redondo Beach before this. He did this for the rest of the tour, every day, but mostly when he was playing in New York with us.

We were thinking of people to replace Robo. This kid Emil replaced Robo about a month after Black Flag came home from England. Three or four months later, everybody was working, and Henry was writing in his journal, and who pokes his head in the office door but Robo. He says, "Hey guys, let's go jam"—a weird situation. Robo caught a flight to Mexico and came across the border in Tijuana. I don't know how he got to L.A. He must have hitched a ride or something.

We were not planning a rehearsal for that day. They may have jammed with him, but I don't know when they told him about Emil. He had to know because Emil used the drum kit that Black Flag had bought for Robo, the Vista Light that you could see through, but Emil decided to spray paint them. Robo had to know. Everybody was being a sport about it, I guess, but Henry was like, "Do you know who needs a drummer? The Misfits need a drummer."

ONE GLANCE BACK OVER THE SHOULDER

I have this friend named Jimmy Wilsey, bass player for a band called the Avengers who became the guitar player for Chris Isaac and helped write the song "Wicked Game." He heard of Black Flag, but he didn't know too much about us. The Avengers came before us. They played the very last concert that the Sex Pistols played in San Francisco in 1978, on the tour when Sid was in the band, when they broke up. After reading Henry's book *Get in the Van*, he commented, "We thought we had it rough. It was like warfare with you guys." And *Get in the Van* isn't even a complete history of Black Flag. It's only a certain point when Henry was in the band. There were the three or four years before that.

It is a mission for musicians to play what they want to play. Black Flag's mission was a little different from that because they wanted to do everything their own way. We didn't say, "Mr. Sony, here is my demo, sir. Please sign my band." We wanted no part of that. We wanted to be a band and playing music, but that was about it. We had so much respect for bands and music, don't get me wrong. But we felt it was the record company people, and people who were not musicians, those people whose goal is to sell it, that didn't understand the idea of music.

This is America, and you can sell people a pile of shit if you package it right, you know? That wasn't for us. My dad used to say, when you put out a record strictly for the sense of making money, that is when it all ends. ∎

SCENE NUMBER TWO
THE FIRST-PERSON PERSPECTIVE

"...back then most big cities on my coast had just such an exclusive club ...

The New Loft was the picture-perfect venue for my first big show."

MY FIRST PUNK ROCK SHOW

Almost three decades ago I found myself at a Circle Jerks show in Baltimore, Maryland, at a club then called the New Loft—a dark, dingy, and smelly place. The ceilings were really high, and graffiti covered one wall front-to-back. As a "club," it exclusively hosted Punk Rock shows. Nowadays, ambitious promoters can find show-spaces almost anywhere, but back then most big cities on my coast had just such an exclusive club: A7 in New York, Love Hall in Philadelphia, and 9:30 Club in D.C. The New Loft was the picture-perfect venue for my first big show.

Lore suggested it was a condemned building spared the city's wrecking ball for damn near four years, which made the place even more Punk Rock. The original Loft, located just down the street from the "New" Loft, was briefly featured in the film *Another State of Mind*. In the film, the Stern brothers and other stranded California travelers heap accolades upon the D.C. scene, Dischord Records, and the band Minor Threat, who, ironically, play a show, sans microphone, at Jules' Loft in neighboring Baltimore.

Between 1983 and 1986, the New Loft was my home away from home. In that time period, every Hardcore band that could manage to mount a tour played there. When I finally got my driver's license, I spent every weekend supporting that scene, so I was lucky enough to see extraordinary bands. At the Circle Jerks show, everything turned around for me. By that time, I was more or less a Punk Rocker (albeit, a "Mall Punk") for about a year, and I knew very little about Punk Rock's roots and history. Without a frame of reference, I had no idea that Keith Morris, the Circle Jerks singer, was the first singer of legendary Los Angeles band Black Flag. Being so new, I was concerned with surviving the show without getting the shit kicked out of me, making the long drive home, and then going to school the following Monday more than I was about Punk Rock's timeline and major players.

"I remember driving around in my buddy's Camaro in the late '80s. I was like eighteen years old, and it was around Halloween. We were drinking and kids were trick-or-treating, and we had the intent of stealing candy from them. We were listening to Drinking and Driving. We were all singing along out the window and scaring people. Funny thing, though, is that we never did steal any candy because we were a bit too scared to do it." -K.E.

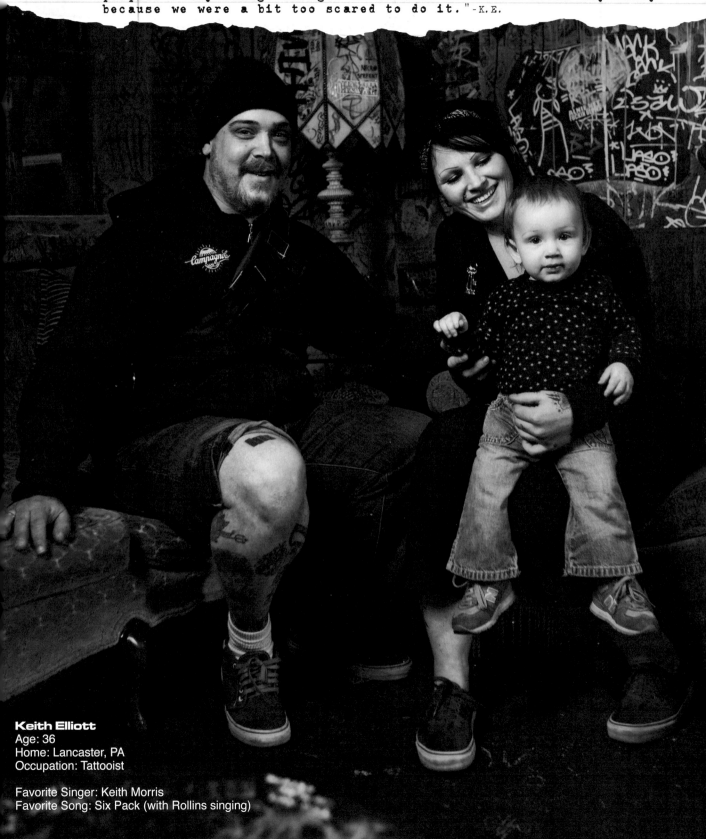

Keith Elliott
Age: 36
Home: Lancaster, PA
Occupation: Tattooist

Favorite Singer: Keith Morris
Favorite Song: Six Pack (with Rollins singing)

```
"You can do anything you
want in this world; you
don't have to take any shit
from anyone at any time.
(On lessons learned from
Black Flag.)"-W.T.
```

Will Tarrant ▶
Age: 38
Home: Brooklyn, NY
Occupation: New York City Social Worker

Favorite Singer: Henry Rollins
Favorite Song: My War
Favorite Album: Damaged

```
"Black Flag's music is like an expression
of this raw, base emotion, and they didn't
gloss over it. It was hardcore. And, when
you first hear something that makes you
experience what makes life hardcore, it
makes you confront yourself and what you
really are."-S.H.
```

◀ **Sweettooth Hinkley Jr.**
Age: 27
Home: Brooklyn, NY
Occupation: Professional Loser

Favorite Singer: Chavo
Favorite Song: Nervous Breakdown
Favorite Album: Damaged

The five of us arrived in Baltimore that night in my parent's aging Chevy conversion van. For four of us, this was our first show outside our own tiny hometown scene. Immediately upon arrival, like little children, we tuned our virgin ears to the advice of the scene veteran in our company. In all, everything went better than expected. From the moment I paid my five dollars and placed my foot firmly in this new world, my life changed forever. Besides our personal Hardcore "guru," who'd been going to shows for a full year or two by that time, all of our lives changed radically, since most of us stayed involved in the Punk Rock scene for a long time afterward despite all moving to disparate parts of the United States.

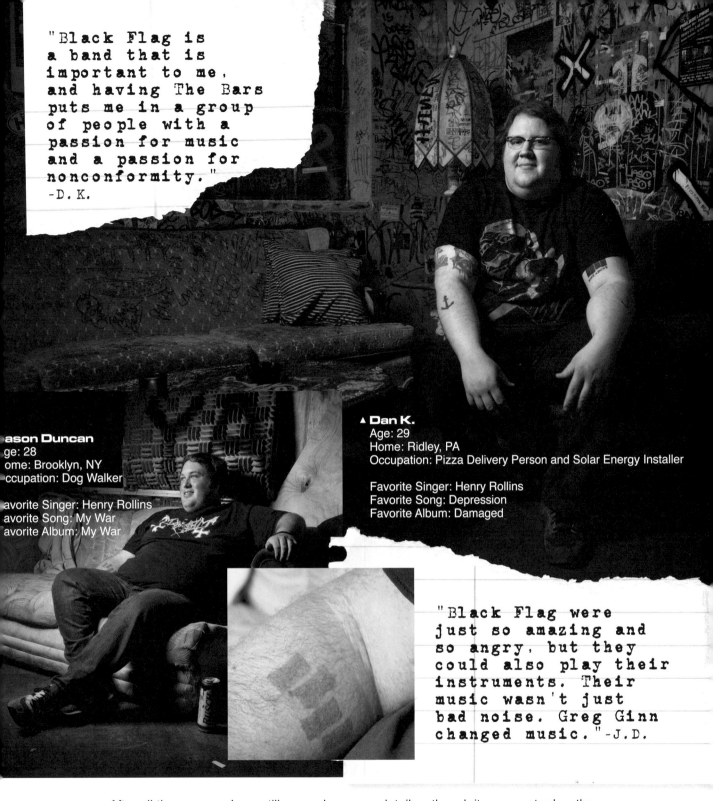

"Black Flag is
a band that is
important to me,
and having The Bars
puts me in a group
of people with a
passion for music
and a passion for
nonconformity."
-D.K.

ason Duncan
ge: 28
ome: Brooklyn, NY
ccupation: Dog Walker

avorite Singer: Henry Rollins
avorite Song: My War
avorite Album: My War

▲ **Dan K.**
Age: 29
Home: Ridley, PA
Occupation: Pizza Delivery Person and Solar Energy Installer

Favorite Singer: Henry Rollins
Favorite Song: Depression
Favorite Album: Damaged

"Black Flag were
just so amazing and
so angry, but they
could also play their
instruments. Their
music wasn't just
bad noise. Greg Ginn
changed music."-J.D.

After all these years, I can still remember every detail as though it were yesterday: the circumstances surrounding my departure from home; the anticipation of going to my first big-city Punk Rock show; the music we listened to on the way from our tiny little town towards the "gigantic" city of Baltimore; how tough and seasoned the other people at the show appeared to me; the way the room smelled of sweat and stale beer, and the change that immediately connected me to the growing Punk Rock culture of the early 1980s. I wasn't on the outside anymore. I was finally an insider!

"The Bars are a simple symbol, but are very strong and very aggressive. They tell the world that I won't back down." -A.D.

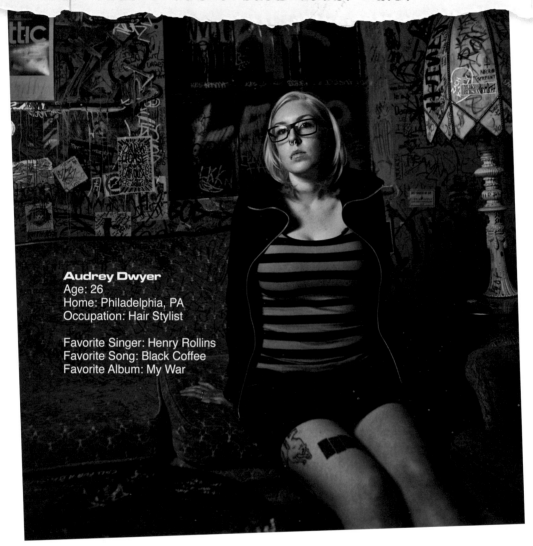

Audrey Dwyer
Age: 26
Home: Philadelphia, PA
Occupation: Hair Stylist

Favorite Singer: Henry Rollins
Favorite Song: Black Coffee
Favorite Album: My War

STUFF OF MYTH AND LEGEND

Looking back, one might think that Punk Rock was as accessible as it is now, like a sort of easy-entry situation, or like an easy opt-out of the mainstream, as portrayed on television or in a shitty movie. Today, parents might actually encourage their child to try out Punk Rock, but in those days, Punk Rock was far stranger, more intense, and considerably more dangerous than it is now. Parents were not encouraging their kids to be Punk Rockers. If anything, home life was made quite difficult since parents didn't really understand Punk Rock as a new and vital "community." In fact, a child's participation in it generally reflected poorly on his or her family. Punk meant stigma.

Most cities were edgy, even cutthroat places, so Punks accepted the danger involved when meeting friends and seeing favorite bands play. That was the reality of Reagan-era America. "Normal" kids didn't do that kind of shit, nor would their parents permit it. Punk Rock thrived on such isolation and outsiderness. It evolved more or less organically, without popular culture influences mitigating the experience of adventure.

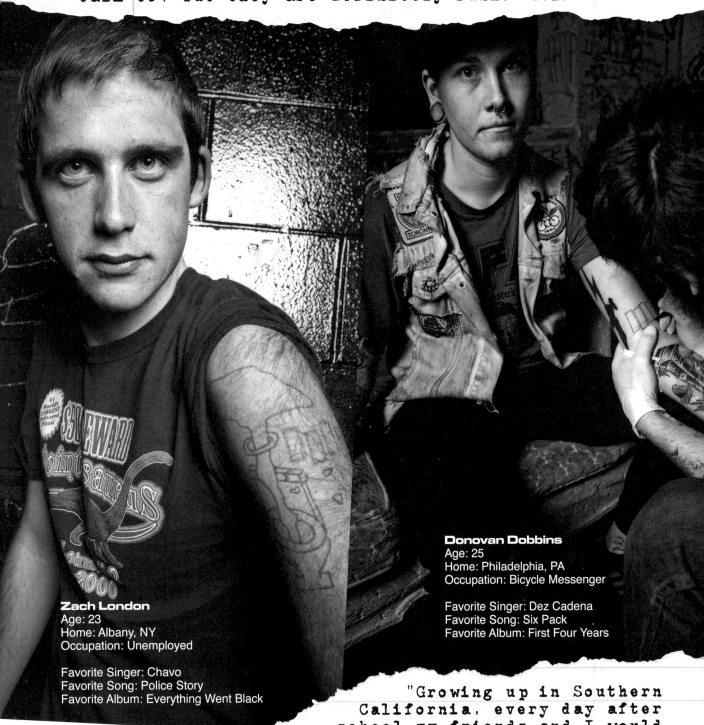

"The Bars kinda mark you as a Punk. When you see somebody with The Bars you know that they are a Punk. They may not be a Punk you wanna talk to, but they are definitely Punk."-Z.L.

Zach London
Age: 23
Home: Albany, NY
Occupation: Unemployed

Favorite Singer: Chavo
Favorite Song: Police Story
Favorite Album: Everything Went Black

Donovan Dobbins
Age: 25
Home: Philadelphia, PA
Occupation: Bicycle Messenger

Favorite Singer: Dez Cadena
Favorite Song: Six Pack
Favorite Album: First Four Years

"Growing up in Southern California, every day after school my friends and I would drink beers and listen to Black Flag whether we liked them or not. Most of my friends had The Bars tattooed on them, and so by getting The Bars tattooed on me it is my little piece of home."-D.D.

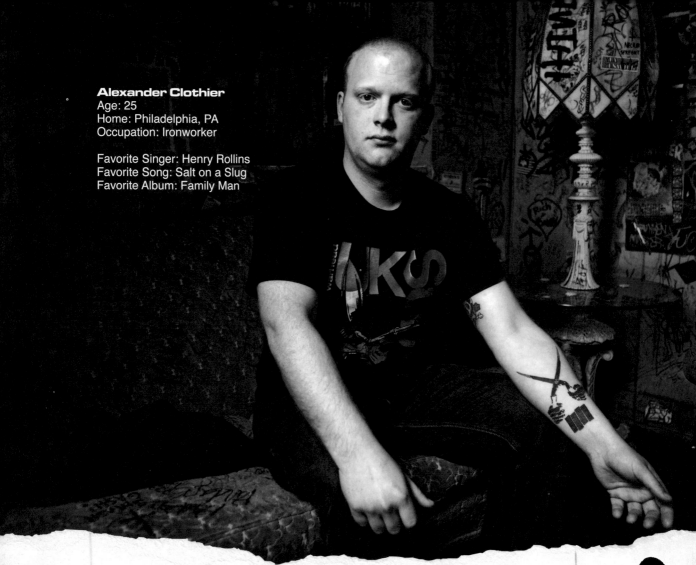

Alexander Clothier
Age: 25
Home: Philadelphia, PA
Occupation: Ironworker

Favorite Singer: Henry Rollins
Favorite Song: Salt on a Slug
Favorite Album: Family Man

"Originally I wanted the Family Man album cover tattooed on my arm; the one with the guy with the gun to his head, but I had a cousin who shot his face off, so I chose the Everything Went Black shears instead." -A.C.

The current slew of books and other material suggest American (or British) Punk Rock culture allowed newcomers to slip mentally into a rebel mindset as an easy option. Once you were in, they purport, you came and went as you pleased, but this doesn't capture the actual tendencies. For instance, in 1982, the kids that stoked the rites of passage in 1981 derided all new participants as poseurs. By 1983, the 1982 kids were veterans and continued the cycle. It was instantaneous and propulsive, fresh and new, and tragically amazing. Hardcore Punk was just a baby, and we guarded the ranks. I might sound preachy, but like anything hard that is worth doing, if you do it half-assed, the half of your ass uncommitted gets chewed up and spit right out.

OPTING FOR A LIFE OF OPTING OUT

If you were just "visiting" the Punk Rock world, likely you were not impressed and did not come back. Normal people didn't see much worth in Punk Rock music or culture, which they deemed as a place for obvious fuck-ups. Normal people didn't want Punks mucking up their happy world either. If I was forced to hear, "Why are you always down on the world, Ebersole? Surely it isn't as bad as you make it out to be?" from some socially and economically entitled white kid in my hometown while the world seemed to

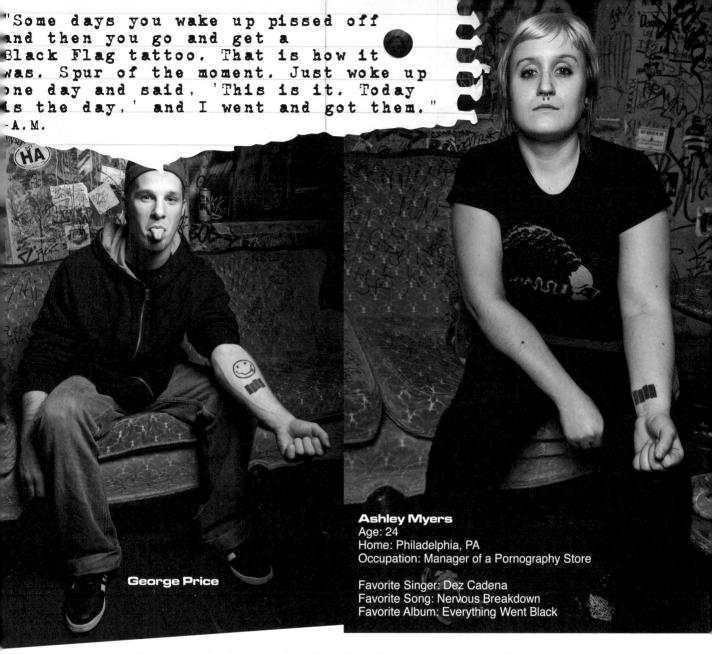

"Some days you wake up pissed off
and then you go and get a
Black Flag tattoo. That is how it
was. Spur of the moment. Just woke up
one day and said, 'This is it. Today
is the day,' and I went and got them."
-A.M.

George Price

Ashley Myers
Age: 24
Home: Philadelphia, PA
Occupation: Manager of a Pornography Store

Favorite Singer: Dez Cadena
Favorite Song: Nervous Breakdown
Favorite Album: Everything Went Black

be falling apart, I felt like exploding. Punk Rock helped allay my fears. It was never easy, but it proved a good fit. As one who saw the world just a little bit differently than the other kids, or was willing to admit it as such, what were my options?

Maybe in order to clean up Punk Rock's negative image; some scenes, at least later in the game, seemed to mimic the normalcy of the *Beverley Hills 90210* trip, at least visually at first sight, but below the surface each and every one of the kids peopling that scene were complete and total fuck-ups in their own special way. Whether they had a serious addiction, or they were from a massively abusive family, or they had nothing of note to live for, even the cleanest of scenes, and those advocating the highest ideals, rode on the shoulders of the most messed-up kids in town.

These kids worked hard to keep it afloat because Punk Rock symbolized alternatives to the stale, crushing, messed-up world and became a wellspring of empowerment during socially paralyzing adolescence. The inside path pursued by the masses seemed completely manufactured by "The Man" himself: if you were a good boy, did well in high

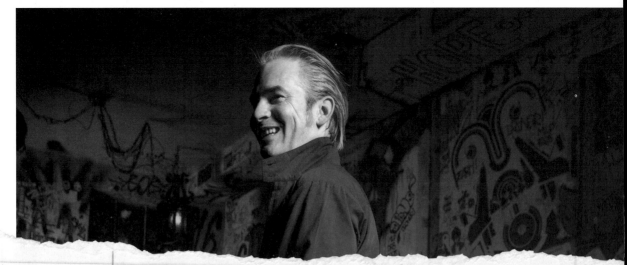

"I got a tape of Damaged in the summer of 1985. It was the heaviest thing that I had heard to that point. By the winter of 1994, when I got my tattoo, The Bars still encapsulated the 'against the grain' attitude to me. I wasn't even that big of a fan of the band but I couldn't deny that they were a self-sufficient unit. They were heavy as shit, but I still didn't really love all of their music."-C.C.

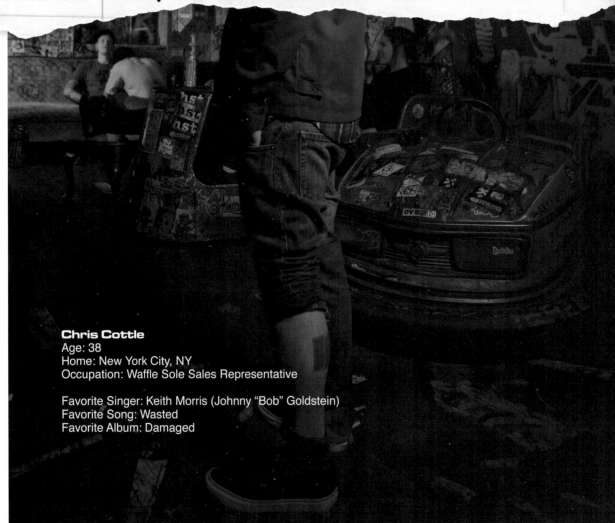

Chris Cottle
Age: 38
Home: New York City, NY
Occupation: Waffle Sole Sales Representative

Favorite Singer: Keith Morris (Johnny "Bob" Goldstein)
Favorite Song: Wasted
Favorite Album: Damaged

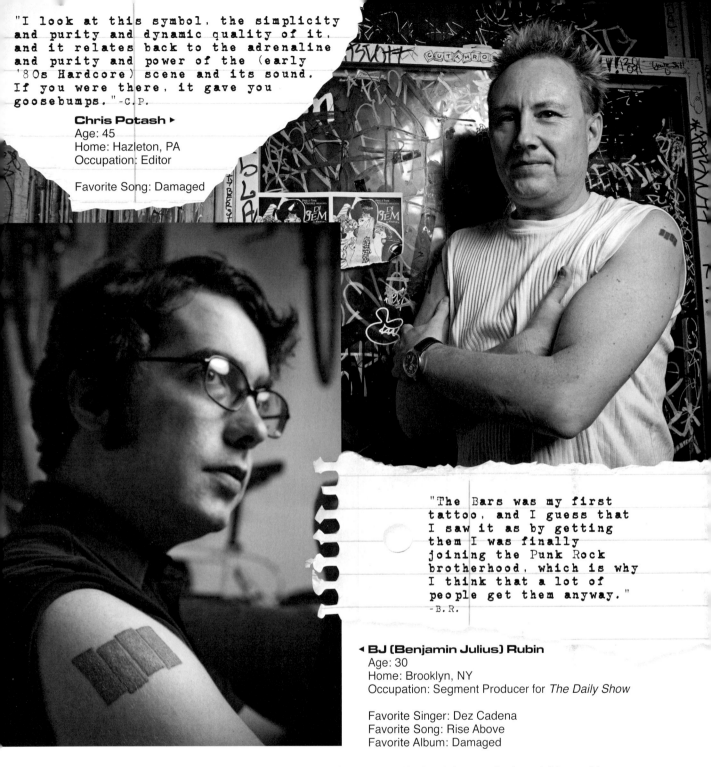

"I look at this symbol, the simplicity and purity and dynamic quality of it, and it relates back to the adrenaline and purity and power of the (early '80s Hardcore) scene and its sound. If you were there, it gave you goosebumps." -C.P.

Chris Potash ▶
Age: 45
Home: Hazleton, PA
Occupation: Editor

Favorite Song: Damaged

"The Bars was my first tattoo, and I guess that I saw it as by getting them I was finally joining the Punk Rock brotherhood, which is why I think that a lot of people get them anyway."
-B.R.

◀ BJ (Benjamin Julius) Rubin
Age: 30
Home: Brooklyn, NY
Occupation: Segment Producer for *The Daily Show*

Favorite Singer: Dez Cadena
Favorite Song: Rise Above
Favorite Album: Damaged

school, studied hard, played sports, and hung out with the right people, invariably you'd get into a good college and go on to an ideal job, mate, house, and kids. This amounted to a whole dream pushed onto yet another unsuspecting generation like a massively addictive drug. However, I wasn't that person.

For the idealistic Bohemian and for the loser alike, a dropout scene has always existed. By the 1980s, the dropout scene was definitely the "nowhere" option. Lucky dropouts might score a job on an assembly line in a factory somewhere, but even those jobs were drying up. Dropping out didn't seem cool, and it certainly wasn't any option for me.

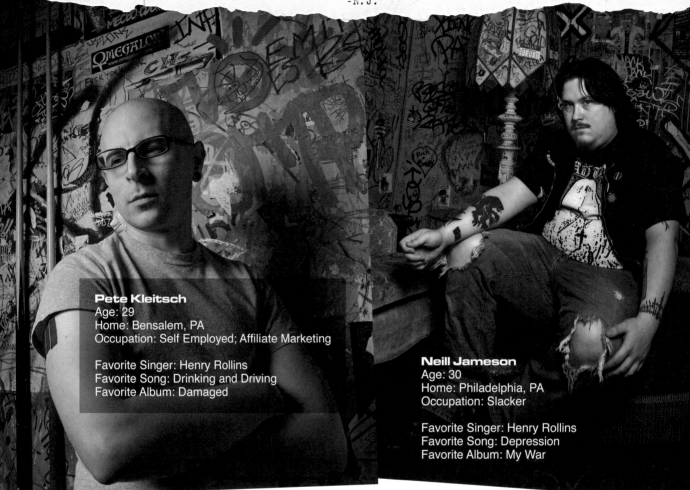

Pete Kleitsch
Age: 29
Home: Bensalem, PA
Occupation: Self Employed; Affiliate Marketing

Favorite Singer: Henry Rollins
Favorite Song: Drinking and Driving
Favorite Album: Damaged

Neill Jameson
Age: 30
Home: Philadelphia, PA
Occupation: Slacker

Favorite Singer: Henry Rollins
Favorite Song: Depression
Favorite Album: My War

I wasn't dumb. I just didn't want to end up on the bottom of the social ladder my entire high school career. I didn't want to decrease my options: I wanted to find better options. I wanted options that were a better reflection of my strengths and weaknesses.

If you were of the dropout mentality, but decided to stay in school, well, you could muster the hesher (also known by colorful names as Hessian, Tread, Head, Farmer, Redneck, Hayseed, or whatever the regional variation for people depicted in the movie *Deliverance*) cultural option. To be a hesher, you blared the more rebellious Heavy Metal music of the day (AC/DC, Iron Maiden, Judas Priest, Accept), drove a muddy pick-up truck to school every day, and wore a blue jean jacket and shit-kicker boots everywhere. You envied the freedom of the Marlboro Man. You smoked cheap weed and cigarettes after school over by the shed where all the sporting equipment was stored, and you considered deer-hunting season a suitable reason to take a day or three off from school. Again, while that may have worked for others, it didn't work for me.

The traditionalist trifecta of the jock, the brain, the hesher, along with the dropout route seemed to me to be the only available options. I didn't much care for those paths, but I knew that if I wanted to do anything else I needed more resources, more information,

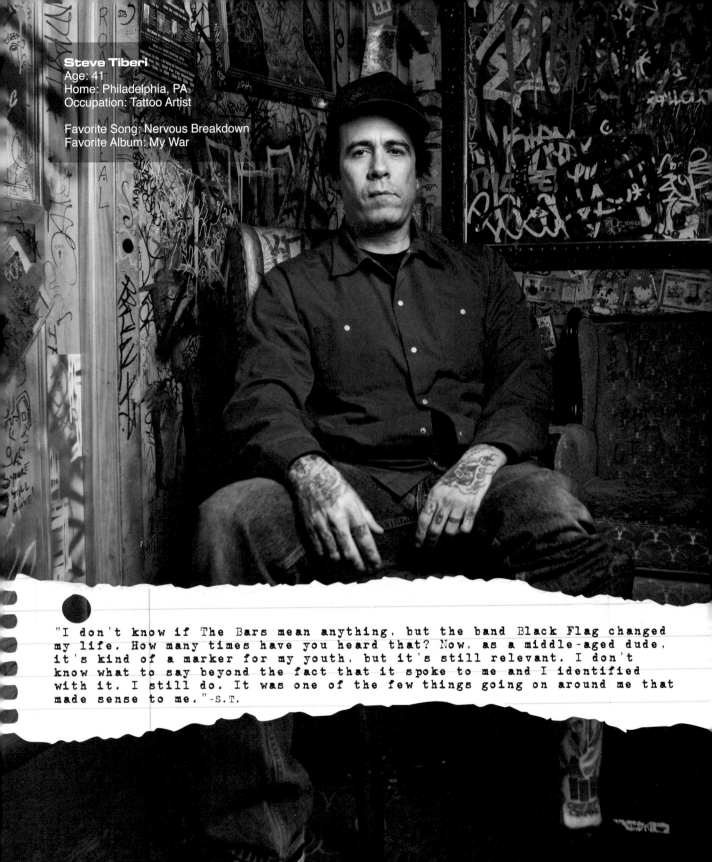

Steve Tiberi
Age: 41
Home: Philadelphia, PA
Occupation: Tattoo Artist

Favorite Song: Nervous Breakdown
Favorite Album: My War

"I don't know if The Bars mean anything, but the band Black Flag changed my life. How many times have you heard that? Now, as a middle-aged dude, it's kind of a marker for my youth, but it's still relevant. I don't know what to say beyond the fact that it spoke to me and I identified with it. I still do. It was one of the few things going on around me that made sense to me."-S.T.

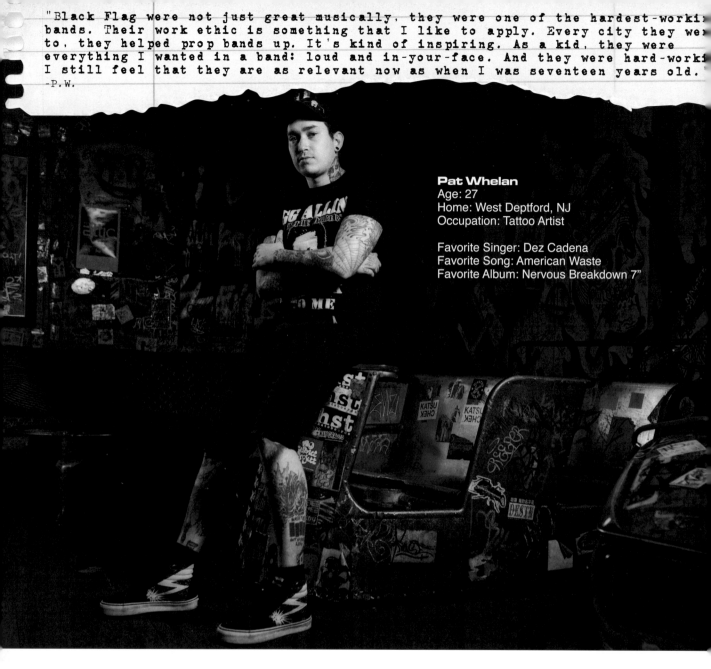

Pat Whelan
Age: 27
Home: West Deptford, NJ
Occupation: Tattoo Artist

Favorite Singer: Dez Cadena
Favorite Song: American Waste
Favorite Album: Nervous Breakdown 7"

and a thicker skin than I had at my disposal at that time. Luckily, I had one thing that a lot of kids didn't have, a big awesome reason to Rise Above trying to fit in; because I never would be able to do anything like that!

GREASER RENAISSANCE MAN
My old man was a greaser Renaissance man in the 1950s. By all accounts, from most of his friends and many living enemies, he was the Arthur Fonzarelli (The Fonz of *Happy Days* fame) of my small Pennsylvania cellblock. With hot cars, tongue-melting chicks, decent jobs, a beaten leather jacket, burly engineer boots, and a greased-up pompadour competing with the likes of Elvis "The King of Rock and Roll" Presley, he was the definition of tough.

To compete with my father—an unstoppable blue-collar superman—people told me I had a lot to live up to. He and his friends kicked more people's asses harder and faster, and with more mess, than twenty years' worth of WWF (and WWE) could possibly muster.

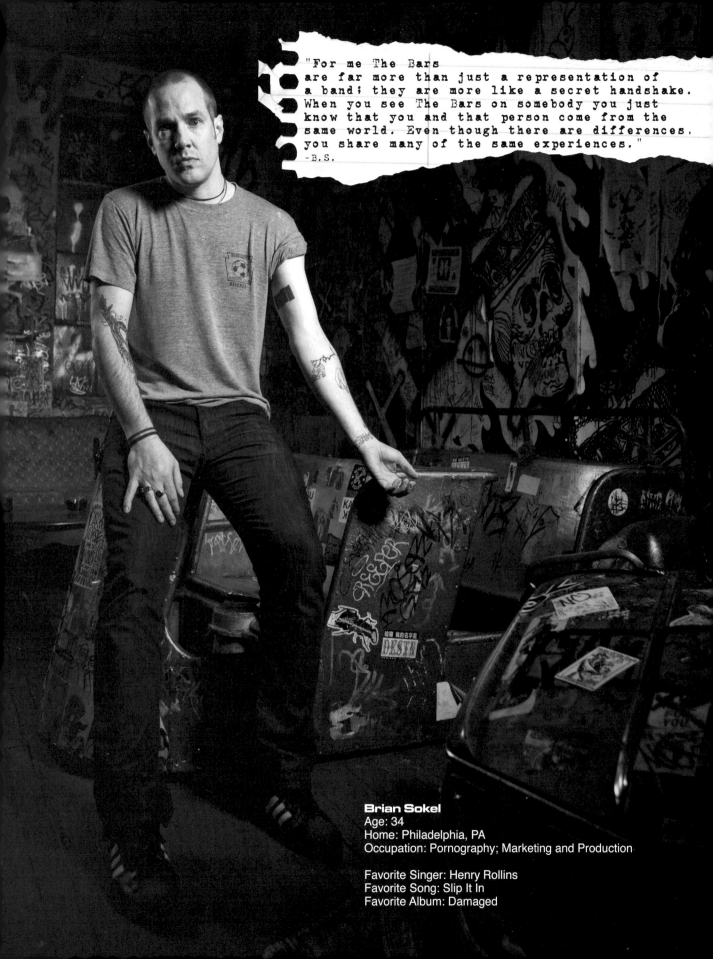

"For me The Bars
are far more than just a representation of
a band; they are more like a secret handshake.
When you see The Bars on somebody you just
know that you and that person come from the
same world. Even though there are differences,
you share many of the same experiences."
- B.S.

Brian Sokel
Age: 34
Home: Philadelphia, PA
Occupation: Pornography; Marketing and Production

Favorite Singer: Henry Rollins
Favorite Song: Slip It In
Favorite Album: Damaged

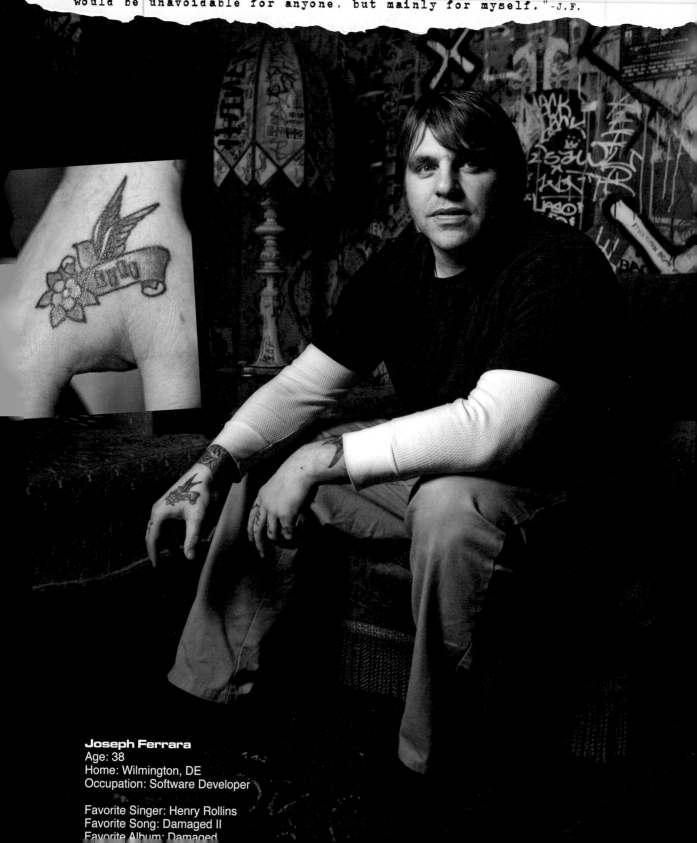

"The Bars remind me of youth, the never-ending rebellion, refusing to conform. I spent eight years chained to a cube in corporate America. You can forget who you are in that shit. I got it on my hand so that it would be unavoidable for anyone, but mainly for myself." -J.F.

Joseph Ferrara
Age: 38
Home: Wilmington, DE
Occupation: Software Developer

Favorite Singer: Henry Rollins
Favorite Song: Damaged II
Favorite Album: Damaged

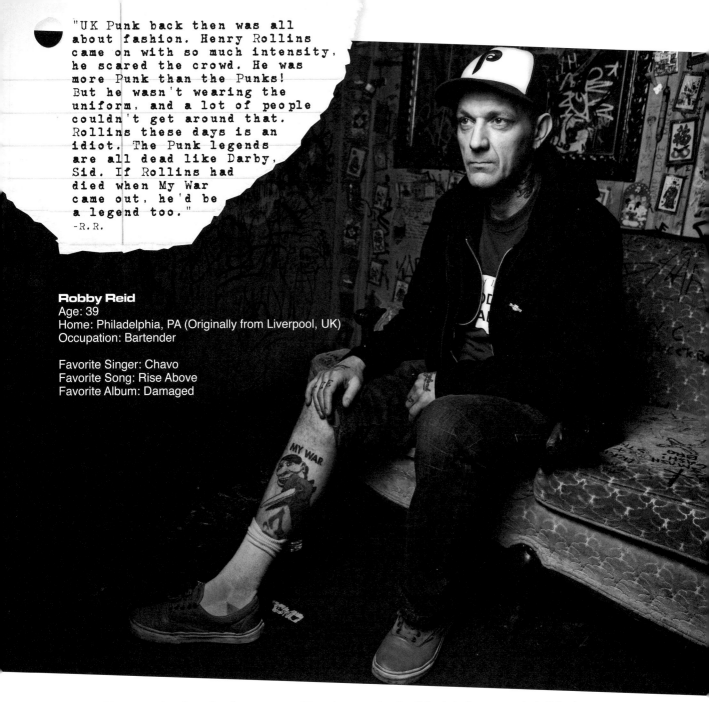

"UK Punk back then was all
about fashion. Henry Rollins
came on with so much intensity,
he scared the crowd. He was
more Punk than the Punks!
But he wasn't wearing the
uniform, and a lot of people
couldn't get around that.
Rollins these days is an
idiot. The Punk legends
are all dead like Darby,
Sid. If Rollins had
died when My War
came out, he'd be
a legend too."
-R.R.

Robby Reid
Age: 39
Home: Philadelphia, PA (Originally from Liverpool, UK)
Occupation: Bartender

Favorite Singer: Chavo
Favorite Song: Rise Above
Favorite Album: Damaged

He was a hardass for the masses. Plus, he eventually did a lot of very cool stuff that didn't involve kicking the living daylights out of people. He wasn't passive, so digging my father's vibe was an acquired thing.

Many of my high school teachers were his high school adversaries, so my instant reputation was unearned. I wasn't much of a hardass, nor was I much of a brain, nor was I much of a jock. I was kind of a wimpy-assed, zit-faced, tall-as-hell kid with two left dancing feet and all thumbs when it came to ass-whoopin'. Sure, I'd been in some prior fights, but I really didn't have the killer's instinct that my dad and his crew embodied. So, I was stuck with a boatload of expectations—to kick ass or have my ass kicked. Even the completely messed-up kids seemed to think they had a rung up on me, so my social ladder was restricted to the bottom few unless I started kicking ass, studying in earnest, playing sports, or hanging out with the "right people." I did no such thing.

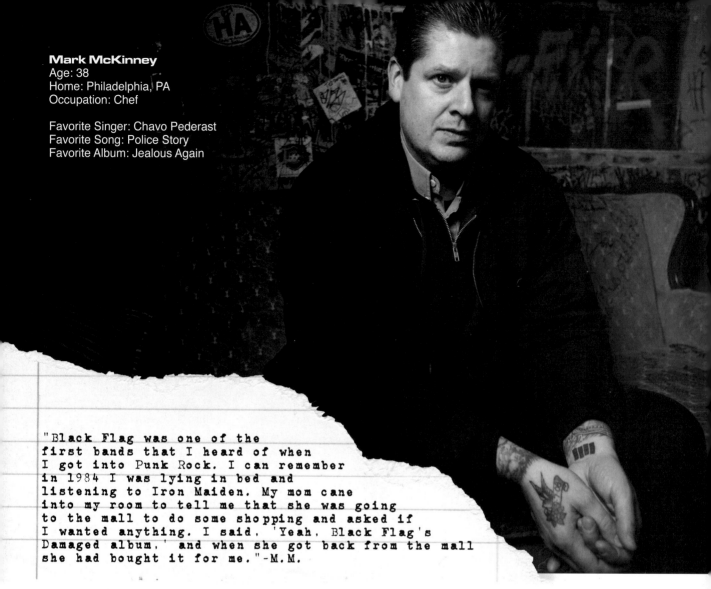

Mark McKinney
Age: 38
Home: Philadelphia, PA
Occupation: Chef

Favorite Singer: Chavo Pederast
Favorite Song: Police Story
Favorite Album: Jealous Again

"Black Flag was one of the
first bands that I heard of when
I got into Punk Rock. I can remember
in 1984 I was lying in bed and
listening to Iron Maiden. My mom came
into my room to tell me that she was going
to the mall to do some shopping and asked if
I wanted anything. I said, 'Yeah, Black Flag's
Damaged album,' and when she got back from the mall
she had bought it for me." -M.M.

For a few years, I dabbled in a variety of antisocial, or as I like to call them, individualistic activities. I rebuilt broken radios in my dad's workshop, I fixed and raced motorcycles, I raised some exceptionally radical show pigeons, I went to vocational school where I studied to become a welder, and probably the strangest of all, I maintained a deep connection to boy scouting with a MacGyver-like interest in repurposing new things from old objects and learning all kinds of old school, outdoorsy tricks of the trade.

If fate was not going to permit me to do anything amazing with my social life at school, well, at least I would, by sheer will, become an Eagle Scout, which I did on my eighteenth birthday. Besides the Eagle Scout thing, none of the other stuff made my family or me particularly happy, so I started hanging out with some of the lesser-hesher kids really getting into freestyle BMX and ramp riding. Buying and building a BMX bike from the ground up was not exactly the liberation I sought, but it was a bit of an alternative from being messed with at school. Finally, after some light hazing, I had a crew.

After school and on some weekends when I wasn't working for my father's business, my friends and I would get together and build little BMX courses and hang out at the abandoned local skatepark, Thunder Dome, where I rode my skateboard with my brothers a few years earlier. On occasion, we'd settle in to watch some of the better kids

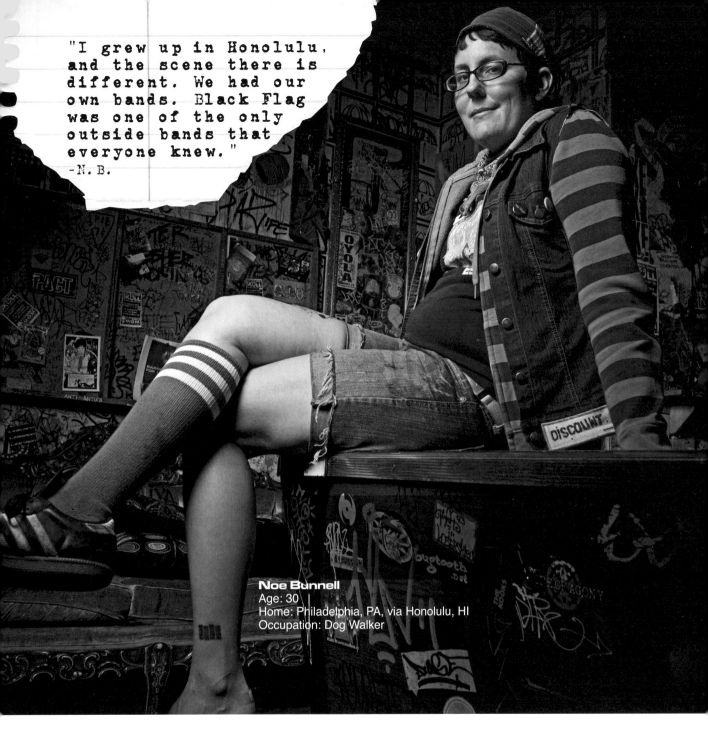

"I grew up in Honolulu, and the scene there is different. We had our own bands. Black Flag was one of the only outside bands that everyone knew."
-N.B.

Noe Bunnell
Age: 30
Home: Philadelphia, PA, via Honolulu, HI
Occupation: Dog Walker

go ape-shit at this local dirt ramp behind a local strip-mall, where I glimpsed X-Game-quality daredevil antics. My friends weren't heshers. They were just lumped into that brand because they liked Heavy Metal and nobody knew where to place them socially. They didn't seem to care all that much about being lumped in with the rednecks, but I found it a bit restricting.

Loosely united, we, the whole bundle of freaks, geeks, and weirdos were just floating around in a raft on a stagnant sea. My pea-sized brain at the time didn't really see grand alternatives, but luckily for me, I had been turned on to Devo, and loosely, to their concept of "devolution." Sure, they scored a huge hit with the song "Whip It" back in 1980, but with the help from a rather unassuming hypermotivated Christian warrior friend

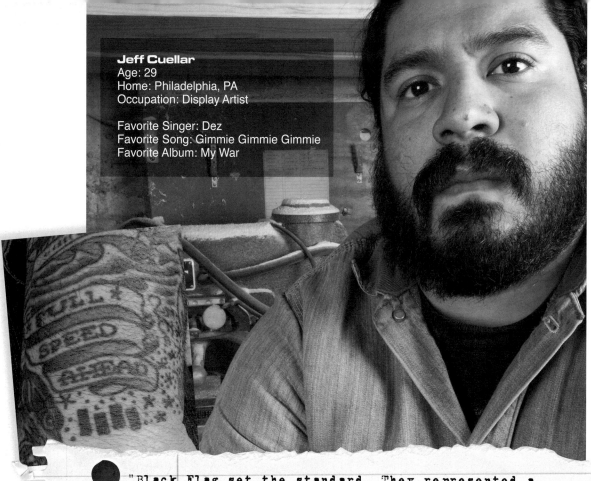

Jeff Cuellar
Age: 29
Home: Philadelphia, PA
Occupation: Display Artist

Favorite Singer: Dez
Favorite Song: Gimmie Gimmie Gimmie
Favorite Album: My War

"Black Flag set the standard. They represented a separatist, underground, anarchist lifestyle, like what the MC5 sort of pursued. It was part of my growing up and wanting to be an outsider as far as the regular, narrow, suburban bullshit was concerned, but still have a place to call home. The Bars represented what I thought was the standard set by the creators of the whole scene that I was part of." -J.C.

that I had known most of my life, I was properly schooled in the concept of devolution and the more obscure music that Devo created long before "Whip It" hit the charts. Unluckily for me, most of my BMX friends thought Devo was a bit too geeky to be cool, so yet again I struck a loser's chord with other losers. For that reason, I never felt totally connected. Yet, I knew other options had to be lurking . . .

PUNK ROCK EXISTED SOMEWHERE, BUT I HAD NO IDEA WHERE
Punk Rock existed but seemed as inaccessible to me as the high school superstar jock dream. I knew so little about it. The only Punk Rock band I'd ever really heard of was the broken-up English Punkers the Sex Pistols. During their 1978 tour of the United States, I was ten years old and recall my mother did not like them one little bit. As she placed dinner on the kitchen table on the day the band played in Texas, my mother made a

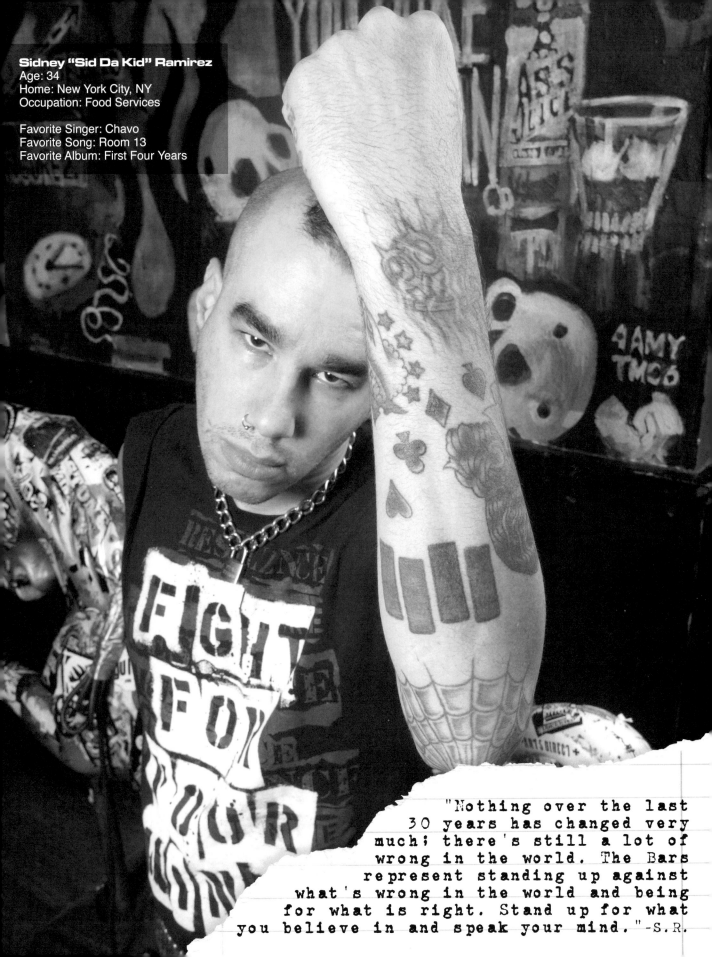

Sidney "Sid Da Kid" Ramirez
Age: 34
Home: New York City, NY
Occupation: Food Services

Favorite Singer: Chavo
Favorite Song: Room 13
Favorite Album: First Four Years

"Nothing over the last 30 years has changed very much; there's still a lot of wrong in the world. The Bars represent standing up against what's wrong in the world and being for what is right. Stand up for what you believe in and speak your mind." -S.R.

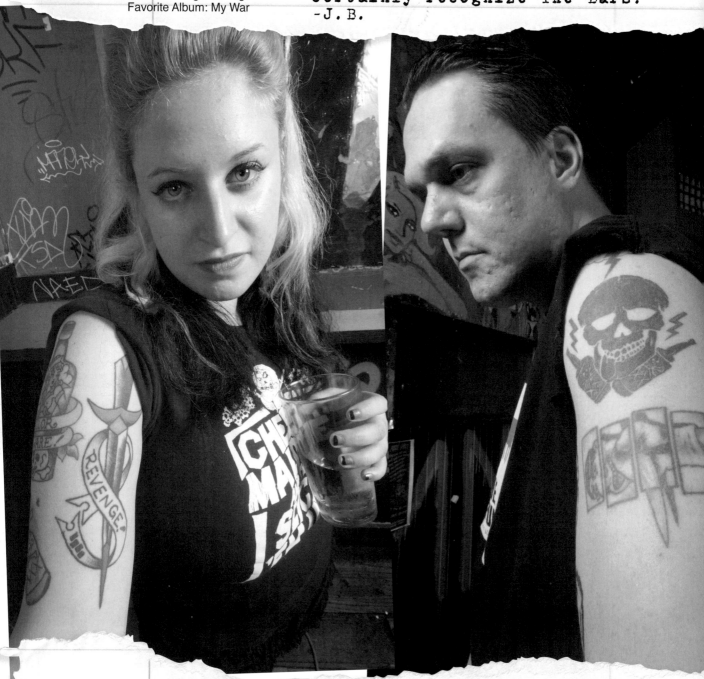

▼ **Jaqueline Blownaparte**
Age: 25
Home: Long Beach, NY
Occupation: Barista and Singer

Favorite Singer: Henry
Favorite Song: Revenge!
Favorite Album: My War

"I work with a bunch of hipster douchebags. They couldn't name one Black Flag song, but they certainly recognize The Bars." -J.B.

"The Bars mean that if you're going to do something, do it ONE-THOUSAND-PERCENT; half-assed bullshit is not acceptable." -A.B.

▲ **Anthony "T-BONE" Begnal**
Age: 40
Home: Brooklyn, NY
Occupation: Graphic Designer and Guitar Player

Favorite Singer: Henry
Favorite Song: Gimmie Gimmie Gimmie
Favorite Album: Damaged

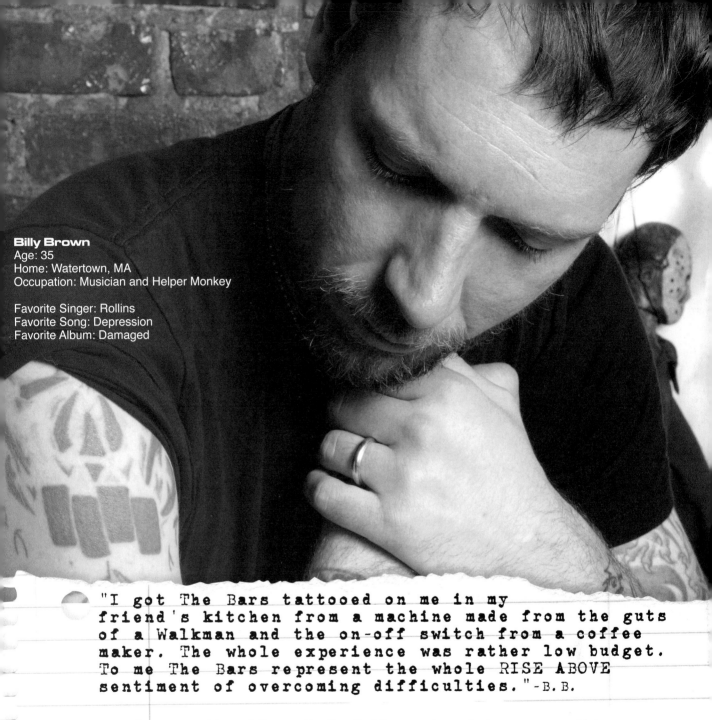

Billy Brown
Age: 35
Home: Watertown, MA
Occupation: Musician and Helper Monkey

Favorite Singer: Rollins
Favorite Song: Depression
Favorite Album: Damaged

"I got The Bars tattooed on me in my friend's kitchen from a machine made from the guts of a Walkman and the on-off switch from a coffee maker. The whole experience was rather low budget. To me The Bars represent the whole RISE ABOVE sentiment of overcoming difficulties." -B.B.

passing comment to my father and brother that it was a shame that our government let the Sex Pistols come to America. My dad and brother seemed perplexed by my mom's concern with a band that neither of them had ever heard of, but my mother had her reasons.

Supposedly, as she had read in the newspaper while making dinner earlier that day, the Sex Pistol's nihilistic and drug-addicted bass player, Sid Vicious, spit or pissed on the Alamo, or something equally as absurd. This tidbit of media hype drove my mother to near frenzy. I didn't understand why she suddenly cared for the Alamo. It didn't matter what we thought. She was angry, and we were going to hear exactly what was on her mind for the entire family dinner. Yes, this was my first inkling of Punk Rock, and it wasn't altogether positive.

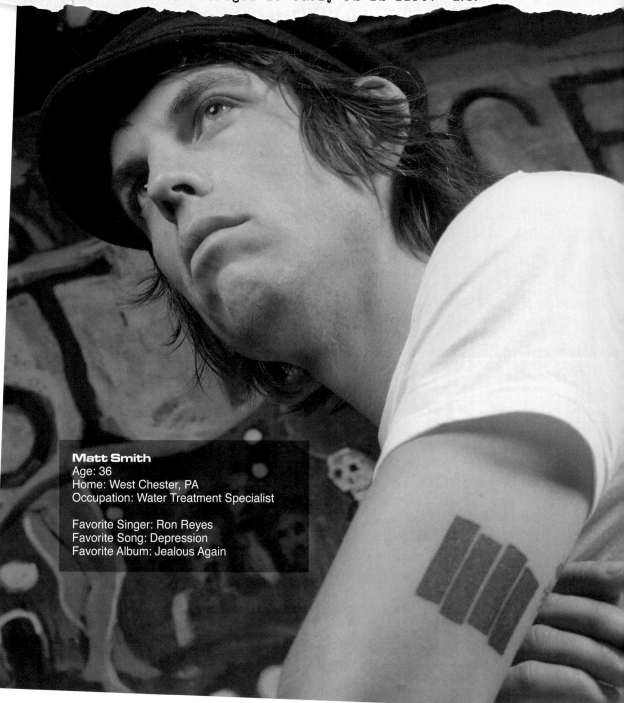

Matt Smith
Age: 36
Home: West Chester, PA
Occupation: Water Treatment Specialist

Favorite Singer: Ron Reyes
Favorite Song: Depression
Favorite Album: Jealous Again

On that very day, Punk Rock registered to me only as a strange image-based music that was played only by one obscure band with a very funny name hell-bent on fucking with Americans, if only for the sake of fucking with Americans. The only thing I knew was my mother took issue with PUNK ROCK, though I don't think that she ever had actually heard Punk Rock music. In fact, I wondered, who did listen to Punk Rock music?

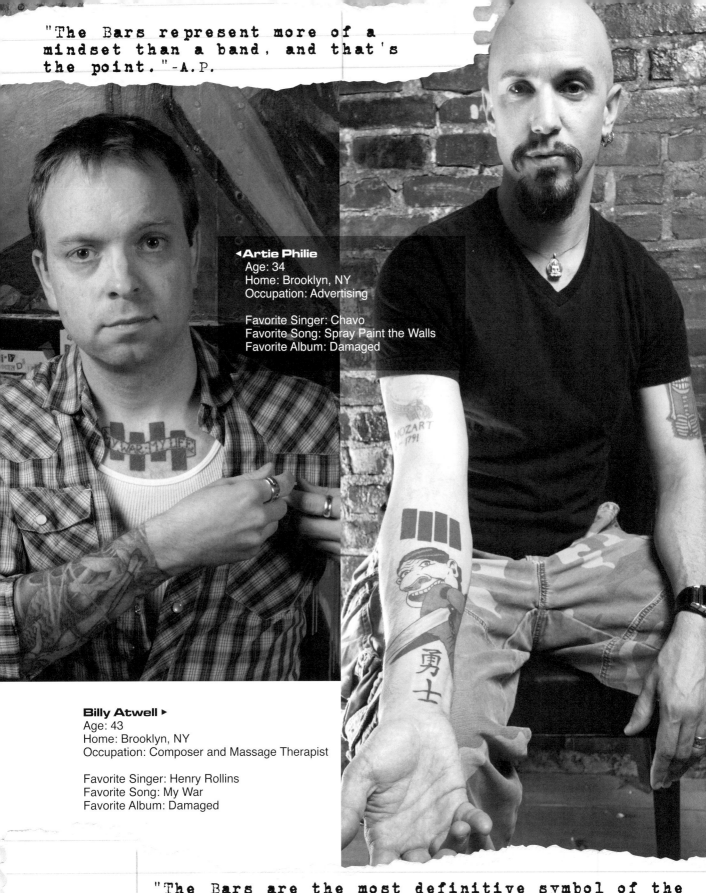

"The Bars represent more of a
mindset than a band, and that's
the point."-A.P.

◄**Artie Philie**
Age: 34
Home: Brooklyn, NY
Occupation: Advertising

Favorite Singer: Chavo
Favorite Song: Spray Paint the Walls
Favorite Album: Damaged

Billy Atwell ►
Age: 43
Home: Brooklyn, NY
Occupation: Composer and Massage Therapist

Favorite Singer: Henry Rollins
Favorite Song: My War
Favorite Album: Damaged

"The Bars are the most definitive symbol of the
American Hardcore movement. They say something
without really saying anything at all."-B.A.

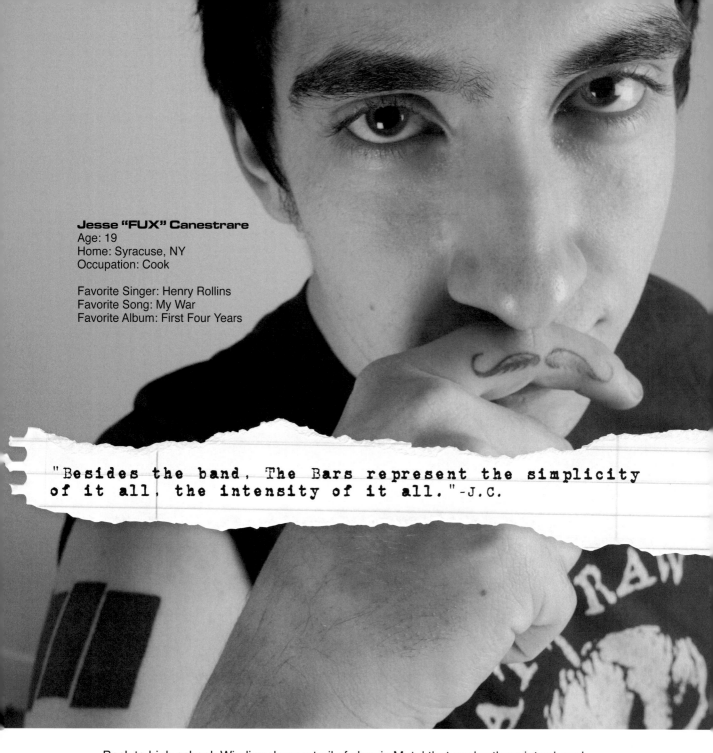

Jesse "FUX" Canestrare
Age: 19
Home: Syracuse, NY
Occupation: Cook

Favorite Singer: Henry Rollins
Favorite Song: My War
Favorite Album: First Four Years

"Besides the band, The Bars represent the simplicity of it all, the intensity of it all."-J.C.

Back to high school: Winding down a trail of classic Metal that my brothers introduced me to, then stumbling onto Devo, and then dabbling in New Wave, I more or less followed the prescribed route many of my friends followed before becoming entrenched in the subterranean world of Punk Rock. For kids to actually find Punk Rock, they had to expend almost every other option out there by snaking their way through just about everything listenable and emerging at the stripped down, nearly unlistenable sound that screamed "this is Punk music!" into your ear.

Having missed out on the first few waves of American Punk music, I felt strange, if not a bit embarrassed, facing a music scene that did not actually die with the passing of the

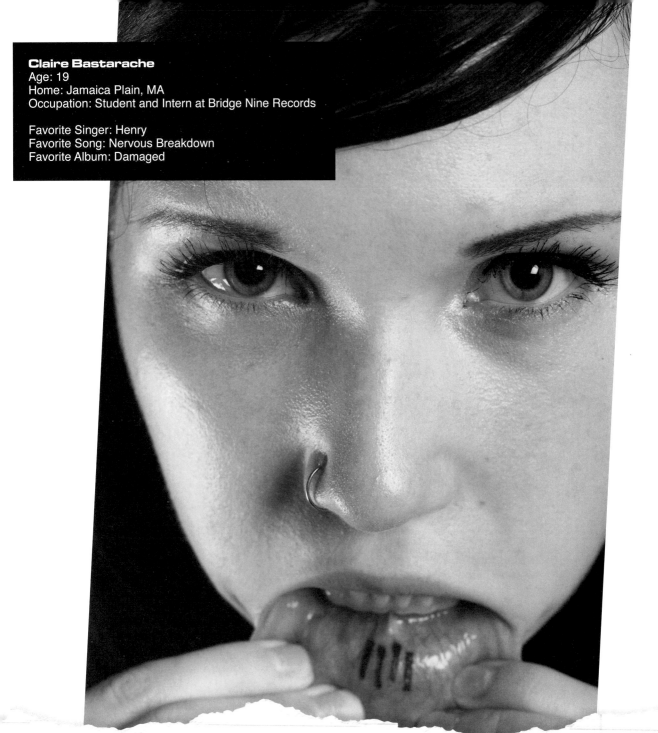

Claire Bastarache
Age: 19
Home: Jamaica Plain, MA
Occupation: Student and Intern at Bridge Nine Records

Favorite Singer: Henry
Favorite Song: Nervous Breakdown
Favorite Album: Damaged

"My aunt and uncle were really involved in Punk Rock and Hardcore in
the '70s. I got The Bars for them, as they said that The Bars are what
they would have gotten if they'd ever gotten a band tattoo." -C.B.

Sex Pistols in January of 1978 but slowly built up momentum and accumulated a vast
and uncompromising history of real-time cultural change here in the States. Important
American Punk Rock bands like the Bad Brains, Black Flag, the Germs, Fear, the Dead
Kennedys, the Circle Jerks, Minor Threat, and most certainly the Ramones had
collectively, though probably unknowingly, laid out the rules of confederation for the early
American Punk Rock music scene across those missing years. What I found when I

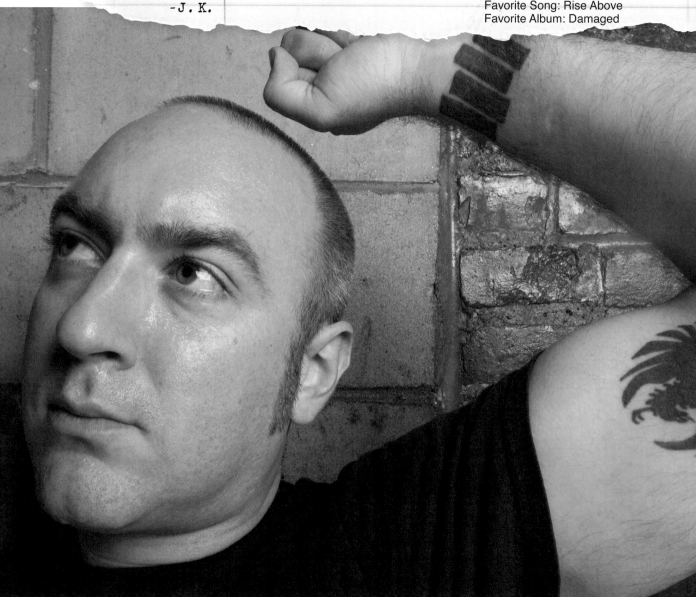

Justin "JK" Kelly
Age: 30
Home: Cambridge, MA
Occupation: General Contractor

Favorite Singer: Rollins
Favorite Song: Rise Above
Favorite Album: Damaged

"I really associate with
Black Flag's blue-collar,
antiauthoritarian roots."
-J.K.

arrived in 1982 was strangely paradoxical: Punk was pure and idealistic, seemingly well established and orderly, and very American and very blue-collar, just like me.

American Hardcore Punk Rock interested me far more than the British Punk that my mother cursed in 1978 because it flaunted not dog collars, eyeliner, safety pins, and parade jackets, but a streamlined social and political consciousness closely connected to the concerns of angry young Americans; it was far less artsy-fartsy and far more down-and-dirty. The music and social aspects of the American Punk scene were not going to be driven by the selfish monetary desires of any one individual like Malcolm McLaren. Instead, the road-rules of the American Punk scene were going to be determined collectively by all of those involved, be they band members or audience. At least in theory, American Punk Rock seemed outright democratic, if not a tad socialistic,

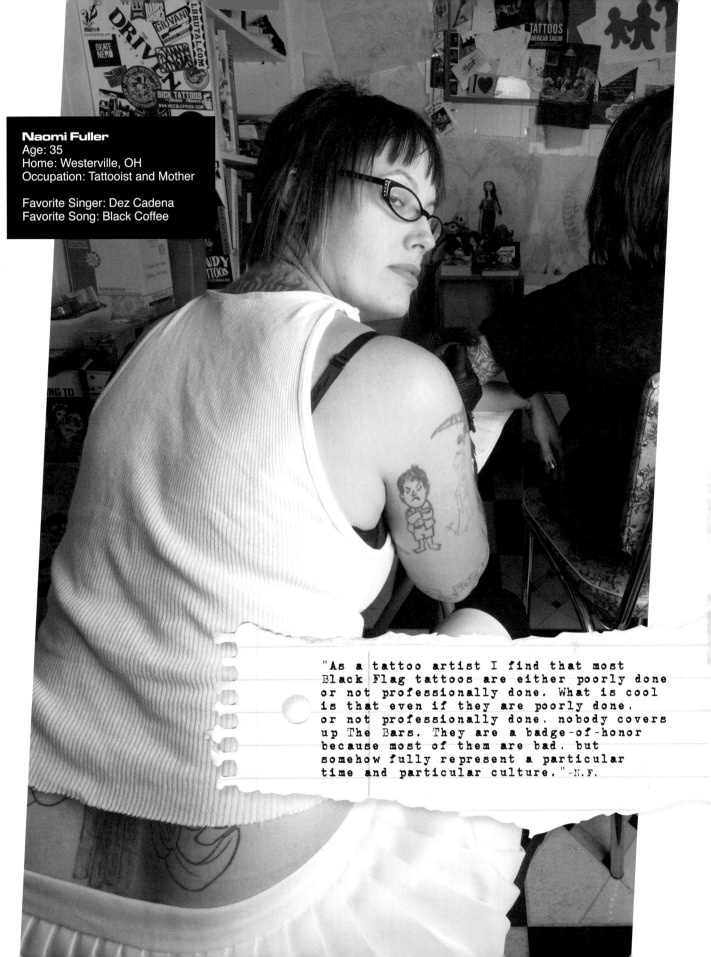

"As a tattoo artist I find that most Black Flag tattoos are either poorly done or not professionally done. What is cool is that even if they are poorly done, or not professionally done, nobody covers up The Bars. They are a badge-of-honor because most of them are bad, but somehow fully represent a particular time and particular culture."-N.F.

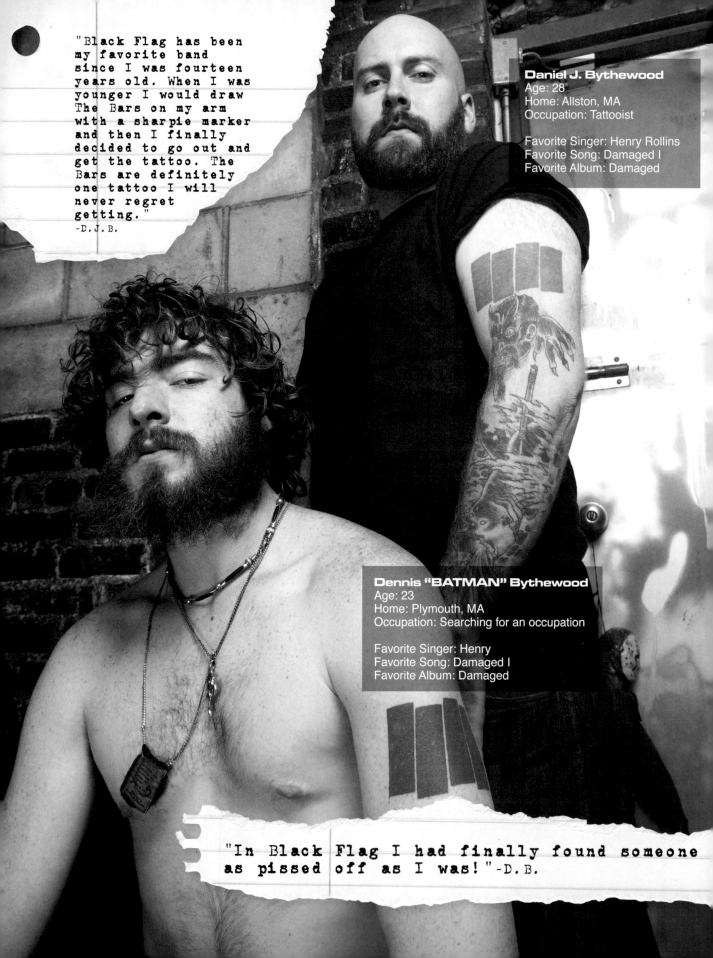

"Black Flag has been my favorite band since I was fourteen years old. When I was younger I would draw The Bars on my arm with a sharpie marker and then I finally decided to go out and get the tattoo. The Bars are definitely one tattoo I will never regret getting."
-D.J.B.

Daniel J. Bythewood
Age: 28
Home: Allston, MA
Occupation: Tattooist

Favorite Singer: Henry Rollins
Favorite Song: Damaged I
Favorite Album: Damaged

Dennis "BATMAN" Bythewood
Age: 23
Home: Plymouth, MA
Occupation: Searching for an occupation

Favorite Singer: Henry
Favorite Song: Damaged I
Favorite Album: Damaged

"In Black Flag I had finally found someone as pissed off as I was!" -D.B.

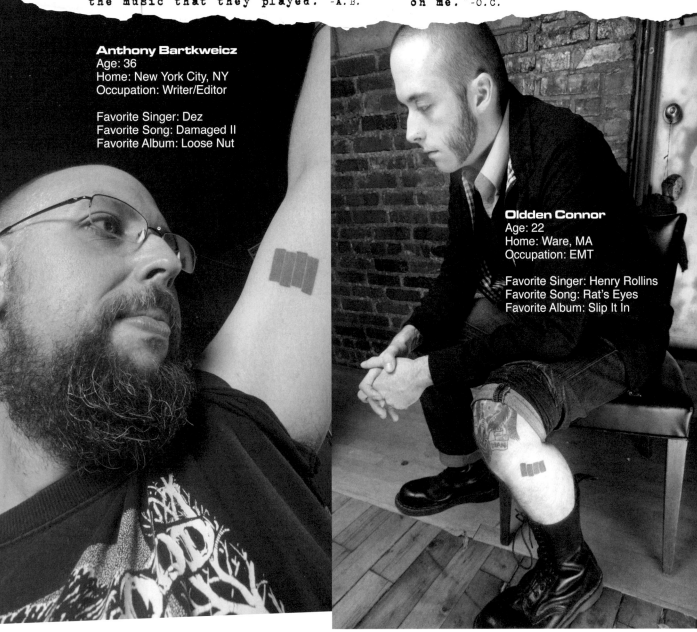

Anthony Bartkweicz
Age: 36
Home: New York City, NY
Occupation: Writer/Editor

Favorite Singer: Dez
Favorite Song: Damaged II
Favorite Album: Loose Nut

Oldden Connor
Age: 22
Home: Ware, MA
Occupation: EMT

Favorite Singer: Henry Rollins
Favorite Song: Rat's Eyes
Favorite Album: Slip It In

and I wanted to be part of it. Sure, the Clash, as I would come to love soon thereafter, would pen some amazing anthems, but for the most part, I was a confused kid from a dying industrial town. I needed music that reflected this atmosphere.

In the American Punk scene, everyone involved seemed to read each band's glaringly antiauthoritarian lyrics and scream in blazing unison, "Fuck yeah, I feel exactly the same way!" with the same enthusiasm these bands poured out to crowds at live shows. Lyrics became our loosely agreed upon manifesto and our moment-to-moment validation. The

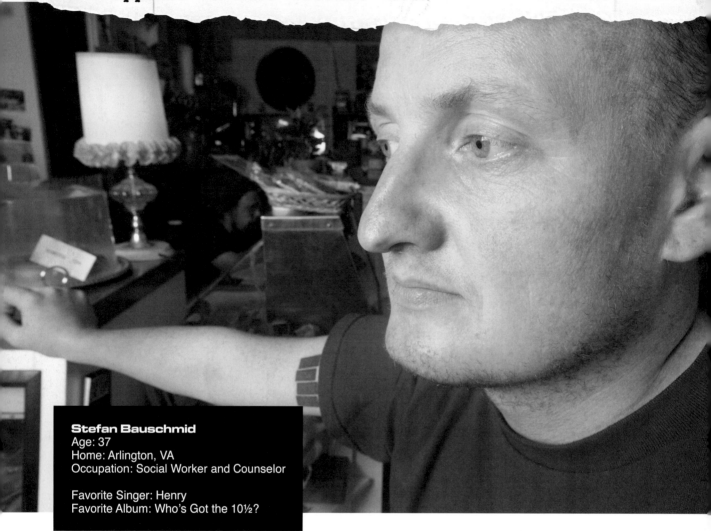

Stefan Bauschmid
Age: 37
Home: Arlington, VA
Occupation: Social Worker and Counselor

Favorite Singer: Henry
Favorite Album: Who's Got the 10½?

sense of unity was intoxicating, and for thousands of angry and disaffected kids across the country, plugging in to this social scene was a way to connect to direct action, to make a change in "our time" and in "our own individual way."

WITHIN A WEEK I WAS "PUNK ROCK," AND NOBODY COULD TALK ME OUT OF IT

It happened over the span of one week, or possibly a month. Like a dam breaking, a few unrelated pieces of the cosmic jigsaw puzzle came together in my world, opening a portal for me just the tiniest bit. While the physical transformation would take place at astonishing speed over the course of just a few days, when I found Punk Rock I had no idea how I lived without it for so long. In fact, I wondered why I hadn't signed up the day my mother denounced the Sex Pistols. What took it so long to find me, and why on earth did I have to find it alone in Red Lion, Pennsylvania, at a time when I was car-less and surrounded by an endless sea of jocks, preps, and rednecks?

"It's going back to my roots.
Punk was really big for me, it
was one of those things that
all my friends and I shared.
Musically, though, things are
so different now. Now the
Punk is all about 'I got
this, I got that, I can't
get a date.' Black Flag
is the opposite of all
that shit."-P.M.

Filthy Phil Miles ▶
Age: 29
Home: Portsmouth, NH
Occupation: Dock Worker

Favorite Singer: Henry Rollins
Favorite Song: Rise Above

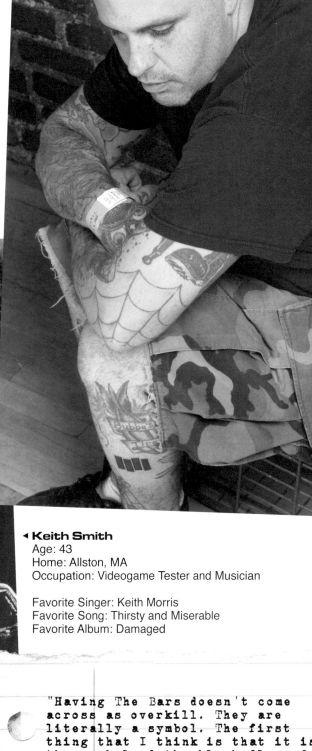

◀ **Keith Smith**
Age: 43
Home: Allston, MA
Occupation: Videogame Tester and Musician

Favorite Singer: Keith Morris
Favorite Song: Thirsty and Miserable
Favorite Album: Damaged

"Having The Bars doesn't come
across as overkill. They are
literally a symbol. The first
thing that I think is that it is
the symbol of the black flag of
anarchism, and that is sort of
the opposite of the white flag
of surrender."-K.S.

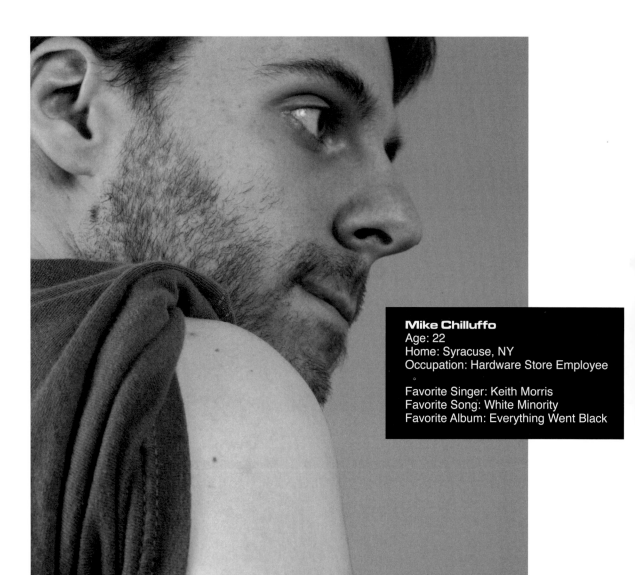

Mike Chilluffo
Age: 22
Home: Syracuse, NY
Occupation: Hardware Store Employee

Favorite Singer: Keith Morris
Favorite Song: White Minority
Favorite Album: Everything Went Black

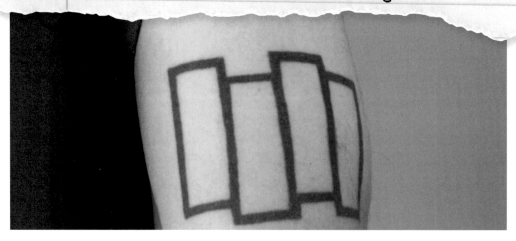

"Black Flag is definitely not my favorite band. I chose The Bars to show that I have been part of the Hardcore Punk culture since I was in the 9th grade." -M.C.

"To me Black Flag stands for Individuality and Independence." -S.P.

"I had a friend in school that wanted to cheat off of one of my tests. In return for cheating rights he loaned me the First Four Years LP. Unfortunately, we both ended up failing the test anyway." -J.Q.

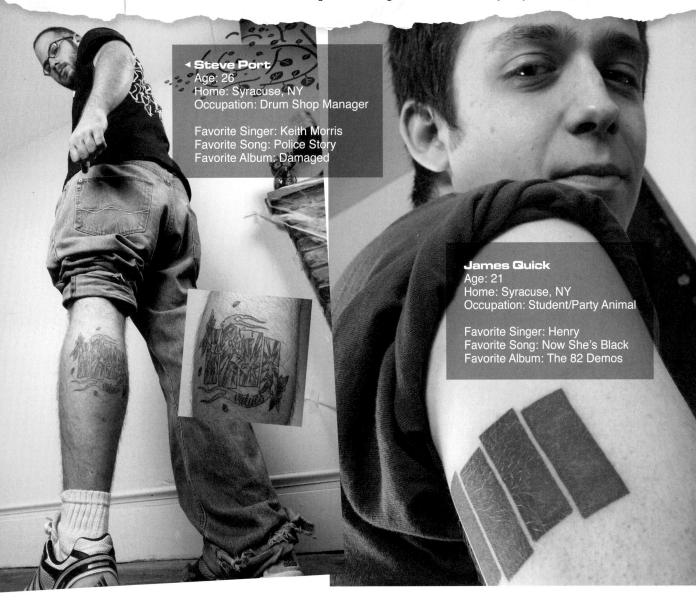

◄ **Steve Port**
Age: 26
Home: Syracuse, NY
Occupation: Drum Shop Manager

Favorite Singer: Keith Morris
Favorite Song: Police Story
Favorite Album: Damaged

James Quick
Age: 21
Home: Syracuse, NY
Occupation: Student/Party Animal

Favorite Singer: Henry
Favorite Song: Now She's Black
Favorite Album: The 82 Demos

My oldest brother entered into the Air Force after a small spat with his girlfriend and his best friend, who were apparently dating behind his back. Not that I agreed with his response, but I liked the fact he left our little town, where he probably would have ended up in jail for an act of passion. Eventually, he ended up stationed in Las Vegas. In 1981, on one of his leaves back home, he mentioned to me he was at a bar having a drink with a girlfriend and a crazy band was playing. "People were jumping off the stage and beating people up while the band just kept on playing," he exclaimed to me. To my brother, the show looked like a straight-up riot. I am still confused as to why he didn't leave the bar the very minute that things turned crazy. Perhaps I should thank him for staying.

Things were weird enough in my life, so I wanted nothing to do with riots, or even big fistfights. Somehow, though, I knew what he described to me wasn't really a riot, it was

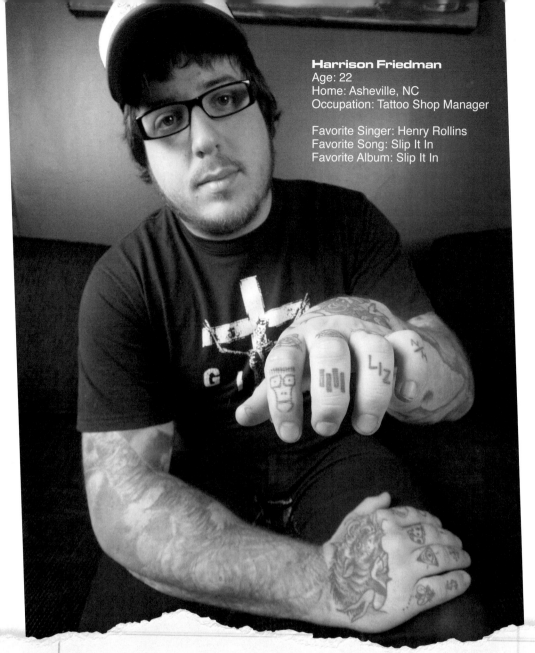

Harrison Friedman
Age: 22
Home: Asheville, NC
Occupation: Tattoo Shop Manager

Favorite Singer: Henry Rollins
Favorite Song: Slip It In
Favorite Album: Slip It In

"The Bars are a classic Punk Rock tattoo: just what you need to
have tattooed on you if you are into Punk Rock. I had an extra
finger to fill and said, 'so why not?'"-H.F.

a sign. My interest was piqued. With my brain mulling over this music that made people crazy enough to jump off a stage, I found myself once again, after a hefty ten-mile ride on a BMX bike, at Thunder Dome. On that day, I was reintroduced to an image I had seen probably two or three times in my entire life up to that point. This symbol was found on the bottom of a skateboard deck, and as soon as I came to know its origin, a lot of things started to make sense to me, as though I'd been struck by lightning or abducted by aliens, or something absurd like that.

You see, competing for space in the reconstructed pools and deeply scarred snake runs of this long-abandoned and decrepit skatepark were the BMXers and the skaters. Most of the BMXers were young teenagers, while more than a few of the skaters were dirty dropouts, probably upwards of eighteen or nineteen years old. Many had the long hair

"The Bars are all about the lifestyle. Everybody that I used to hang out with at the time when I got my tattoo lived through the exact same shit, and some of them got The Bars, too."
-R.G.

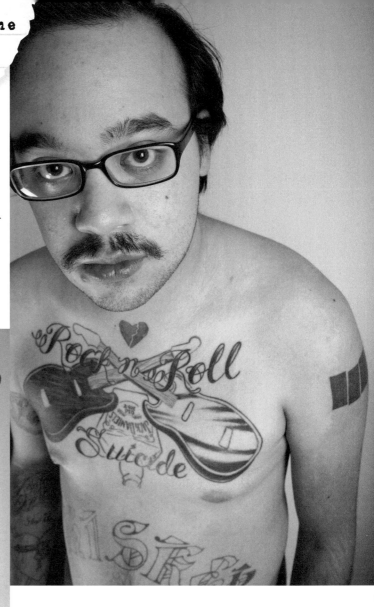

Ryan "PANIC" Godwin ▶
Age: 21
Home: Syracuse, NY
Occupation: Wine Salesman

Favorite Singer: Rollins
Favorite Song: Wasted
Favorite Album: Wasted Again

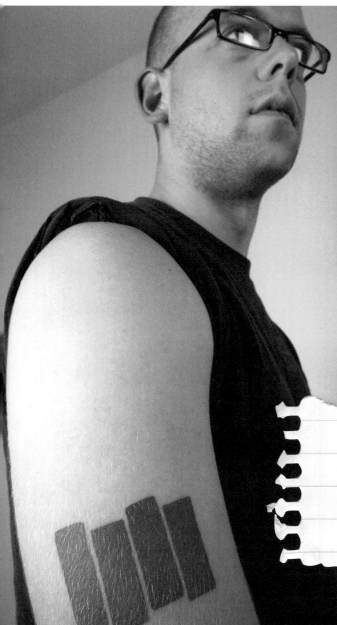

◀ Chris McQuinn
Age: 22
Home: Syracuse, NY
Occupation: Insurance Company Temp Worker

Favorite Singer: Henry Rollins
Favorite Song: Nothing Left Inside
Favorite Album: My War

"The first time that I heard Black Flag was on a skate video called Dying To Live. A skater named Jim Greco had Fix Me playing as his background music, and I had never heard anything like it. I was blown away by it."-C.M.

"Black Flag were definitely the most important Punk band. They just covered so much ground." -G.H.

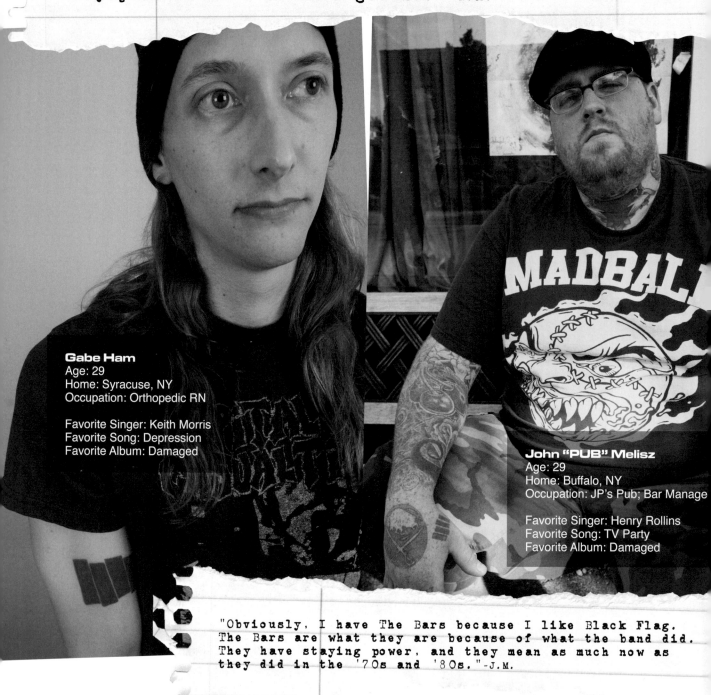

Gabe Ham
Age: 29
Home: Syracuse, NY
Occupation: Orthopedic RN

Favorite Singer: Keith Morris
Favorite Song: Depression
Favorite Album: Damaged

John "PUB" Melisz
Age: 29
Home: Buffalo, NY
Occupation: JP's Pub; Bar Manage

Favorite Singer: Henry Rollins
Favorite Song: TV Party
Favorite Album: Damaged

"Obviously, I have The Bars because I like Black Flag. The Bars are what they are because of what the band did. They have staying power, and they mean as much now as they did in the '70s and '80s." -J.M.

left over from their stint as 1970s-era hippy stoners. Some had beards, and almost all of them wore colorful headbands and wristbands.

We didn't have much in common, bikers and skaters, and we didn't have much to say to one another, but I was always blown away by the intensity of some of these dirtballs with gnarled hair and tattoos. Sometimes, they would take a hit off an insanely colorful bong in public, in broad daylight, pass it off to their buddy and proceed to rock that lumpy pool like it was made of smooth concrete. For dirty fucking skaters, they were a ballsy gang. They were prone to JUST DOING IT long before Nike gave people permission to do so. Accordingly, I was in awe.

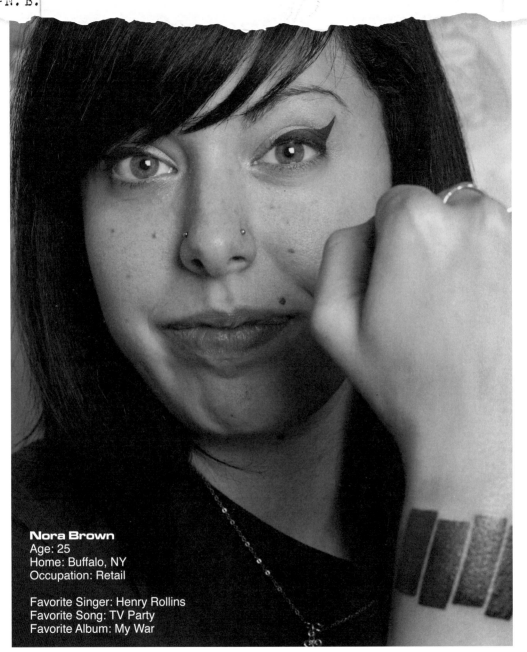

Nora Brown
Age: 25
Home: Buffalo, NY
Occupation: Retail

Favorite Singer: Henry Rollins
Favorite Song: TV Party
Favorite Album: My War

As it turns out, one of the skater kids was this wiry New Waver kid, complete with wrap-around sun glasses, who, when I was a fellow New Waver, wouldn't give me the time of day at the tech school that I attended. On that day, he was all-smiles when I walked over to the pool to watch. Compared to his boys, he kind of sucked, but had he not called me over to chat, I may have never ever talked to any of those beastly dudes.

As I dropped my bike to sit down and talk with him, the communal pile of skateboards lying beside me suddenly seemed so much manlier to me than my two-wheeled ride. The new boards were so much wider than they'd been in the past, and the trucks were

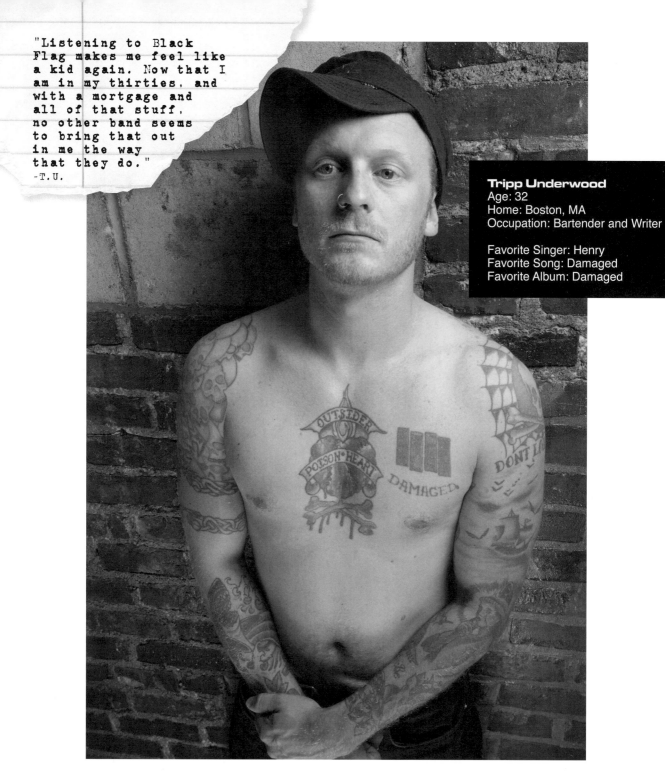

"Listening to Black Flag makes me feel like a kid again. Now that I am in my thirties, and with a mortgage and all of that stuff, no other band seems to bring that out in me the way that they do."
-T.U.

Tripp Underwood
Age: 32
Home: Boston, MA
Occupation: Bartender and Writer

Favorite Singer: Henry
Favorite Song: Damaged
Favorite Album: Damaged

wider as a result. The wheels were smaller, stiffer, and more colorful, too. The most important thing I noticed was the prominent new graphics and designs—skulls, tombstones, dragons, and people's names on fire. I hadn't seen a skateboard in years, so I was kind of blown away by this new imagery.

Few of the old brands could be found. Sims and Powell (now Powell-Peralta) were there, but now there was Vision, Hosoi, Dogtown, Veriflex, and a few others. I studied the boards, and finally had come across a beaten-down board with the words "Black Flag,"

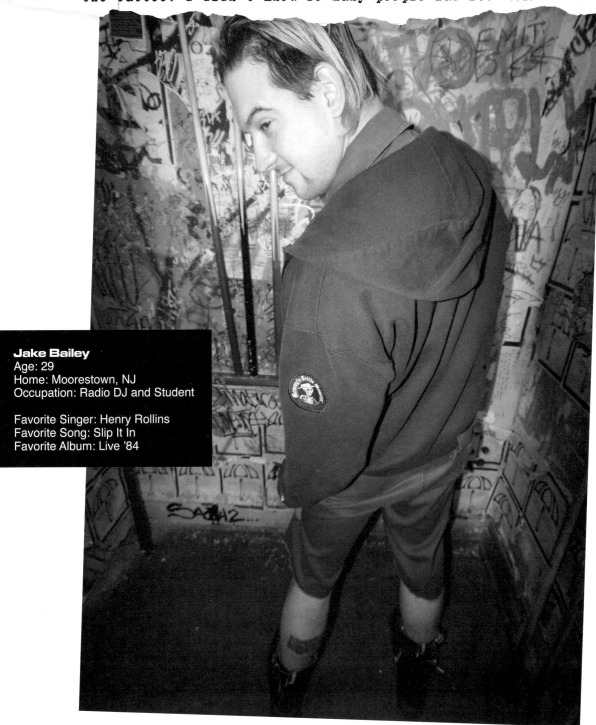

Jake Bailey
Age: 29
Home: Moorestown, NJ
Occupation: Radio DJ and Student

Favorite Singer: Henry Rollins
Favorite Song: Slip It In
Favorite Album: Live '84

along with their logo, The Bars, covering the entire board. It was beaten up, well used,
which was a bit odd because I saw a similar board at a surf shop at the beach earlier
that summer. Black Flag seemed to be either a surfboard or skateboard company, but
I really didn't know anything for sure. It just stuck out to me as odd, peculiar, and of no
consequence. I, after all, was a geeky BMXer, not a pothead skater. So, things stayed
that way for a little while longer, but I knew something changed in me that day.

"Black Flag was one of the first bands that had a truly iconic logo. I am a student of Graphic Design, and I've come to realize that Black Flag was one of the first Punk bands to actually brand themselves."-C.G.

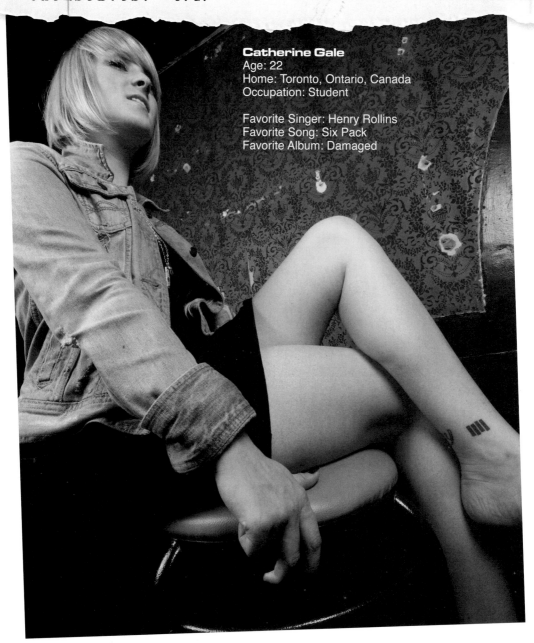

Catherine Gale
Age: 22
Home: Toronto, Ontario, Canada
Occupation: Student

Favorite Singer: Henry Rollins
Favorite Song: Six Pack
Favorite Album: Damaged

OUT WITH THE OLD;
HARRASSMENT TO FOLLOW

Over the next few weeks, I began finding my way out of the BMX scene and slowly started associating with the skaters at Thunder Dome. My obsession with riding my bike was done, so I decided to sell it and buy my first skateboard. I started dressing like surfers from the mall bookstore's surfing magazines and from my brothers' old skateboarding magazines, and tried my best to pretend I wasn't getting harassed hundreds of times a day at school by other students, teachers, and administrators, and even the parents of other students. Stumbling upon skateboarding culture, while empowering, was also kind of killing me socially.

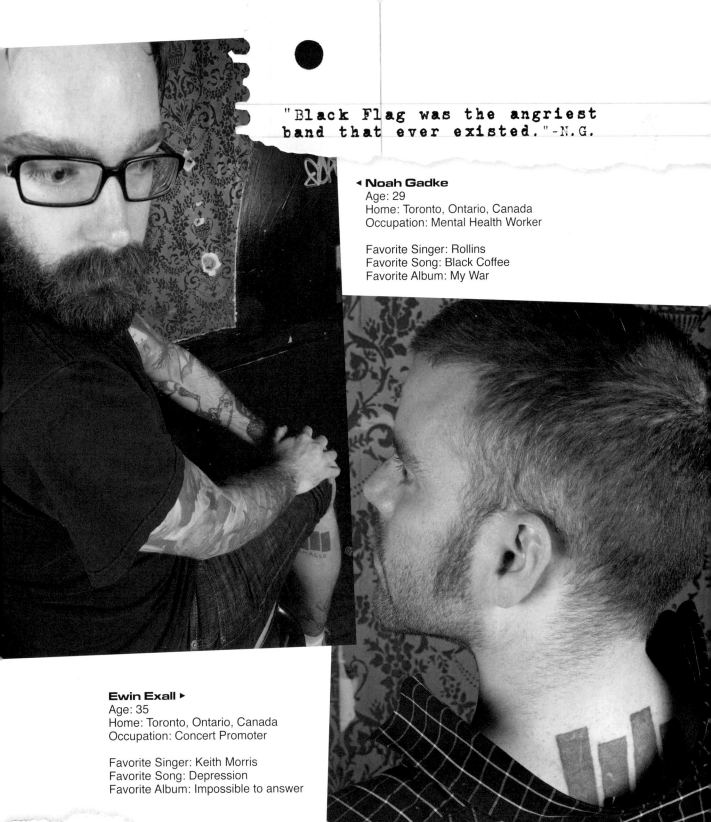

"Black Flag was the angriest
band that ever existed."-N.G.

◄ Noah Gadke
Age: 29
Home: Toronto, Ontario, Canada
Occupation: Mental Health Worker

Favorite Singer: Rollins
Favorite Song: Black Coffee
Favorite Album: My War

Ewin Exall ►
Age: 35
Home: Toronto, Ontario, Canada
Occupation: Concert Promoter

Favorite Singer: Keith Morris
Favorite Song: Depression
Favorite Album: Impossible to answer

"A Black Flag tattoo is a symbol that you have the
basic rage of a North American Punk Rocker. You can
understand the rage because you lived it."-E.E.

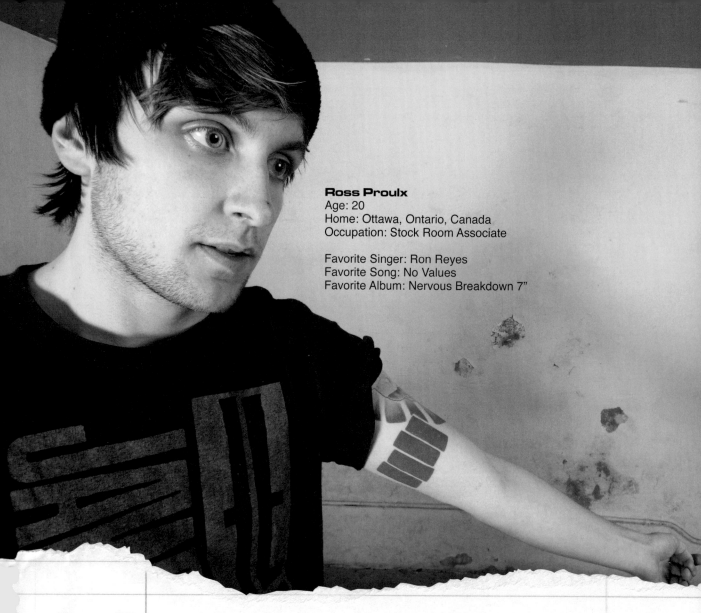

Ross Proulx
Age: 20
Home: Ottawa, Ontario, Canada
Occupation: Stock Room Associate

Favorite Singer: Ron Reyes
Favorite Song: No Values
Favorite Album: Nervous Breakdown 7"

"The Bars was my first tattoo, and also my brother's. Our parents went out of town and so we decided to go get them together and that meant a lot to me. The Bars represent who I am and symbolize a particular way of life that I live."-R.P.

One of my still-close BMX friends had an issue of *Action Now* with the photography of Glen E. Friedman that his very cool brother had lent to him. It blatantly laid out California as a mecca for stupid-assed slacker, surfer, skater, rocker kids like me. There was surfing, there was skateboarding, there was BMX, there was Devo, there was a lashing out at New Wave, and there was Black Flag, the band. The *band* Black Flag?

There was that name again. There was the logo again. The zines featured pictures of the band going fucking nuts yet looking mysteriously pedestrian in jeans and collared shirts, which were unlike the pics I'd seen of the Sex Pistols in the newspaper years before. Plus, there was a little snippet about Black Flag organizing a number of their fans to raid a nearby Adam and the Ants show with signs saying "Black Flag Kills Ants On Contact." The irony was not lost on this little kid who was so ready to trade in his odd mix of Devo and the Cars for something much more ass-kickingly aggressive at that very

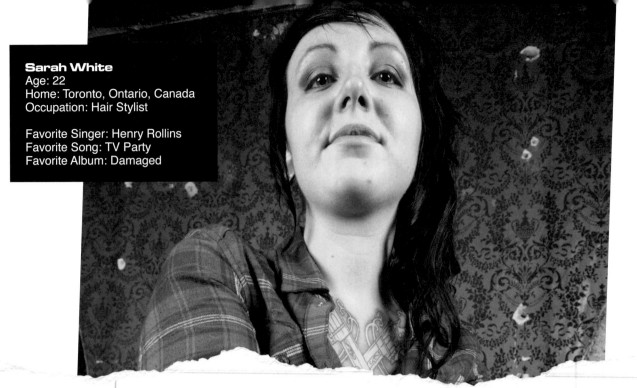

Sarah White
Age: 22
Home: Toronto, Ontario, Canada
Occupation: Hair Stylist

Favorite Singer: Henry Rollins
Favorite Song: TV Party
Favorite Album: Damaged

"My big brother was in love with Black Flag and he got me into it. I don't have The Bars but I decided on 'Rise Above' because it was my favorite song. I remember that when I first heard that song I was smashed in the back of a car, rocking out."-S.W.

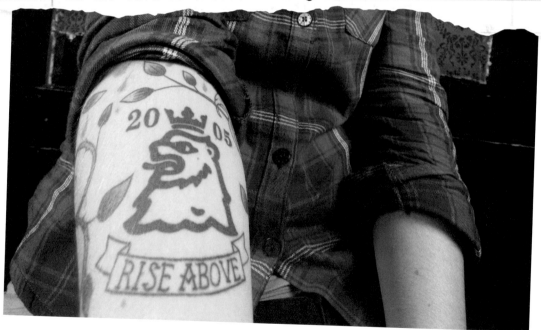

moment in time. I thought this might be the music my ultra-hip brother told me about a few months beforehand, the music that made kids so frantic they kicked each other's asses and leapt from the stage. I hoped so.

I knew that I was going to take even more shit at school from that day on, so when I threw away all of my New Waver Surfer clothes in exchange for a skateboard, a new pair of camo pants, a pair of Vans (which I already owned), and favored my shredded flannel in all sorts of weather, well, the shit just started coming at me from every possible

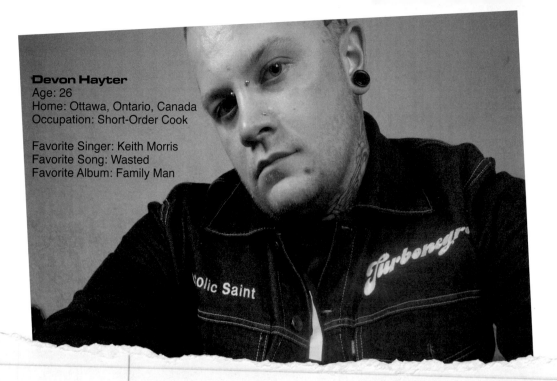

Devon Hayter
Age: 26
Home: Ottawa, Ontario, Canada
Occupation: Short-Order Cook

Favorite Singer: Keith Morris
Favorite Song: Wasted
Favorite Album: Family Man

"The Bars are an iconic image that speaks to angry and pissed-off kids everywhere. Listening to them at age thirteen was a total kick in the face." -D.H.

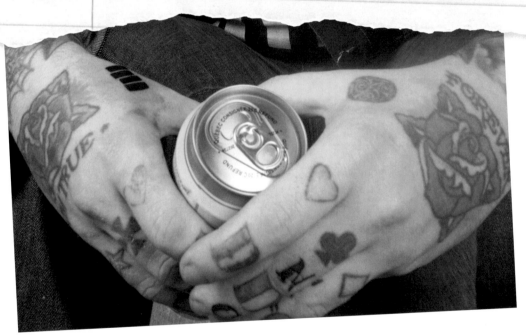

angle. There was no love whatsoever for a Punk Rocker deep in the heart of blue-collar Pennsylvania, no matter how much I related to everybody who disliked Ronald Reagan. I had successfully made myself a target and challenged all comers to take their best shot. My mohawk stated clearly, "This kid has lost his fucking mind, people. Be advised to steer clear of him!"

From the second I found Punk Rock, I never let go. I was Punk "Fucking" Rock to the hilt, and my life finally felt amazing. Nothing that anybody could put in front of me—not a

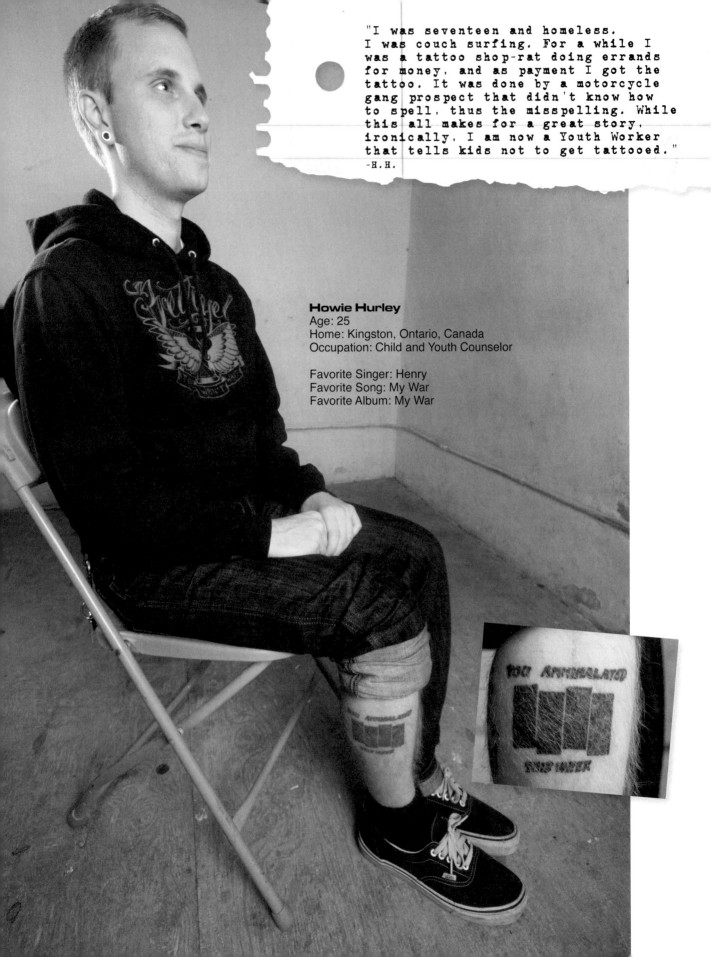

"I was seventeen and homeless. I was couch surfing. For a while I was a tattoo shop-rat doing errands for money, and as payment I got the tattoo. It was done by a motorcycle gang prospect that didn't know how to spell, thus the misspelling. While this all makes for a great story, ironically, I am now a Youth Worker that tells kids not to get tattooed."
-H.H.

Howie Hurley
Age: 25
Home: Kingston, Ontario, Canada
Occupation: Child and Youth Counselor

Favorite Singer: Henry
Favorite Song: My War
Favorite Album: My War

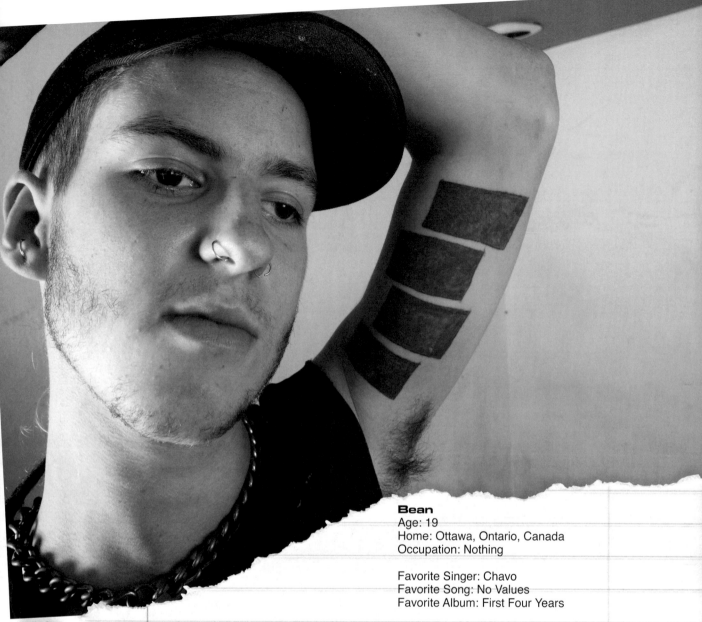

Bean
Age: 19
Home: Ottawa, Ontario, Canada
Occupation: Nothing

Favorite Singer: Chavo
Favorite Song: No Values
Favorite Album: First Four Years

"When I got The Bars tattooed on me it took two hours to do with just one needle, while drinking Colt 45 from a bottle. The Bars still represent the idea of the band, Black Flag, but I think that they mean chaos to most people." -B.

job, not an opportunity to be one of the cool kids—came close to the support that I was getting from my little scene of fellow miscreants and weirdos. Finally, I was somebody, despite what I was hearing from behind my back. Everybody had an opinion about me, which proved I was becoming possibly the biggest, if not weirdest, threat at school.

If my dad had issue with my new suit of armor, I always pointed the finger right back at him and said, "It may be different music, Pop, but the apple didn't fall far from the tree, right?" I don't think he ever agreed, but we did eventually bond over our coupled disdain for the really cool kids, the uber-jocks, and the upper rungs of the social ladder. My mom wasn't such an easy sell. Punk Rock really wrecked our relationship. Eventually she got

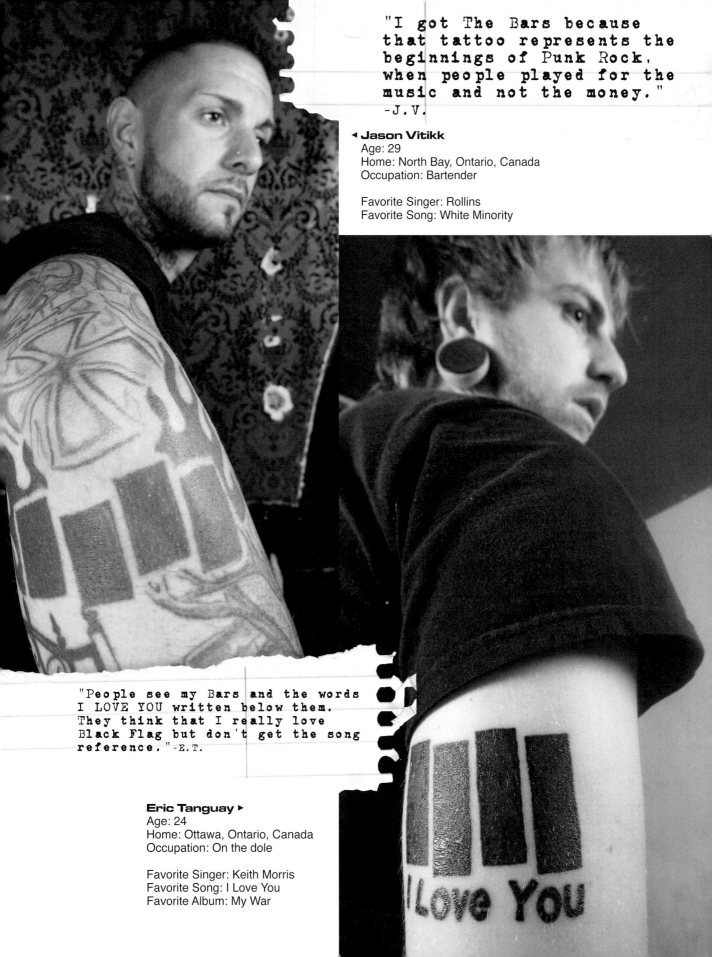

"I got The Bars because
that tattoo represents the
beginnings of Punk Rock,
when people played for the
music and not the money."
-J.V.

◄ **Jason Vitikk**
Age: 29
Home: North Bay, Ontario, Canada
Occupation: Bartender

Favorite Singer: Rollins
Favorite Song: White Minority

"People see my Bars and the words
I LOVE YOU written below them.
They think that I really love
Black Flag but don't get the song
reference."-E.T.

Eric Tanguay ►
Age: 24
Home: Ottawa, Ontario, Canada
Occupation: On the dole

Favorite Singer: Keith Morris
Favorite Song: I Love You
Favorite Album: My War

I Love You

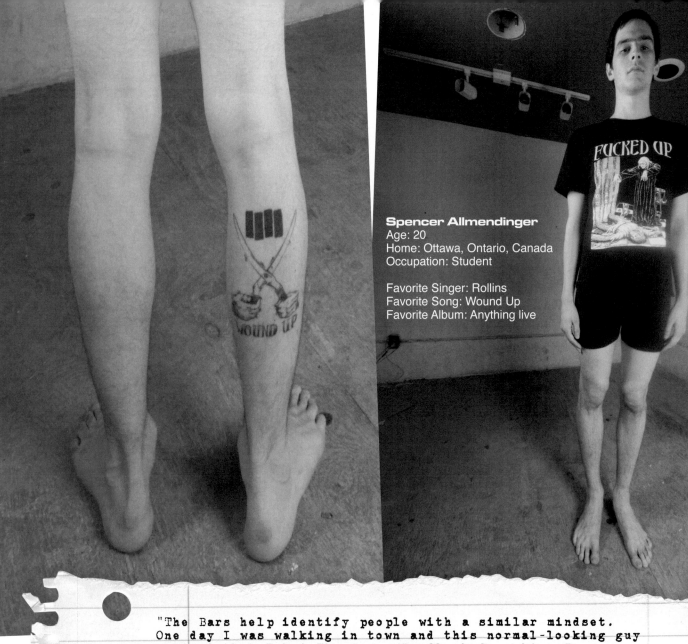

Spencer Allmendinger
Age: 20
Home: Ottawa, Ontario, Canada
Occupation: Student

Favorite Singer: Rollins
Favorite Song: Wound Up
Favorite Album: Anything live

"The Bars help identify people with a similar mindset. One day I was walking in town and this normal-looking guy noticed that I had The Bars. He flashed me his. He was dressed in a suit and kind of looked like the guy in that movie Falling Down. It was totally unexpected." -S.A.

it, but until she did, I didn't care. I had everything that I needed, and I didn't need her daily batch of rubbish bringing me down.

FINDING THE DOOR TO SOMETHING NEW

While the Black Flag Bars are the topic of this discourse, Minor Threat's classic "Black Sheep" image from the *Out of Step* album cover conveys what I am saying here rather powerfully. Punk Rock was the alternative for society's black sheep, if you were conscious enough to "get it." While it seemed kind of stupid to those that didn't "get it," and was almost always portrayed as aggressively negative by the popular media, those of us who found our way to the inside knew better. The culture was way more accepting of strange ideas than the one we'd left, so there was, and still is, a feeling of unity inside the culture that bonds its people together very tightly. After all, we all found our way inside in much the same way, so the unity was celebrated, especially in song.

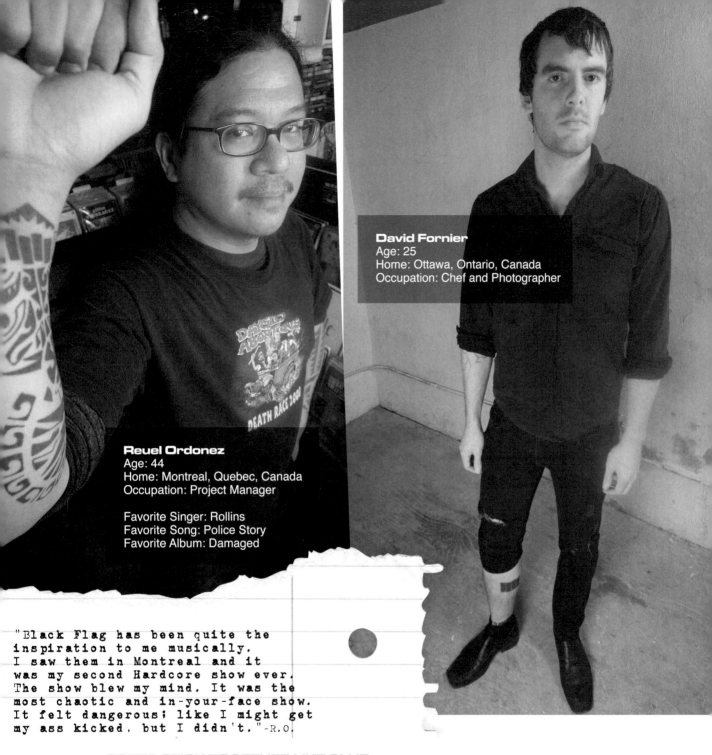

Reuel Ordonez
Age: 44
Home: Montreal, Quebec, Canada
Occupation: Project Manager

Favorite Singer: Rollins
Favorite Song: Police Story
Favorite Album: Damaged

David Fornier
Age: 25
Home: Ottawa, Ontario, Canada
Occupation: Chef and Photographer

```
"Black Flag has been quite the
inspiration to me musically.
I saw them in Montreal and it
was my second Hardcore show ever.
The show blew my mind. It was the
most chaotic and in-your-face show.
It felt dangerous; like I might get
my ass kicked, but I didn't."-R.O.
```

GOTTA STICK TOGETHER LIKE GLUE

Early unity-driven bands like Seven Seconds and Minor Threat provided much of the fuel for the later Youth Crew movement in Hardcore. Even bands prone to penning Punk Rock fight songs, such as SSD and Agnostic Front, were chiming in on "Scene Unity." SSD's "Glue" and Agnostic Front's "United and Strong" not only pushed for early Punk Rock unity but also suggested that we fight like caged tigers against the mainstream that despised us for jumping ship. The unity trip was intoxicating. On almost every record that hit my turntable, I felt like somebody, somewhere, had my back, and some of those people were very, very tough. When the last wall fell for me, I desperately needed some unity in my corner, and I got it inside the Punk Rock culture.

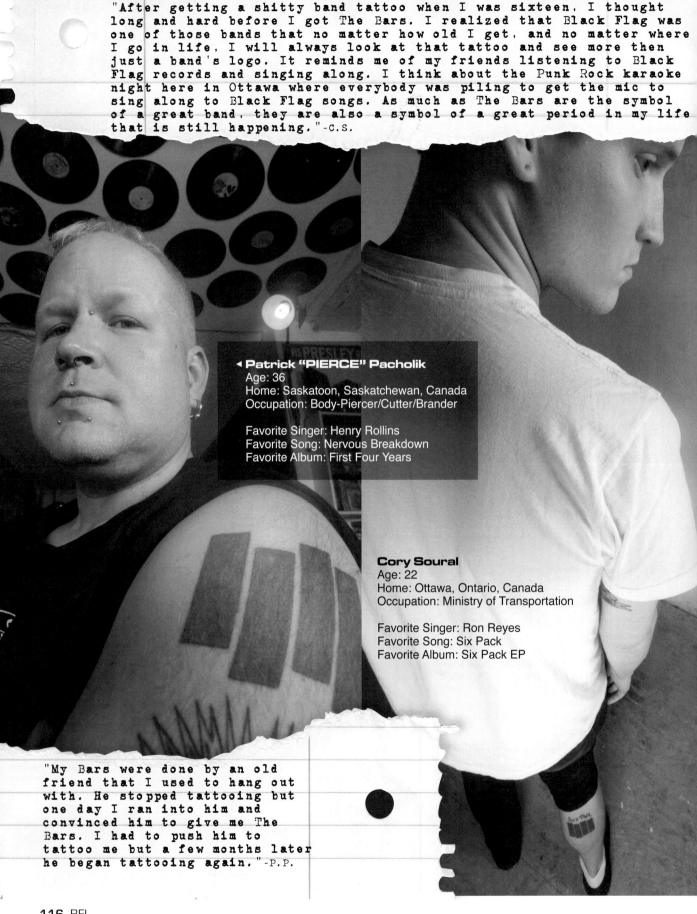

"After getting a shitty band tattoo when I was sixteen, I thought long and hard before I got The Bars. I realized that Black Flag was one of those bands that no matter how old I get, and no matter where I go in life, I will always look at that tattoo and see more then just a band's logo. It reminds me of my friends listening to Black Flag records and singing along. I think about the Punk Rock karaoke night here in Ottawa where everybody was piling to get the mic to sing along to Black Flag songs. As much as The Bars are the symbol of a great band, they are also a symbol of a great period in my life that is still happening."-C.S.

◄ **Patrick "PIERCE" Pacholik**
Age: 36
Home: Saskatoon, Saskatchewan, Canada
Occupation: Body-Piercer/Cutter/Brander

Favorite Singer: Henry Rollins
Favorite Song: Nervous Breakdown
Favorite Album: First Four Years

Cory Soural
Age: 22
Home: Ottawa, Ontario, Canada
Occupation: Ministry of Transportation

Favorite Singer: Ron Reyes
Favorite Song: Six Pack
Favorite Album: Six Pack EP

"My Bars were done by an old friend that I used to hang out with. He stopped tattooing but one day I ran into him and convinced him to give me The Bars. I had to push him to tattoo me but a few months later he began tattooing again."-P.P.

"When I was fourteen years old, the only access I had to a record player was my dad's house, which was set up in our living room. The rules for using the record player were fairly straight forward, (1) no jumping around while the needle is down (2) listen to the full album, no skipping tracks. Both rules were non-negotiable. Only much later did I come to appreciate these rules. I remember the needle dropping on Nervous Breakdown and instantly feeling like all was understood and that I had become part of something that was bigger than me."-M.F.

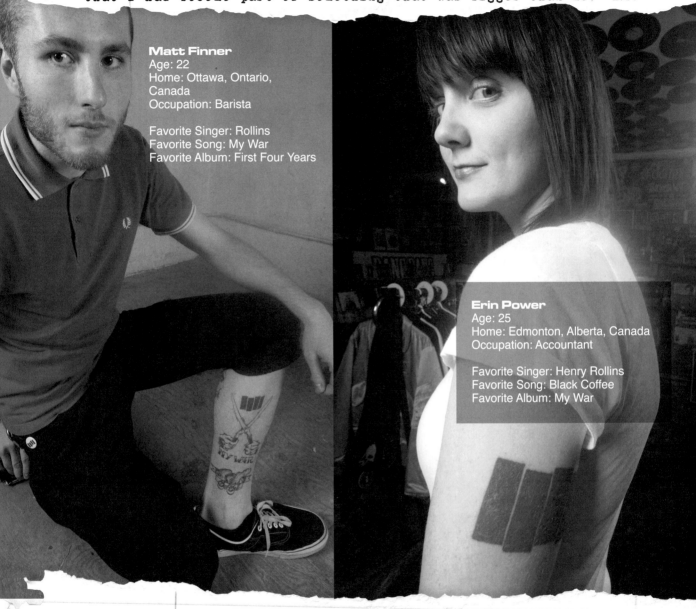

Matt Finner
Age: 22
Home: Ottawa, Ontario, Canada
Occupation: Barista

Favorite Singer: Rollins
Favorite Song: My War
Favorite Album: First Four Years

Erin Power
Age: 25
Home: Edmonton, Alberta, Canada
Occupation: Accountant

Favorite Singer: Henry Rollins
Favorite Song: Black Coffee
Favorite Album: My War

"When I first saw the video for TV Party I liked it but thought that it was pretty silly. So I decided one day to go out and buy Damaged, and my getting into Black Flag all started right there."-E.P.

Professional sports teams, special military forces, and even secret societies require a total commitment. Sports are about winning and the military is about achieving an objective, while a secret society maintains secrecy and order. Punk Rock was about getting a second chance and making a difference. It amounted to a society with a different name and handshake. In a world full of unknowns, insiders share something nearly unspeakable with new brothers and sisters that they share with nobody else,

"Alcohol and drugs easily could have won...

but I found fiery music, unforgettable people, and an unbound life..."

except for maybe their immediate family. Punks share a common history, community, and mission to rise above former stations.

A feeling of awe set in. Luckily, a few old-timers were willing to show me the ropes if I could just sit still and listen, but it was ultimately my responsibility. Having guidance did help me avoid having to figure out the culture, plus I'd already made plenty of mistakes and didn't want any redux. Bands like Black Flag, the Circle Jerks, the Dead Kennedys, DOA, the Bad Brains, SSD, Agnostic Front, and all of their contemporaries lit the path for a kid from the sticks of south-central Pennsylvania that finally mustered courage to take on this amazing culture. Alcohol and drugs easily could have won, as they did with many of my high school contemporaries, but I found fiery music, unforgettable people, and an unbound life was much more to my liking, and I found a lot of like-minded people were right there with me almost the instant I stumbled in the door.

AND SO THERE I WAS

. . . in this dilapidated building on Baltimore's west side, preparing for the show that took me in total over three years to find. I knew a few Circle Jerks songs from having played their records over and over, so I climbed onto the stage with about five other kids, did my little skanking guy dance for just a second, and was summarily thrown off the stage by none other than Mr. Keith Morris. It was my first stage dive at a big Hardcore show, and Morris successfully initiated me.

Falling flat onto my back, and then quickly picked up by faceless kids in the pit, I knew I was finally on the right path. I was home in a sweaty, stinky, confused, smoke-filled, and chaotic place surrounded by people who were just as confused, sweaty, and stinky as me. I successfully made the conversion from first-class loser to first-class threat and seemed simultaneously confused, angered, and empowered. I was "Punk Fucking Rock," man. Simple as that. ∎

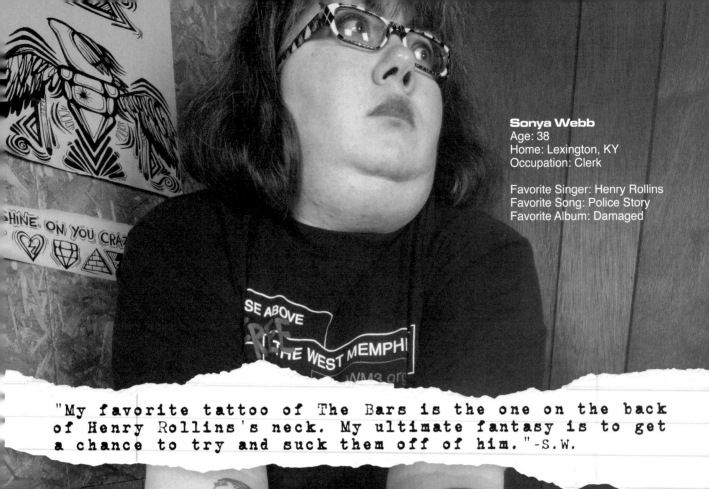

Sonya Webb
Age: 38
Home: Lexington, KY
Occupation: Clerk

Favorite Singer: Henry Rollins
Favorite Song: Police Story
Favorite Album: Damaged

"My favorite tattoo of The Bars is the one on the back of Henry Rollins's neck. My ultimate fantasy is to get a chance to try and suck them off of him."-S.W.

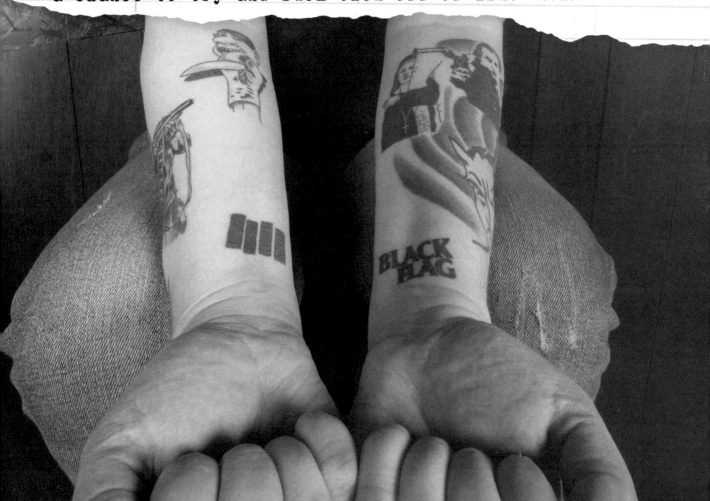

INTERVIEW

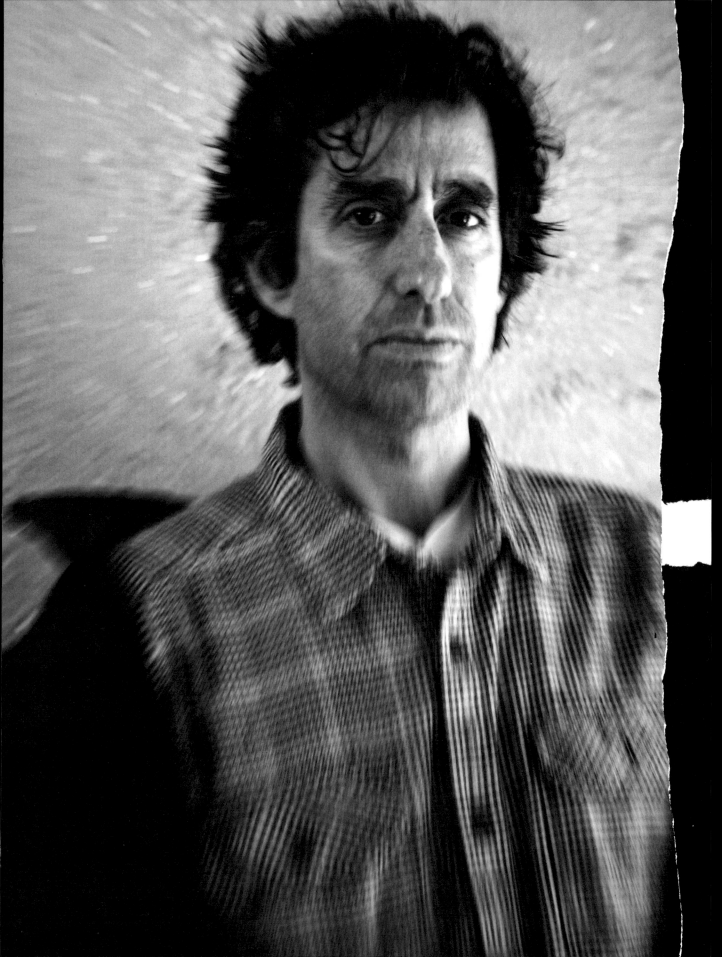

"I always tried to provide an accurate account and capture the intensity of a Black Flag show. My goal was to take pictures of this incredible energy on stage so people could see the scene's vitality. This group on stage was blowing my brains out and inspired me to be a more intense, radical person."

ONE FOOT IN THE PUNK ROCK DOOR

I was a skateboarder. [In the early years] it wasn't like you just got into Hardcore. You first got into Punk Rock music, which was the next level of exciting and intense music after Ted Nugent. Before Punk Rock music, he was the most aggressive and abrasive music out there. Unfortunately, the guy is a total asshole, but nobody knew that back in the 1970s.

Punk Rock and skateboarding were a natural progression and went hand-in-hand. The music was made for sport. There was really nothing like it before, and I was a kid motivated and interested in looking at new things, a rebellious lifestyle, and really wanted to change things. Punk offered to expand my horizons in that direction. I've always been DIY. Sometimes you have to make things happen yourself, if you want to make a change.

In the beginning, we shut out the past and moved forward. I started listening to English bands. I was finishing high school in New York and going to Los Angeles for my school breaks because my mom lived there. Pre-1980, you knew everything was happening and you were part of the scene. You went to record stores, you saw what was coming out that week or month, and listened to everything. Punk music wasn't that available, and not all of it was good, but you listened to it anyway. Everything seemed unique at that time.

In high school, pre–Black Flag, we would go into Dairy Queen just to scare people. Trust me, I didn't look very Punk. I didn't have a mohawk, but I looked a little bit weird. People like me wore leather jackets with some badges, hair a bit shorter than average, high-water pants and Converse sneakers, and people wanted to beat us up. They called us "faggots" and other names. On the subway, somebody might say, "Whip It, Devo!" It was so weird, it was comical, but they couldn't relate. They had no idea what you were thinking or where it was coming from.

When I lived in New York in 1979 or 1980, the Stimulators and Bad Brains played to very small audiences, like ten or twelve people. I knew everybody there, if not by name by face. In Los Angeles in 1978 or '79, maybe a hundred people went to shows at the Starwood. Punk Rock in New York was kind of divided. Young Punks and older Punks were divided into the avant-garde, the art, and the gay scene. At fifteen or sixteen, we weren't that sophisticated yet. We were young kids into aggressive and fast music. That all started with the Ramones.

I found out about Black Flag on one of my trips to California right after the first EP came out. I had

probably seen X that night at the Starwood, where Rodney had a version of his old 1970s club The English Disco and played "Nervous Breakdown." That single was like nothing that I'd ever heard before. The production was ridiculous, not to mention the lyrics. It was the best thing I'd ever heard, so aggressive and obnoxious.

There weren't any rules per se. Apparently, Greg Ginn was inspired by the Stooges, Black Sabbath, and the Grateful Dead, but the equipment he had, the sound he liked, and the studio he worked in helped create that incredibly horrible, dirty-but-fantastic sound. I don't think Greg's guitar sound was premeditated, but the way it was put on the tape is kind of remarkable.

GIVING BACK—USING TECHNICAL SKILL SETS TO FEED THE FLAG LORE
When I was impressed by something, and if it inspired me, I would help it inspire other people. With skateboarding, those guys were doing things other people weren't doing. I didn't see it being portrayed in magazines the way I was experiencing it every day as a teenager. So, I started photographing skaters and figuring out a way to get more people exposed.

By the time Black Flag came along, I had a reputation as a photographer with some pull at *Skateboarder* magazine, which was distributed internationally and had over a million readers in 1978, which was huge back then for a magazine geared towards youth culture. They were still writing about Jan and Dean from the 1950s because they had songs about skateboarding and sidewalk surfing, or writing about the Eagles and Fleetwood Mac.

I thought pushing Black Flag might diversify the magazine a little bit. I thought, "These people are from the beach . . . these people ride skateboards . . . this is what is happening now," so this is what the magazine should write about. They gave me a little bit of space, which gave the music a little

popularity. I felt it was my personal responsibility since Black Flag inspired me so much. I hoped to inspire other people.

I also made it a personal responsibility to see them play at the Church just before it closed down, one of the last shows with Ron. The next time I saw them was in East Los Angeles, one of Dez's early shows, right before the *Jealous Again* EP. I think [Black Flag's producer] Spot recognized me from skateboarding. I introduced myself to them, told them what I did, and said I wanted to take pictures. I probably didn't even take pictures that night because I used to be afraid to take my camera places because cameras break, and who wants to carry a camera around while trying to enjoy a show?

Chuck told me they had a new record coming out and were sending out copies to be reviewed, so I got Black Flag a review in *Action Now*. This was some of the biggest publicity available at the time. Kids all over the world interested in skateboarding culture used *Action Now* as a Bible and got their hands on it as soon as it hit the shelves. Black Flag's record review certainly helped spread their seed. The last issue of *Action Now* featured a picture of the Black Flag bars, the band's logo, on the cover, which was bizarre.

When it came to promoting skateboarding and bands, the two cultures were so intertwined. Henry Rollins was a skater, and he ended up in the Dogtown documentary. He was a skater and a Punk Rocker. So was Ian MacKaye of Minor Threat. They both knew me before I knew them because they were into skateboarding, and I was at the magazine admired all over the world by that subculture.

STEALTH MODUS OPERANDI: CREEPY CRAWL LOS ANGELES
Black Flag controlled their own public relations, PR, with stickers, graffiti, and massive amounts of flyering. They put flyers where other people wouldn't even think of putting them. They'd go into record stores that wouldn't even carry their record. They'd put them everywhere. I can remember

flyering with them once on Sunset Blvd., not just in Hollywood but all the way up through Beverly Hills, where there are no flyers on poles ever. Sure, they were probably taken down the next day, but people on their way home from clubs that night saw them and were like, "Who the fuck is Black Flag?"

We had wheat paste in the trunk of my car. I'd drive the guys somewhere and drop them off, and they'd put up flyers. Black Flag had a very impressive logo. So did a lot of other bands that were around at the time, but Black Flag just worked it. The Bars were everywhere. They were easy to spray paint, so you would see them on highway overpasses on your way to the airport. In Hollywood, you'd see The Bars too. If you didn't know what they were, it wouldn't matter to you. They didn't necessarily write Black Flag above it or below it. Los Angeles is a pretty wide-open place, so I don't think people wondered what these four lines meant unless they had some sort of interest.

In the early days of Punk Rock, people wanted to keep the culture inside their own little clique, but I never believed in that. I don't think that Black Flag ever believed in that either. We wanted to get more people involved, at least in the beginning. We wanted more people to be turned on to it. If people came to a show, and they were turned off by it, that was fine. We wanted to expose Black Flag to more people.

I wasn't out there shooting pictures of them all the time, though. Sometimes I would go to a practice just to listen. I had the opportunity to sit in a room and have Black Flag play for me alone. Most of the time their rehearsals were as intense, if not more intense, as their actual shows. The band members would change clothes after a rehearsal. They just worked really, really hard. Not being a musician, I didn't know what it takes to be that tight, but these guys had a work ethic like nobody else. People thought Punks really didn't give a shit and were just a bunch of belligerent assholes. The truth was far from that. Black Flag had an agenda—conquer everything they could, musically—to show people

they could smash everything that came before them. They wanted to create an entirely new musical paradigm, and maybe even a new paradigm for life.

The first band that should be given credit for setting up a tour network in the early days was DOA from Canada. They wanted to play all over the country too, but they just didn't have the notoriety Black Flag had. People liked DOA, so I don't know what happened. Black Flag took their ball and went further with it. It was always in Greg and Chuck's head that if somebody was going to let them play somewhere, they were going to play there. They wanted to conquer everything. Black Flag really turned people on. It made people become aggressive and want to become part of this new movement.

Black Flag worked very hard at promoting, making themselves sound great, and getting people out to shows. It certainly didn't pay off financially. Getting more and more people out to shows caused them more and more trouble and money. All of a sudden, they started getting a lot of attention after police saw their flyers all over town. They wanted to be able to control what was going on. The first time I saw this happen at a Black Flag show, hundreds of police were harassing the kids. It looked like a military operation going on. The police were all carrying batons and wearing helmets. Phalanxes of police lined the street with the intention of destroying anything that was in their path and shutting down the club.

This was all happening while Dez was singing. At the Longshoreman's Hall in downtown L.A., I turned a corner and saw hundreds of police, like a military situation. At similar shows, they'd march in, shut down the show, and force all the kids out one door. On the way out, they'd tell the kids never come back unless they wanted to end up in jail. Black Flag were playing holes in the walls, dungeons, and places where other shows were not being played, some really weird places.

GLEN E.

It was both scary and exciting because you couldn't believe it. Call me naïve, but why would the police hurt you if you didn't do anything wrong? The LAPD, the Los Angeles Sheriff's Department, and the California Highway Patrol did their best to stop these shows. Perhaps the club was overcrowded, the promoter didn't want the people there, or shows were not supposed to be happening in this neighborhood. The kids did not generally cause the trouble police were supposedly responding to in the first place. These shows were no worse than shows happening anywhere else. Of course, kids drank and did drugs, but no more or less than at other clubs or scenes.

I was always thinking, "I must be involved in something pretty important here, why else would these police be threatening my life?" With my own eyes, I saw police beat kids up, break the windows out of storefronts, and blame it on kids in the news. Once, police officers said, "Stop right there. If you go one step further, I will beat you into the ground." I didn't have any tattoos or piercings and didn't really even look that peculiar, like a social deviant. I was just at a Black Flag show. It was just a really intense time in Los Angeles, especially in the evenings when walking to or from Punk Rock shows. Yet, documentaries overstate the violence at shows themselves and try to characterize Punks as brainless idiots. A very small minority of people were violent.

The news portrayed tough kids cutting each other and putting safety pins through their cheeks, which could be pretty scary if you were a parent with Punk Rock kids. Scarification and tattoos made the news and influenced other kids. Chuck Dukowski appeared on *Two on the Town,* saying, "If it stands there too long, you have to tear it down because it is evil," which appealed to young kids. The clips of kids at shows were supposed to scare people. I think that it did the opposite. It exposed more people to it. The culture of energy and excitement, not necessarily drugs and violence, drew people to the scene. Once Chuck was out of the band, something

changed. The later manifestations don't even come into my equation at all. While they could play well, I didn't like the music. The band just wasn't as exciting.

PETTIBON'S FINGERPRINT ON THE BRANDING OF BLACK FLAG
Pettibon's artwork was intense and kind of provocative. It was very aggressive, looked like it was made for Black Flag, and was really cool. Raymond is a part of the Black Flag legend, myth, and look. Pettibon's artwork helped to identify the band. In a few instances, they didn't use his artwork, and there were some problems.

Greg really wanted to have an image for the band, an image to leave an impression, like good propaganda. Raymond's drawings were scary to me sometimes, pretty grotesque, also very revealing, in terms of psychopathic behavior being exposed. It was powerful but probably shocking to people that didn't see the in-depth social commentary.

The "Police Story: Make Me Come Faggot" T-shirt was aggressive at that time. Unbelievably, they actually printed that image onto a shirt when the police were already trying to kill them. It's funny, but I am not even sure that Raymond put those words in that little bubble there or whether somebody else did. It is not written in his handwriting; it is in a font that somebody added later.

This art was Raymond's first big exposure. He wasn't showing in galleries yet. Having your images on a flyer sort of compromises your art in a way, especially if the band's logo is on the artwork all the time. He probably resented his artwork being treated as background for the information on the flyer, but he probably wouldn't have received the notoriety without being associated with these flyers. I didn't know until recently that he actually designed The Bars, which are really intense and genius, and so simple compared to everything else he does.

"The 'Police Story: Make Me Come Faggot' T-shirt was aggressive at that time. Unbelievably, they actually printed that image onto a shirt when the police were already trying to kill them."

SEEING MY WAR UNFOLD: THE BLACK FLAG PHOTOGRAPHIC LEGACY

I always tried to provide an accurate account and capture the intensity of a Black Flag show. My goal was to take pictures of this incredible energy on stage so people could see the scene's vitality. I wasn't trying to photograph some cultural phenomenon of fucked-up kids and hanging out as an outsider. This group on stage was blowing my brains out and inspired me to be a more intense, radical person.

This band's music was pushing me to places I had never gone before. I wanted to shoot the most intense pictures humanly possible. Drawing on my background from a few years before, when I shot skateboarding, I had a sense of timing and composition that other photographers perhaps did not. My "in-your-face" photography, using wide-angle lenses, caught the action at the exact right moment. I tried to shoot everything as close to perfect as possible. If one of the bands wasn't very good that night, or if there was something wrong at the venue, and things were as good as they could be, I would still try to shape it in a way that made it look exciting. Black Flag, though, normally lived up to the hype.

They were always so incredible on the surface that I couldn't hide it. Some of my greatest photos of them took place during practices. When I printed some of them out for my zine, I didn't tell people they were shot in a practice space, which is embarrassing for me, but they were more intense because they weren't performing for anybody. They weren't showing off for anybody. I doubt that they were showing off for me; I was just a guy sitting in the room. I learned that I needed to get more of the audience in the pictures so people would know the performance wasn't just a sound check. In just about every picture of Black Flag after 1981 or '82, you notice the audience. In fact, I hate looking at band pictures even to this day, modern bands, old bands, or whatever, where the photos look like they could have been taken at a sound check.

I have many [Black Flag] pictures I love, but my favorite one is a vertical shot with Greg, Chuck, and Henry at one of Henry's first shows at the Cuckoo's Nest in 1981. Very rarely would I shoot a vertical shot because our eyes see horizontal. But I was shooting for *Skateboarder*, and a vertical shot would get me a full page, and a bigger photo of the band, as opposed to a horizontal shot, unless you were getting a center spread. So, I happened to get this one incredible shot of them just going off. It is one of the most used Black Flag photos. It just kills everything!

In the photo, Black Flag all look a little retarded. Henry looks like a cartoon character in it. Sweat pours from both Chuck and Greg. Henry isn't wearing a shirt, but his pants are stained from the sweat. The composition is perfect; Chuck's bass is going one way, and Greg's guitar is going the other way, and Henry is in the middle.

Another picture I like is from a show at Mike Muir's house. I produced Suicidal Tendencies's

GLEN E.

first album and was their manager. Black Flag did me a favor and played the show; in return, I did all of their photography. We wanted to have a little party because the kids, maybe a hundred or so that followed Suicidal, had these crazy hand-drawn T-shirts. We wanted to have a party so I could get photos all of them.

They played in a garage in Culver City for about fifty Suicidal fans. Oddly, the kids didn't really like them because they were just starting to play "Scream," entering into a new era of playing slow, drudgingly heavy stuff. In one particular picture, a horizontal shot with my fisheye lens, Henry bends over backwards with the microphone in his mouth. You can see everybody in the shot, plus it was Dez's last show with them.

THE FUTURE NOW

Recently, I bought like ten Black Flag T-shirts for my two-and-a-half year old. As he starts growing, he will always have a Black Flag shirt to wear. Black Flag is the first band that he will know by name. Very strait-laced fathers will see him on the playground in his Black Flag shirt and smile, or nod, or say, "Hey, where'd you get that shirt?" So, Black Flag definitely has resonance with me. Yet, I know of only about a hundred people on this planet that have more of a connection to Black Flag than I do, so I never expect people to have experienced what I have. I hope that at least 50 percent of what others love about Black Flag is the same thing that made them special to me. I hope that at least 50 percent are inspired by the same parts as me. If The Bars represent something so inspirational you want to burn them into your skin for the rest of your life, fine. Black Flag can hold that banner, inspire people, and kick their ass.

PUNK NEARING THE RETIREMENT AGE

I've listened to Black Flag almost my whole life. I will always listen to Black Flag. Nothing has come along to take its place, which is strange to me. Ian MacKaye said, "It is as if I were inspired by Buddy Holly and just kept on playing Buddy Holly music,"

which is the equivalent of kids still listening only to Black Flag and Minor Threat. He created his own thing back then, and kids today are beating a dead horse maybe.

Black Flag songs have as much resonance now as they did when they were written. The Dead Kennedys' lyrics don't as much, mostly because they mentioned Ronald Reagan. That puts a date on them. They mention Alexander Haig in a great song, but Black Flag songs were never that specific. Black Flag was always dealing with "personal politics," which was almost a cop-out then because I was really political and aggressive in the 1980s. I thought politics were very important. I wasn't old enough, or sophisticated enough, to understand: Black Flag were avoiding topics I thought they should tackle and destroy, like Reagan and conservative thought because their philosophy was deeper and much more intense. They conquered those politics without being so specific as to name names.

THE CREDOS CONTINUES

Seeing the SST guys living in a space only twenty-five feet long and ten feet wide with a tiny bathroom in the back and guys living in bunk beds built out of two-by-fours was inspiring. Some lived under a desk in this apartment that looked like it could have been a storefront in Redondo Beach, with all the records stacked up at the front. They believed in what they were doing, weren't trying to become rock stars, and wanted to promote these progressive ideals and get out their emotions. They never thought that they were going to make any money. In fact, they made little or no money ever. They hoped they could continue to do this until they didn't want to do it anymore and move on to their next phase in life. I never thought that I was going to be a photographer, you know? Just because they lived in such squalor trying to accomplish something doesn't mean you have to live that way.

Even if it didn't last that long and broke down, it is still inspiring. ■

IN DEFENSE OF BROAD-SWEEPING GENERALIZATIONS

"It was a crazy place, especially if people really enjoyed the chaos."

With a twenty-plus-year tour of duty under my belt, I chose to write *Barred for Life* more as my epitaph than as a volume to help keep some spirit alive within me. Pop Culture drop-outs peppered the Punk Rock scene since the beginning, but not everybody likes the volatility and decides to stay. The attrition rate was high in my era. One day, my best friend and I were skateboarding at a neighborhood ramp, and by the next week he was one of those jocks threatening to kick my ass at school. A week later, he was back beside me at the ramp. It was a crazy place, especially if people really enjoyed the chaos.

The Loft, my little Punk Rock playground, closed in 1986, so grabbing flyers from every show, analyzing them carefully, and gleaning information about the next show became necessary. Shifts in "established" venues, the frequency of shows, and the quality of the shows fluctuated widely. I recall driving to another city to see a show, only to discover the venue was closed. Suddenly, the trip was for nothing. Going to see bands play in Baltimore started to become a chore too…

"All my friends have The Bars, and so I wanted them too. On the day that I got them I asked my tattooist to draw up lipsticks in the shape of the Black Flag logo, and when she started working on them everybody in the shop became jealous and wanted to be the one to tattoo them on me." -K.B.

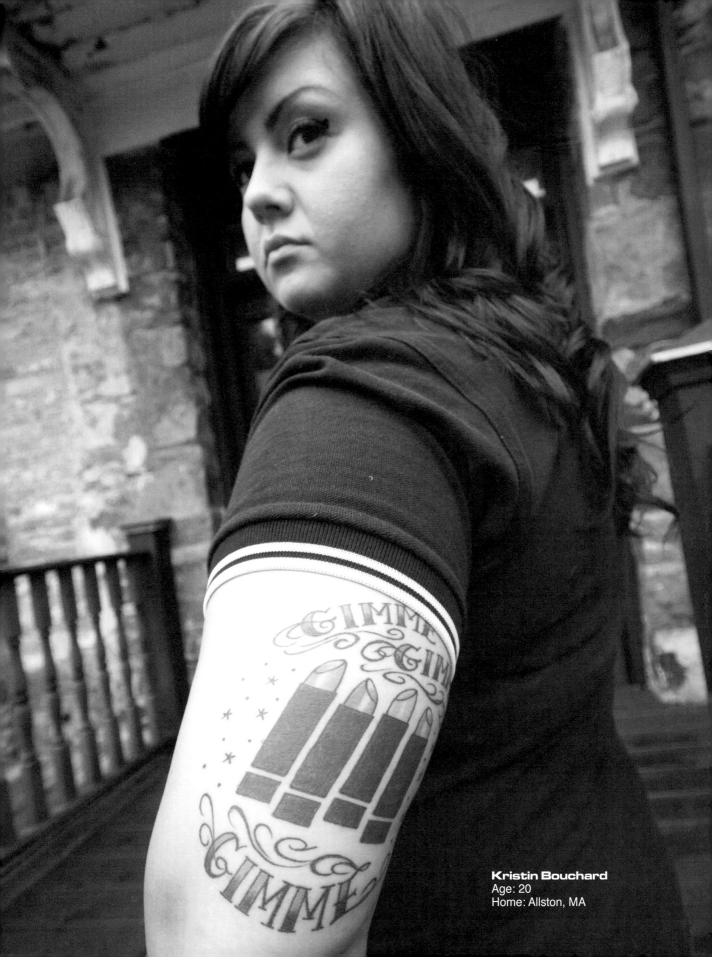

Kristin Bouchard
Age: 20
Home: Allston, MA

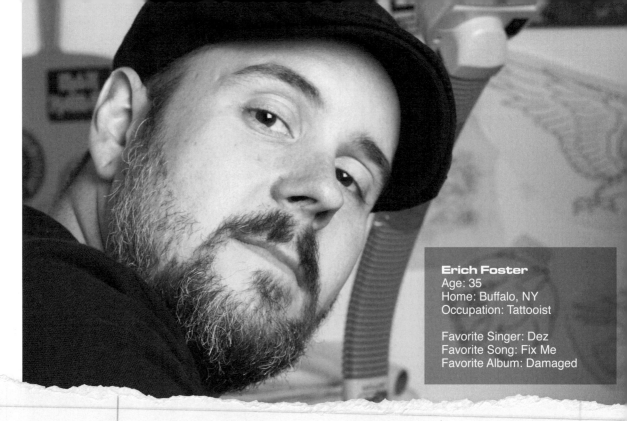

Erich Foster
Age: 35
Home: Buffalo, NY
Occupation: Tattooist

Favorite Singer: Dez
Favorite Song: Fix Me
Favorite Album: Damaged

"I already had so many other tattoos before I got The Bars, so I got them to show that I am part of the Punk Rock community. In that respect, I guess that I needed to have that tattoo."-E.F.

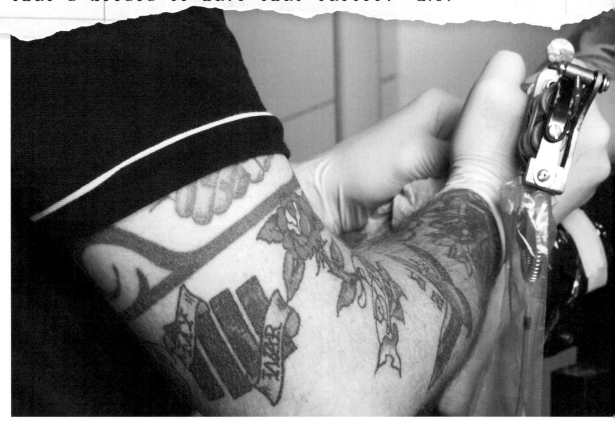

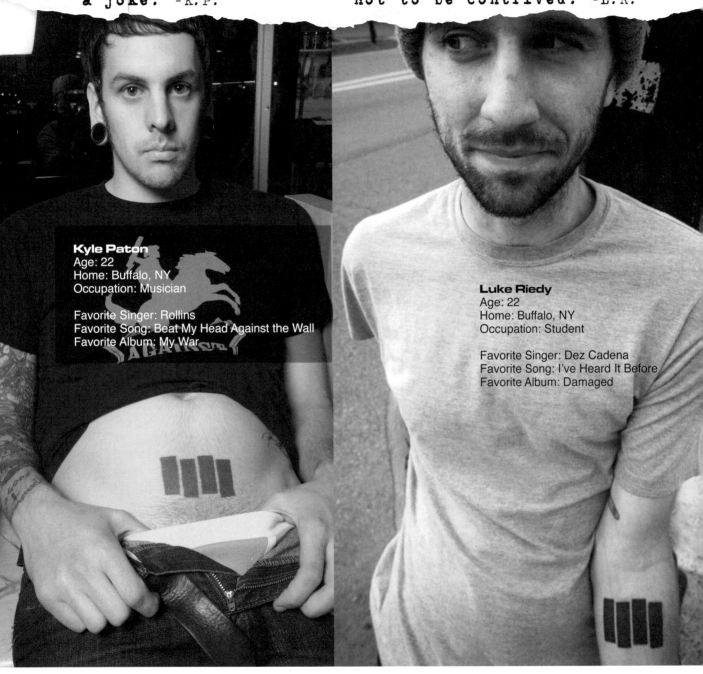

"My friends thought that it was funny to get The Bars tattooed where I got them. I am gonna get 'Slip It In' tattooed above it as a joke."-K.P.

"It was Raymond Pettibon's artwork that got me into it. The comical illustrations meant to me that Black Flag were aiming for honest expression, and attempting not to be contrived."-L.R.

Kyle Paton
Age: 22
Home: Buffalo, NY
Occupation: Musician

Favorite Singer: Rollins
Favorite Song: Beat My Head Against the Wall
Favorite Album: My War

Luke Riedy
Age: 22
Home: Buffalo, NY
Occupation: Student

Favorite Singer: Dez Cadena
Favorite Song: I've Heard It Before
Favorite Album: Damaged

There was more flux, like losing friends, girlfriends, jobs, bands, and facets of my old life. I learned to rely wholly on myself. Committed Punks pressed forward and kept matters relevant. A mere gig-goer at first, I gradually took on other responsibilities in and around my hometown to keep things fresh. I booked shows, helped people build skateboard ramps, and always offered rides to shows in other cities in my beat-to-shit van. Whatever needed done, I'd do it, if I had the energy, which others helped me stoke.

"[Punk Rock] was my home for nearly twenty-five years, and like anything that is in your blood for twenty-five years, I will never fully separate from what I was able to do for the culture and what the culture did for me."

Nearly fifteen years later, a few other dedicated friends and I single-handedly built a scene in our adopted hometown of Cincinnati, Ohio. Transplants and locals joined together to build a scene because it simply had to happen. Nobody was stepping up to make it easy, so we had to do it ourselves. The tools were available, and everybody knew they had to build their version of an alternative community. Like everything else, our scene didn't last but a few years, but it was fucking amazing while it lasted. It died and became replaced by another generation. Being a Punk Rocker stopped fulfilling me, and even for a kid committed fully to the cause, it was beginning to look like it was time for me to exit, though it would take me nearly half a decade to do so.

Feel free to call me a sell-out, or whatever you like. I will just shrug it off. No matter what happens, I will always feel a kinship to subcultures, and specifically to those subcultures that empower their members to do more good than bad and are often smeared due to little negative episodes. That was Punk Rock to me. It was my home for nearly twenty-five years, and like anything that is in your blood for twenty-five years, I will never fully separate from what I was able to do for the culture and what the culture did for me. ∎

"I wanted to link myself to the tradition of The Bars, but The Bars are so serious and I wanted to deconstruct that myth a little bit. By having The Bars tattooed as bacon strips I wanted to poke fun at the seriousness."-M.P.

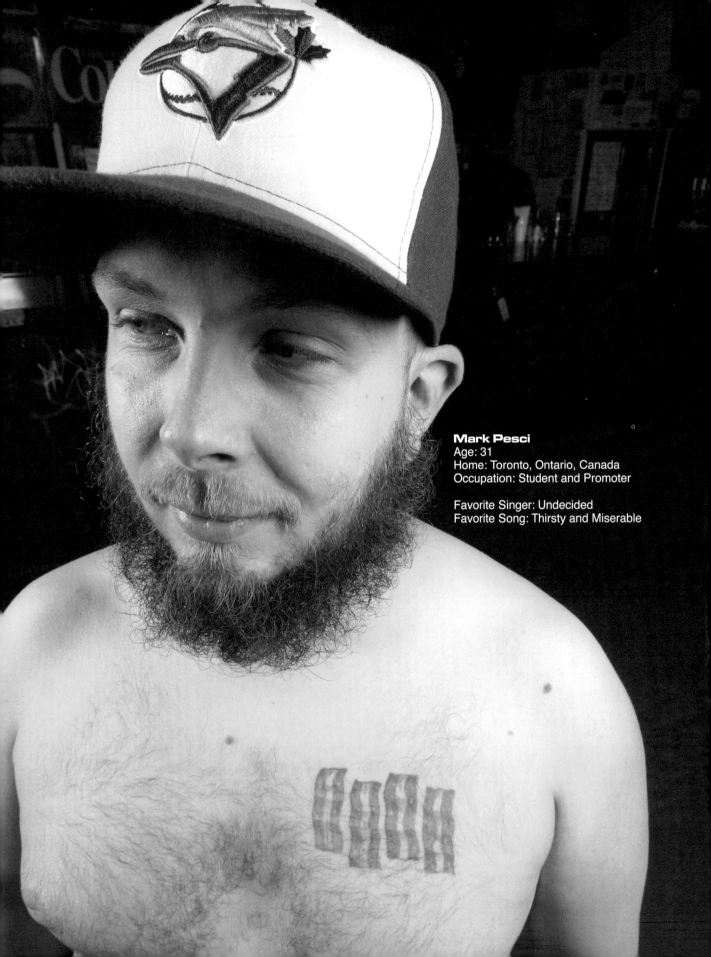

Mark Pesci
Age: 31
Home: Toronto, Ontario, Canada
Occupation: Student and Promoter

Favorite Singer: Undecided
Favorite Song: Thirsty and Miserable

INTERVIEW

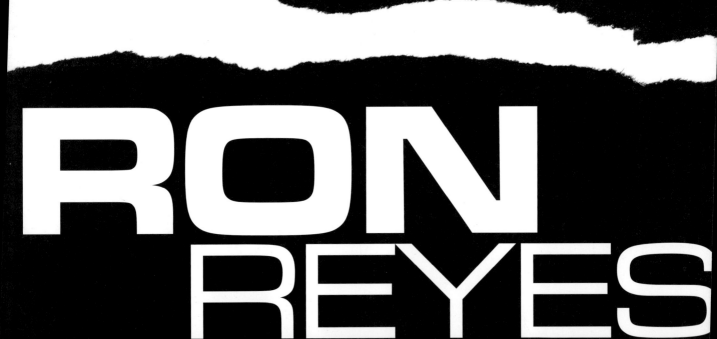

TALENT HAD NOTHING TO DO WITH IT. FOR ME, IT WAS ALL JUST A STATE OF MIND.

RON REYES

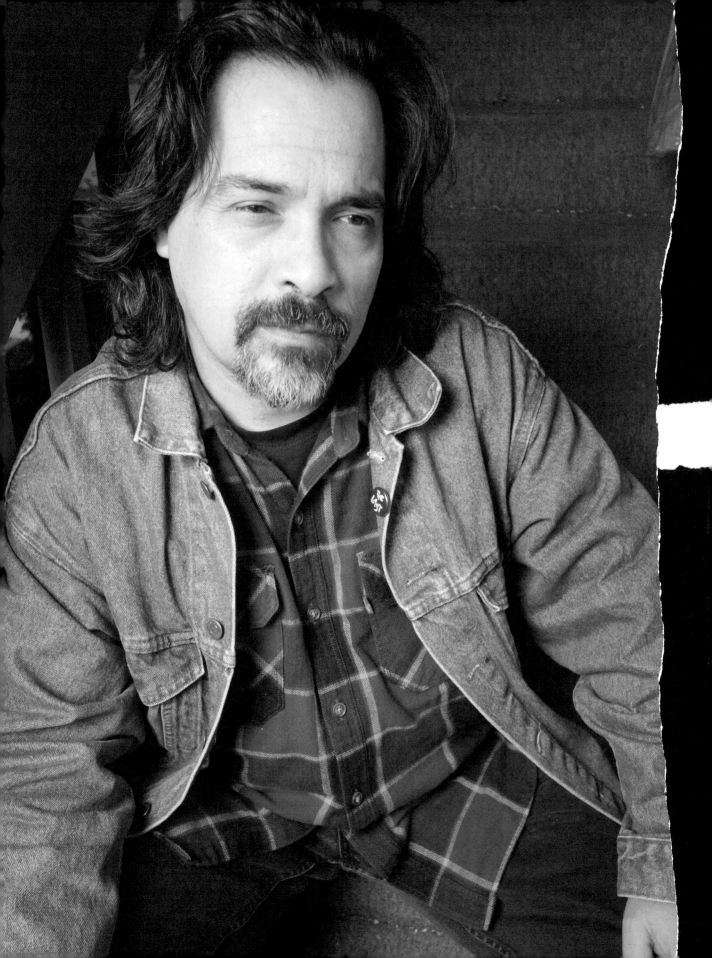

> **"Many bands of that era built their sound and image from what was coming out of New York and London. Visually, there was nothing remotely cool or dignified about Black Flag."**

A KID FROM THE OTHER SIDE OF THE TRACKS RISES ABOVE

I was fortunate enough to experience the early days of The Masque and the Whiskey. First and foremost, I was a fan. I listened to a lot of glam from the 1970s and rock bands like the MC5 and the Stooges. I heard about new music happening in New York and England but never imagined anything like that could happen on the West Coast of California. A friend of mine from school told me about a scene developing in Hollywood. She told me about The Masque, so I started seeing gigs there. The energy coming out of that place seemed to come out of nowhere, and it caught my attention, totally. I was a rabid fan of those early bands, in particular L.A. bands like X, the Germs, the Screamers, and the Avengers too, from up the coast a bit. They were fantastic.

I was born in Puerto Rico and spent the first couple of years in New York, as most Puerto Ricans do, but then we moved to Florida, then the West Coast, to get that American Dream happening. My mom was a single parent, so she moved my brother and me out to the West Coast. She did the best she could as a single parent through my early years. When I was like ten or eleven, my step-dad came on the scene. He was a very blue-collar worker, but most of my clothes came from the Salvation Army, so we weren't well off.

My mom put me into this school that wasn't in the school district where we lived. We lived in the district for Redondo Beach High, a place with gangs, drugs, and alcohol. She sent me to Mira Costa High School in Manhattan Beach, California, which is pretty preppy and straight, and a bit more of an upper-class school. This was terrible for me. Socially and culturally, I was a complete outcast, and the plan just backfired.

When I was going to Manhattan Beach, I was kind of the invisible minority. I don't recall any black kids there, and I was probably only one of the Hispanics, so I felt a little out of place. My family was not that well off, and I was going to a *Beverly Hills 90210* kind of school. It was terrible. I didn't have any friends in high school, so it was pretty hard.

I met Dez Cadena around 1978 or '79. We were neighbors in Redondo Beach. Having just dropped out of Mira Costa in my senior year of high school, I was staying in the garage in my brother's house. Dez's family had a yard sale every weekend, and they lived like three houses down from my place. One day, I was walking by the yard sale and heard some of Dez's music playing in the background, so we started talking. We found out we liked a lot of the same bands. He had records that I really liked, and since we lived three houses apart, we'd get together and listen to those records and Rodney on the ROQ. We heard the first Black Flag single, "Wasted," on KROQ.

Redondo Beach is next-door to Hermosa Beach, and we started hearing about a band called Panic, pre–Black Flag, and would go see them rehearse. By this time, both Dez and I were seeing shows in Hollywood, like the Germs, X, and Weirdos, and all of those great bands, but they all had an artsy-fartsy background. Black Flag was totally intense in a way we hadn't heard before or could have anticipated. Ginn's guitar playing was just so intense.

There wasn't much of a scene in those days, so we started hanging out at their rehearsal place in Hermosa Beach. Bands like The Last were from

RON

Hermosa, and the Descendents were probably just starting. When Keith quit the band, or got kicked out of the band, I still don't know the whole story on that one, Greg asked me to join. I immediately picked up my bags from Redondo Beach and walked over to Hermosa Beach and rented a tiny space at this church called the Arts and Crafts Community Church.

The place I rented soon became the South Bay's hangout for people into the same music we were into. There was graffiti on the walls, records playing all of the time, and bands started setting up their equipment there. My place became the nucleus of that scene, and things started to come together, then expand outward.

SONIC REDUCERS AND PLAIN-CLOTHED POWERHOUSES

Many bands of that era built their sound and image from what was coming out of New York and London, like, "We are going to be like the Pistols or the Ramones." Black Flag were completely oblivious to that kind of stuff. I know the guys were into the Ramones, but looking or sounding like them didn't ever enter into their consciousness. Visually, there was nothing remotely cool or dignified about Black Flag. They dressed in clothes that looked like something your dad would wear. In Hollywood, the bands had some kind of look or image, marketable to some degree. You could actually visualize them on a cover of a magazine. Black Flag, though, looked like poor old men from the beaches . . . so bizarre.

Sonically, even today, Greg Ginn's guitar was just so brutal and so intense. You couldn't say he modeled his sound after Johnny Thunders. The first time that I'd seen them live, I was like, "Okay, this is way, way, way, way different than anything that I've seen up to this point." We used to kid around with Chuck and say his bass sounded like a muffler was being dragged along under a car. The closest thing to Chuck's sound is Lemmy from Motörhead. Chuck's bass sound was not Dee Dee Ramone or Sid Vicious. None of the bands in L.A. came anywhere close.

PIMPLED PUNKS FROM THE BEACH

Black Flag played the infamous Pollywog Park gig in Manhattan Beach. The opening band was the Tourists, who later became Red Cross (and later known as Redd Kross) and started hanging out at the Church. They needed a drummer so they asked me. I wasn't a drummer, so I didn't know how, but I did own a drum set. I said, "Sure, why not" and joined the band. Probably within a week or two we were in the studio recording the first 12" record, after Posh Boy had picked them up.

Talent had nothing to do with it. For me, it was all just a state of mind. The Red Cross stuff was so Punk Rock. Steve was like twelve years old, and they were from the beach. Nothing was defined yet. There wasn't a template of what a Punk Rock band is supposed to sound or look like in California. There wasn't a blueprint, so you had these kids from Hawthorne, Steve and Jeff, beach kids with zits and pimples and shit, like Punk Rock band groupies. Nobody asked me to try out. Nobody asked me about my chops. We were part of something, and nothing else mattered. I was terrible. I knew one beat: the "My Sharona" beat that used to drive people crazy. I had no clue what I was doing, but I had energy and loved it. Other people were digging it, and that is all that really mattered.

My involvement with Red Cross and Black Flag is almost like one of their songs, like a two-minute song with so much energy packed into it. It wasn't about quantity; it was about quality. It was energy that lasted for just a moment, then it was gone, and something else came along to replace it. Red Cross never toured. We played a lot of gigs in the South Bay area and became media darlings particularly because Steve was not old enough to be in the bars we played. The music was great, too, kind of pop but totally Red Cross, just totally unique. Then Black Flag called me, and I answered . . .

All the bands I liked at that time were Hollywood bands, so naturally I gravitated up there. Black Flag, though, were very proud to be from Hermosa Beach, so they resisted the temptation to be part

of the Hollywood scene. If I wanted to be in Black Flag, I had to go back to Hermosa. Dez and I were like their best fans. We were at all of the shows when Keith was singing. We were up front and getting crazy, so it was like this family. I doubt that Greg or Chuck would have even considered going to Hollywood to find a singer when there was a guy right [in front] that knew all of the songs.

It wasn't like they held auditions. Greg just asked me. I was like, "Of course. I love the band." The fact that Keith was no longer in the band didn't even faze me because I didn't think that mattered. It wasn't like, "Oh, no, a founding member is out of the band!" To me, there was always going to be this rapid changing and evolving movement in different directions. Even very early, Greg was moving forward and planning the next gig, the next song, the next flyer, and writing new music and putting together the next rehearsal.

WORK HARD, PLAY HARDER: THE BLACK FLAG WORK ETHIC
The Black Flag work ethic is unparalleled. Nothing in the American Punk Rock world comes anywhere close. A lot of bands tried to pattern themselves after it, and only a few have succeeded to some degree. In Vancouver, DOA really had something going on then too. Their work ethic was amazing as well. Remember, we weren't part of the Hollywood scene, and there wasn't a South Bay scene. We had to do it ourselves. Nobody loved Black Flag during those times; nobody was knocking down the door asking to be part of this. It was just very unappealing to a lot of people, and I am sure that all of the Hollywood bands were not into them.

Greg already had SST electronics. He was a business owner, so he knew what it took to keep a business afloat and prosper, so I am sure that he took that attitude with his band. I never saw Greg do anything that wasn't in some way related to Black Flag or SST records. If he wasn't working with his business, he was writing songs, or he and his brother were doing posters. It wasn't a part-time thing. He and Chuck seemed to be born to take over the world. Keith and I were more interested in

finding the next six-pack or party. Greg and Chuck, though, wouldn't allow us to just sit on our ass and be part-timers. This was all-or-nothing.

ENTERING THE MAELSTROM: SIX MONTHS AS THE VOICE OF BLACK FLAG
So much happened in such a short period of time. In a whirlwind six-month period, we did a couple of West Coast tours and recorded an EP, which was actually going to be the first full-length album but was reduced down to an EP. We did the movie *The Decline of Western Civilization*, and the scene in South Bay developed. The Orange County scene filtered through the Church, and we were taking notice of what was going on in the South Bay.

Then it came to an end. It is very strange. We went to Vancouver, B.C., a couple of times, and I really fell in love with it. We played San Francisco and Seattle too, but Vancouver really resonated with my spirit. I began to see things in L.A. start to fragment. There was the Hollywood scene, the South Bay scene, and the Orange County scene. People from one scene didn't want to be part of another scene, and I just wanted to play music. Vancouver was just different. The scene was smaller and didn't have that fragmentation. Multiple bands shared members, like Dimwit or Chuck Biscuits were in five different bands. People played guitar in one band and sang in another. It was more vibrant, fresh, organic, and unspoiled, which really caught my attention.

WHERE IT ENDED FOR ME
We went back to L.A. and did a show at the Fleetwood in Redondo Beach, two blocks away from where Dez and I lived. At that time, a lot of the Orange County crowd started coming with an energy and violence that didn't resonate with me. Don't get me wrong, there was a lot of shit to get angry about, and there still is, but people can generate "heat" or "light." To me, the OC scene was generating a lot of heat, and it was going nowhere.

No matter what I was singing or saying, the audience was completely detached from what was happening on the stage. I was kicking my ass on

RON

stage and honestly didn't feel like anybody cared. In the audience, some friends were getting hurt, and I really didn't want to be part of it anymore. It wasn't a conscious decision to leave the band completely, but I just walked off the stage. I had enough and was just like, "See ya," because I didn't want to be the soundtrack to what was going on.

The band kept playing and playing as if nothing ever happened. I thought, if the crowd doesn't care, and the band doesn't care, that is good enough for me. There were no great animosities when I left. I just decided to go and check out Vancouver. Many of the songs that ended up on the *Damaged* album were in the process of being recorded, or at least already written. Just like with Red Cross, I had no experience in the studio, especially as a singer, so recording was difficult for me. I was very spontaneous and loved live shows—giving everything for twenty, thirty, or forty-five minutes. You can really kick out the jams for thirty minutes.

I really didn't like recording at all. I lost my interest in being in the studio real fast, singing the song over and over again. The first couple of sessions must have been pretty bad. Greg is a bit of a perfectionist, so there was an element of "let's get this right." I am sure that Spot, who was recording the record, had a hard time with me. It was obvious I was not coming back from Vancouver to finish what we started in the studio, but Greg wanted me to finish, so I agreed. Because I wanted to get the recording over, the recording went quite smoothly and was actually quite fun. Things just seemed to loosen up a lot, and I really enjoyed recording what would become the *Jealous Again* EP.

SURNAME OR SLUR?

After I recorded the EP, I moved from California up to Vancouver. I was in a record store in Vancouver looking through the records and somebody told me the new Black Flag record came out, so I found *Jealous Again*, turned it over, and saw this vocalist named Chavo Pederast. I was like, "Oh, cool, they got a new singer." I wasn't really in touch at the time, so I didn't know what was going on. I brought it home, put it on my record player, and was like,

"Man, this new singer sounds an awful lot like me." Sure enough, it was me, except for the last song where Chuck is singing. I was thinking, "Chavo Pederast? Where did that come from?" When I was in the band, I, nor anybody else, had any nicknames. Even Chuck was going by his real name at the time, and certainly I wasn't calling myself Chavo Pederast.

It took me a little while to figure out. The negative connotations associated with being a pedophile sort of pissed me off a little bit. To be honest, though, I really didn't care at the time because I was young and dumb. Later on in life, when I was around my kids and stuff, I was a little bit concerned. The kids were like, "Hey, Dad, we heard you were in this band called Black Flag and your name was Chavo Pederast. What does Chavo Pederast mean?" which was weird to explain.

THE LONG HAUL LEGACY

When I was in Black Flag, I could not envision anything past the evening, let alone a quarter of a century. By that time, the Sex Pistols had broken up, and I didn't have any conscious idea where Punk was going at all. Black Flag happened nearly thirty years ago, and they are still fresh. New people are committed to the band. I don't know anybody that is a Black Flag fan that isn't super-passionate about them. It is not totally unique, because other bands command loyal followings, but if you are willing to go out and get a Black Flag tattoo, that is a pretty hardcore statement about your passion. People don't get the cereal brand they eat in the morning tattooed on them. Being Barred for Life means something and definitely transcends a lot of other bands.

Without a doubt, my favorite Black Flag lineup is with Henry on vocals and Bill on drums, around the *My War* and *Slip It In* era. When I went down for the reunion show, they were rehearsing for eight hours and playing those songs, and they just blew my mind. To me, Henry is the definitive Black Flag singer. A lot of people out there are going to be very passionate about whether they love or hate Henry. Yet, the band didn't end with Keith, it didn't end with me, and it didn't end with Dez, but it did end with Henry. That is something. ■

SCENE NUMBER FOUR
ADDING UP THE COLUMNS, IT WAS TOTALLY WORTH IT

"I felt among peers and elders, not spoken down to.
Most of the iconic bands of the hardcore era made me feel this way."

THE ADVICE OF A FRIEND; A VERY TOUGH FRIEND

Henry Rollins screaming his way through "Rise Above" felt like the advice of a very tough friend. When Ron Reyes told me he is accused of having "No Values," Keith confided he was on the verge of a "Nervous Breakdown," and Dez broke down and admitted he might, in fact, be an "American Waste," I felt among peers and elders, not spoken down to. Most of the iconic bands of the Hardcore era made me feel this way.

Minor Threat gave my straight-edge life a name, while SSD and DYS, and many others too, helped me to define it more clearly. During the mid-1980s, Dischord Records' music opened me up just enough to accept literary references as replacements for straightforward yelling and screaming. The music not only connected directly to my pride and frustrations, it offered a bona fide alternative to the crazy world I'd just exited. Some people were just way more dedicated than I was, which was greatly inspiring too.

The Hardcore era was an epic time musically, socially, and communally. Anybody dismissing the generation as full of folly would not only be poorly informed but also stating a lack of truth. Some books about the early American Hardcore scene have made their way onto shelves and into people's subcultural relic collections, but obviously more should be published because Punk Rock changed many people's lives in profound ways. So why are there so few?

Since every scene has its own independent identity, trying to make all scenes to conform to some "standard" might raise a few eyebrows and invite voices of derision. Though Steven Blush's *American Hardcore* is an achievement, many of my peers and friends immediately condemned how he put a date on the grave of Hardcore music. Due to Blush's focus on larger U.S. scenes, kids from smaller scenes around the country felt chagrined because their town was not mentioned. Achieving consensus among jaded Punk Rockers, and I should know because I am one, is almost impossible. Writing just

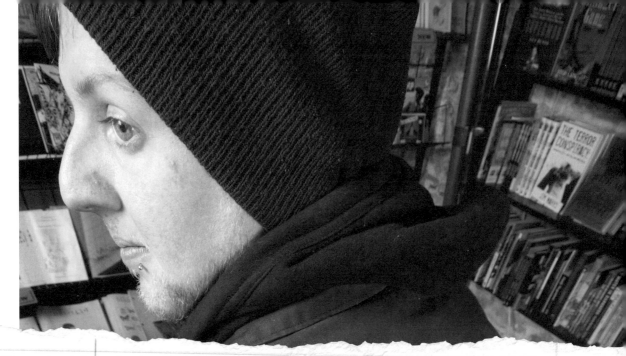

"My tattooist didn't want to tattoo The Bars on me,
and so I had to convince him to do it by offering
a trade of some Slayer stuff that I had collected
from when I worked at a record store."-J.C.

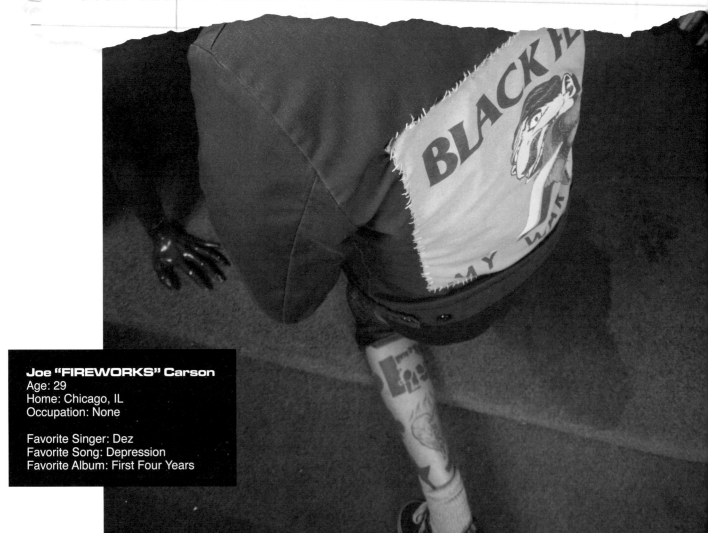

Joe "FIREWORKS" Carson
Age: 29
Home: Chicago, IL
Occupation: None

Favorite Singer: Dez
Favorite Song: Depression
Favorite Album: First Four Years

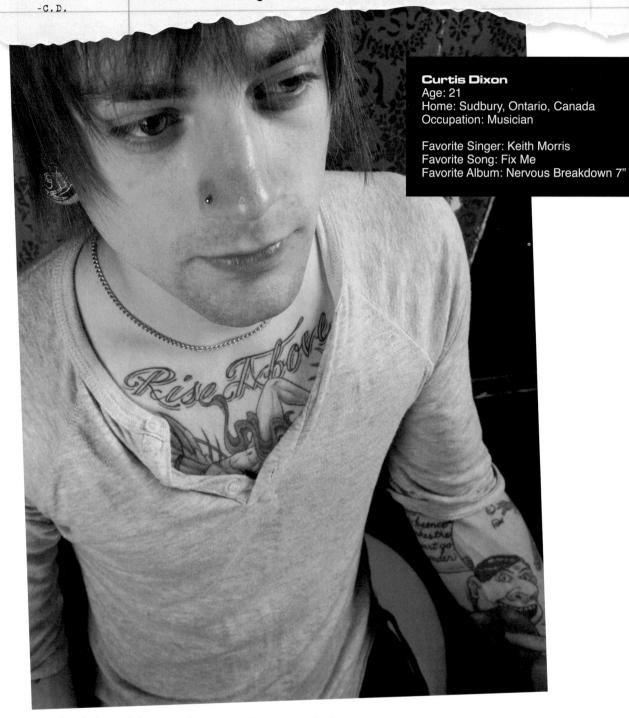

Curtis Dixon
Age: 21
Home: Sudbury, Ontario, Canada
Occupation: Musician

Favorite Singer: Keith Morris
Favorite Song: Fix Me
Favorite Album: Nervous Breakdown 7"

one book that might cover the era in a hyper-detailed sort of way would require a
hundred volumes. Blush's effort did really try to reign in ideologies and note
commonalities instead of jamming new wedges between existing rivalries. Personally,
I am in his debt for paving the road and for noting Punk Rock's bounty instead of trying
desperately to discredit it.

The truth is, Punk Rock managed to rearrange much of the Rock and Roll rulebook with
very little capital, and kids handled much of the heavy lifting. That is worth celebrating.

(Pounding on his chest and pointing at his tattoo)
"**The Bars are such a great logo.**" -N.

"I got The Bars in my friend's living room. It is a stick and poke job done while listening to Black Flag. Even though you can barely see it, the stick and poke was the perfect style for me."
-J.W.

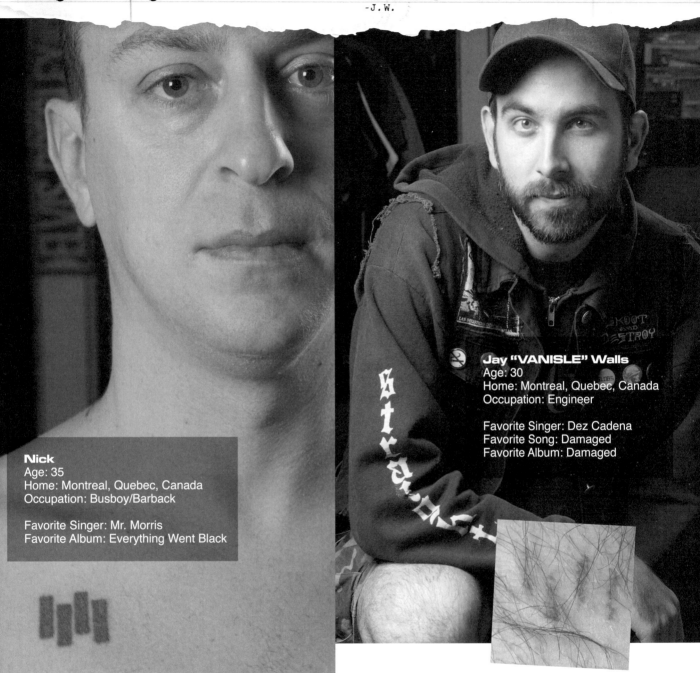

Nick
Age: 35
Home: Montreal, Quebec, Canada
Occupation: Busboy/Barback

Favorite Singer: Mr. Morris
Favorite Album: Everything Went Black

Jay "VANISLE" Walls
Age: 30
Home: Montreal, Quebec, Canada
Occupation: Engineer

Favorite Singer: Dez Cadena
Favorite Song: Damaged
Favorite Album: Damaged

Plus, Punk Rock music infiltrated a bloated corporate money making music machine full of extravagances and entitlements. Making small changes to what already exists is one thing, but creating an entire semi-secret culture, replete with an operating system, requires equal parts future-vision and reckless abandon. Had it been just a stupid idea, one with little application in the real world, surely the early Punk Rock scene would have fallen apart, died, and been lost to history.

But it didn't…

Julia Vandermolen
Age: 23
Home: Grimsby, Ontario, Canada
Occupation: Office Administrator

Favorite Singer: Henry Rollins
Favorite Song: TV Party
Favorite Album: My War

"I know a lot of people that got
The Bars on their wrist or arm
where they could cover them up.
Since I knew that this is the
only tattoo I was going to get
above my neckline, it had to be
something important to me." -J.V.

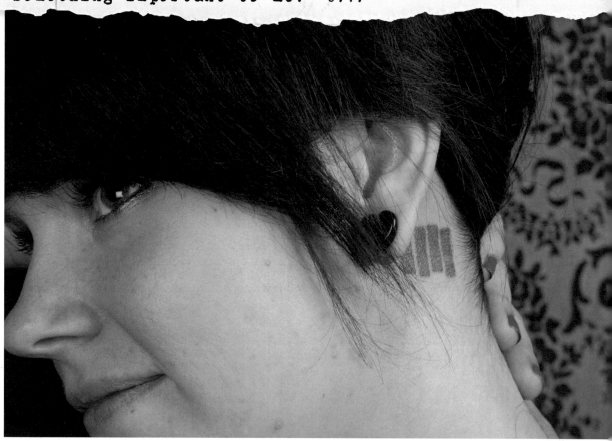

I DON'T GIVE UP

Post Y2K, I spent more and more time getting into bands peopled by kids half my age. While not a huge deal, I was always aware of how I might come across as the creepy old dude at shows. I didn't hide, nor did I ever find myself close to the stage, so my attendance at shows usually found me standing near a wall somewhere with either earplugs or a camera, and usually only talking to the one or two other people I knew from back in the day, often both younger than me, and themselves considered old timers. What did that make me then?

On some random weekend, finding myself at a Blood Brothers show at a large venue in Philadelphia, the City of Brotherly Love, I took the opportunity to sit on the balcony and drink a glass of wine or three. Below me were hordes of kids, maybe half my age, or possibly younger. Where I could remember my experiences in these inhumanly large circles of sweaty dudes stomping around in unison to music played twice as fast as the fastest popular music of the day, I was now watching as individuals, seemingly at random, would break out in these spasmodic martial art displays to music played twice as fast as the Hardcore music of my day.

Watching the faces of unsuspecting bystanders getting pummeled by moshing idiots, I noticed that the expressions of fearful audience members changed very little over the

"My tattoo reminds me of getting drunk and listening to Black Flag. With just about anybody that has The Bars tattooed on themselves, whether you really know them or not, you know that you at least have something to talk about with them."-C.W.

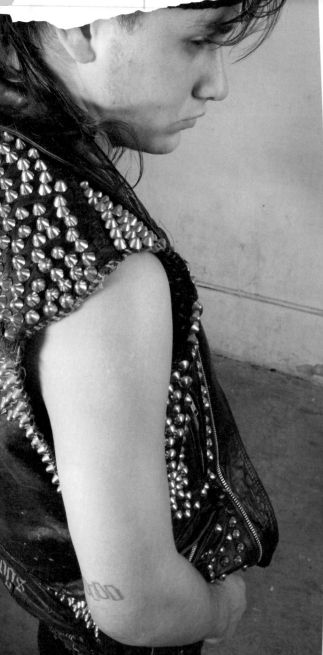

◄ **Cody White**
Age: 21
Home: Stratford, Ontario, Canada
Occupation: Musician

Favorite Singer: Chavo
Favorite Song: Depression
Favorite Album: First Four Years

Joel Fisher ►
Age: 30
Home: Toronto, Ontario, Canada
Occupation: Youth Worker

"I got these a long time ago when I was in a Hardcore band called Left For Dead. The drummer tattooed the entire Six Pack cover on my arm. It was a crazy time for Hardcore in southern Ontario and this tattoo represents my mindset and lifestyle at that time."-J.F.

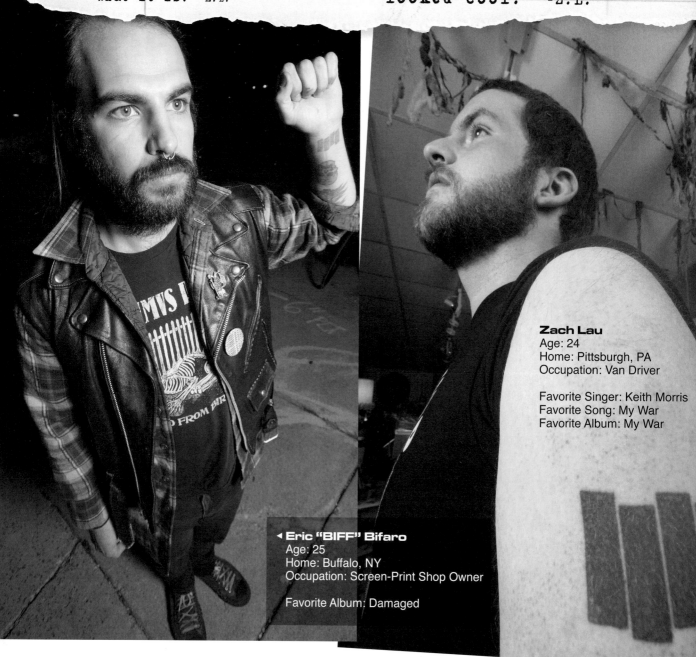

"I could see the idea of tattooing yourself on a whim taken the wrong way. I have thought about having my Bars touched up, but how shitty they look actually adds character to what it is." -E.B.

"I'd like to say something more deep, but I got The Ba because I thought that they looked cool." -Z.L.

Zach Lau
Age: 24
Home: Pittsburgh, PA
Occupation: Van Driver

Favorite Singer: Keith Morris
Favorite Song: My War
Favorite Album: My War

◄ **Eric "BIFF" Bifaro**
Age: 25
Home: Buffalo, NY
Occupation: Screen-Print Shop Owner

Favorite Album: Damaged

twenty years I'd been watching them. Where before, some random kid escaping the vortex of the circle pit could be predicted with some ease, what I was watching was sneak attacks that were happening so unexpectedly that there was no time to prepare. Hands and feet flying in every direction seemingly at one time, I was watching things get out of hand in about five different places all at once. The evolution of the pit had obviously gone from a big circle with a loosely configured set of rules to random beatings at the hands of uncontrollable kung-fu fighters. The half of me that was laughing at the clownery was masking the half of me that was shrugging my shoulders, slamming the last of my glass of wine, and looking for the exit before a youth riot broke out.

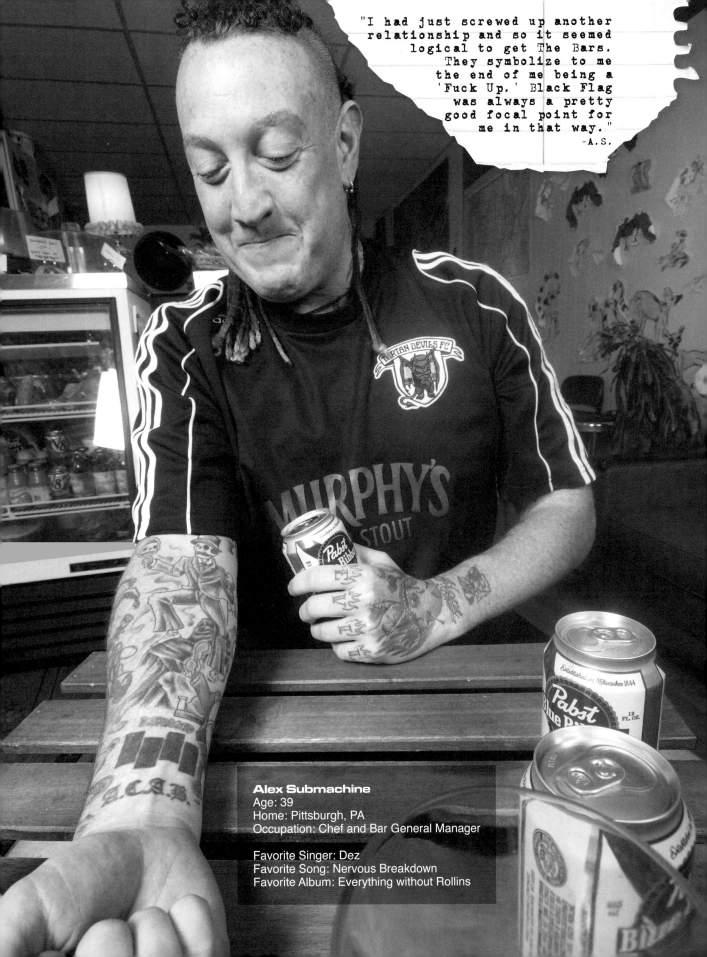

"I had just screwed up another relationship and so it seemed logical to get The Bars. They symbolize to me the end of me being a 'Fuck Up.' Black Flag was always a pretty good focal point for me in that way."
-A.S.

Alex Submachine
Age: 39
Home: Pittsburgh, PA
Occupation: Chef and Bar General Manager

Favorite Singer: Dez
Favorite Song: Nervous Breakdown
Favorite Album: Everything without Rollins

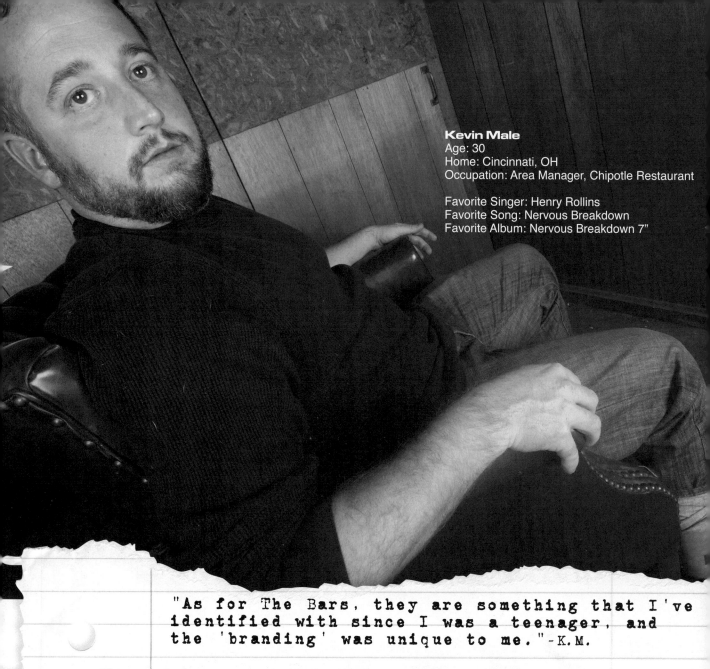

Kevin Male
Age: 30
Home: Cincinnati, OH
Occupation: Area Manager, Chipotle Restaurant

Favorite Singer: Henry Rollins
Favorite Song: Nervous Breakdown
Favorite Album: Nervous Breakdown 7"

"As for The Bars, they are something that I've identified with since I was a teenager, and the 'branding' was unique to me."-K.M.

The scene had outgrown me, and I was no longer having fun at live shows. Having chosen no other active alternatives to replace my live Punk Rock show experience, I was feeling forced into listening to my record collection alone at home, and that just wasn't a scene that I wanted to be part of for the rest of my life. I wanted something, but I didn't know what.

Monday came, and while sitting alone and eating breakfast before class, one of my students approached me excitedly and proclaimed quite loudly, "Mister E, I saw you at the Blood Brothers show on Saturday!!! You were up in the balcony, right??? I didn't know that you liked new bands???"

As a teacher, even a Punk Rock teacher at a boarding school, it is not a good idea to make nice with your students on the level of attending shows (even if this one happened to be at a large venue), and so I felt a little bit of panic set in. My students knew me to be something of an "alternophile" when it came to music, and on more than

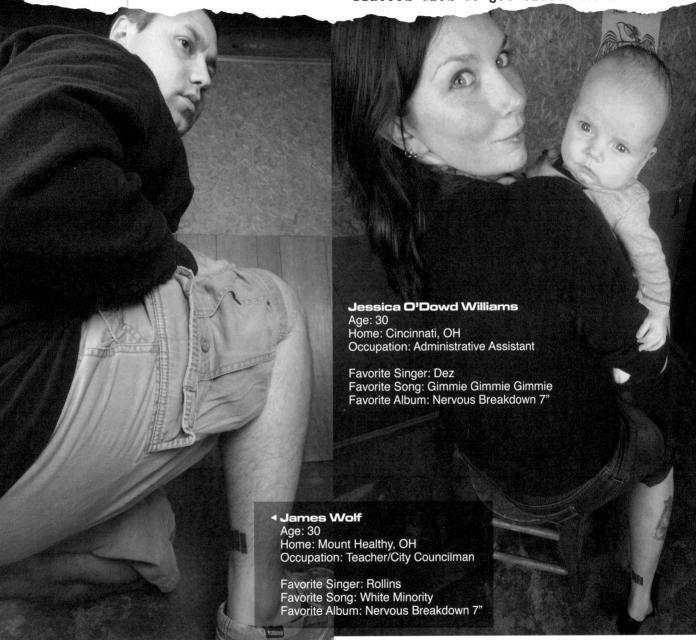

"The Bars remind me that I can still be 'dangerous,' all while being a teacher or councilman." -J.W.

"My friends and I were in our late twenties and early thirties when we got The Bars. I presume that we are much older than average, and for some reason I feel like we should have been sixteen when we got them." -J.O.W.

Jessica O'Dowd Williams
Age: 30
Home: Cincinnati, OH
Occupation: Administrative Assistant

Favorite Singer: Dez
Favorite Song: Gimmie Gimmie Gimmie
Favorite Album: Nervous Breakdown 7"

◄ **James Wolf**
Age: 30
Home: Mount Healthy, OH
Occupation: Teacher/City Councilman

Favorite Singer: Rollins
Favorite Song: White Minority
Favorite Album: Nervous Breakdown 7"

one occasion an old Punk Rock favorite would pop up on one of my iTunes mixes that I would play while my students were working on group projects. I felt very comfortable introducing my students to music that they might not hear elsewhere, but I didn't want to favor any kids over others. So when a handful of my burgeoning Punk Rocker students spotted me on the balcony at the Blood Brothers show, I became startled.

At that moment I asked myself, "If this gets out, if the news makes it to my boss, and then to her boss, is this incident going to cost me my job?" Given my history of getting

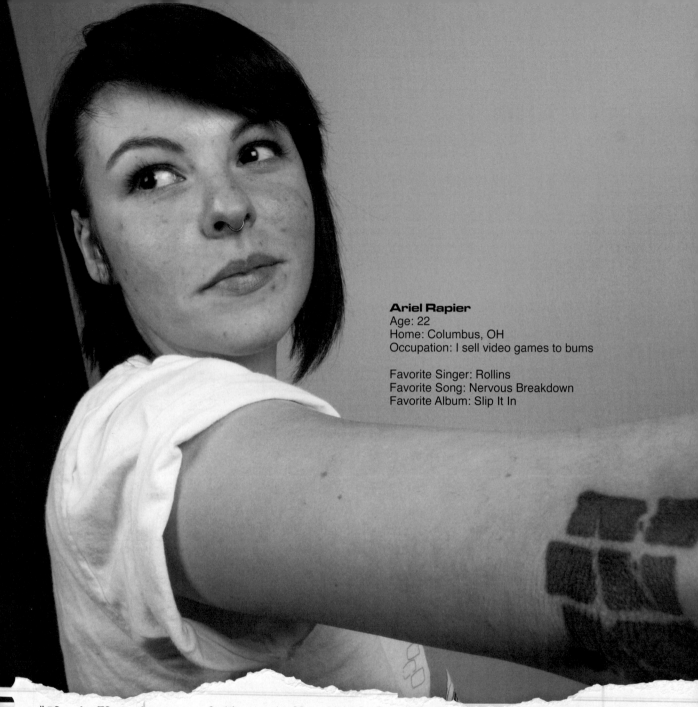

Ariel Rapier
Age: 22
Home: Columbus, OH
Occupation: I sell video games to bums

Favorite Singer: Rollins
Favorite Song: Nervous Breakdown
Favorite Album: Slip It In

"Black Flag is one of those influential Punk Rock bands that opened the gatew
for every young kid who's not 'normal.' Bands like Black Flag and Minor Threat
are the starting blocks into an awesome scene where your differences are
accepted, and it is okay to be a loser, a reject, or just angry."-A.R.

into sticky situations with my boss in the past, my inner voice howled a resounding
hell yeah, this is going to get me fired. And that is pretty much when I'd realized that I'd
had enough, both of investing so much energy in a music scene that I'd outgrown years
before *and* of being a teacher, ironically.

Depending on just how deeply you connect to the culture determines the level of
difficulty you might expect upon exiting. Certainly there are people out there that are,
and were, connected to the Punk Rock scene way more than I am, or ever was for that

"Dickie Peterson of Blue Cheer died today and I felt that he died for his art, which is kind of what I think that The Bars communicate."
-C.L.

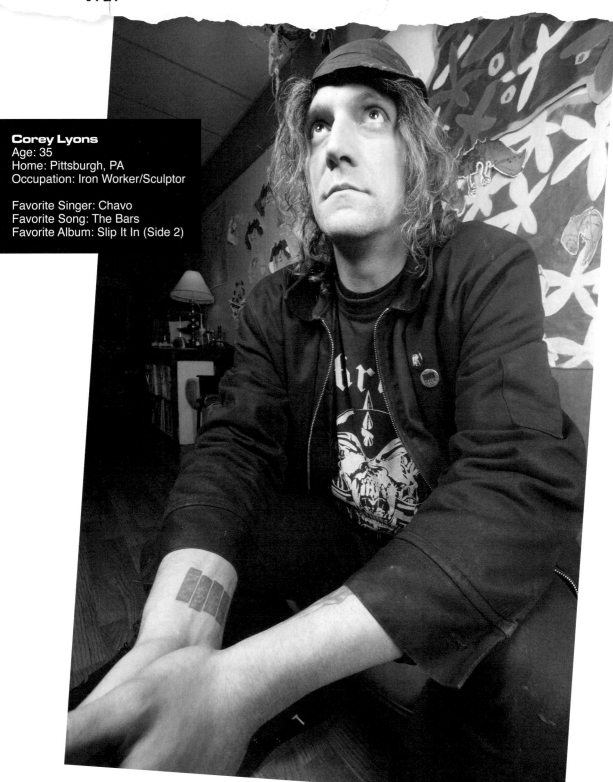

Corey Lyons
Age: 35
Home: Pittsburgh, PA
Occupation: Iron Worker/Sculptor

Favorite Singer: Chavo
Favorite Song: The Bars
Favorite Album: Slip It In (Side 2)

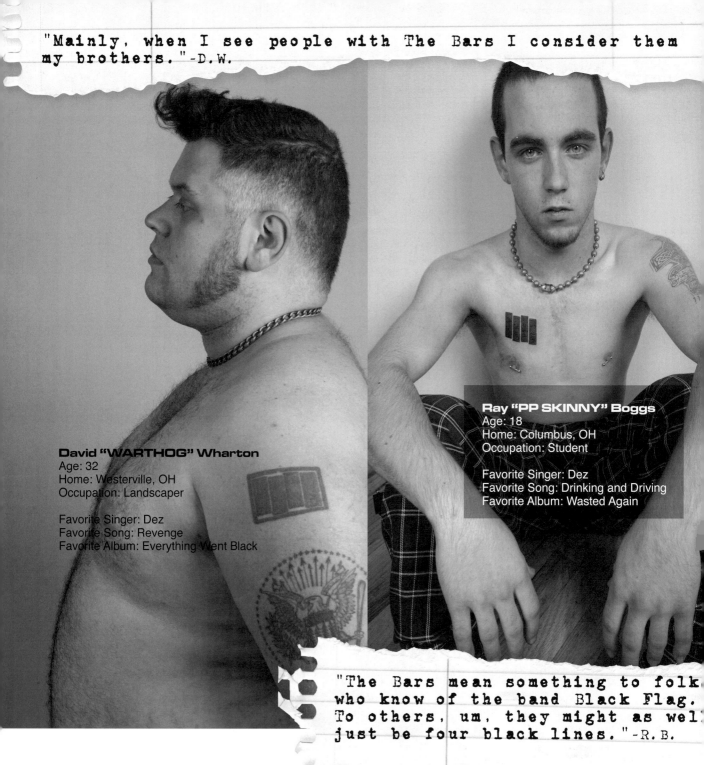

"Mainly, when I see people with The Bars I consider them my brothers." -D.W.

David "WARTHOG" Wharton
Age: 32
Home: Westerville, OH
Occupation: Landscaper

Favorite Singer: Dez
Favorite Song: Revenge
Favorite Album: Everything Went Black

Ray "PP SKINNY" Boggs
Age: 18
Home: Columbus, OH
Occupation: Student

Favorite Singer: Dez
Favorite Song: Drinking and Driving
Favorite Album: Wasted Again

"The Bars mean something to folk who know of the band Black Flag. To others, um, they might as well just be four black lines." -R.B.

matter. Some are in it for life. You can see it in their eyes, the way that they have successfully avoided getting too caught up in the real world, and who still connect in a very direct way with the culture. For others, those who are able to easily switch gears, disengaging, or dislodging themselves as the case may be, was fairly easy. For some, and don't ask me how they pulled it off, no matter what their connection at one time, they've totally disengaged and never really looked back. Cool for them, but that wasn't the path that I chose. It wasn't the path that many of my friends chose either, so there is this generation of folks that refuse to give up completely on alternatives to the mainstream, but who are not exactly amped on staying current. What's in it for them?

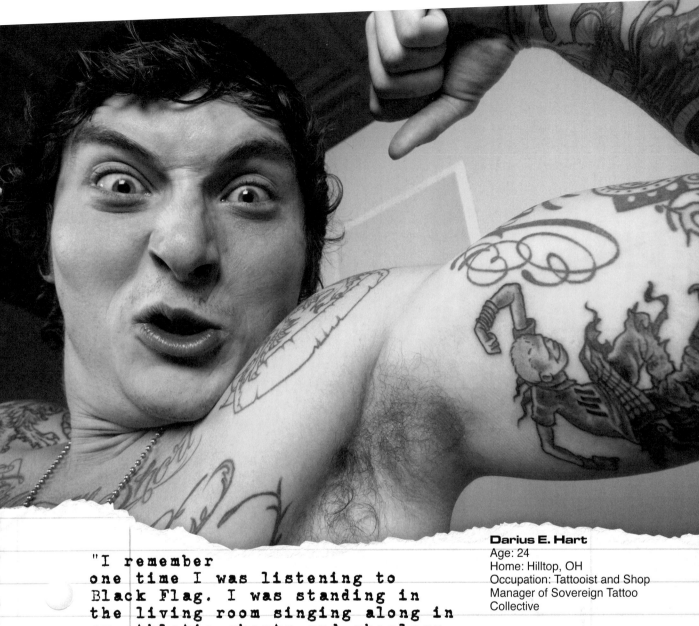

"I remember one time I was listening to Black Flag. I was standing in the living room singing along in my athletic shorts and shoeless, just like in those classic pictures of Rollins." -D.H.

Darius E. Hart
Age: 24
Home: Hilltop, OH
Occupation: Tattooist and Shop Manager of Sovereign Tattoo Collective

Favorite Singer: Rollins
Favorite Song: TV Party
Favorite Album: Damaged

Who knows? Who cares, really? The mainstream still sucks, and I don't care if I don't connect all that well with what is new in Punk Rock culture. I do appreciate the fact that it still exists. As I already mentioned, after many, many years invested in Punk Rock, I've seen far too many people proclaim its death at exactly the point that they bailed out. So for all of those people around the world who still hold tightly to the idea that within their scene is an alternative to a world gone mad, maybe the proliferation of The Bars addresses this issue of hope.

I cannot really address this issue directly since I can only speak for myself, but for me a total exit just isn't, and never really was possible. It wasn't that Punk Rock wouldn't let me out, but too much of who I've become was forged in that fire.

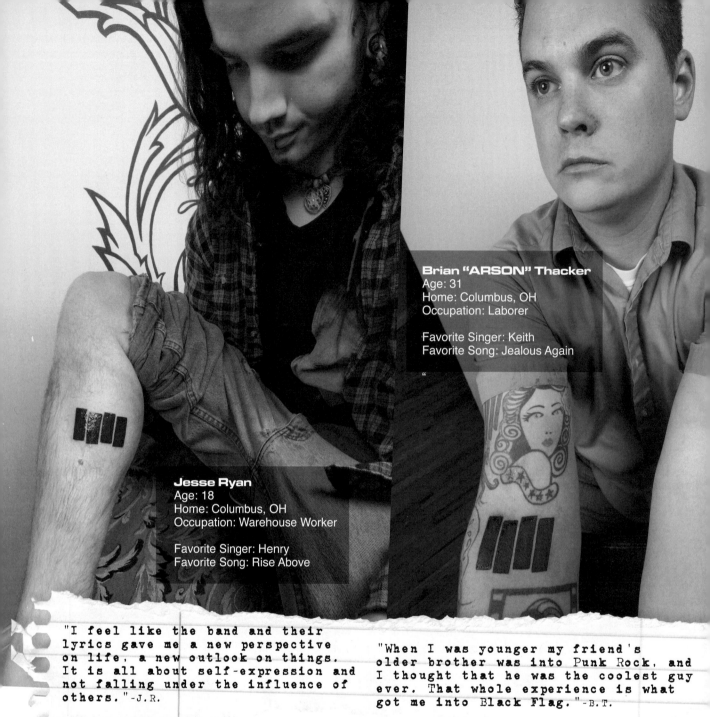

Brian "ARSON" Thacker
Age: 31
Home: Columbus, OH
Occupation: Laborer

Favorite Singer: Keith
Favorite Song: Jealous Again

Jesse Ryan
Age: 18
Home: Columbus, OH
Occupation: Warehouse Worker

Favorite Singer: Henry
Favorite Song: Rise Above

"I feel like the band and their lyrics gave me a new perspective on life, a new outlook on things. It is all about self-expression and not falling under the influence of others." -J.R.

"When I was younger my friend's older brother was into Punk Rock, and I thought that he was the coolest guy ever. That whole experience is what got me into Black Flag." -B.T.

BUT BEFORE I GO, LET ME GIVE YOU SOMETHING REALLY AMAZING

Feeling a bit disconnected and ready to pull the plug on my Punk Rock life altogether, I scrambled to get some tattoo time with my dear old friend Mike Dorsey in Cincinnati, Ohio, before making any hard and fast decisions in terms of my career and lifestyle choices. Much like every important event in my life, everything came together like a car crash in which the only way to gain clarity was to wake up suddenly in the middle of the fire, run for shelter, brush yourself off and figure out what to do next under the shade of a roadside tree. The authorities would be along any time.

Yes, I'd lost patience with Punk Rock. Yes, I'd lost patience with my career, and I was not at all sure what was waiting for me on the other side of this massive mid-life rift.

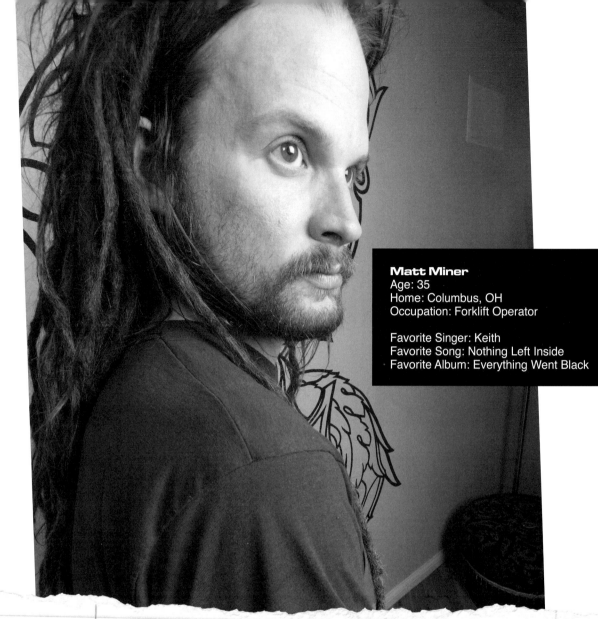

Matt Miner
Age: 35
Home: Columbus, OH
Occupation: Forklift Operator

Favorite Singer: Keith
Favorite Song: Nothing Left Inside
Favorite Album: Everything Went Black

"When I was in the 7th or 8th grade my mom let me take a day off of school. While they were gone I listened to Black Flag really, really loud, raided my parents' liquor cabinet, and got wasted."-M.M.

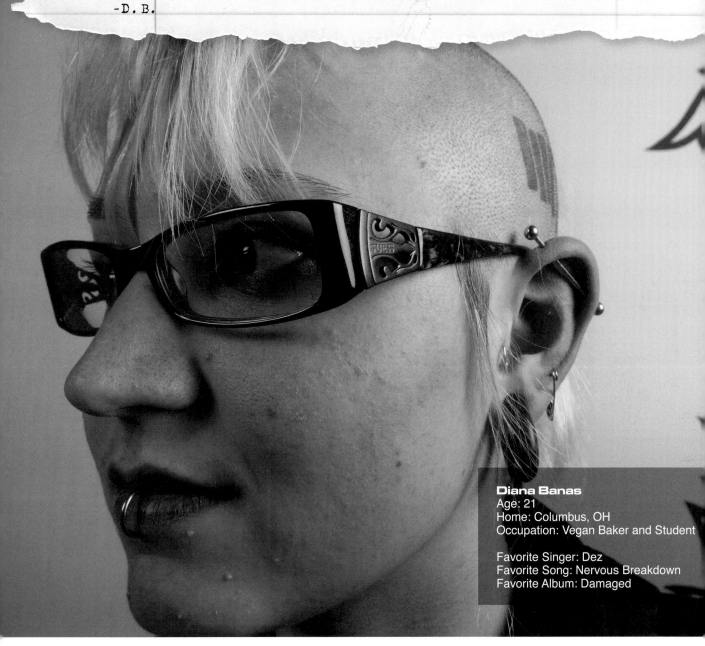

"Black Flag was one of the first bands that I was introduced to in junior high school. There was just something about their energy that connected with me, and my tattoo sums up that connection for me."
-D.B.

Diana Banas
Age: 21
Home: Columbus, OH
Occupation: Vegan Baker and Student

Favorite Singer: Dez
Favorite Song: Nervous Breakdown
Favorite Album: Damaged

Deep on the inside, I knew I was going to walk away from both. It was a huge decision. Strangely enough, like every time that I've made an important decision in my life, I made them while getting tattooed.

Sure, I could have sought a therapist, but I chose my tattooist. The trip itself proved to be hugely important in all respects. On that trip, I ended up surrounded by numerous other people with Black Flag tattoos who were more or less on the fringes, stepping away from Punk Rock culture, just like me. The situation was ironic, humbling, and almost ridiculous: *Barred for Life* was going to be my major transition.

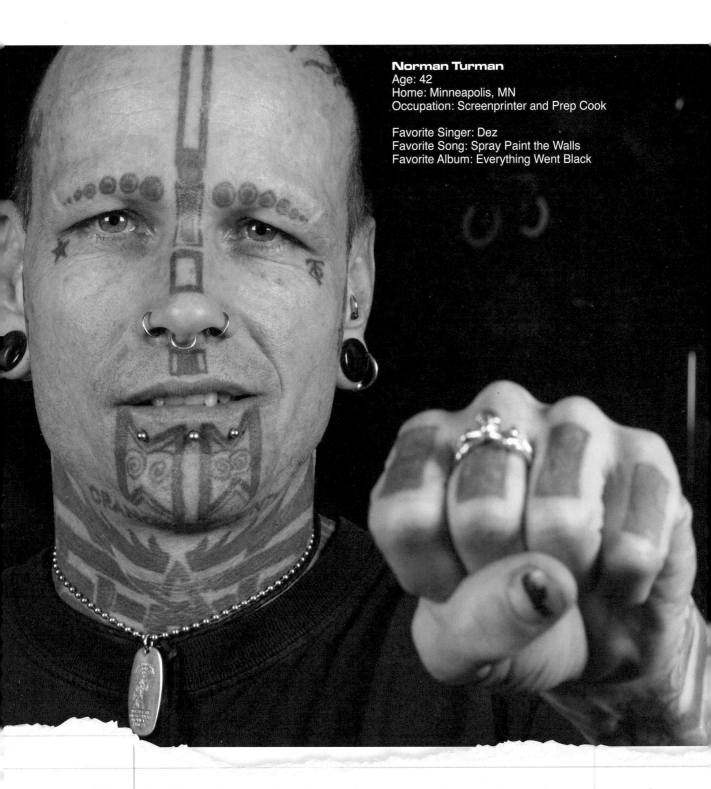

Norman Turman
Age: 42
Home: Minneapolis, MN
Occupation: Screenprinter and Prep Cook

Favorite Singer: Dez
Favorite Song: Spray Paint the Walls
Favorite Album: Everything Went Black

"I got The Bars tattooed on my knuckles because of the Damaged LP cover. When I saw the record in the record store it had a sticker on it that said, 'AS A PARENT I FOUND THIS TO BE AN ANTI-PARENT RECORD.' It was then that I knew that I had to have it because I didn't want to be anything like my parents." -N.T.

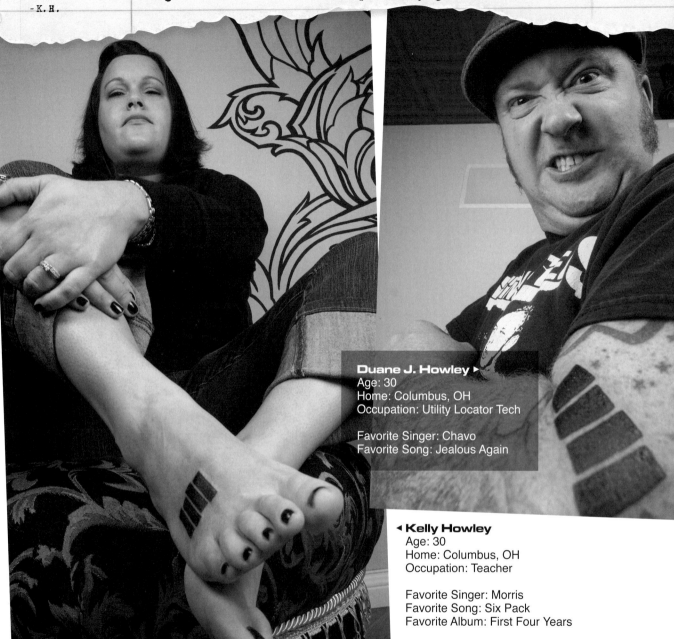

Duane J. Howley ▶
Age: 30
Home: Columbus, OH
Occupation: Utility Locator Tech

Favorite Singer: Chavo
Favorite Song: Jealous Again

◀ **Kelly Howley**
Age: 30
Home: Columbus, OH
Occupation: Teacher

Favorite Singer: Morris
Favorite Song: Six Pack
Favorite Album: First Four Years

Mostly, it is only Punk Rockers that recognize and understand the point of The Bars. When elder Punk Rockers, and many new schoolers, speak about Punk Rock history, Black Flag is spoken about just as old people might compare the John F. Kennedy Presidency to later Bush presidencies, or compare World War Two to Vietnam or the Gulf War. In other words, in the light of the Vans Warped Tour or Lollapalooza, people tend to moralize the merits of Black Flag and their contemporaries. Yet, Black Flag rarely mentioned politics, which could have easily put an expiration date on their music

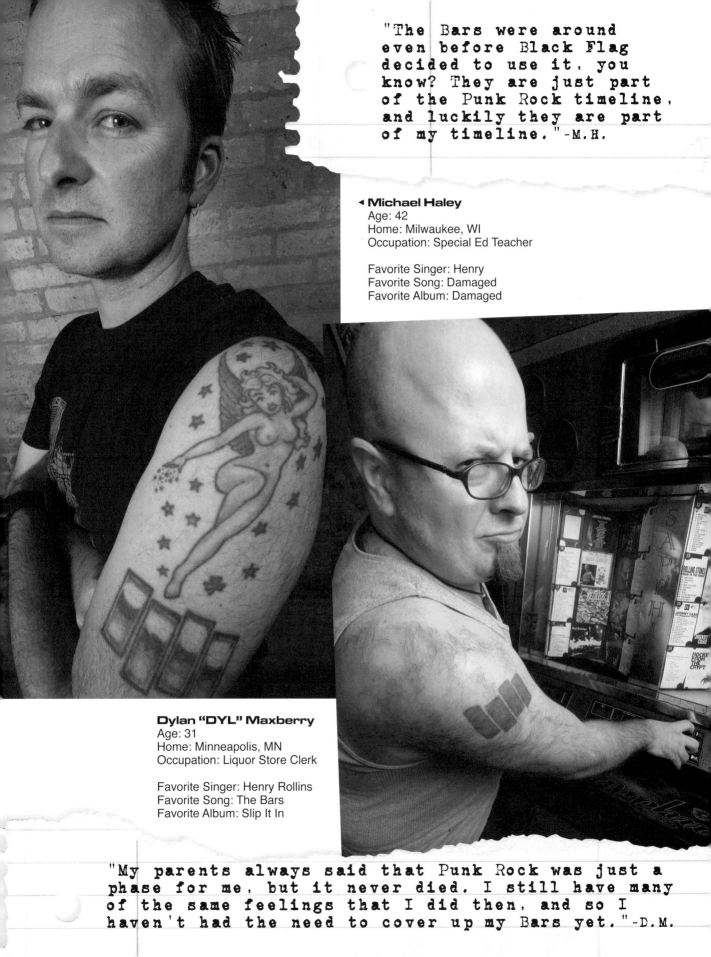

◄ **Michael Haley**
Age: 42
Home: Milwaukee, WI
Occupation: Special Ed Teacher

Favorite Singer: Henry
Favorite Song: Damaged
Favorite Album: Damaged

Dylan "DYL" Maxberry
Age: 31
Home: Minneapolis, MN
Occupation: Liquor Store Clerk

Favorite Singer: Henry Rollins
Favorite Song: The Bars
Favorite Album: Slip It In

"My parents always said that Punk Rock was just a
phase for me, but it never died. I still have many
of the same feelings that I did then, and so I
haven't had the need to cover up my Bars yet."-D.M.

"The Bars are like illuminati symbols of Punk Rock,

known to a precious few and endowed with such a multitude of potential meanings."

and the band itself. They were ambitious about their program. They built a bridge to the world, which at that time was a world that really didn't want them, paving a path that many now take for granted. Black Flag didn't operate in a vacuum. Surely, their peers aided Punk Rock's big enterprise and helped to create a huge corporate rock entity known as Indie Rock, but the Black Flag and SST dynasty remains seminal.

Others may have done it better, but Black Flag did it first. They set the bar high. While some leapt over the bar later, Black Flag gets trailblazer status. The Bars are like Illuminati symbols of Punk Rock, known to a precious few, and endowed with such a multitude of potential meanings. In fact, Black Flag has all but taken a back seat to their logo. The Bars evoke a poetic flow and embody the virtues of Punk Rock rather than the failures. The range of answers to my questions, and the range of emotions, touched me, to say the least. To some, just having The Bars, being Barred for Life, was kind of an honor. For some people, their continued connection with the Punk culture and Black Flag is so intense that there is an element of heartbreak: if Punk Rock ever fully goes away, so will this person's will to live.

While I can relate to the heartbreak of watching something that used to be my life, something so dear to me, die, it is like mourning the loss of a loved one. It can get kind of creepy at times, but rest assured that somewhere down the road another "movement" will come along to save the supposed wretched from a really wretched popular culture. Until then, we can at least read through the testimonies herein and get a sense of where that movement might go, who might lead it, and how long it will take for the leaders to burn the movement to ashes. In the aftermath, another person just like me will be there to document the most obvious symbolism of the movement-gone-haywire. History will have repeated itself. Once again, just like in the movie *Groundhog Day*, we are merely human to allow such disasters to repeat themselves. ∎

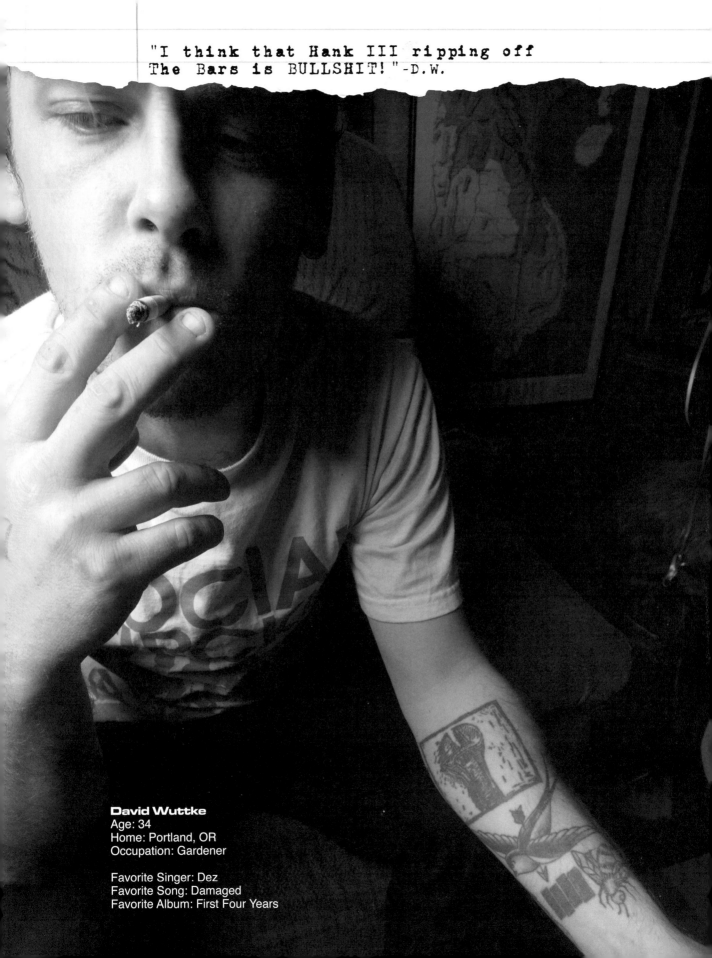

"I think that Hank III ripping off
The Bars is BULLSHIT!"-D.W.

David Wuttke
Age: 34
Home: Portland, OR
Occupation: Gardener

Favorite Singer: Dez
Favorite Song: Damaged
Favorite Album: First Four Years

INTERVIEW

I CAME FROM THE BEACH AND PIER-RATS. THAT WAS IN MY BLOOD.

KEITH MORRIS

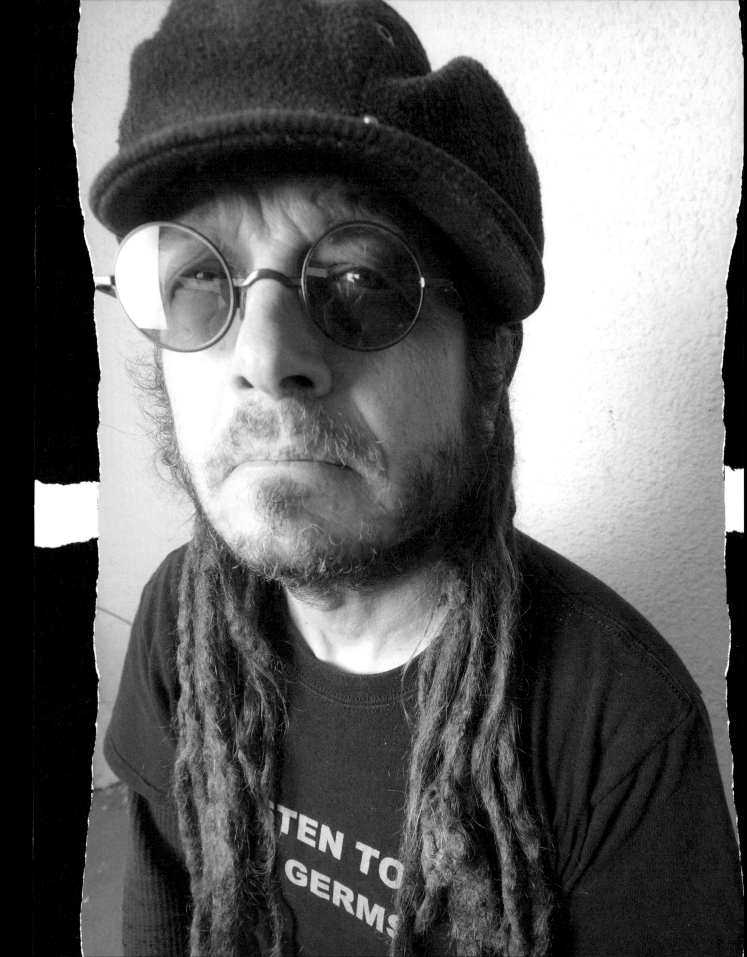

> **"Each Black Flag line-up had a personality and vibe. They were all totally aggro and totally rocking. I saw Black Flag with Ron Reyes when they filmed the 'Decline' segment, and that was pretty happening. I never got to see them with Dez as vocalist, though I did see them with Dez on second guitar, but I didn't really like it. In fact, I left the show. I very rarely leave shows."**

THE LAND OF SUN AND FUN: LOS ANGELES BEFORE PUNK ERUPTED

Living in L.A. before Punk existed, on a musical level, at least early on, was pretty fantastic because we had a lot of Rock'n'Roll Hall of Fame bands like the Byrds, Love, the Seeds, the Standells, and the Doors. After a while, though, we had Fleetwood Mac, feathered hair, snorting cocaine from a spoon, and drinking wine coolers. We had a flood of Country Rock, Americana, and all of these bands coming out of Laurel Canyon, like Jackson Browne: be mellow, be laid-back.

We weren't hearing enough Black Sabbath or Ted Nugent. We just didn't have a lot of bands in Southern California that had that Spinal Tap approach, where you just crank it up to eleven and blow people's heads off. We liked stuff like the MC5, even Cheap Trick, even though they were a pop band. They had their aggressive moments, and that was enough to get us off, you know? The Dogs moved here from Detroit. They were a big influence on both Greg Ginn and myself. There was a band called The Last, who weren't necessarily a Punk band, but they did have that sort of energy. You could go and see them, listen to their music, and tell they didn't have that Laurel Canyon–Southern California, "I hang out at the beach. I tan in a tanning booth" kind of mentality. There was no "I gotta look really good. The car has to be really shiny. Oh, look at me" to these bands. There were other bands too, like the Weasels and the Imperial Dogs.

We were tired of these watered-down, homogenized bands. You can go to the Warped Tour today, with two hundred bands at the show. Afterwards, they go to the bank to deposit the money. The manager will be happy, the record label will be happy, the publicist will be happy, the person who is selling their song to all of the movies and television will be happy, and everybody will be making millions of dollars. They will own homes up in the hills. The problem is these "kids" are led around like they have a ring in their nose, like they are on a chain or leash, and line up to get into the mall to buy a CD. We were against all of that. At the time, we had no idea that [Punk Rock] would turn into some ultra-mega conglomerate record company owning six hundred other record companies.

We'd get off of work at six or seven o'clock. We'd start practicing at nine until midnight, or one or two in the morning. We'd be practicing, drinking, being

KEITH

friends and bros, and basically playing to please ourselves. There was nobody that liked us. There was nobody that even knew about us, so we had these little "baby" steps we took because we had no awareness of the business. We didn't know the most necessary steps that needed to take place in order for us to get ourselves out there.

DIGGING THEIR HEELS IN: BLACK FLAG BEGINS TO INFILTRATE HOLLYWOOD

Our thing was word of mouth: print flyers and handbills and go to clubs with these new bands like X, the Germs, the Weirdos, the Dils, the Screamers, and the Controllers, the Bags, the Eyes, and bands that came down from San Francisco, like the Dead Kennedys and the Avengers. We didn't look like any of them, though. We looked like we just walked out of the Grateful Dead concert or were roadies for Peter Frampton. We didn't really fit in. That became the most difficult situation we would find ourselves in.

Everybody had a network. Everybody would go to the clubs where all of these bands were playing and pass out flyers. That was our line of communication. That was our attempt to let other people know we existed as a band and we were playing. Occasionally, we'd pull in some of these bands to play with us so we could get the people that followed them to follow us. We would play wherever we could because we didn't know how to go to a club promoter or booking agent and go, "Hey, we're Black Flag, this is what we sound like, and this is what we do." We didn't have anything recorded.

We didn't have the wherewithal to give a cassette recording to the booking agent at, say, the Starwood or the Whiskey a Go-Go. We would attend larger concerts that crossed over a little more into the mainstream, like the Clash and Bo Diddley at the Santa Monica Civic Center. They could easily get three thousand people at the Santa Monica Civic, and we'd be down there passing out flyers to everybody, like music critics, people from radio stations, and people that worked in record stores that weren't going to underground things.

Eventually, we infiltrated the "Hollywood People," which was helped by the first EP, *Nervous Breakdown*. People were like, "Wait, those people do that? Wow!"

JOURNEY TO THE BLACK SUN: BECOMING BLACK FLAG

I met Greg Ginn through his younger sister, Erica, who is Raymond Pettibon's twin sister. We were all students at the same high school. We probably saw each other in the halls or were in the same line at the cafeteria. Maybe we bumped elbows at the snack machines on occasion. I worked at a record store, and my friend that owned the store developed an insane crush on Erica. She would come into the record store, and my friend would hang out with Erica. They'd leave to go to the liquor store, go get cigarettes, or get Dr. Peppers.

When they left, I would remove whatever was on the turntable and replace it with some rock noise a la Ted Nugent or Aerosmith. I played whatever was in the collection resembling something with volume and energy. The guy who owned the store would go to Hollywood. He'd be eating lunch. He'd look to his left, and Joni Mitchell would be eating lunch next to him, which meant he'd say hello and ask a few questions. He'd immediately come back to the record store, open every Joni Mitchell record, and we'd listen to her for the next week, like a constant mellow bombardment, just too much niceness. I wondered, where were the baseball bats, hand grenades, and flamethrowers? Where were freaky dudes with beards and long hair snorting speed, riding motorcycles, screaming, "Down with the government. Down with the Pigs. Kill your parents. We're gonna blow up the pier!"

Erica would bring Greg along with her. He looked like a computer whiz. All of us in Black Flag were just sort of nerdy, geeky, weird kids anyway. That was pretty much our bond. We were always the last kids to be picked for the sporting teams in high school, if we were even picked at all. We would be the guys that got messed with by jocks, and all of that fun stuff, like "Punk Rock, faggot, Devo, go

"One day, I just broke down, saying, 'I don't want to be in this band.' Black Flag was a band I started. I should be able to voice my opinions, but I wasn't. I was raging on white powder and whatever alcohol I could get my hands on."

home, we want to kill you, you're not American, you're Communist, heroin-using people." That brought us together. Yet, the first drummer for Black Flag was actually one of the popular pier-rats that always knew where the good parties were happening. He knew all of the hot, loose, sun-baked, and overly-tanned beach bunnies, and he knew where to score elephant tranquilizers. We were goofballs. We certainly weren't making any fashion statements.

GOING FROM HERE TO THERE WITHOUT A ROADMAP

We would read fanzines like *Slash*, *Backdoor Man*, or *Flipside* and occasionally find a Patti Smith record, but we were still listening to Ted Nugent, Black Sabbath, Blue Öyster Cult, and Iggy and the Stooges. We were still interested in Glam, so we were listening to the Sweet, Bowie, and Suzie Quattro, and even Lynyrd Skynyrd, Aerosmith, Mott the Hoople, but all of a sudden there was a "new wave" of bands.

It started with the Damned and the Clash and the Sex Pistols, and then the Buzzcocks in England, and the Ramones, Cramps, and the Dead Boys in New York. Los Angeles had bands like the Weirdos, the Screamers, the Germs, and the Flesh Eaters. What was insanely genius about these bands is they didn't sound the same. Each band had its own personality. You are not going to find that now. Back then, everybody would rant and rave about New York or London, but our scene here was just as cool. It was so underground.

None of the bands were being signed to major labels, except the Dickies, and a few years later, bands like Fear. The major record labels here in L.A. couldn't have cared less. They weren't sending A&R guys out to see bands in basements at places with broken bottles in the parking lot. There was no sense of danger amongst these people, so when it came to major labels, we had this flat-line. The L.A. scene was something we could really sink our teeth into, so we welcomed it with open arms. It was our cup of tea, exactly what we were looking for.

Greg and I started hanging out. He had an electronics company where he was building parts for ham-radios. We would hang out in his space, listen to the radio, and hope something excited would come on. We would play records, and Greg was still a Deadhead that had been playing guitar and writing songs. We'd gone back and forth asking, "Hey, do you want to start a band?" and he said, "Well, do you know guys that play instruments?" The only guys I knew were from North Redondo and the epitome of stoners, like fucked-up all day. They'd hang out at the pier. They weren't even energetic enough to play volleyball. They might go body surfing. They might get back on their bike and ride home. One of our early drummers was Brian Migdol. He had the drum kit, so he played the drums. All of these stoner guys knew where parties were happening, so we started playing them.

We were just rehearsing and playing to please ourselves because we had all of this pent-up energy,

KEITH

this anger because "they" don't like us, won't accept us, don't know us, we don't look like them, our parents want us to go to college and graduate and become doctors, lawyers, astronauts, and that shit . . . pushed down a path and then dropped into a slot. We were lashing out against society. "I hate you, man" and "Your authority is bumming me out and bringing me down" were tossed into the pot and stirred up. Being able to get into some electricity and make a lot of noise got us off.

We were different from other musicians in the South Bay that aspired to be in Top 40 bands like Doobie Brothers, Led Zeppelin, Journey, and Survivor, or whatever sold zillions of songs. We didn't sound like that. We didn't sit down and plan. There was a bit of chaos, anarchy, and uncertainness to it. We had no map. The music was an extension of us. We had no idea we were going to be music innovators.

We started getting shows in Hollywood, and all of these new people started coming in from the suburbs from the Valley, San Bernardino, Orange County, and Long Beach. They didn't know the proper way to act at a Punk Rock concert. These suburban kids were riding skateboards and riding bikes. We came from a bunch of surfers, and when you couldn't surf, you would skate. It became a big party.

But with the party came all of the headaches. There were more people and male hormones raging. It became more aggressive. The Hollywood people were really put off by it. Some of the people in X suddenly saw what could've been called a "fairly dangerous situation becoming even more dangerous" by a factor of ten.

The scene became all-ages and territorial due to these young, studly, athletic types coming into the scene and forming cliques, like guy-gangs. Yet, we were the loose party people looking for a good time, not to beat somebody upside the head. Black Flag got to the point where we played all of the parties and had to rent places to put on "teen dances" and other fun events. We developed toughness when we played, like blasting through sixteen songs—the best feeling in the entire world. This was our bliss, our nirvana.

THE BAND MUTATES

When Chuck Dukowski joined the band, it became more regimented, structured, and work-like. Even though Greg Ginn was a business major at UCLA, between the two of them, the business minds started clicking more and the work ethic flowed into place. I was there, but they were upset with me. For some reason, I lost my enthusiasm.

I came from the beach and pier-rats. That was in my blood. At one point, we were practicing five, six, seven nights a week for four or five hours, and I wanted to see friends playing in bands. When we'd finish rehearsing, we'd load up whatever vehicle we were using and drive to a gig just to hand out flyers. I wanted to chill out for a while, to relax and have a cold adult beverage, and maybe even do a couple of white lines. I was the monkey on a leash wanting to bust loose. Black Flag played some of these clubs. After we finished, we weren't allowed to come back and play again.

We lost places to play faster than we could play them, and that added to my frustration. Eventually, I was like, "This isn't fun anymore." It was a slow accumulation of things, like getting into arguments with the other guys in the band, three against one, and I wondered, "What am I doing here?" My friendship with Greg deteriorated because he was getting closer with the other guys. I was closest to Robo, but even he began to grind on me about drinking too much or doing too many drugs, or pushing me to rehearse more frequently so we could learn more songs. I was at the end of my rope.

One day, I just broke down, saying, "I don't want to be in this band." Black Flag was a band I started. I should be able to voice my opinions, but I wasn't. I was raging on white powder and whatever alcohol I could get my hands on. I probably wasn't pleasant to be around. I did a lot of wacky things to upset record companies. I was the court jester. I guess

the band got sick of me being out of my mind and raging full on, like an idiot, so leaving made perfect sense.

STARTING THE NEW CHAPTER: THE CIRCLE JERKS

I was still living in the Church and Ron Reyes was living in the basement where Red Cross (later known as Redd Kross) was practicing. He played drums for them. Ron quit Red Cross, and Greg Hetson was on the verge of quitting because the McDonald brothers didn't want to practice. Red Cross wanted to keep it loose, wanted to party, and wanted to hang out with all of their friends because the McDonald brothers were really popular with the Punk Rock girls in Hollywood.

Greg got fed up with that situation. Red Cross brought in Lucky Lehrer, who was going to play drums for them, but later played drums in the Circle Jerks. The McDonald brothers didn't like Lucky because he was too proficient, too good. He was Jazz-trained and played things a lot of drummers weren't able to play. The McDonald brothers weren't down with that. Greg was frustrated. I got to hear the tail end of Lucky's audition, which I thought sounded fantastic, so I suggested we start a band. About a week later, I found a bass player outside the Anti Club.

The Circle Jerks didn't have a work ethic. Our credo was the complete opposite of Black Flag, which was very serious and work-like. They wanted to tour the world and be gone 360 days of the year, playing every major city at least three times each tour. The Circle Jerks were happy-go-lucky guys that wanted to party, hang out with our friends, and play all sorts of places. Our popularity blew up on us. We didn't expect it.

We had no set list. We had no plan. We had no manager or record company behind us. That wasn't happening. For us, it was just "let's go." We wanted people to go off, blow off steam, be aggressive, but not be moronic about it or an overzealous jock.

We were playing to all of the same types of people we played to in early Black Flag. The Circle Jerks' music had an explosiveness and humor. Black Flag really didn't have a sense of humor. Black Flag rarely ever ventured into political awareness too, and that divided the two camps.

Greg was part of Red Cross, and Red Cross was tight with Black Flag. One time, we were rehearsing in my garage over in Englewood, and we had seven or eight songs. I turned to the guys and said, "Hey, you've been in other bands. You've written songs for other bands. Is there any music from them we could use, like shorten or lengthen parts, and add a bridge . . . ? Is there music from your other bands we can use?"

The McDonald brothers told Greg that Red Cross was breaking up, and he could use whatever music he wrote for Red Cross. Black Flag was principally Greg Ginn's creation. He wrote all of the songs for Black Flag, but every now and again I would write lyrics, like "Wasted" and "I Don't Care." I said, "Look guys, I wrote these lyrics, so I own them."

We worked up a new version of "Wasted" and a Red Cross song that became "Live Fast, Die Young." All of a sudden, we were getting bad vibes from these bands. They were saying, "How can you just do that? I wrote that song!" I wanted to feel bad about it, but I decided not to. To me, it was like, "Hey, the more the merrier." No animosity came out of our camp. We didn't care. We were just too excited. We were on a roll, and we were just going with it. Who cares what anybody else thinks? Circle Jerks didn't really want to conquer the world; we wanted to conquer a case of beer and a pizza.

Circle Jerks took a little bit from each previous band. We had no idea it would become a competition or involve hatred. I had no idea Black Flag's "You Bet We've Got Something Personal Against You" was directed at me. A lot of negativity sprang from that band, a real dark side. Black Flag were so caught up in that energy that people could be killing themselves in the audience, and we

KEITH

didn't care. For one thing, we never knew unless somebody told us.

In Black Flag, we approached the music like a full-on attack. We didn't know any better. We never thought to take a break, to take a sip, to look at each other or the set list; it was like, "No, let's go. Let's not mess around." Consequently, because of the music, the energy, and the volatile aspect of the music, there was a lot of violence. With the Circle Jerks, it was a totally different story. It was like, "No, no, no, no, no . . . ! We are not going to allow you to ruin our party. We're having a party, we are playing the music for the festivities, so let's get real. If you've come to fight, be macho, or beat people up, then you've come to the wrong place."

CHANNELING THE RAGE: PETTIBON'S INK

Raymond's dark, dry humor was working right along with Black Flag. He fell into the same category as the band. Some artists get extremely lucky and get a break, like him, but he stayed true. Maybe he was on some secret mission or crusade. Raymond wasn't in the bands, though. He did the artwork for Black Flag and SST Records. He had his own work ethic. He had his own program he was adhering to, deeply connected to Black Flag. Many artists lived in L.A., so the Circle Jerks chose to use the art of other artists and photographers. Raymond and I didn't have a falling out. I was just too busy getting on with my own thing.

FROM VENERATION TO TEARS

Each Black Flag lineup had a personality and vibe. They were all totally aggro and totally rocking. I saw Black Flag with Ron Reyes when they filmed the *Decline* segment, and that was pretty happening. I never got to see them with Dez as vocalist, though I did see them with Dez on second guitar, but I didn't really like it. In fact, I left the show. I very rarely leave shows.

I saw Black Flag on a Sunday over in Hollywood with Green On Red and the Bangles. The only

similarity between bands was that they all plugged into the back wall to get power for their amplifiers. Henry came out, and it was one of the most exciting shows I'd ever seen. After they finished, I was in tears and felt as though I had cement shoes and couldn't move. I was like, "You fucking idiot, why did you quit this band? What the fuck . . . !" ∎

"Henry came out, and it was one of the most exciting shows I'd ever seen. After they finished, I was in tears and felt as though I had cement shoes and couldn't move. I was like, 'You fucking idiot, why did you quit this band?'"

SCENE NUMBER FIVE
AWKWARD MOMENTS AND AMAZING RECOVERIES IN THE HISTORY OF PUNK ROCK MUSIC

"Some bands that chose not to disband, and who stuck to their tried-and-true formulaic music, appeared outdated and irrelevant even to some of their dedicated fans."

CHANGING THE GUARD

By the mid-1980s, many of the keystone bands that formed the first wave of American Hardcore chose this as the perfect time to call it quits. This mass exodus left large and geographically sporadic holes in the fabric of a scene that just a year or so before was moving full-speed-ahead with no signs of slowing, let alone stopping. Some bands that chose not to disband, and who stuck to their tried-and-true formulaic music, appeared outdated and irrelevant even to some of their dedicated fans. Some of the more adventurous bands scrambled to stay relevant by playing a sort of jacked up Punk/Speed-metal hybrid music referred to at the time as "Crossover." Others, as if inspired by something otherworldly, began making cacophonous noises that bore little resemblance to anything they played previously. The scene and the music were obviously evolving, but my youthful enthusiasm wasn't exactly ready for the changes being made.

Looking back from a music point of view, this was certainly a weirdly experimental time. Somehow, though, a piece of the Punk Rock scene in and around 1985 and 1986 recovered from this hiccup, though some rather significant changes were rendered in both the musical and social arenas. After the fallout, though, things were just not the same, which isn't to say things were not good or even amazing at times: they were just inexplicably different. Some of the crucial pieces of the "scene" were apparently lost and gone forever. Ironically, these pieces returned into Punk Rock's collective consciousness.

"Live Fast Die Young" was the nature of the culture. From the initial rise to the ostensible end of the first wave of American Hardcore, only a handful of bands were able to keep themselves together and stay intact. As I recall, most bands of that time period, formed

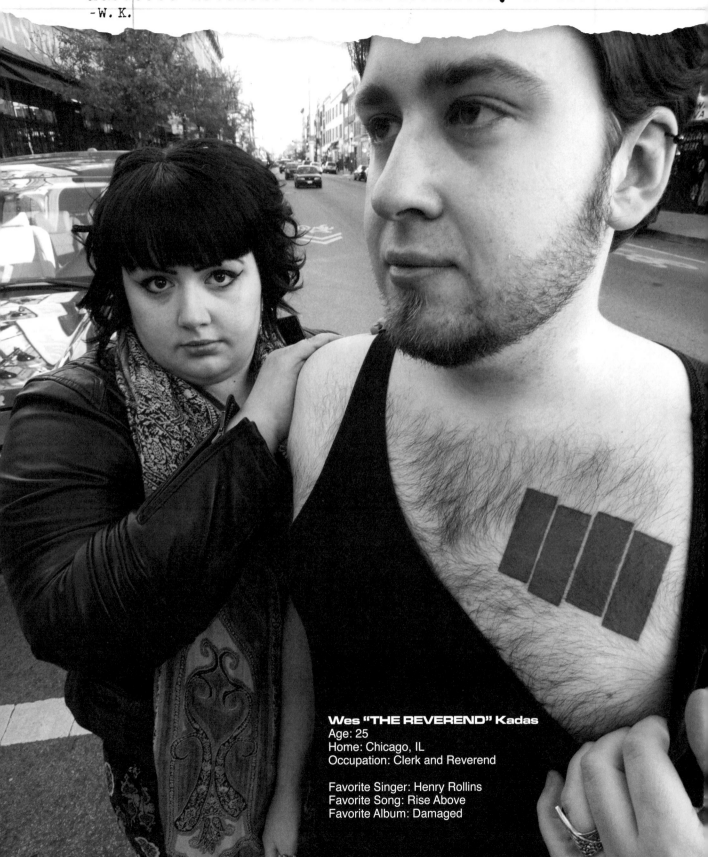

"To me, Black Flag is the be-all-end-all Punk Rock band, and if I had to put a logo on the entire Hardcore movement it would definitely be The Bars."
-W.K.

Wes "THE REVEREND" Kadas
Age: 25
Home: Chicago, IL
Occupation: Clerk and Reverend

Favorite Singer: Henry Rollins
Favorite Song: Rise Above
Favorite Album: Damaged

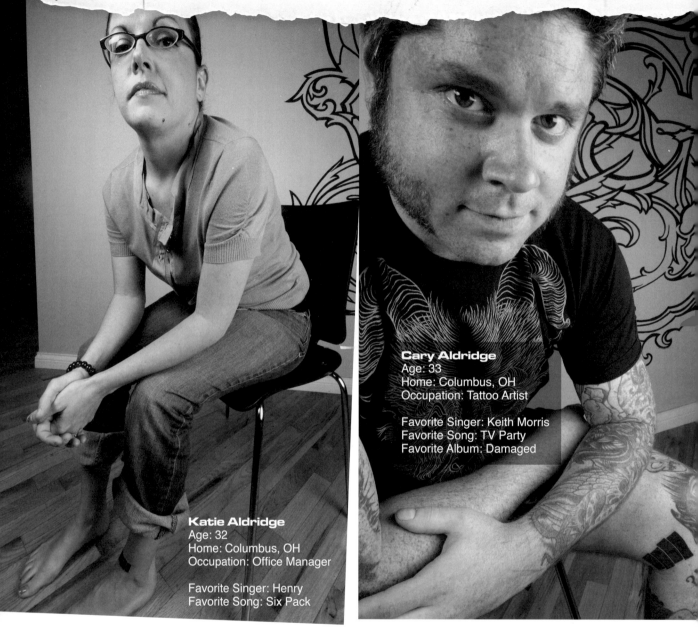

"The Bars are a symbol of a generation. They are a kind of indicator where you can see who grew up in the same way that you did."-K.A.

"I am into Punk Rock, and I see Black Flag as one of the most influential bands of the genre. I was never a huge Black Flag fan, but I have to acknowledge them as being a major influence on the music that I listen to now."-C.A.

Katie Aldridge
Age: 32
Home: Columbus, OH
Occupation: Office Manager

Favorite Singer: Henry
Favorite Song: Six Pack

Cary Aldridge
Age: 33
Home: Columbus, OH
Occupation: Tattoo Artist

Favorite Singer: Keith Morris
Favorite Song: TV Party
Favorite Album: Damaged

roughshod in basements and garages across the country, garnered some exposure and even small cult followings before unceremoniously breaking up. Hundreds, if not thousands, of bands did this every year. Surprisingly, if not miraculously, some of Hardcore's first wave lasted and quite a few bands had enough staying power that they were raised up to the status of scene granddaddies.

Viewed from this new millennium perspective, bands like the Bad Brains, Dead Kennedys, DOA, SSD, and the Circle Jerks seem amazing from start to finish. However, having been around at the time when many of these bands were releasing their more "experimental" music, it looked to me as if they were sabotaging their prior good

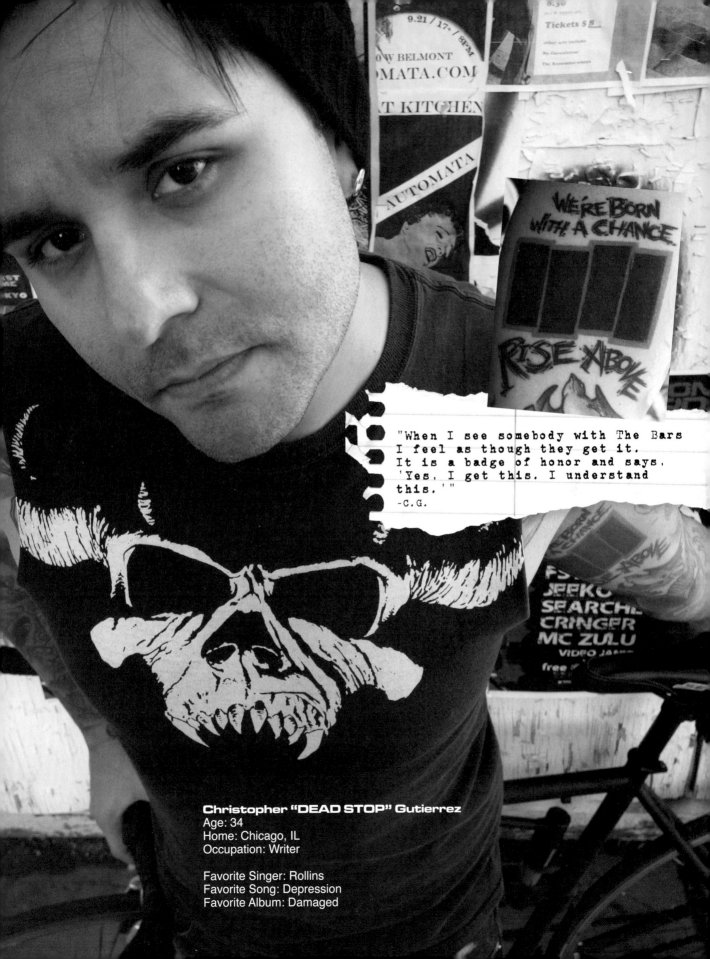

"When I see somebody with The Bars
I feel as though they get it.
It is a badge of honor and says,
'Yes, I get this. I understand
this.'"
-C.G.

Christopher "DEAD STOP" Gutierrez
Age: 34
Home: Chicago, IL
Occupation: Writer

Favorite Singer: Rollins
Favorite Song: Depression
Favorite Album: Damaged

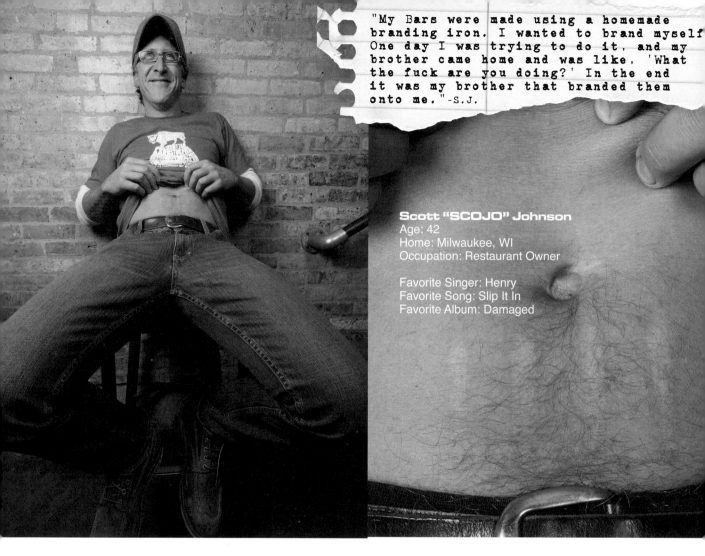

"My Bars were made using a homemade branding iron. I wanted to brand myself! One day I was trying to do it, and my brother came home and was like, 'What the fuck are you doing?' In the end it was my brother that branded them onto me." -S.J.

Scott "SCOJO" Johnson
Age: 42
Home: Milwaukee, WI
Occupation: Restaurant Owner

Favorite Singer: Henry
Favorite Song: Slip It In
Favorite Album: Damaged

standing. Possibly not liking the new rigidity the scene was demanding, some bands broke up, while others broke rank and tried their luck at a new sound. The efforts of some were well-received. Others, unfortunately (or fortunately), flopped.

For me, recalling the feeling of complete jubilation after picking up the Dead Kennedys' *In God We Trust, Inc.* is interesting. On that record were, and remain still, some solid Punk Rock hits, some easily digested lyrics, and verbal venom to spare. My feeling of jubilation, however, turned to confusion upon receiving my copy of *Frankenchrist* in the mail. I can remember waiting for the mailman's delivery. Upon receipt, I hurried up to my room to blast what could only be called (at that time, and by me) as, um, "interesting" music. *Frankenchrist* was not a bad record, but gone were the hooks, the sing-along choruses, and hyperventilation-inducing speed of *In God We Trust*. All the venom was there, but this new venom was coming at me from a totally different place than earlier Dead Kennedys releases, as if challenging me to look at that insane Geiger rendering of multiple dirty penises penetrating multiple dirty assholes. I feasted my ears on the hypnotic, Summer-of-Love inspired, garage guitar riffs, and involved myself deeply in the similes and metaphors of Biafra's poetry. I had to either get it, or, well, get out.

Dead Kennedys connected with me on the most visceral level beforehand. After *Frankenchrist*, I was trying to figure it all out. Where I was once being clobbered over the head with a baseball bat of sarcasm, now I was being clobbered over the head with a spider's web of cynicism and erudition. I had to grow quickly with the band's new

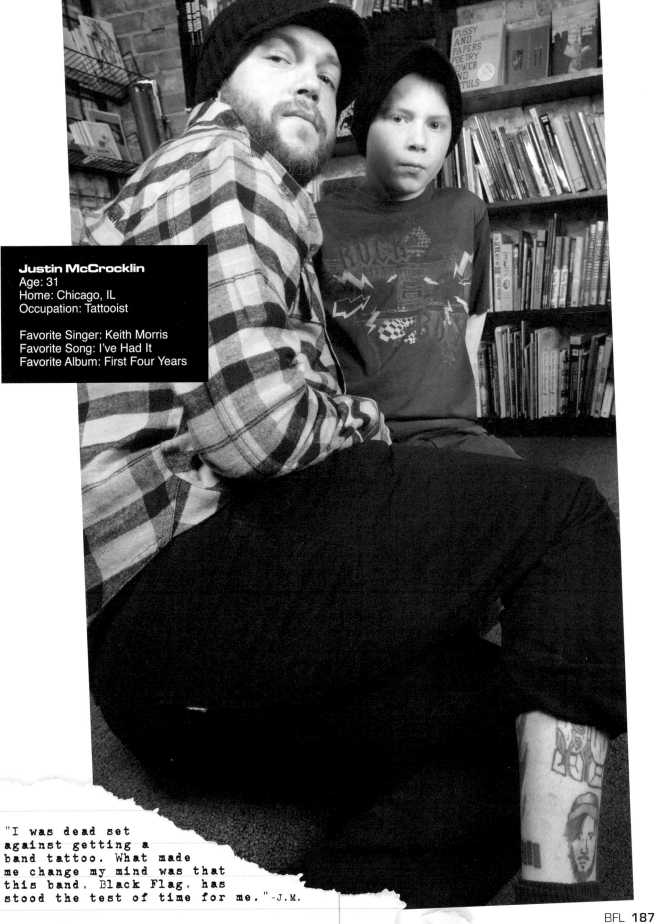

Justin McCrocklin
Age: 31
Home: Chicago, IL
Occupation: Tattooist

Favorite Singer: Keith Morris
Favorite Song: I've Had It
Favorite Album: First Four Years

"I was dead set against getting a band tattoo. What made me change my mind was that this band, Black Flag, has stood the test of time for me." -J.M.

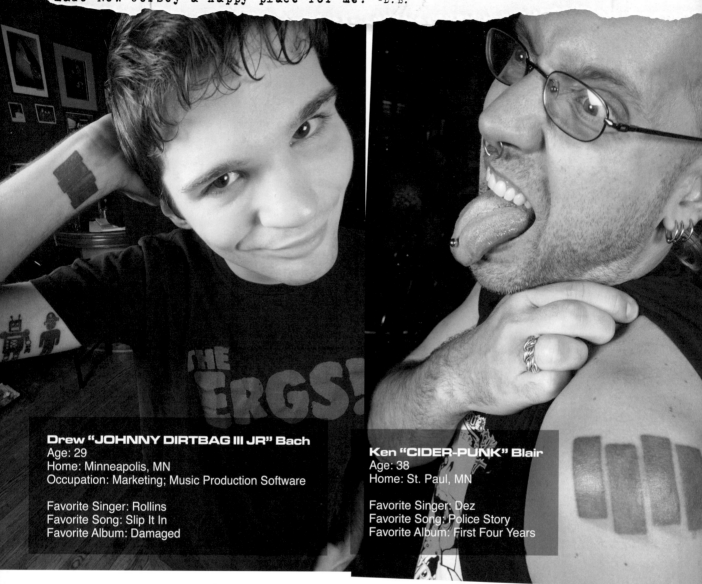

"The Bars were my very first tattoo. I was always against getting tattooed and I don't know why, but The Bars were a tattoo that immediately made sense after years of getting branded. Black Flag made an unfamiliar place very familiar to me, and even made New Jersey a happy place for me." -D.B.

"Black Flag is a band that everybody's gonn remember." -K.B.

Drew "JOHNNY DIRTBAG III JR" Bach
Age: 29
Home: Minneapolis, MN
Occupation: Marketing; Music Production Software

Favorite Singer: Rollins
Favorite Song: Slip It In
Favorite Album: Damaged

Ken "CIDER-PUNK" Blair
Age: 38
Home: St. Paul, MN

Favorite Singer: Dez
Favorite Song: Police Story
Favorite Album: First Four Years

direction or find some other band to love. Call me old-fashioned, but by 1986, just three years after getting solidly into Punk Rock, I just wanted one of my old favorites to kick my ass and keep me connected. Sadly, that just wasn't happening.

I cannot overstate how strange all of these new changes were affecting me, and presumably most of my Punk Rocker friends, but for a while I think that we were all too afraid to speak up for fear of seeming immature and unable to comprehend the "deeper" channel on which those bands were now broadcasting.

Oddly, though, I can remember a handful of my close friends embracing the old bands' new sounds. In an epic argument, one that lasted a few months of back and forth bickering, one of my best friends would send jabs my way for not buying SSD's later release entitled *How We Rock*. *Get It Away* blew my fucking doors off. I am not

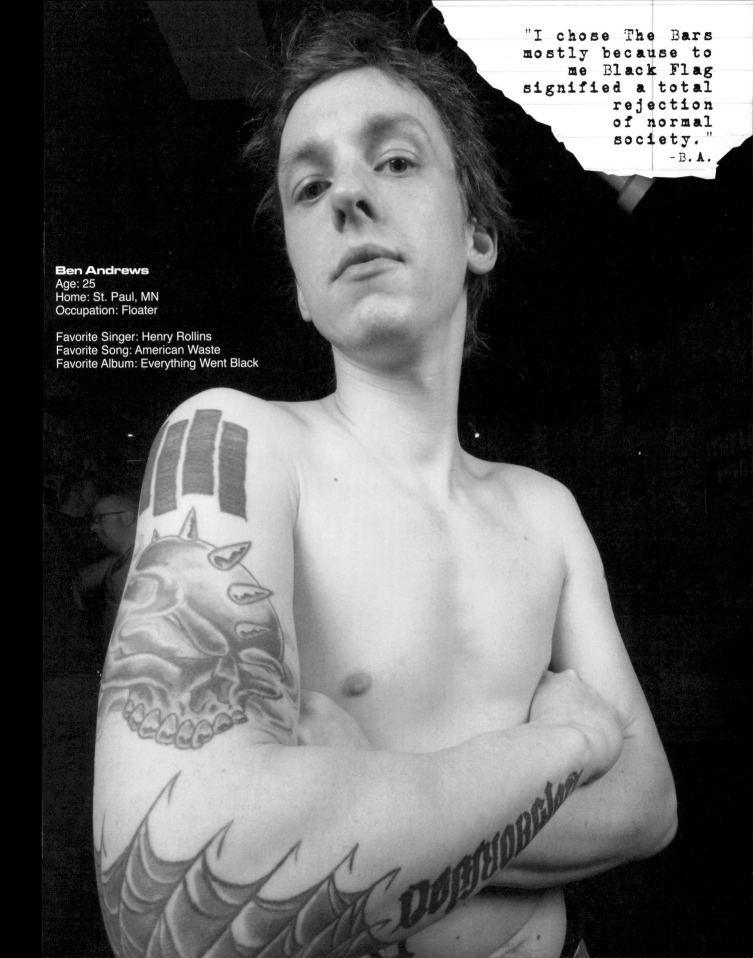

Ben Andrews
Age: 25
Home: St. Paul, MN
Occupation: Floater

Favorite Singer: Henry Rollins
Favorite Song: American Waste
Favorite Album: Everything Went Black

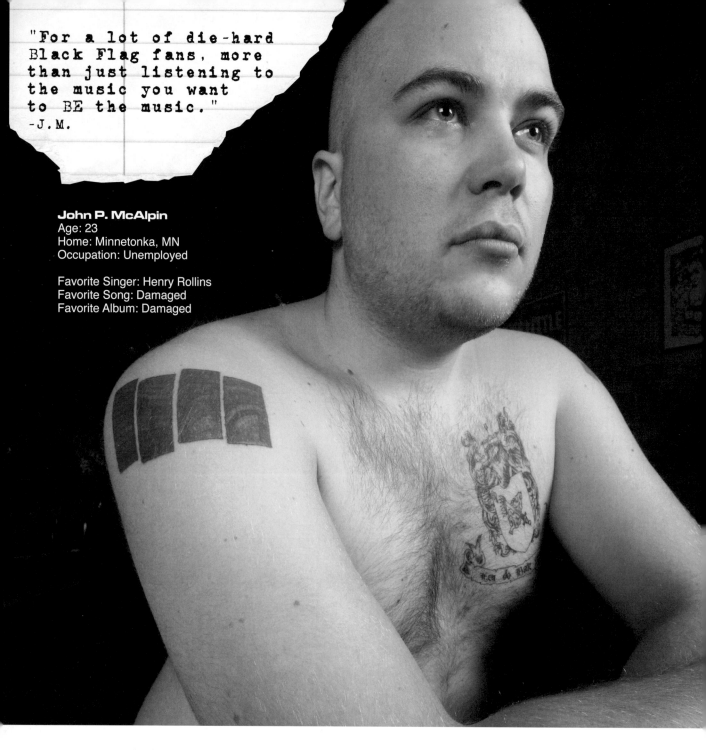

"For a lot of die-hard Black Flag fans, more than just listening to the music you want to BE the music."
-J.M.

John P. McAlpin
Age: 23
Home: Minnetonka, MN
Occupation: Unemployed

Favorite Singer: Henry Rollins
Favorite Song: Damaged
Favorite Album: Damaged

sure whether it was the Pushead art on the cover, or if it was all of those amazing jump-caught-in-mid-air photographs on the back cover, or songs sung in such an angry tone as to render the lyrics undecipherable. That record—one of the prides of my record collection to date—was epic to me when it came out.

Happily, I was just not ready to be bent toward bad Metal when *How We Rock* hit the shelves. I missed the aggression, anger, and great Punk Rock art. Not only was it gone, it was replaced by something mediocre at best. For years, I thought I was stupid and missed the point. However, after watching the shirtless Springa in a British Bobby cap clip in *American Hardcore*, well, I don't think I missed the point at all. In fact, I laughed,

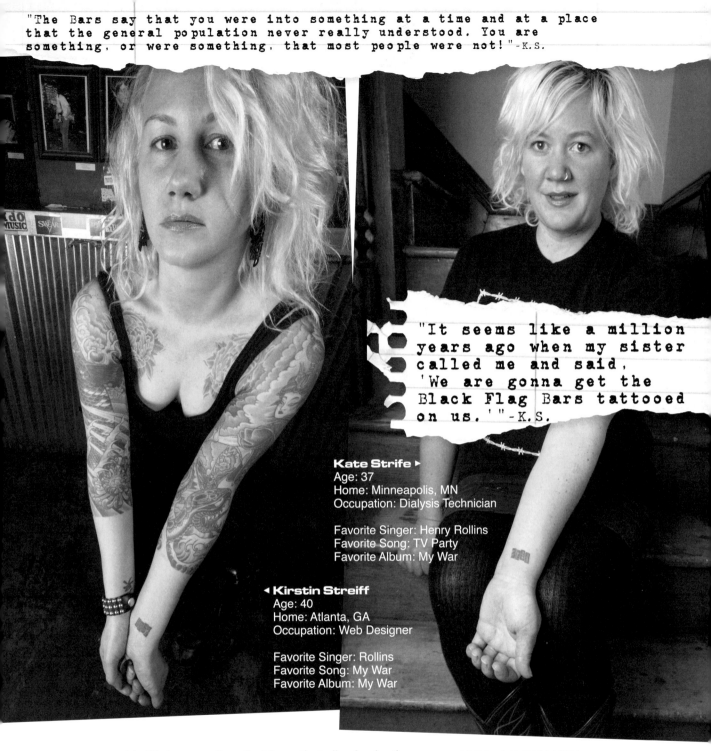

"The Bars say that you were into something at a time and at a place that the general population never really understood. You are something, or were something, that most people were not!" -K.S.

"It seems like a million years ago when my sister called me and said, 'We are gonna get the Black Flag Bars tattooed on us.'" -K.S.

Kate Strife ▶
Age: 37
Home: Minneapolis, MN
Occupation: Dialysis Technician

Favorite Singer: Henry Rollins
Favorite Song: TV Party
Favorite Album: My War

◀ Kirstin Streiff
Age: 40
Home: Atlanta, GA
Occupation: Web Designer

Favorite Singer: Rollins
Favorite Song: My War
Favorite Album: My War

and I still do every time that I see that clip. Again, those were some very, very, very weird times to be a Punk Rocker, but you really didn't have a choice. Most of the bands were changing. Collectively conceived or by coincidence, "maturing" bands were taking jabs at the naïve kids trying to keep Hardcore tied to a tight leash and discouraging its natural evolution.

I always questioned Hardcore's natural evolutionary endpoint, racing down the path of Metal music in the vein of AC/DC and Black Sabbath seemed odd. These bands were not bad, but I didn't believe Hardcore music's true endgame was to emulate them. To me, that progression always seemed contrived to a large degree, never organic.

"When I got my Bars I was nearly 40, so it was kind of a mid-life sort of thing. In that year I climbed Mt. Rainier and got The Bars tattooed on my arm."
-N.H.

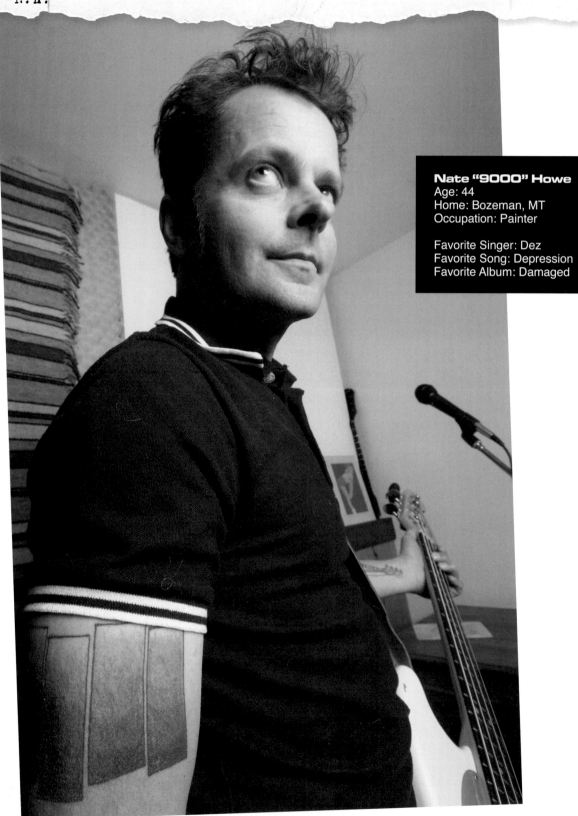

Nate "9000" Howe
Age: 44
Home: Bozeman, MT
Occupation: Painter

Favorite Singer: Dez
Favorite Song: Depression
Favorite Album: Damaged

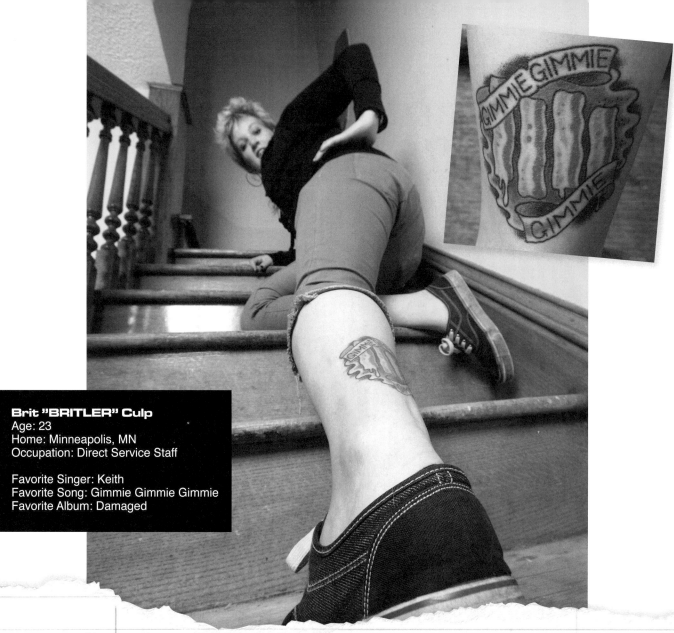

Brit "BRITLER" Culp
Age: 23
Home: Minneapolis, MN
Occupation: Direct Service Staff

Favorite Singer: Keith
Favorite Song: Gimmie Gimmie Gimmie
Favorite Album: Damaged

"Not only do I like Black Flag quite a bit, but I was also
up early one morning eating bacon, and it just came to me
to get the Bacon Bars. I love bacon. I've been on the
national news for my love of bacon. So, it looked like the
Bacon Bars were just bound to happen."-B.C.

I clawed for inspiration from new bands and similar sounds coming from many bands
featuring members from my former favorites. While some of these bands were totally
engaging, I still hoped the changes were just a phase and some older bands would put
out something truly inspired and amazing. Predictably, it just didn't happen very much.
So, the scene didn't seem to evolve with those bands, but more or less developed away
from them. Hardcore Punk Rock survived, but most of the bands that made the most
severe changes were dropped from marquees.

EVOLVING GENERALISM
AS A MEANS TO SURVIVE THE DEATH OF HARDCORE
Black Flag transcended it all—started its life as one thing, ended as another, and was
seemingly never influenced by the trends of the time. In fact, Black Flag seemed to be

"Black Flag built a legacy that Punk Rockers still believe to be a birthright, for Black Flag hardwired the system from start to finish."

calling the shots and were largely responsible for the day-to-day evolution of the American Hardcore ethos throughout their existence.

More frequently than not, this band and its entire philosophy was communicated across space and time via their ubiquitous logo, The Bars. You draw The Bars on your backpack, and if somebody was able to make the connection to the band Black Flag, then you knew you were in good company. So, while other bands had names, Black Flag possessed a simple symbol that stood for everything, whether we, the kids, knew what "everything" was or not. One band seemed unable to be pinned down to one style of anything—Black Flag was that band.

Maybe more than any other Punk Rock band, no band was loved or hated more than them throughout their long and sordid history. They helped unravel the first wave of Punk Rock. They also placed a wedge between themselves and their massive fan-base. On one hand, Black Flag didn't seem to care about anything. At the same time, they seemed intent on challenging their fans at every single conceivable level.

On their deathbed in 1986, the mighty Black Flag neither resembled nor sounded even remotely similar to their late 1970s and early 1980s manifestations. Through that ten-year history of writing and playing music, Black Flag built a legacy that Punk Rockers still believe to be a birthright, for Black Flag hardwired the system from start to finish. Historically speaking, Black Flag defined Punk Rock ambition. They didn't really need anybody, and everybody eventually relied on them for something. So, when Black Flag unceremoniously decided to call it quits, they left a gaping hole in the fabric that proved impossible to repair. No matter how I actually felt about them at any given time back then, I was quite aware that they were probably the most important band of their time. Their influence was immense and unforgettable. ∎

"When I got into Black Flag it changed my outlook on life. I don't do a lot of advertising with my tattoos, but I was okay with The Bars. To me they say, 'Just let me be me.' It is amazing that so many people still get them, and hopefully they get them for all the right reasons."-S.S.

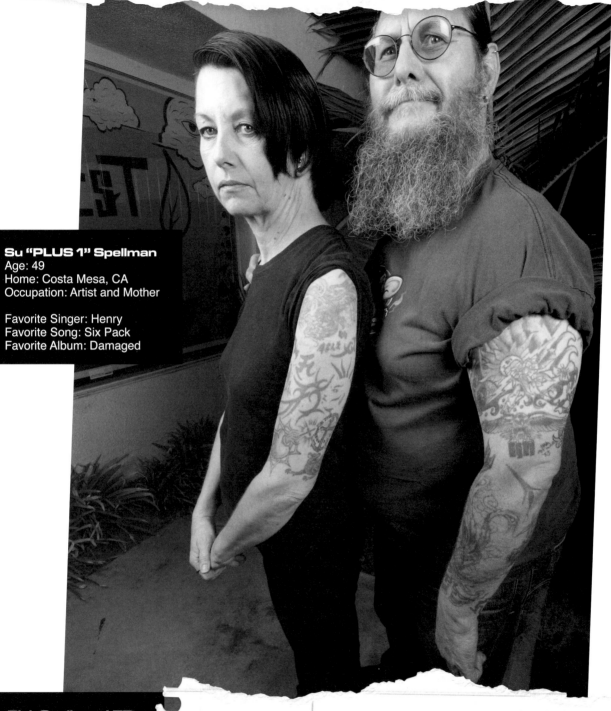

Su "PLUS 1" Spellman
Age: 49
Home: Costa Mesa, CA
Occupation: Artist and Mother

Favorite Singer: Henry
Favorite Song: Six Pack
Favorite Album: Damaged

Rick Spellman LTD.
Age: 51
Home: Costa Mesa, CA
Occupation: Tattoo Artist

Favorite Singer: Ron
Favorite Song: Damaged II

"I spent a lot of time with the Black Flag guys. They were kind of a family to me at a time when I didn't have a lot of family around."-R.S.

INTERVIEW

I WAS JUST AT THE RIGHT PLACE AT THE RIGHT TIME.

RICK SPELLMAN

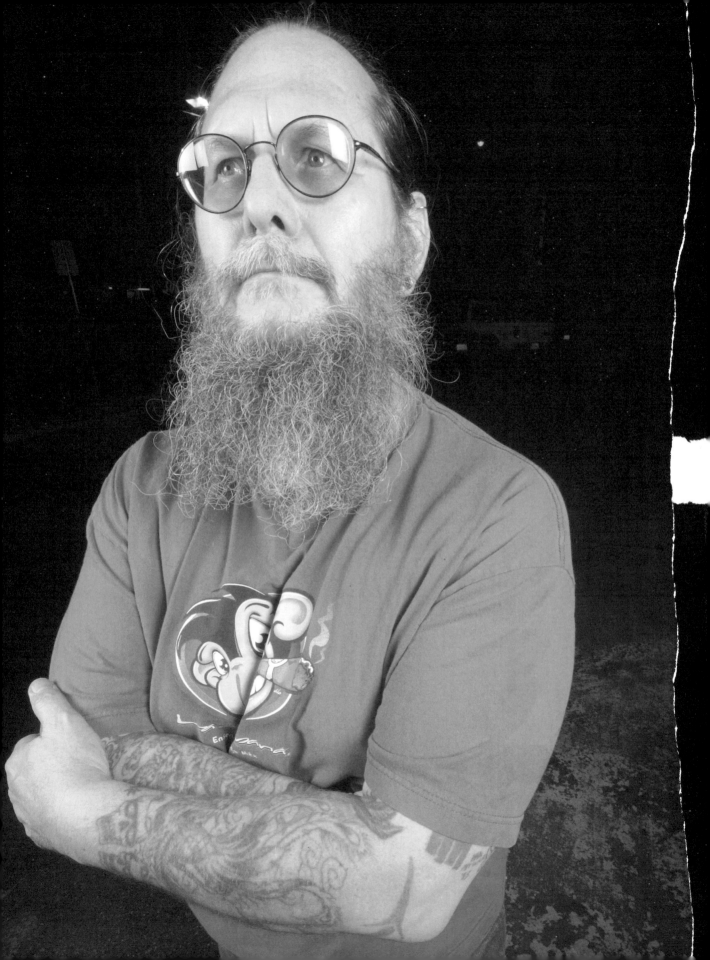

> **"Greg and Chuck had this real hard regimen. Like a real job, they would practice for five or six hours a day. This approach showed in their music. They were unbelievably tight. I know the intensity was really hard on Henry in particular."**

THE BACK OF THE TITAN: HENRY'S ICONOGRAPHY

I am a second-generation tattoo artist. My father was a tattoo artist before me, and I've been working hard to carry on the family tradition. My dad was self-taught. He was fifteen when he and his brother considered doing it, which was unusual for that time. He worked with many "name brand" tattoo artists—Ed Hardy, Don Noren, and Zig Owens—and became quite good himself. Ed Hardy did about 90 percent of my tattoos, and my dad did the other 10 percent.

I started tattooing in June of 1977. Getting "flash" from national tattoo suppliers was most common, but right after I got into tattooing things began changing. Ed Hardy had the first "by appointment only" shop with all custom designs. He would draw the design right onto your arm with a ball-point pen. Strange to think about it now, but when the Punk movement started happening, I really didn't notice a lot of people at shows with tattoos. Over time,

people were exposed to talented artists, and I started seeing more people with designs with feeling, not simply "flash" pulled from a wall.

I was just at the right place at the right time I guess. I tattooed Henry Rollins, Dez Cadena, and Robo from Black Flag. I did Jerry Only, Doyle, and Glenn Danzig from the Misfits. I tattooed people in Saccharine Trust and the Circle Jerks.

In terms of exposure, Henry's back piece was really good for me. He decided what he wanted as an image, and I took some artistic liberty because his design was kind of boring. Since Henry was this dynamic singer, I wanted to make this screaming skull that would show Henry's aggression and emotions, but he didn't want that. He settled on an image from a deck of tarot cards. He showed me these different cards and images of the sun. He wanted something more than "Hardcore," more personal than just a screaming skull. From those images, we came up with the design that we tattooed on his back.

THE BAND, THE MYTH, THE LEGENDS

My wife and I would go to [Punk Rock] shows early on and collect flyers with really nice artwork. Mad Marc Rude from San Diego made artwork for bands like the Battalion of Saints and did a cover for a Misfits record or two. His artwork appeared on flyers for shows down there, and I started to collect these things. By having them, we'd be able to look at them down the road.

So, I first saw Black Flag at a show at the Cuckoo's Nest. A friend of mine said, "Black Flag is playing, and I think that you would really be into them." We ended up going to see them at a matinee or an early evening show. I had some of their music on vinyl, probably one of the early EPs, but I hadn't seen them. I was amazed. They were really one of the greatest bands to have ever walked the earth. Greg Ginn was playing the guitar. Dez, replaced as singer by Henry, was playing second guitar. Then there was Chuck Dukowski and Robo. It was pretty phenomenal, maybe Henry's second or third

RICK

show with the band after he had moved here from Washington, D.C.

They would start to play, and everybody would just come alive. It was just this forward motion. They were playing to a lot of troubled kids, so their shows could become a little bit violent. Maybe it was the chemistry of the band, but the whole package was so moving.

PUNK FAMILY BUSINESS VALUES

Black Flag was a lifestyle, not the way bands do things today. If you were in Black Flag, the band was a functioning unit. It didn't matter if you were in the band or a roadie, you were part of the unit. You hear stories about them living on two dollars a day on tour, and that wasn't a lot of money, but it was all that they had. They could have starved to death.

Greg and Chuck had this real hard regimen. Like a real job, they would practice for five or six hours a day. One time, Henry and Dez were late for practice, and they got in trouble because they were supposed to be there on time, just like a job. This approach showed in their music. They were unbelievably tight. I know the intensity was really hard on Henry in particular.

I became really close to Henry. He used to stay with us a lot at our home. When things weren't going so well with the band, we'd get a call from Henry. They all lived in an office. It was tight quarters, and people lived under desks. That was their living space. All these folks lived on top of one another, and every so often it really got to one of them. We'd get a call from Henry, pick him up, and he would come spend the weekend with us.

OUT OF THE CLOSET: COMIC PROPS IN THE CHAOS

[While things were intense in the Black Flag camp] I can remember a gentleman living an "alternative" lifestyle came to a Black Flag show. Henry wasn't too happy with the particular show, so afterwards he went into a little closet because they didn't even have a back room. This gentlemen wanted to talk to Henry after the show, so he went to the door and

knocked. Henry said, "Okay, I am coming out now," to which the guy responded, "If you are coming out of the closet now, then you are coming home with me." It was quite funny to all of the people there. Seeing everybody laughing and making a joke out of the whole scene was cool.

BARRED FOR LIFE

The Bars on my left forearm were done by my father, but another smaller nearby set of them were actually done by Henry Rollins. A mutual friend of ours sort of shamed him into giving me the tattoo. I wanted Henry to give me a tattoo, but he said he wasn't a very good artist, and he wasn't really interested in doing it. We kind of trapped him at my shop one night. I got everything ready and set up the machine, so there wasn't any way he couldn't tattoo me. Henry used to sign things with his initials and the four bars, so I have four little bars, with his initials beside them. That is my little souvenir from the ages.

The Bars have branched out. Though still directly connected with Black Flag, with each generation a new crop of people gets into it, so it means different things to them. Some kids with The Bars weren't even born until after the band broke up. People get into a particular style of music and want to have something related to that music, like a T-shirt or tattoo. Black Flag had The Bars. You get them tattooed on you, and they live forever (laughs)…∎

"Black Flag was a lifestyle, not the way bands do things today."

SCENE NUMBER SIX
BLACK FLAG AND MY PUNK ROCK LIFE

"Every song spoke directly to me like the voice of a very, very tough friend and gave me hope that I alone might change that situation."

HERE IS HOW IT LOOKED TO ME

Sad to say it, but Black Flag was never my favorite Punk band. Devo (debatably not a Punk band at all) held that title for me. But Black Flag, at the very least, was indispensable and deeply influential. Like every Punk Rock kid of that era, I had one or five or ten favorite Black Flag songs that I knew by heart or I could relate to in a visceral way. Black Flag's message was powerful emotional ammunition for an angry and misunderstood high school loser like me, but they were never quite my favorite band. Sorry.

As an angry and misunderstood kid, every real or envisioned encounter with authority demanded a real-time soundtrack, and Black Flag had a song for every encounter: out of control moment—"Rise Above"; loser at love—"Jealous Again"; alone at home in my dark bedroom—"Depression"; getting busted for riding my skateboard—"Police Story"; hating my boss at my crappy minimum wage retail job—"Clocked In"; another asshole fucking with me for being Punk Rock—"Revenge." Every song spoke directly to me like the voice of a very, very tough friend and gave me some hope that I alone might change that situation. If for some reason I couldn't change that situation by myself, at least I felt some comfort knowing that many kids all over the country were feeling the exact same stings in life as me, and they wanted to make some changes too. Just how did I know this to be true? Well, because Black Flag said so. End of story.

Each song was more powerfully relevant to my spinning-out-of-fucking-control teenage world than the one before. Black Flag's songs related to the audience amazingly well, suggesting they felt the same way as me about the problems facing youth in America and around the world. I hoped they were not faking it. In my eyes, they could not be posing. To me, Black Flag was an aggro, blue-collar, Americanized version of Sex Pistols or the Clash and were way more real to me than all those glossy Brit Punk bands of the previous generation.

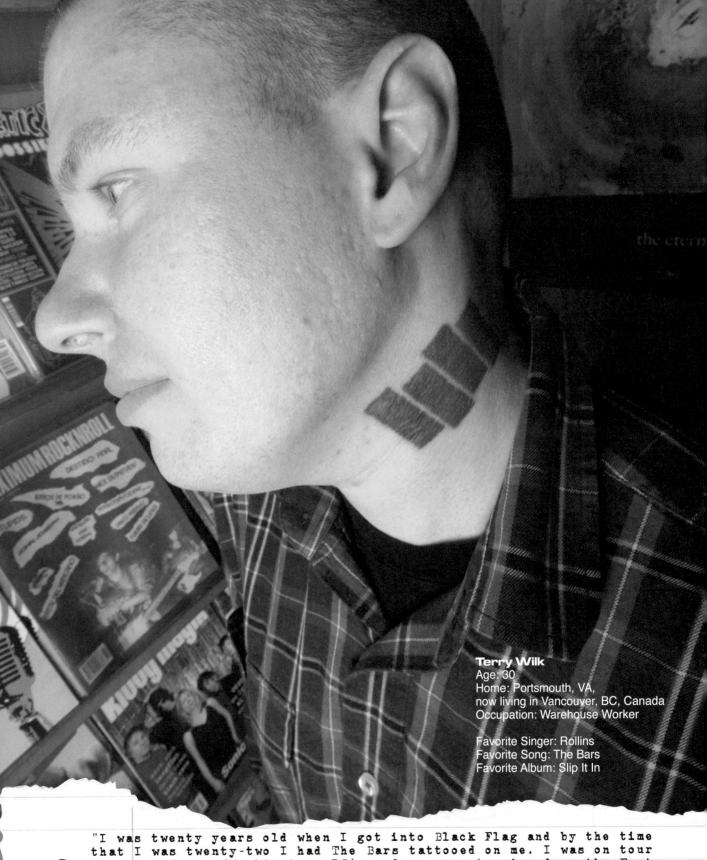

Terry Wilk
Age: 30
Home: Portsmouth, VA,
now living in Vancouver, BC, Canada
Occupation: Warehouse Worker

Favorite Singer: Rollins
Favorite Song: The Bars
Favorite Album: Slip It In

"I was twenty years old when I got into Black Flag and by the time
that I was twenty-two I had The Bars tattooed on me. I was on tour
with The Front (Washington, DC), and we were touring down the East
Coast of the U.S. We were in one of the Carolinas on my birthday and
so I went to a shop and got it as a birthday present to myself. It is
not like you can get rid of a tattoo so I went for the neck because
that is exactly where I wanted it."-T.W.

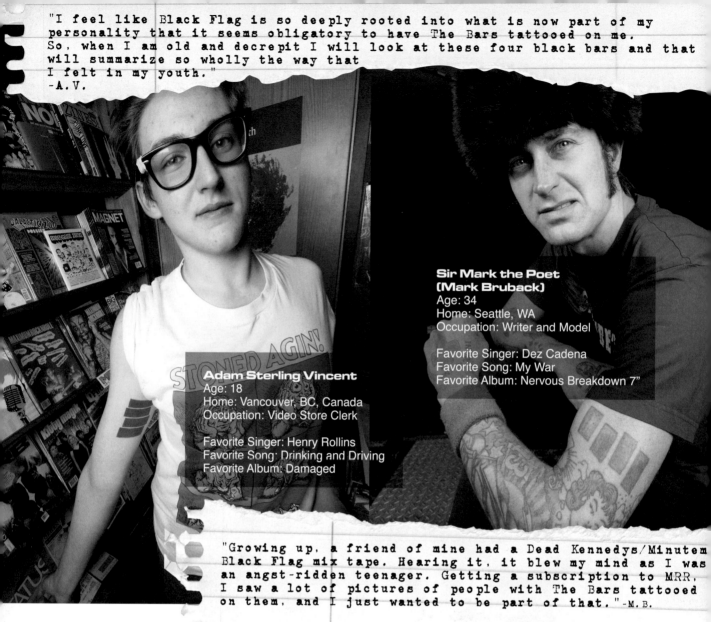

"I feel like Black Flag is so deeply rooted into what is now part of my personality that it seems obligatory to have The Bars tattooed on me. So, when I am old and decrepit I will look at these four black bars and that will summarize so wholly the way that I felt in my youth."
-A.V.

Sir Mark the Poet (Mark Bruback)
Age: 34
Home: Seattle, WA
Occupation: Writer and Model

Favorite Singer: Dez Cadena
Favorite Song: My War
Favorite Album: Nervous Breakdown 7"

Adam Sterling Vincent
Age: 18
Home: Vancouver, BC, Canada
Occupation: Video Store Clerk

Favorite Singer: Henry Rollins
Favorite Song: Drinking and Driving
Favorite Album: Damaged

"Growing up, a friend of mine had a Dead Kennedys/Minutem Black Flag mix tape. Hearing it, it blew my mind as I was an angst-ridden teenager. Getting a subscription to MRR, I saw a lot of pictures of people with The Bars tattooed on them, and I just wanted to be part of that." -M.B.

Black Flag's man-on-the-street personae was conveyed by Penelope Spheeris's cult-classic film *The Decline of Western Civilization* when I viewed it in the summer of 1984. Spheeris interviewed the band in 1980, at a time when the American Hardcore scene was in its infancy. Black Flag was already a few years old and working with their second singer, Ron Reyes. The interview was mind-blowing. It changed my perception of Black Flag, as a band and as individuals, in just a heartbeat.

On screen was a band well on its way to being one of the most memorable American Punk bands and nothing remotely profound flowed into the interview. Was Black Flag's revolutionary rhetoric merely an act, I wondered? Even when asked, "What does the name Black Flag mean?" a rather confused Greg Ginn answers shyly, "Um, anarchy. It means anarchy." They were more like me than I could have ever hoped: they were shy, rather geeky, ironic, frequently confusing for the sake of being confusing, often lacking any semblance of self-confidence, and as individuals they were far from being the most ideal mouthpieces of a youth rebellion. I happily accepted the fact that they were not overtly political or preachy and were simply human. Black Flag were shoddily dressed, ill-kept weirdos just like me, but their songs and the energy of their live show straightforwardly spoke the language of revolution.

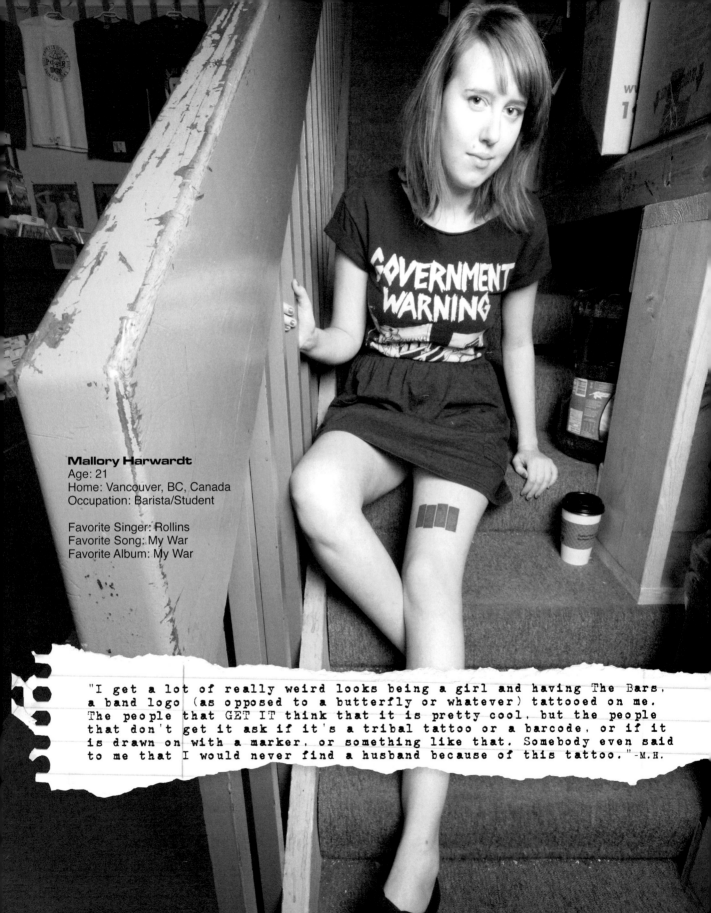

Mallory Harwardt
Age: 21
Home: Vancouver, BC, Canada
Occupation: Barista/Student

Favorite Singer: Rollins
Favorite Song: My War
Favorite Album: My War

"I get a lot of really weird looks being a girl and having The Bars,
a band logo (as opposed to a butterfly or whatever) tattooed on me.
The people that GET IT think that it is pretty cool, but the people
that don't get it ask if it's a tribal tattoo or a barcode, or if it
is drawn on with a marker, or something like that. Somebody even said
to me that I would never find a husband because of this tattoo." -M.H.

Heidi Elise Wirz
Age: 27
Home: Portland, OR
Occupation: Artist and Bartender

Favorite Song: Depression
Favorite Album: First Four Years

"I really connected with Black Flag's music. They seemed like broke-assed kids just like me, so the connection made sense."
-H.W.

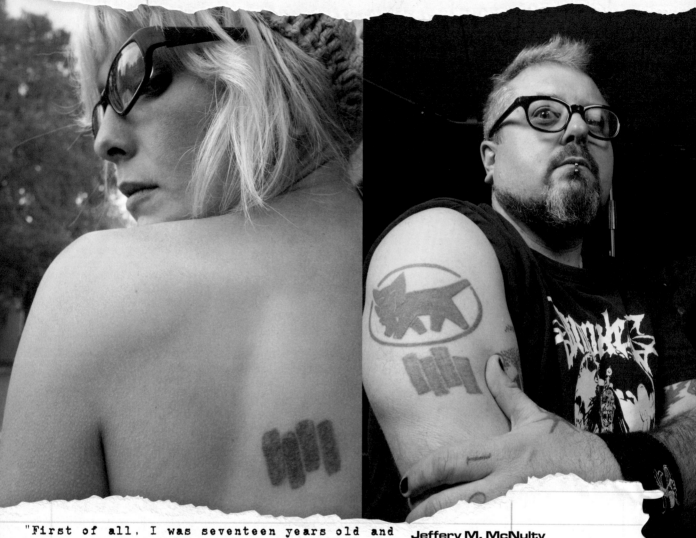

"First of all, I was seventeen years old and had just gotten kicked out of my house. I lived in a Punk Rock house where there was this guy who was going to tattoo me. He had been doing jailhouse tattoos for a while, and he made me sharpen the bass-string needle and insisted that we finish a bottle of tequila, and eat the two worms, since it was my first tattoo."-J.M.

Jeffery M. McNulty
Age: 38
Home: Seattle, WA
Occupation: Sound Engineer

Favorite Singer: Johnny "Bob" Goldstein (Keith Morris)
Favorite Song: Jealous Again
Favorite Album: Jealous Again

In contrast to all of the classic Los Angeles Punk bands caught on Spheeris's film playing on stages so high above the crowd that they appear as idols being worshiped by throngs of leather-clad kids with bad haircuts, terrible dye-jobs, and even shittier attitudes, Black Flag played on a tiny, dimly lit stage just a few inches above the crowd. Ron Reyes (credited on some recordings as Chavo Pederast) threw himself out into the crowd possibly more than he stood on the stage with his band mates. No walls, no barricades, no thuggish security—NO PROBLEM, they signaled. This connection

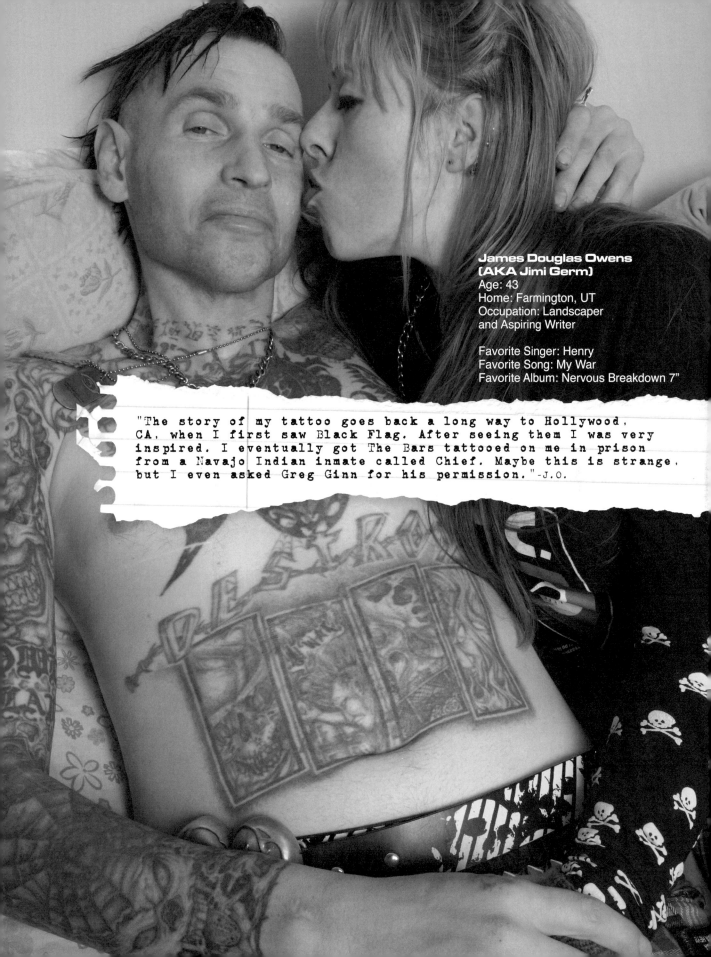

**James Douglas Owens
(AKA Jimi Germ)**
Age: 43
Home: Farmington, UT
Occupation: Landscaper
and Aspiring Writer

Favorite Singer: Henry
Favorite Song: My War
Favorite Album: Nervous Breakdown 7"

"The story of my tattoo goes back a long way to Hollywood, CA, when I first saw Black Flag. After seeing them I was very inspired. I eventually got The Bars tattooed on me in prison from a Navajo Indian inmate called Chief. Maybe this is strange, but I even asked Greg Ginn for his permission."-J.O.

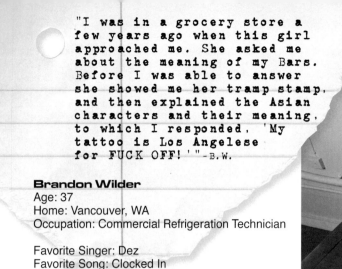

"I was in a grocery store a few years ago when this girl approached me. She asked me about the meaning of my Bars. Before I was able to answer she showed me her tramp stamp, and then explained the Asian characters and their meaning, to which I responded, 'My tattoo is Los Angelese for FUCK OFF!'"-B.W.

Brandon Wilder
Age: 37
Home: Vancouver, WA
Occupation: Commercial Refrigeration Technician

Favorite Singer: Dez
Favorite Song: Clocked In
Favorite Album: Damaged

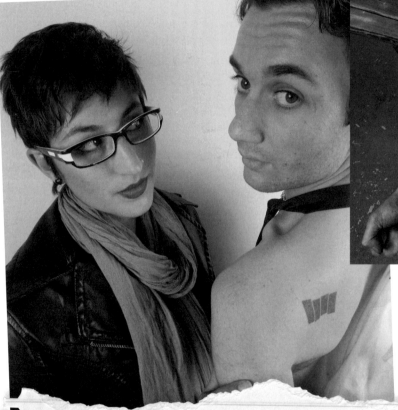

◄ **Anthony Anzaldo**
Age: 23
Home: Oakland, CA
Occupation: Youth Development Coordinator

Favorite Singer: Chavo
Favorite Song: My War
Favorite Album: Jealous Again

"I was born the same year that Black Flag broke up, and it is awesome to see that The Bars still have not become a 'Mall Punk' logo. They have sort of stayed in the same form they were intended for back when Black Flag were still together."-A.A.

between band and audience—or should I say, this lack of noticeable barriers between them—came to define the American Hardcore scene in the 1980s. Audience members fully participating in a show by climbing onto the stage, singing along to their favorite songs, or diving off of the stage and into the crowd without fear of expulsion from the show was foreshadowed by Black Flag. They helped forge a precedent: a more interactive band and audience relationship was possible. Beyond their music and public persona, Black Flag transcended the simple title of Punk Rock band. They seemed able to market and sell their cultural ideas using their very own built-from-the-ground-up record label, SST records.

"I got The Bars when I was sixteen in a garage in my neighborhood. I had pink hair at the time. Getting The Bars was part of me finding my own 'thing.'" -D.F.

"I feel like never having seen Black Flag helped me to keep my 'virginity.' Black Flag was one of the hardest-working bands out there when I started touring, and I feel like my tattoo is a nod back to how Black Flag did it." -R.N.

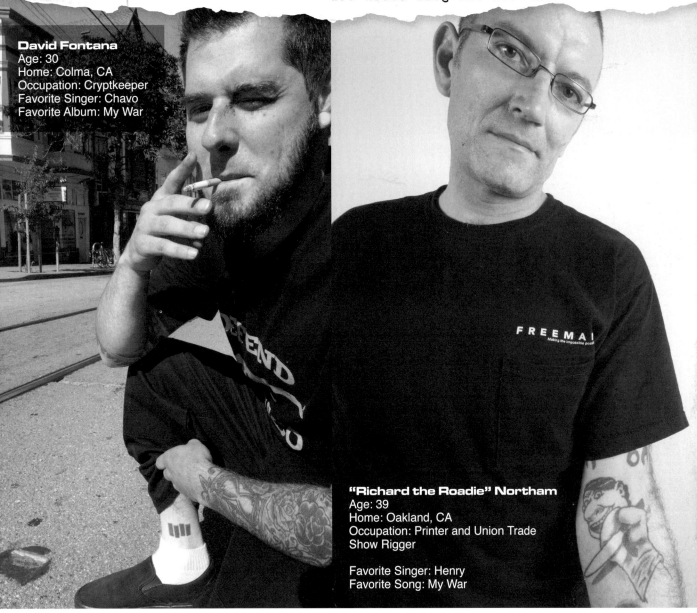

David Fontana
Age: 30
Home: Colma, CA
Occupation: Cryptkeeper
Favorite Singer: Chavo
Favorite Album: My War

"Richard the Roadie" Northam
Age: 39
Home: Oakland, CA
Occupation: Printer and Union Trade Show Rigger

Favorite Singer: Henry
Favorite Song: My War

The mighty SST ("Solid State Transmitters" denotes the original business venture), started by Greg Ginn, Black Flag's guitar player and founder, housed such classic Punk Rock bands as the Minutemen, Hüsker Dü, the Dicks, and the Stains, alongside some hard-to-classify rock bands like Saint Vitus and Saccharine Trust. Eventually, SST would go on to include Blast, the Bad Brains, Sonic Youth, and even Seattle's Soundgarden. Even with these bands, Black Flag's output continuously dominated their much-in-demand, photocopied, and collage-like order forms.

Included as well in SST's early arsenal were not only records but Black Flag skateboards, band T-shirts, books of poetry, posters, and books of drawings by

"I wanted a Black Flag tattoo because they were my favorite band all throughout high school, and my early twenties. However, I didn't just want to get The Bars since everybody that I knew had them. I wanted something that was nearly the same thing, but just a little bit different, which is why I chose the actual barcode from my favorite Black Flag album, The First Four Years."-N.T.

"I was at a tattoo shop to get my grandfather's portrait done. Then Dama came on and we were talking about how to ali the portrait, and I said 'Just put the fucking ba on me,' and I dedicated them to my grandfather instead."-M.M.

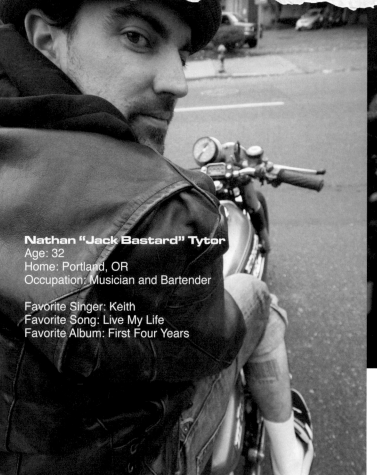

Nathan "Jack Bastard" Tytor
Age: 32
Home: Portland, OR
Occupation: Musician and Bartender

Favorite Singer: Keith
Favorite Song: Live My Life
Favorite Album: First Four Years

▲ **Mat Mathews**
Age: 38
Home: Seattle, WA
Occupation: Drummer and Computer Scientist

Favorite Singer: Henry
Favorite Song: Thirsty and Miserable
Favorite Album: My War

Raymond Pettibon—the creator of Black Flag's classic show posters and album cover designs. He designed their logo, known affectionately as The Bars, as well. There was so much great shit available on SST's order form that I never had enough money to buy what I wanted. As I discovered much later in life, behind all of this merchandise and mail order chaos were Greg Ginn and the hands of just a few dedicated kids with some affinity for Black Flag making records, selling records, promoting bands, booking tours, and kicking ass.

If manufacturing and promoting were their hidden talents, then touring seemed to be Black Flag's out-and-out frontal assault on the music world. Rumors flew around the early American Hardcore scene that Black Flag toured nonstop, sometimes for a year at a pop, which made it hard to believe they had time to front their own record label in a world devoid of cellular phones, wireless Internet, and the portable laptop computer. If the accounts of Black Flag's ambitious tour schedule (particularly during the Henry Rollins years, as presented in his memoir *Get in the Van*) are accurate, they really spent much of the year on the road, but maybe not all at one shot.

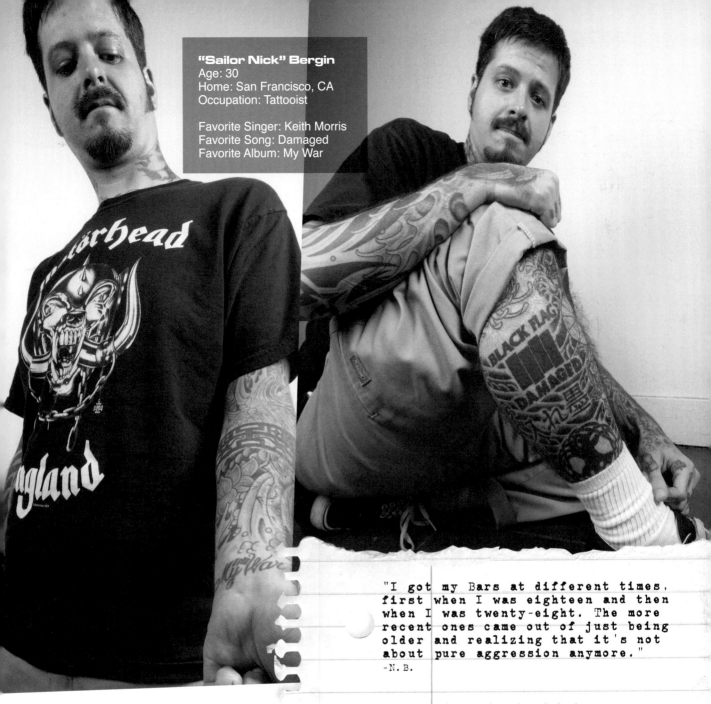

"Sailor Nick" Bergin
Age: 30
Home: San Francisco, CA
Occupation: Tattooist

Favorite Singer: Keith Morris
Favorite Song: Damaged
Favorite Album: My War

> "I got my Bars at different times,
> first when I was eighteen and then
> when I was twenty-eight. The more
> recent ones came out of just being
> older and realizing that it's not
> about pure aggression anymore."
> -N.B.

Having been in touring bands and promoted all-age shows for nearly a decade in the 1990s, I am still astounded how American Punk bands of the late 1970s even toured at all. Punk Rock was certainly a new and novel music culture, but it most certainly was not a unified scene like it would become later. If you were in a Punk band from New York, how on earth did you get your records to, let alone a tour date in, California? Who did you call? And even more difficult to imagine, who was the crazy promoter booking Punk Rock shows in Oklahoma or Nebraska in 1978? Who was going to go and see a Punk band play in Oklahoma or Nebraska?

Bands toured and scenes around the country started growing as a result. Part of the mind-boggling mythology of Black Flag's tour legacy is, according to many, they actually created the tour routes that Punk Rock bands of the era followed and, to a large degree, contemporary bands still use. Black Flag apparently knew whom to call!

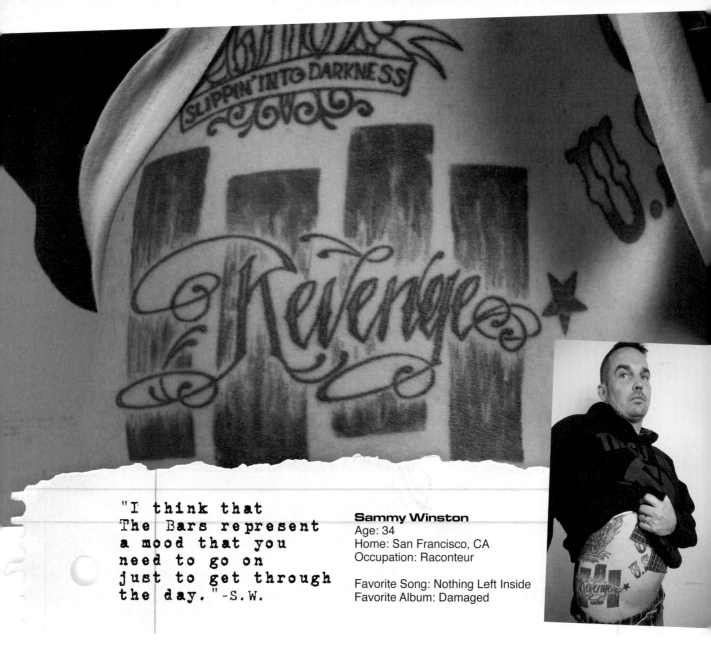

"I think that
The Bars represent
a mood that you
need to go on
just to get through
the day."-S.W.

Sammy Winston
Age: 34
Home: San Francisco, CA
Occupation: Raconteur

Favorite Song: Nothing Left Inside
Favorite Album: Damaged

Making something from nothing in a rather hostile new music scene seemed to be what Black Flag, and other bands of that time period, did best. At the time, I had no idea how bands toured. As long as the bands continued playing in or near my town, that was all that really mattered, not how they got there.

To say Black Flag rose above the problems facing rock bands throughout time and across genres would be a grotesque understatement. Vicious band infighting, rapid-fire membership changes, angered bailouts, and fictitious characters being given credit for recorded music seemed par-for-the-course, and their problems were amplified to epic proportions by a venomous alternative media that pigeonholed Black Flag as either pointless rabble-rousers or sell-outs from the very start. Rarely were Black Flag given the benefit of the doubt on any issue, but they did not seem to care anyway.

Probably the most outstanding example of problems inside the Black Flag camp is the Ron Reyes/Chavo Pederast mess. Ron Reyes, personally my favorite Black Flag singer, did not appear on any of Black Flag's recorded material by name. But even

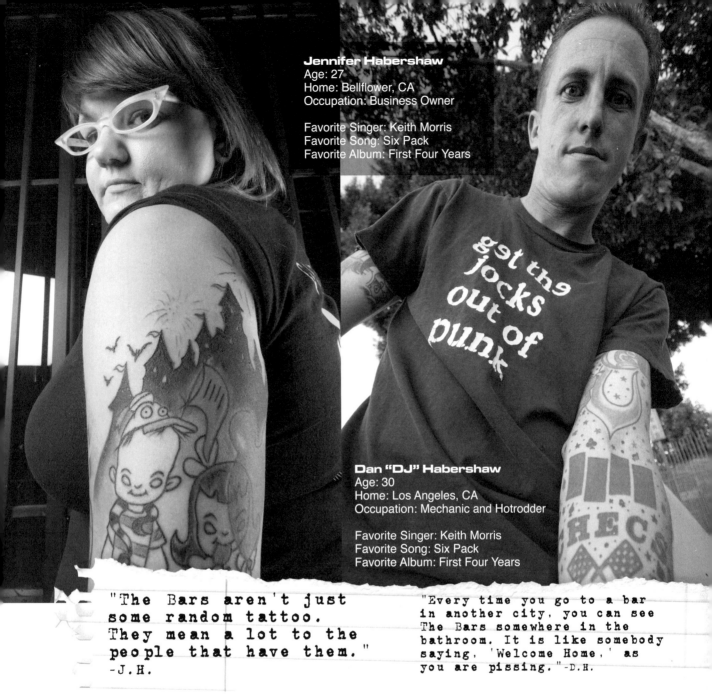

Jennifer Habershaw
Age: 27
Home: Bellflower, CA
Occupation: Business Owner

Favorite Singer: Keith Morris
Favorite Song: Six Pack
Favorite Album: First Four Years

Dan "DJ" Habershaw
Age: 30
Home: Los Angeles, CA
Occupation: Mechanic and Hotrodder

Favorite Singer: Keith Morris
Favorite Song: Six Pack
Favorite Album: First Four Years

"The Bars aren't just some random tattoo. They mean a lot to the people that have them." -J.H.

"Every time you go to a bar in another city, you can see The Bars somewhere in the bathroom. It is like somebody saying, 'Welcome Home,' as you are pissing."-D.H.

while watching *Decline*… back in 1984, I knew his distinctive voice from listening to the *Jealous Again* EP over and over again until the vinyl was nearly ruined. Supposedly, a guy named Chavo Pederast sang all of those great songs. For about fifteen years, I really believed that there was a Black Flag singer named Chavo Pederast until I heard a rumor, substantiated by the release of the *First Four Years* album, that Chavo and Ron were the same person.

Reyes decided to walk out in the middle of a Black Flag set in L.A., thus forcing the band to play an extended version of "Louie Louie" without a real singer. The audience took their turns at the microphone one after another. Reyes never returned to the stage that night, but he did return to the studio to finish the *Jealous Again* EP. Afterwards, Reyes disappeared forever from the annals of Punk Rock and will eternally be known as Chavo Pederast, even to diehard Black Flag fans, including me.

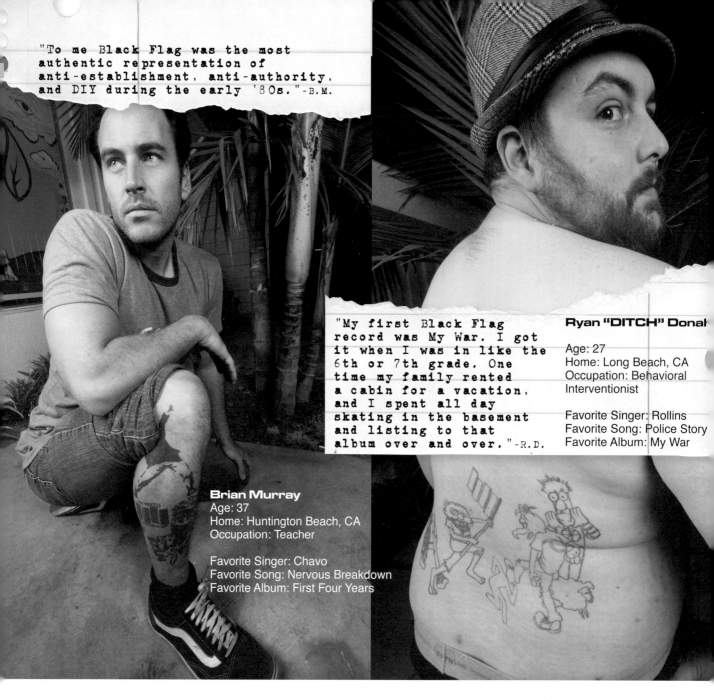

"To me Black Flag was the most
authentic representation of
anti-establishment, anti-authority,
and DIY during the early '80s."-B.M.

"My first Black Flag
record was My War. I got
it when I was in like the
6th or 7th grade. One
time my family rented
a cabin for a vacation,
and I spent all day
skating in the basement
and listing to that
album over and over."-R.D.

Ryan "DITCH" Donal

Age: 27
Home: Long Beach, CA
Occupation: Behavioral
Interventionist

Favorite Singer: Rollins
Favorite Song: Police Story
Favorite Album: My War

Brian Murray
Age: 37
Home: Huntington Beach, CA
Occupation: Teacher

Favorite Singer: Chavo
Favorite Song: Nervous Breakdown
Favorite Album: First Four Years

During the Henry Rollins years, their historic, youth-centered lyrical themes remained constant but later Black Flag songs were constructed around a more twisted internal anger, a self-hatred of sorts, that didn't make much sense to kids that were looking for the tools with which to dismantle the system. "Rise Above" became "My War," "Jealous Again" became "Slip It In," while "TV Party" morphed into "Annihilate This Week." It was a striking change that happened over a very short period of time. I hated what I was seeing and hearing, but I kept buying their records, though I don't remember why exactly.

Their collective persona changed dramatically too. Gone were the thrift-store-clad kids of the early 1980s. They were replaced by an image based on the shirtless, shoeless, longhaired, tight running shorts wearing, singing madman that resembled Charles Manson—Henry Rollins. No Punk Rocker I knew during these years wore tight running

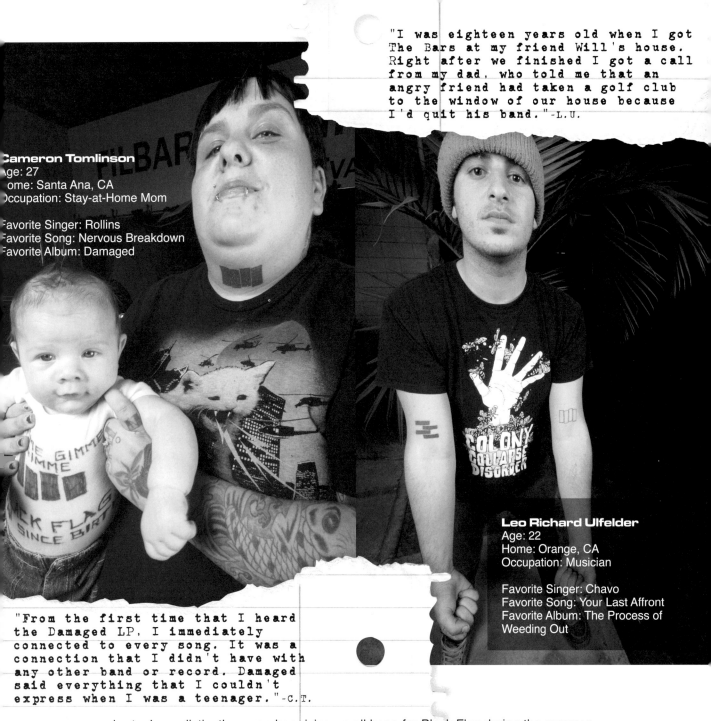

Cameron Tomlinson
Age: 27
Home: Santa Ana, CA
Occupation: Stay-at-Home Mom

Favorite Singer: Rollins
Favorite Song: Nervous Breakdown
Favorite Album: Damaged

Leo Richard Ulfelder
Age: 22
Home: Orange, CA
Occupation: Musician

Favorite Singer: Chavo
Favorite Song: Your Last Affront
Favorite Album: The Process of
Weeding Out

"From the first time that I heard
the Damaged LP, I immediately
connected to every song. It was a
connection that I didn't have with
any other band or record. Damaged
said everything that I couldn't
express when I was a teenager."-C.T.

shorts. I can distinctly remember giving up all hope for Black Flag during the summer of 1985 and vowing never to see them live, even if they came to my parents' house to play my very own birthday party. I was furious, and it seemed that everybody around me was furious too. Henry Rollins was our obvious target. We weren't alone. The Punk Rock media of the day was blasting this new aesthetic as an old, tired, and weak attempt at replicating Psychedelic Metal in the vein of Black Sabbath.

Everybody seemed confused by the suddenness and the direction of the change. At the time, Black Flag appeared to be in a downward spiral of self-sabotage or playing a cruel joke on the Punk establishment. Whatever the case, they kept on putting out records, touring incessantly, and as in the past, they simply did not care what the Punk Rock establishment thought; in retrospect, that idea was very, very Punk Rock.

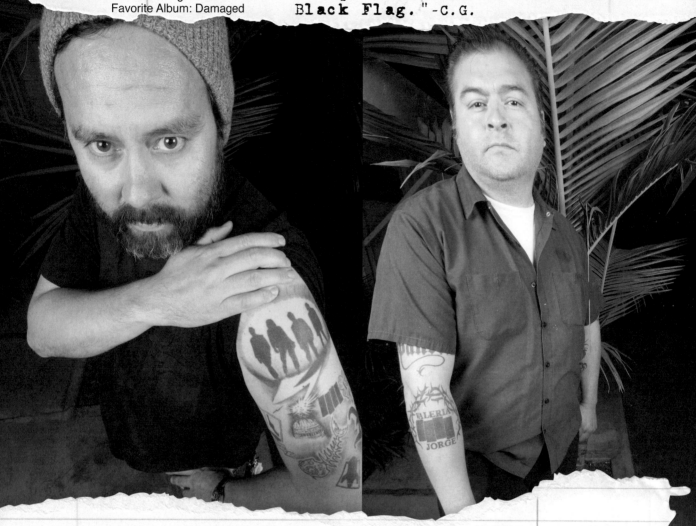

▼ **Chris Gronowski**
Age: 40
Home: Orange, CA
Occupation: Skate Shop Owner

Favorite Singer: Keith Morris
Favorite Song: Wasted
Favorite Album: Damaged

"At this point The Bars have become more symbolic of a mind state or of a movement. They are symbolic of a feeling rather than just a representation of the band Black Flag." -C.G.

"The Bars are something deep within my heart. The Bars are surrounded by thorns and my children's names, and that is so sacred to me. I grew up with Black Flag's music. It helped me to identify with the things all around me and the music still does today." -J.S.

▲ **Jorge "SPANTOS" Santos**
Age: 41
Home: East Los Angeles, CA
Occupation: HAZMAT Technician

Favorite Singer: Keith Morris
Favorite Song: Nervous Breakdown
Favorite Album: Everything Went Black

It is important to remember that Black Flag began playing in 1976. By the time of the change, they had been playing songs like "Nervous Breakdown" for almost eight years. The old songs were growing old and stale. In fact, the American Hardcore scene itself was getting a little old and stale. In a scene where bands generally lasted a year or two, Black Flag were Punk Rock's very old guard.

Many of my more adventurous friends continued to see them live long after I boycotted them. During this time, the show-going public defined Black Flag in the following way: There were the good years (defined by the singers Keith Morris, Ron Reyes, Dez

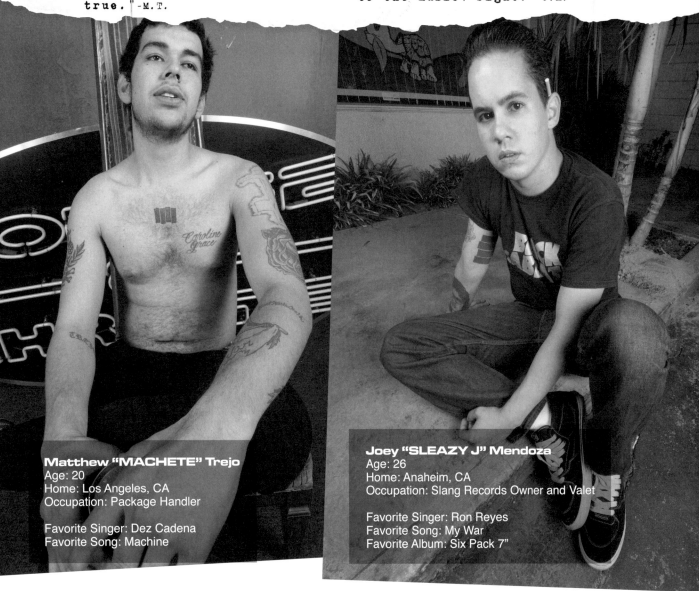

Matthew "MACHETE" Trejo
Age: 20
Home: Los Angeles, CA
Occupation: Package Handler

Favorite Singer: Dez Cadena
Favorite Song: Machine

Joey "SLEAZY J" Mendoza
Age: 26
Home: Anaheim, CA
Occupation: Slang Records Owner and Valet

Favorite Singer: Ron Reyes
Favorite Song: My War
Favorite Album: Six Pack 7"

Cadena, and early Henry Rollins) and the Rollins years (Henry Rollins post-*Damaged*).
The kids and the media were unduly harsh toward Rollins, and he made an easy target,
as if the ultimate scapegoat. After all, Black Flag was one of the very few remaining
threads connecting many us to the beginnings of the American Hardcore scene, and
those threads were fraying very fast. We were frightened of being cut loose. What would
we do without them?

To say Black Flag made bad music is a misstatement. As a fan, sure, the music became
almost unlistenable to me at the time. The songs were too long, the solos too extensive
and out of tune, and everything was just overly wanked-out. Yet, this direction change
was a bold step in the evolution of Black Flag. Always a step ahead of their harshest
critics, Black Flag were writing completely new and unexplored material much as they

"While the early years represent some of their most memorable music, their late-period music shaped a lot of bands…"

had done in the early years, even while outpacing and outgrowing their loyal fan-base. While the same motives and energy were at play, the audiences of the day remained disenchanted, and any criticism of the band's output was not generally favorable.

From the perspective of a kid growing up in the first wave of American Hardcore, I was surprised to discover just how important the later Black Flag material was to the evolution of the music world outside the Punk Rock scene. While the early years represent some of their most memorable music, their late-period music shaped a lot of bands, particularly those bands breaking from the strict conformity of the 1980s Punk Rock scene. Bands like Neurosis, Fu Manchu, or Kyuss owe much to Black Flag's later spirit. Black Flag's legacy, at least in terms of many popular contemporary music-makers, is weighted toward the post–*My War* output. They were blazing a new musical trail, just like in the early years, only this time it wasn't so well received by an established scene of thousands upon thousands of jaded and angry kids. They were rather unapologetic and did not tell us anything we wanted to hear in interviews. In fact, they were making fun of us for being closed-minded kids. Suddenly, Black Flag wasn't my friend anymore.

In 1986, Greg Ginn placed a call to Henry Rollins to say he was quitting the band. It was over. Like that, Black Flag unceremoniously ended. As I suspected at the time, they would never reunite. American Punks were cut loose, but somehow we survived. In fact, it came to me as a bit of a relief to hear they broke up, but I was nineteen years old and a bit confused. Did I make the wrong decision by boycotting their live shows? I had to live with it and move on with my Punk Rock life. In the aftermath, connecting with another band that spoke to me like Black Flag spoke to me just a few years before was difficult. I would eventually find the inspiration again, but in a far different scene, though no less amazing, from what I experienced back in the early 1980s. Black Flag's demise wasn't actually Punk Rock's demise.

And luckily for the world, they left their logo behind for me to ponder… ∎

"The lyrics to Fix Me just seemed to hit a chord in me that resonated. I could relate to what Keith Morris was saying. I wanted someone to fix my brain, take out the part that hurts and let the rest remain. Could it be that easy? The angst and heartfelt plea that he was singing those lyrics with fit my situation to the T. At the core of my issues I just wanted to be fixed. I wanted to be well so that I could be present for my daughter, not get side tracked by my hang-ups or emotional state so she could have the childhood and the father that she deserved."-C.M.

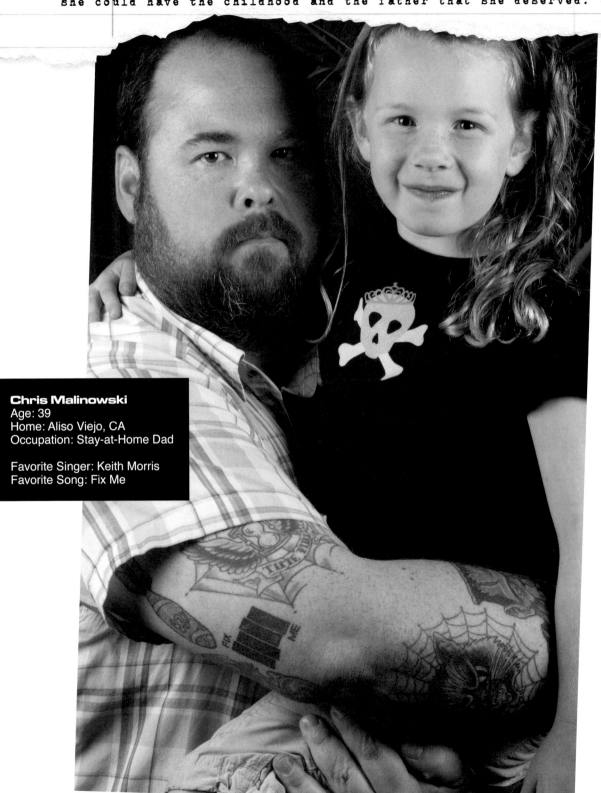

Chris Malinowski
Age: 39
Home: Aliso Viejo, CA
Occupation: Stay-at-Home Dad

Favorite Singer: Keith Morris
Favorite Song: Fix Me

INTERVIEW

I JUST WANTED TO PLAY MUSIC.

CHUCK DUKOWSKI

> **"Certainly, part of the ethos, to me, is that it is time to 'come forward,' time to 'act not dither.' It is like, 'No, Black Flag aren't hanging out and talking about it because this is an action movement.'"**

STARTING POINT:
A HOUSE FULL OF MUSIC

When I was really young, my parents listened to classical music. We would go to a lot of concerts and listen to a lot of records around the house. I was still pretty little, like in third or fourth grade maybe, when I became interested in music. At that time, it was mostly the 1950s rock, "rockin' around the clock" and "splish splashin'" kind of thing. Eventually, the Beatles came onto the scene and took over. Around sixth grade, I got more seriously interested in the Pop Music of the time, and I started buying every record that I could get my hands on.

I'd read my dad's *Time* magazine about the hippies. It all seemed pretty cool, and the music coverage had the Stones and all sorts of stuff from the 1960s. Eventually, I got into Zeppelin, Sabbath, the James Gang, Captain Beyond, the Allman Brothers, T-Rex, Alice Cooper, David Bowie, and Hawkwind. I would try to learn everything that I could about them. I'd follow the band members, in case they were doing something else, or if they were forming another band, I'd track that down.

Reading all of the rock magazines opened the door to different bands that came to town and performed. I would get curious. Finally, come 1969, I went to my first concert, which was Sly and the Family Stone and Mountain. That was a pretty epic concert, and both were great bands. I remember there was a riot, and the Shore Patrol shut it down. Everybody got pretty crazy and stormed out across Long Beach. … I knew I'd arrived.

SO, LET THE BASS RUMBLE

I just wanted to play music. I started on the drums, but my parents wouldn't let me have a drum set in the house, so I bought a bass. Early on, I played bass through my dad's stereo, and it sounded pretty good. I'd have my friends over to jam in the living room. My personal style started right away when I was playing through the stereo. I remember cranking it up. It would fuzz out and sound badass. I would lay down heavy and distorted lines, but I never really learned covers. I'd just play. If I met a guy who played drums, I'd go up to him and say, "Hey, you wanna jam?"

I put a band together for a while with my first drummer. That didn't go anywhere, but it was fun. We never played in front of anybody. Then we got with a friend of ours that had a really sweet set-up at his house—a garage converted to a bedroom, a big space separate from the rest of the house. We could party more there. I'd go over to his house and hang out, and he would let me play his bass, which is actually how I got started. Then I played his really nice Fender P-bass, and I ended up buying a bass from Montgomery Ward, which I reshaped, rebuilt, and made a new body for.

WÜRM HITS THE ROAD:
THE PRE–BLACK FLAG YEARS

My buddies and I were jamming in high school, and that turned into the band Würm, a band from 1973 until Black Flag formed in 1977. The guitar player, Ed, and I, were hell-bent to travel around and play music, but mostly just to travel. So, for the next couple of summers after high school was over, we bought a VW bus and traveled through Canada, the United States, and Mexico with this 12-volt amplifier, and we would jam through that. We realized we loved being on the road, we loved jamming, and we needed to tour somehow.

CHUCK

Before Black Flag, those guys were a group called Panic. During that time, Würm moved to Hermosa Beach into an abandoned beach restaurant/locker room/bath house/sauna that we called the Würm Hole. We set up a studio in the restaurant, and upstairs we knocked out some walls and some of the changing stalls, and we made it into an apartment. We lived up there.

The Würm Hole lasted a little bit longer than a few months. We met Keith Morris while we were there, and Keith introduced us to his band, Panic, and they were sans bass player. They came to the Würm Hole and hung out with us a fair amount, and Keith would come every day in the afternoon. We jammed every day all day long. Then we would jam in the evening, and sometimes all night. Usually, a lot of people would come over at night, and there would be parties and this ongoing program.

PANIC MORPHS INTO BLACK FLAG, AND I WAS ON BOARD

The restaurant had three big rooms, and Panic jammed with this other bass player from a band called the Street Kids. Street Kids had the first room, and Panic had the other room, and Würm had the biggest room: the room that we'd already developed. We had it all set up with a pressure lock at the main entrance, so if the police came, and if they made it through the first door, there would be another door. There would be no storming right in. We had it set up so that it was relatively secure. It would be hard to bust. And, it was also quiet.

All three bands got real tight. Sometimes Panic's bass player, Jim, would go off places with the Street Kids, and on those occasions, I would fill in with them, and eventually that stuck. Around that time, Ed became frustrated with Würm, and he decided to go to Chicago to be with his girlfriend, so we split up. The Panic thing became official, and about four or five months later, whenever it was, Panic became Black Flag. We all hung out together all of the time anyway, so we got along well. As a band, I think that we all wanted to make an impact in some way, shape, or form. At least I know that I was hell-bent!

DO IT YOURSELF MEDIA: THE PUNK METHODOLOGY

I was trained as a biopsychologist but decided to try and make my way with music and art. There was no roadmap; nobody is telling you how to do that kind of thing. I wanted to go on tour, and I wanted to push what we were doing forward. In college, I ran a concert promotion company and realized that to make a dent you really had to push hard. I saw local bands struggling before there was any kind of a scene, so I repeated the things that worked for me before, added other people's things to it, and I kept pushing forward. I wasn't messing around. I applied that same mindset to Black Flag.

After all of those years with Peter Frampton and other such trash, something was breaking loose. There was music that had more guts to it, had more meaning to it, and I felt like it was at least relevant to me. It was real "step into it" aggressive music with strong and powerful statements as well. It was coming from the heart. I thought that my own music and my direction were a little different from others, but then again, everybody is different. I wanted to push forward ideas and try and change the world for the better.

I watched how bands made a dent flyering. I tried to take the flyers to the people that we wanted to be at the shows, and they were people like me. I thought about myself in high school or junior high. If somebody would have posted a flyer on a pole outside of my school, I would have gone to the show. So, I made sure to do that. Greg and Keith were all doing the same thing in their own way, and at the same time bringing energy to it. I went around to the high schools and junior colleges, and even to some middle schools, and I put up the flyers. I didn't just go to the shows and hand out flyers because those people were already into it.

Raymond Pettibon circulated on the edge of the whole thing all of the time. He hung out with us and would be the guy sitting in the corner at the Würm Hole drawing on little scraps of paper. He was just part of it all. His art always spoke to me. I always felt that his art was really powerful. For the first

Black Flag flyer I made for the Moose Hall gig, I took a picture out of his *Captive Chains* book, and I just wrote the text while I was doing my laundry. I was like, "I have to do some flyers for this show," so I wrote it with a marking pen and Xeroxed it at the Post Office, or someplace nearby, then went and passed them out.

Once we really got going, we would make around five hundred of them. Two hundred and fifty to five hundred was a standard run. We were doing a show every week, so like on Tuesday I would go and make a flyer and take them up to Hollywood and plaster them up around the Whiskey, and then hit the record stores on the way back, and maybe do a stop here or there to drop some off or plaster them up on certain poles before we would head back home. In time, we got some momentum, and then we got more people to help us.

There were definitely flyers that I made for Black Flag shows that didn't include Raymond's art, but his art just always spoke to me. The art is powerful and it comes with a lot of the same edge as the music. By being consistent with the image, we gained an identifiable character with the association. I felt like there was a strong synergy both ways, you know? Ray got promoted with tens of thousands of flyers, even hundreds of thousands of flyers, and he enjoyed the synergy of the very visceral energy of rock bands. The powerful energy went both ways.

PETTIBON'S DARK VISION OF LOS ANGELES

Interestingly, Ray turned on the hippie era. He would work different themes, and when he got into the hippie era he picked Manson as the dark "anti-hippie" hippie. Manson was really an interloper in the later hippie scene during its dark cult-commune days, and Black Flag used that imagery for one flyer. I didn't really like that flyer, but I couldn't really help but think that it was challenging too. This was the flyer for our first show in a big aboveground venue, and it had this long hair on it. We made little buttons with the image too, and the venue didn't do anything. They didn't seem to care.

Ray contributed The Bars. It was representative of a flag, if you think of a flag flying, and then you digitize it, pixilate it, and then you get The Bars. Black Flag had the name and we were looking for a logo, and Ray contributed it. At the time, there was Black Flag, the ant and bug spray, and some people did use that logo [on some flyers], but it was a company's trademark. The Bars were our trademark. You know, the imagery Black Flag was using was sincere and earnest. Certainly, I was not just cynical. I wasn't just choosing these images just to get one over on somebody. It wasn't like Black Flag were trying to get popular so that we could sign a Nike shoe deal.

AGGRESSION AND ACTION—THE WAY OF BLACK FLAG

When I would hear a band and wanted to see them live, I would always look at the elements of what they were doing that I wanted to incorporate into what I was doing, and also the elements that I thought were missing, that I needed to add to it. The aggression and spontaneity of Iggy was like, "Whoa." Nobody that I'd ever heard before had brought that to the music, and that was striking. Iggy and The Stooges were confrontational. The Sex Pistols got up in people's grills. Part of the Punk Rock thing was to be confrontational, but not all of the bands did it. Certainly, part of the ethos, to me, is that it is time to "come forward," time to "act not dither." It is like, "No, Black Flag aren't hanging out and talking about it because this is an action movement."

I remember that The Masque was having a series of benefits, and the cops were busting in there and walking up and down the aisles beating kids up one after another and hauling them away, and this band was just dallying around on stage. They weren't playing. They weren't doing anything. And they were somehow trying to placate the police. "What the fuck," you know? So, something was missing, and that had a huge impact on me.

I remember very early on swearing to myself that if I was in the position where it was incumbent upon

CHUCK

me to stand up against the pigs, I wasn't going to back down because so often in my life performers had been on stage, and they'd been ask to stop, and they'd take the mic and say, "Well, we are trying to work it out, and they want to shut the show down," and they'd hem and haw. I was like, "No!" I wanted somebody to say, "Screw these guys. Screw the fucking pigs." So, every time that it came to me, I did.

I found it to be a challenge to come forward, but I felt that it was culturally what needed to happen, which is why it became an imperative. Action isn't always the best way to handle things, but certainly Black Flag had taken too much, and it was time to shake some things loose.

[In terms of recording] Black Flag had hoped to be on a record label, and when we realized that it wasn't going to work out, we had this meeting in the car where we decided to put out the first record, *Nervous Breakdown*, ourselves. Greg came up with the money and pressed some singles.

After that, it was all about selling the singles to the stores. We'd take some to Hollywood with us when we would go to do some flyering and stop by Tower Records and Zed and sell them some singles. Everywhere we'd go, we'd try to sell some singles. Usually, they'd take them on consignment, but we kept records of who we'd consigned them to. After I quit my job, I called them all back up and asked if they wanted more, and most of them did, so we would sell them some more.

Eventually, Greg hooked up with a distribution company, and we sold our records through distribution as well as selling them individually. Black Flag did another record, *Jealous Again*, about two years later, and that was formatted as a 12". That record was easier to sell.

FINDING FRIENDS IN LOW PLACES: BUILDING THE SST STABLE

The first bands Black Flag worked with were from the South Bay. We were promoting one of our first shows after a gig at the Santa Monica Civic Center, and we ran into the Minutemen guys. They were doing a show down in Pedro, and I am from Pedro, so I was like, "Whoa, there is a band in Pedro besides Titanic?" a big cover band that played the hall party dances and stuff. They were like, "Yeah, we're the Reactionaries," and Black Flag became friends with them. Mike would call up and talk to us all the time, and so a relationship formed there. SST did the single with the Minutemen.

The second band was Saccharine Trust that we sort of met through that Pedro connection. Joe Baiza was this short guy with straight up hair, and Jack Brewer had this Eraserhead look. They were so weird looking. I remember seeing them at a show and being like, "Whoa, it is you guys?" I was so tripped out by Joe's music and his playing, and by Jack's performance. They always spoke to me, so I was really into putting their records out.

The Stains came to see us play at Club 88. They took a bus here from East L.A. to see us play in Santa Monica, and they were cool. They were so into what we were doing, so they invited us to come hang out in East L.A. They'd fall apart and get back together in different forms for a good year. I remember that it was like 1980, and Media Art Studios was closing. SST had our eye on the Stains for a while. So, we bought some cheap studio time at Media Art. SST got them in there, and they were quite the crazy guys, but they were good.

BLACK FLAG DECIDES TO STAND UP AND BE COUNTED

By the time we put out The Stains record, I had quit my job. Greg was running the electronics company, and we were partners in this fledgling record label. I was working a job making pool tables, and I took money from my savings and invested it in the recording of our second record, *Jealous Again*. Black Flag wanted to tour, so I just quit my job.

I realized that if I was going to make a go of it, I better not sit on my hands. It was time to work. It was time to get something started and make it feed us, and we knew that it was going to be hard. We

already worked hard to get a groundswell going, with an eye on the future. Now, we were going to go on tour for the first time. When going on tour, you cannot keep your day job, so I felt like it was super-important. I decided to show up, work, and figure it out.

Those tours went fairly well, really. I got better and better at coordinating tours, and Black Flag played shows, made friends, and developed audiences. There was a little bit of a scene everywhere. I think that it shows people the spirit, to borrow from Rosie the Riveter, that "yes we can." Black Flag was trying to show people, "We're out there doing it, so you can do it also." That had a big impact on people and instilled a sense of unity. This was not the Internet age. People weren't as well connected on a national and international level. You had to make a telephone call, or you had to get the information through the media, which was not as ad-lib as it is on the computer. It was whatever somebody gave you. Though the magazines were probably the freest form of media, there was a fair amount of filtering.

Establishing networks back then was harder than now. It would be the same footwork, but it is much easier to navigate a world with a web search than it was to decide what to do in, say, Portland, back then. For instance, I heard of this place in Portland called the Long Goodbye. I would call people in Portland and ask them if they knew of this place. I worked off this list from the Dead Kennedys. Like Black Flag, the Dead Kennedys had been collecting information for a while. I had been collecting information from magazines and from my records from the different parts of the country. I would flip over the record and see where the band was from, and then I would give them a call or write a letter.

Other people did things, but I did work my butt off, and I did have a concept: I wanted to develop sustainable tour routes. Mostly what I wanted to do was what I did with Würm—travel and play music. That was the intrinsic side of it, which is what kept me going. Every step of the way was fun. I was doing exactly what I wanted to do the most

in my life, which would give me the opportunity to explore new towns. It was like, "Hmmm, I've never played Wichita, Kansas, let's go to Wichita," or, "What about Baltimore? Is there anything going on in Baltimore?" So you're talking in D.C. and you ask them, "Is there anything going on in Baltimore? Where else?" You ferret out all of the different places, and eventually you link together a bunch.

At first, I would set them up just a little too late, just a little too close to the actual dates, and would end up doing a lot of the booking while we were traveling instead of having it all set, or at least most of it set, before Black Flag went. Once you've done it, you can do a fair number of repeats. If you played a place once, usually the guy would book you again, unless of course he hates you, but Black Flag usually made friends with our promoters. They were helping us, you know? These were people who were also taking risks and doing something different, so I very rarely felt at odds with our promoters. People running the clubs and people doing the promoting were generally on our side, and it was obvious that they were on your side because they were doing the show.

Black Flag went up and down the West Coast a bunch. I wanted to branch east a little bit, so I booked shows for the Subhumans in Tucson and Phoenix. I traveled out there with them on those shows, and then I took Black Flag out there. We had a pretty well worn tour route up and down the coast, and then we started pushing east. Black Flag got a show from a guy in Chicago who wanted to have us play out there. He offered us $500 to play, so Black Flag booked the show, and then we booked a tour to go with it. That was $500, and that was an anchor gig because at most shows you are playing for points, a percentage of the door. Who could guess how much you were going to make in, say, Houston or wherever?

NOT BUYING THE NEW HARDCORE IDENTITY
I felt that when Black Flag first got going the L.A. scene had some really great bands in it. There

were X, the Plugz, the Germs, the Weirdos, the Chiefs, the Controllers, the Alley Cats, and more. There was so much good music in L.A., including smaller bands like Middle Class, Rhino 39… San Francisco had a great music scene too, with the Dead Kennedys, the Mutants, and Flipper, a really amazing band still very relevant today. Up the coast in Portland there were the Wipers and the Imperialist Pigs, and then up in Seattle there was Soldier and some other bands. Up in Vancouver, they had an amazing scene with DOA, the Subhumans, the Modernettes, the Pointed Sticks, and the Braineaters. Vancouver was one of the other great spots on the West Coast for music. In Phoenix, there were the Feederz . . . And I used to really love this band called the Surfers in Tucson. We played a lot of shows with them, and they went on to become Green On Red, I believe. We played with Minor Threat, Bad Brains, SSD, and the Freeze. In Austin, we played with the Dicks and the Big Boys, so, yeah, it was exciting.

Not all music is as good once you have a roadmap. All those early bands had very different styles. With a scene, the same challenges exist as in a reggae band or a blues band. You want to have a Hardcore band, and it just isn't that exciting, is it? The element of the unknown, your style, and the freedom and responsibility to bring something original are what is exciting both for the doer and consumer of the music. Ultimately, things run their course. They kind of get intellectualized. Certain people try to define it, and others try to live the definition that is ideologically, stylistically . . . way less interesting thing than inventing something.

That doesn't mean that all of the music sucks. It means that somebody invented this thing called Hardcore. We didn't invent Hardcore, but people put it around Black Flag, the Bad Brains, and a few other bands. Black Flag were making music. Art, ideas, and everything in life are living things, and you cannot pin them down, just like every person is different, and every art is as different as every person and every moment is new, so you cannot

look back because "you will turn to stone" as they say. You just have to keep on going forward. If people try to "relive," then whatever they are "doing" dies. It is like getting writer's block or something.

THAT WAS THEN, THIS IS NOW

After Black Flag, I kept doing what I was doing with SST. I liked working with musicians and people who were interested in music. I liked doing the tours, the people in the record business, plus I liked the bands. I always thought that it was important for me to have an interface with the bands. I don't have anything to do with the legacy. I made the music and that was my job; that was my business. I am happy that it has made an impact with people, and I feel more than comfortable.

I am not that different. I don't sit around and play the old songs. Occasionally, I play some of them, but I don't really even know how to play most of them anymore. I am mostly moving forward, just like I did in the very beginning. I sit down, or stand up, and I play my guitar, or my bass, and I jam out. I go, "That sounds cool," or, "That sounds badass." I make up some riffs and I play them for a while, and then I go, "This one is cool," and I bring it to some people to play with me and have a band… It is all the same.

Music and art and expression are really, really important to me, and I think that they are important to all people in some way, shape, or form. Nobody is the same, everybody is different, and people are specialists. So, I think recognizing the power of what you are and aligning yourself with it is important. Then you can have that power. To the degree that I've been successful, I've done that. To the degree that I've been less successful, I haven't done that, and that is my message. We can blow off "The Man" because ultimately the whole goal in the long run is to make what they say not matter.

I think that Black Flag was successful. Everything is done in small steps, but I think that there was an impact made, and it continues forward, really. ∎

SCENE NUMBER SEVEN

MY BARS, YOUR BARS, AND THE BARS

"The Bars are such an economical design: four offset rectangles, black in color."

THE BARS

The Bars are such an economical design: four offset rectangles, black in color. If you squint your eyes tightly enough, you might actually see a waving black flag take shape. While a totally fitting logo for Black Flag, the history of this symbol dates back to the era of sea-going pirates sailing under the black flag of no country.

The pirate flag, frequently adorned with various dancing skeletons holding tankards of ale and occasionally some aggressively stated Latin script, was at best just a way to scare the britches off sailors aboard ships about to be boarded and commandeered by a bunch of hairy, bearded, drunk men carrying daggers in their mouths. I don't know much about pirates, their lore, or their flags even, but these black flags flown by various pirates amount to a fantastic corollary for Punk Rock. Punk Rockers are the figurative descendents of Black Beard, Red Beard, and the like. Punk Rock, while not so radical as to commandeer ships and such, does seem to work from its own set of rules.

In my vision, though, pirates are more like the dirty bikers of the 1960s, '70s, and the '80s, of the Pagans and of Hell's Angels fame. If pirates, not counting those of modern day Somalia, were hanging about in the Caribbean or Mediterranean today, I suppose they would love their cheap American beers, their big guns, and would probably be listening to classic AC/DC, Iron Maiden, Molly Hatchet, and possibly even Merle Haggard and Willie Nelson. It would be a grand leap of faith to think that classic pirates would like Punk Rock in the least. In fact, they'd probably be more prone to kicking the shit out of a kid with a Mohawk than having Mohawks for themselves, unless they earned one on a drunken dare.

More recently, however, the black flag has represented anarchist political movements throughout a large chunk of the 19th, 20th, and 21st centuries. Whether you believe anarchy to be a run-amuck mass of riotous drunkards or an fully organized political

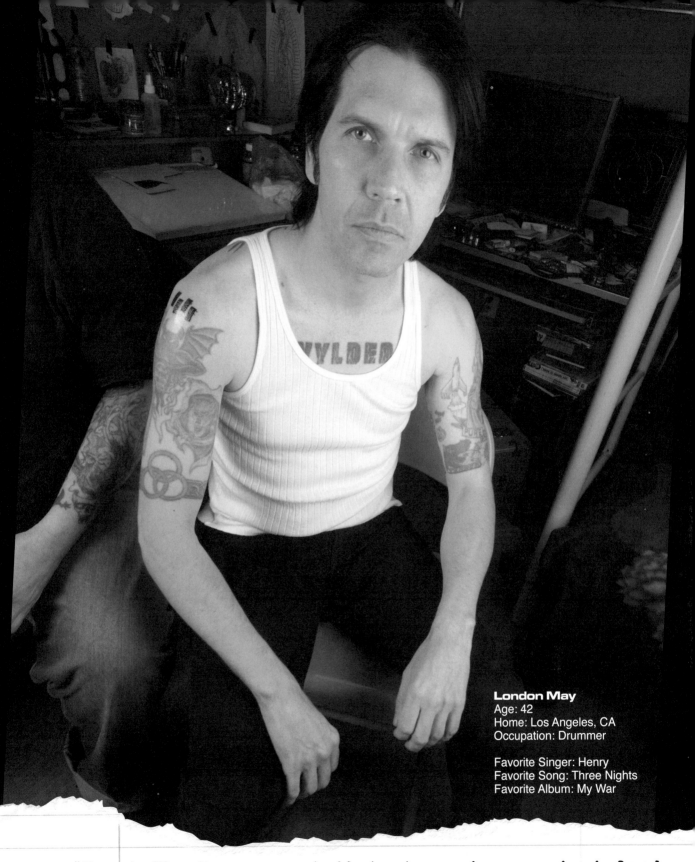

London May
Age: 42
Home: Los Angeles, CA
Occupation: Drummer

Favorite Singer: Henry
Favorite Song: Three Nights
Favorite Album: My War

"I got The Bars as a tribute to my heroes who helped guide my life and career for almost 30 years. Anyway, it's about fucking time that I got them, and to have Rick Spellman do them really means a lot to me."-L.M.

> "The Bars have definitely gone beyond the boundaries of Black Flag's musical style. I see them in a lot of different places. Other bands use them, and I've even seen them on TV shows and in movies." -J.G.

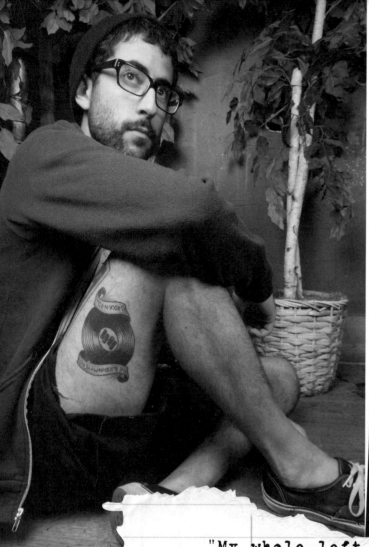

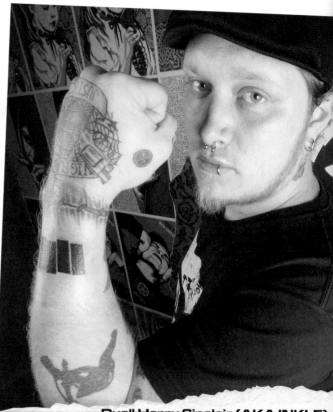

◄ Joe "CHUCHO" Gonzalez
Age: 28
Home: San Diego, CA
Occupation: Backstock for Retail Store

Favorite Singer: Henry
Favorite Song: Jealous Again
Favorite Album: Jealous Again

> "My whole left sleeve (tattoo) is dedicated to all of my musical influences, and Black Flag was a very BIG influence." -D.S.

Duell Harry Sinclair (AKA INKLE)
Age: 25
Home: Austin, TX
Occupation: Bouncer at Emo's Bar

Favorite Singer: Rollins
Favorite Song: Rise Above
Favorite Album: Damaged

entity that favors full consensus over representative decision-making, anarchy has always been a sort of rallying cry for Punk Rockers. At least for this one because it seems to include blind rebellion and massively complex political and social philosophies perfectly suited for my mind.

Dating back to the earliest chunks of the British Punk Rock, the circle-A was out in full force as a representative symbol for the movement. Hearing Johnny Rotten and his Sex Pistols proclaiming "Anarchy in the UK," one might envision hordes of crazed kids in leather jackets sporting insane haircuts, ripped jeans, bondage gear, and Doc Marten boots running through the streets of London and attacking every object that represented

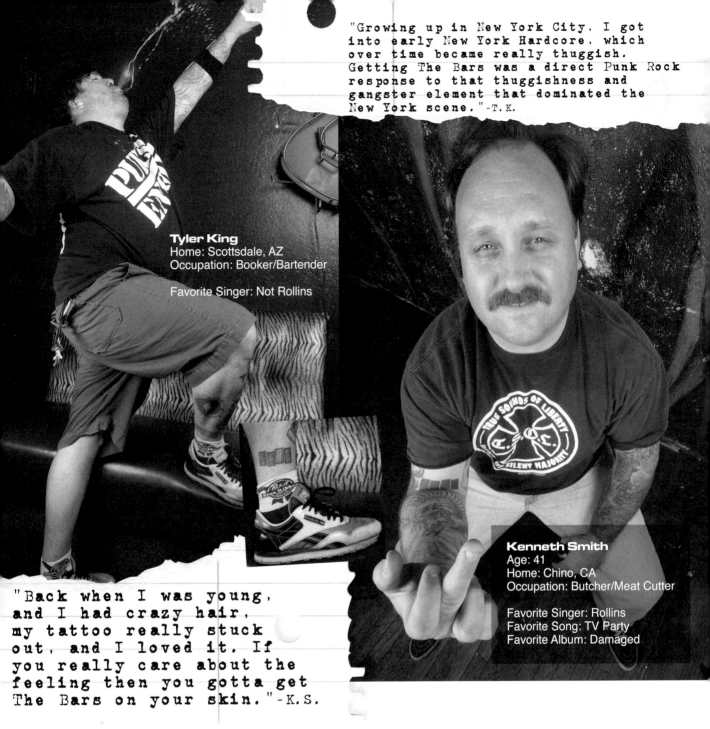

"Growing up in New York City, I got into early New York Hardcore, which over time became really thuggish. Getting The Bars was a direct Punk Rock response to that thuggishness and gangster element that dominated the New York scene." -T.K.

Tyler King
Home: Scottsdale, AZ
Occupation: Booker/Bartender

Favorite Singer: Not Rollins

"Back when I was young, and I had crazy hair, my tattoo really stuck out, and I loved it. If you really care about the feeling then you gotta get The Bars on your skin." -K.S.

Kenneth Smith
Age: 41
Home: Chino, CA
Occupation: Butcher/Meat Cutter

Favorite Singer: Rollins
Favorite Song: TV Party
Favorite Album: Damaged

the British Empire, finally settling into Parliament where they declare, in a sort of reckless abandon, Punk Rock rule of law for the new citizens of their Anarcho-Empire. However, I don't think that was ever the plan.

Anarchist ideology was too wild to be easily understood by such a historically conservative society. Not unlike early capitalist visions of Communists as baby-eating, nun-killing, and dog-kicking inhuman robots, anarchism carried the same connotations by people predisposed to following orders and traveling on a path easy on the eye and spirit. Anarchy is no such thing. It is way easier to reduce the word to a kind of "pure chaos" than to understand it. It is very simple to flip between the two modes and still come off sounding a bit like a Renaissance man—a bit tough and a bit philosophical.

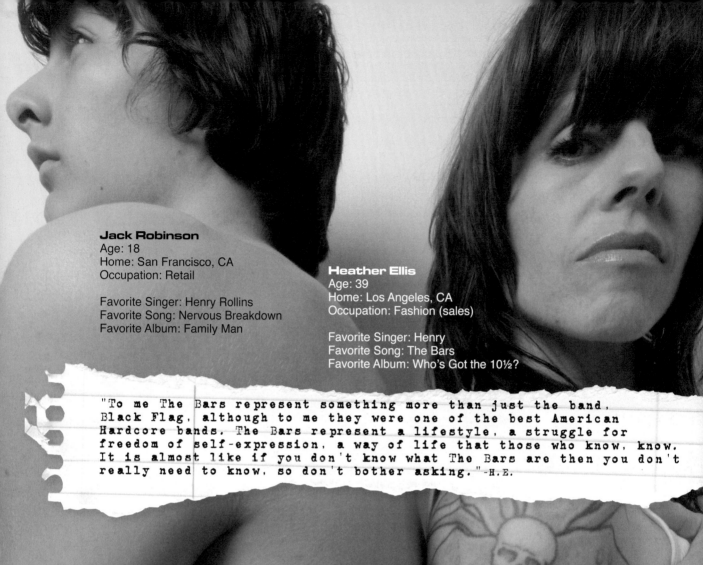

Jack Robinson
Age: 18
Home: San Francisco, CA
Occupation: Retail

Favorite Singer: Henry Rollins
Favorite Song: Nervous Breakdown
Favorite Album: Family Man

Heather Ellis
Age: 39
Home: Los Angeles, CA
Occupation: Fashion (sales)

Favorite Singer: Henry
Favorite Song: The Bars
Favorite Album: Who's Got the 10½?

"To me The Bars represent something more than just the band,
Black Flag, although to me they were one of the best American
Hardcore bands. The Bars represent a lifestyle, a struggle for
freedom of self-expression, a way of life that those who know, know.
It is almost like if you don't know what The Bars are then you don't
really need to know, so don't bother asking."-H.E.

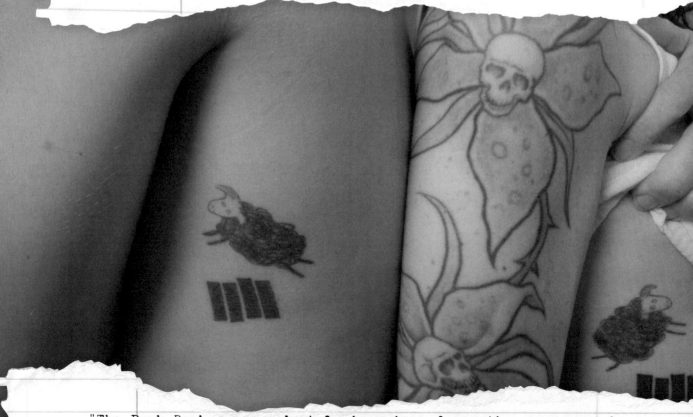

"The Punk Rock scene and style is unique from other scenes and
styles, and The Bars represent that to me. They also represent the
end of the line of the culture that Black Flag helped to create."-J.R.

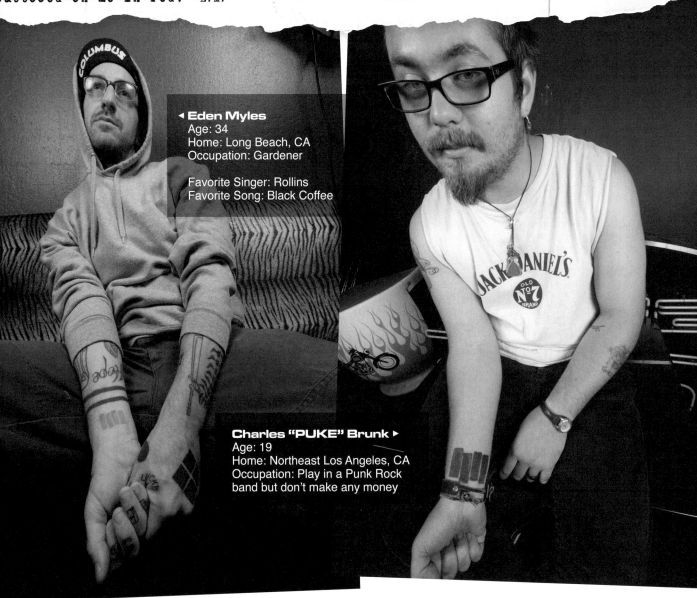

"Back in 2006 I was dating this girl. It was a 'rebound relationship,' and she had told her psychologist about me. He called me a 'red flag,' and I immediately thought Black Flag, and so I decided right then to get The Bars tattooed on me in red." -E.M.

"The Bars just remind me of the Punk Rock scene." -C.B.

◄ **Eden Myles**
Age: 34
Home: Long Beach, CA
Occupation: Gardener

Favorite Singer: Rollins
Favorite Song: Black Coffee

Charles "PUKE" Brunk ►
Age: 19
Home: Northeast Los Angeles, CA
Occupation: Play in a Punk Rock band but don't make any money

The logo of the waving black flag of anarchism is an amazing image for the American Punks, given that the Brit Punks were so damned obsessed with their circle A. Even if the Americans more or less invented Punk Rock, the Brits made it a loosely configured movement under the sturdy helmsman called Malcolm McLaren. He gave Punk Rock a solid public image and presumably aggressive credo, so when this genre was re-imported back to America, a few tweaks were in order, and Raymond Pettibon was up to the challenge.

As younger brother of Black Flag's founding member Greg Ginn, he masterminded the visual imagery of SST by throwing together The Bars when his brother's band, Panic, was being asked politely to give up the name since another band had been using it for a bit longer. As our non-pirate lore suggests, Pettibon suggested the band be renamed

Beth Demmon
Age: 24
Home: San Diego, CA
Occupation: Artist, Blogger, and unwilling 9-to-5'er

Favorite Singer: Dez
Favorite Song: Six Pack
Favorite Album: My War

"Black Flag is one of the bands that I can listen to anytime. I feel like I can return to them and listen to them for the rest of my life." -B.D.

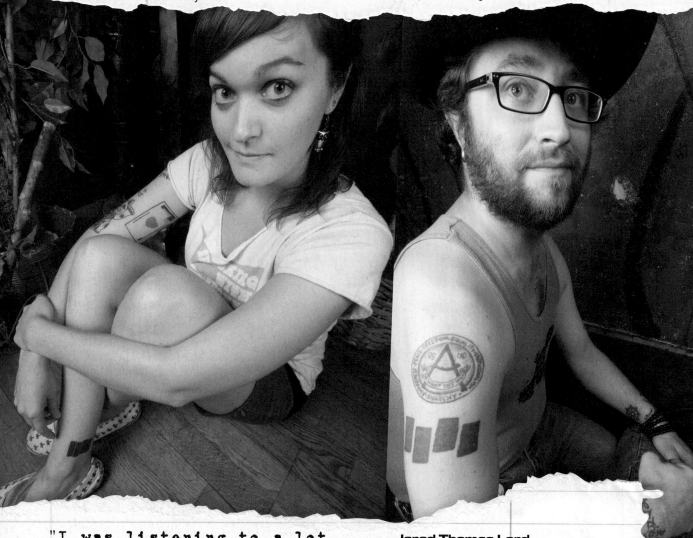

"I was listening to a lot of Black Flag, especially the My War album, during a really tough time in my life, and it was that band's music that got me through." -J.L.

Jared Thomas Lord
Age: 34
Home: Las Vegas, NV
Occupation: Cowpunk Musician

Favorite Singer: Dez
Favorite Song: American Waste
Favorite Album: First Four Years

Black Flag, since he already had a very good logo ready to go. Accordingly, the name stuck, and Panic pushed its new name, its aggressive brew of party-down music, and its tireless work ethic upon anybody lucky enough, or unlucky enough, to hear them.

About two years ago, in a series of events resembling a 1960s spy thriller, I conversed with Ben, an artist friend and Black Flag and Raymond Pettibon fan that DJed at a renowned bar in Philadelphia. I happened upon him on my way home for the evening while he was standing outside in a thoroughly sweat-soaked v-neck T-shirt. Suggesting that I was nearing the point where I'd be touring to take photographs for

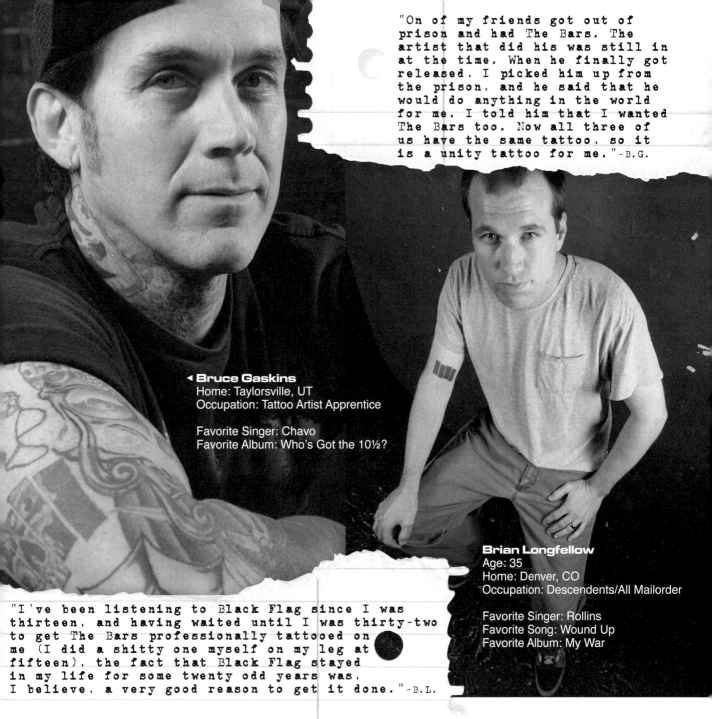

◀ **Bruce Gaskins**
Home: Taylorsville, UT
Occupation: Tattoo Artist Apprentice

Favorite Singer: Chavo
Favorite Album: Who's Got the 10½?

Brian Longfellow
Age: 35
Home: Denver, CO
Occupation: Descendents/All Mailorder

Favorite Singer: Rollins
Favorite Song: Wound Up
Favorite Album: My War

"I've been listening to Black Flag since I was
thirteen, and having waited until I was thirty-two
to get The Bars professionally tattooed on
me (I did a shitty one myself on my leg at
fifteen), the fact that Black Flag stayed
in my life for some twenty odd years was,
I believe, a very good reason to get it done."-B.L.

Barred for Life, Ben leaned, dulled his voice down to a bit of a whisper, and said, "You do
know that Raymond got the idea for The Bars from the cover of a book called *The Black
Flag of Anarchy*, right?" I had no idea this book existed, let alone inspired the image I
was pursuing all across the world. "What? Are you kidding me?" I uttered. The Bars were
a rip-off of some existing book cover, and I was spending all of this time, and all of my
money, I thought, trying to document this phenomenon as being totally unique? Well,
yes. Sort of…

Twenty minutes later, I was home and at the controls of my laptop, asking Google to
find me images associated with this hugely important book. Seconds later, in bold
red-and-black, I saw the book called *The Black Flag of Anarchy* and the origin of Black
Flag's logo laid out right there before me on its cover. Unlike Pettibon's icon, the image

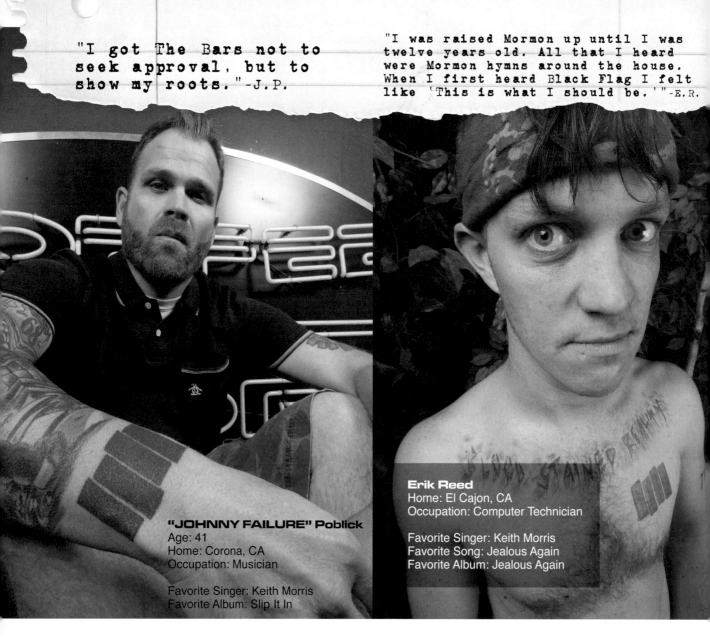

"JOHNNY FAILURE" Poblick
Age: 41
Home: Corona, CA
Occupation: Musician

Favorite Singer: Keith Morris
Favorite Album: Slip It In

Erik Reed
Home: El Cajon, CA
Occupation: Computer Technician

Favorite Singer: Keith Morris
Favorite Song: Jealous Again
Favorite Album: Jealous Again

on this book left little to the imagination. The waving black flag encompassed just two bars. Satisfied, I let out a huge sigh of relief. True, he was inspired by this classic text about anarchism, but he honed it down to simple rectangles, lost the pole, and made a logo that resembled this image but remained dissimilar to dissuade a copyright issue. I could, though, squint and see the inspiration. While not dead on, The Bars are a very literal translation of the image pictured on the book's cover. I might have actually liked Black Flag even more if Black Flag would have called themselves The Black Flag of Anarchy. Just think of the ruckus that would have caused to their public relations persona. It would have been instantly devastating.

Thanks to Pettibon's wacky take on things, everything was reduced down to base objects and a minimum of words, if my theory holds correct, though many urban myths abound in Punk Rock, especially regarding Black Flag.

At a time when bands were scrambling for the most offensive names and infamy-securing images, Black Flag became a supercharged band with a name

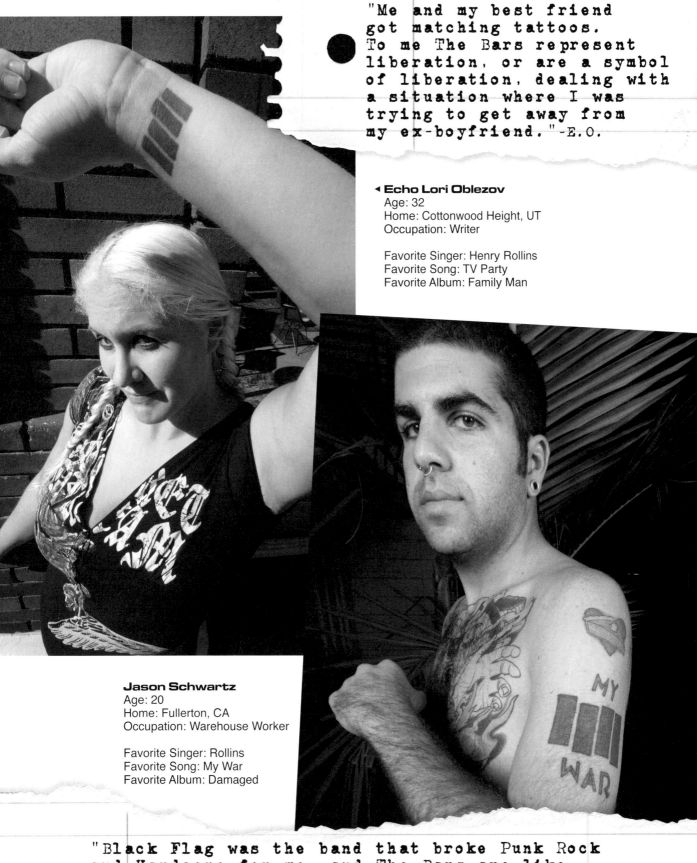

"Me and my best friend got matching tattoos. To me The Bars represent liberation, or are a symbol of liberation, dealing with a situation where I was trying to get away from my ex-boyfriend."-E.O.

◄ **Echo Lori Oblezov**
Age: 32
Home: Cottonwood Height, UT
Occupation: Writer

Favorite Singer: Henry Rollins
Favorite Song: TV Party
Favorite Album: Family Man

Jason Schwartz
Age: 20
Home: Fullerton, CA
Occupation: Warehouse Worker

Favorite Singer: Rollins
Favorite Song: My War
Favorite Album: Damaged

"Black Flag was the band that broke Punk Rock and Hardcore for me, and The Bars are like a rite of passage that show other Punks that you know the roots."-J.S.

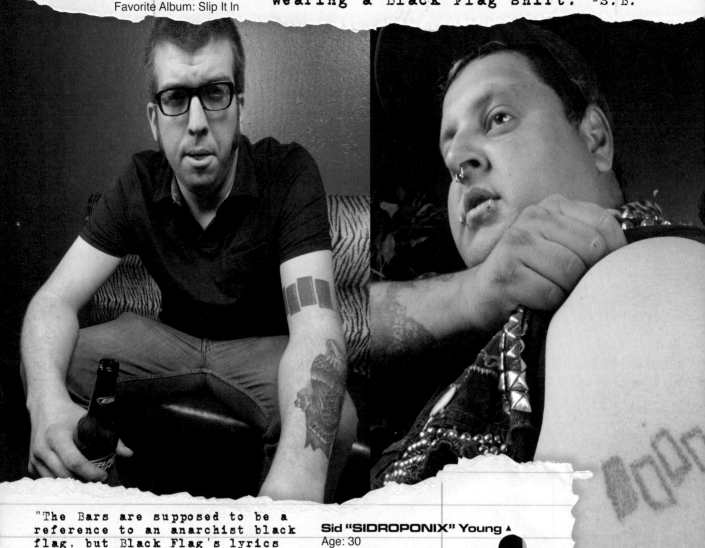

▼ **Sean Bailey**
Age: 30
Home: Tucson, AZ
Occupation: Mechanic

Favorite Singer: Rollins
Favorite Song: Depression
Favorite Album: Slip It In

"The first time that I saw The Bars was in the late '80s. I had an older sister that was into Metal and one of her friends came over to our house wearing a Black Flag shirt."-S.B.

"The Bars are supposed to be a reference to an anarchist black flag, but Black Flag's lyrics don't really have anything to do with that. More than that, I feel that they represent a certain attitude that holds to this day of 'Damn the Man,' or 'Fuck the Ruling Class, I want to do my own thing.'"-S.Y.

Sid "SIDROPONIX" Young ▲
Age: 30
Home: North Park, CA
Occupation: San Diego Pirate Punk

Favorite Singer: Chavo
Favorite Song: Depression
Favorite Album: First Four Years

depicting aggressively distributed chaos. I couldn't imagine there were more brutal visual symbols that could compete. Like Romulus defeated his brother Remus and took the reins of Rome, Black Flag overtook Panic, and they began grabbing the helm of West Coast American Punk Rock.

MY BARS

When I stepped out of my cozy little messed-up normal life in 1982, I began planting my feet in Punk Rock's soil. I embraced almost anything, visual or sonic, that pissed off as many people as humanly possible in the shortest amount of time. The sounds that were

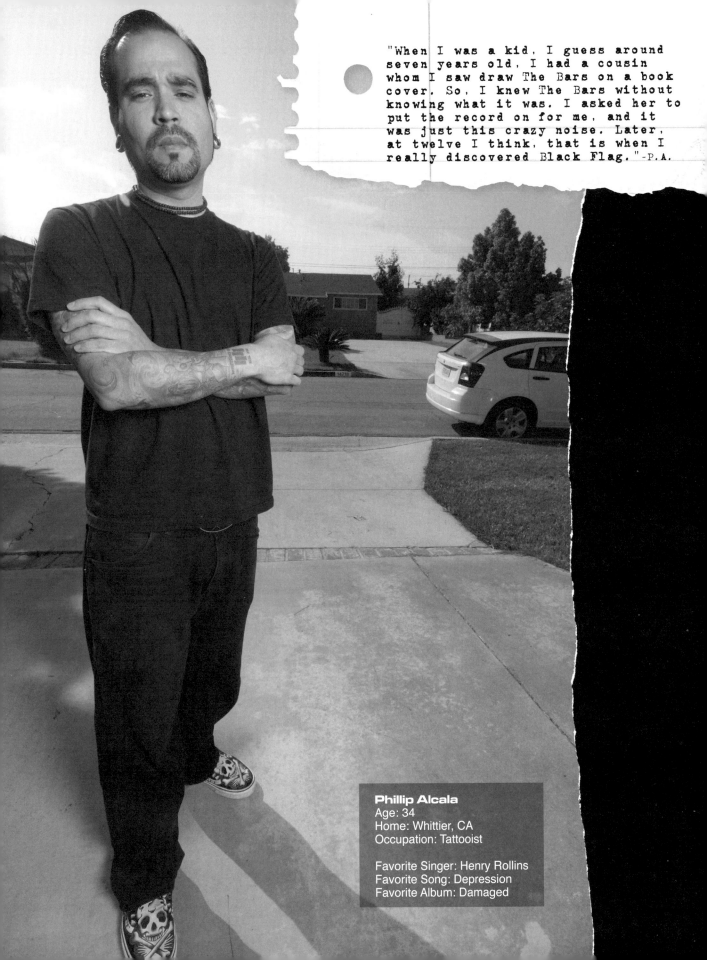

"When I was a kid, I guess around seven years old, I had a cousin whom I saw draw The Bars on a book cover. So, I knew The Bars without knowing what it was. I asked her to put the record on for me, and it was just this crazy noise. Later, at twelve I think, that is when I really discovered Black Flag."-P.A.

Phillip Alcala
Age: 34
Home: Whittier, CA
Occupation: Tattooist

Favorite Singer: Henry Rollins
Favorite Song: Depression
Favorite Album: Damaged

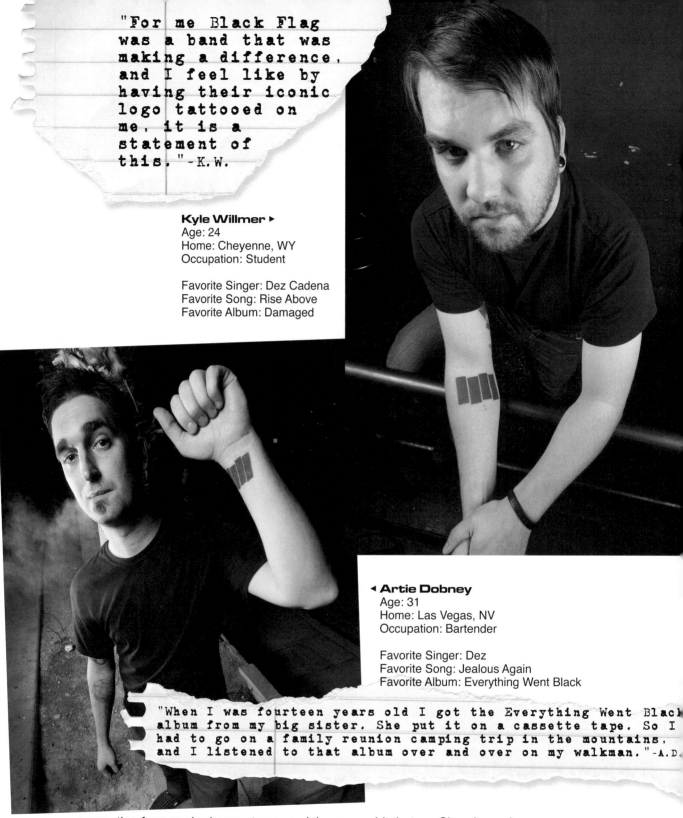

Kyle Willmer ▶
Age: 24
Home: Cheyenne, WY
Occupation: Student

Favorite Singer: Dez Cadena
Favorite Song: Rise Above
Favorite Album: Damaged

◀ Artie Dobney
Age: 31
Home: Las Vegas, NV
Occupation: Bartender

Favorite Singer: Dez
Favorite Song: Jealous Again
Favorite Album: Everything Went Black

"When I was fourteen years old I got the Everything Went Black
album from my big sister. She put it on a cassette tape. So I
had to go on a family reunion camping trip in the mountains,
and I listened to that album over and over on my walkman."-A.D.

emanating from my bedroom stereo, and the crazy shit that my Sharpie marker was imparting on almost everything that I wore, were enough to scare the crap out of my parents, my neighbors, my former friends, and random passersby. I was a six-foot-something, mohawked, visual explosive. Not that I was anything different than the group I joined, but to the unsuspecting small-town public, I appeared as though I lost my fucking mind. My parents were in agreement. To them, I had all together lost it.

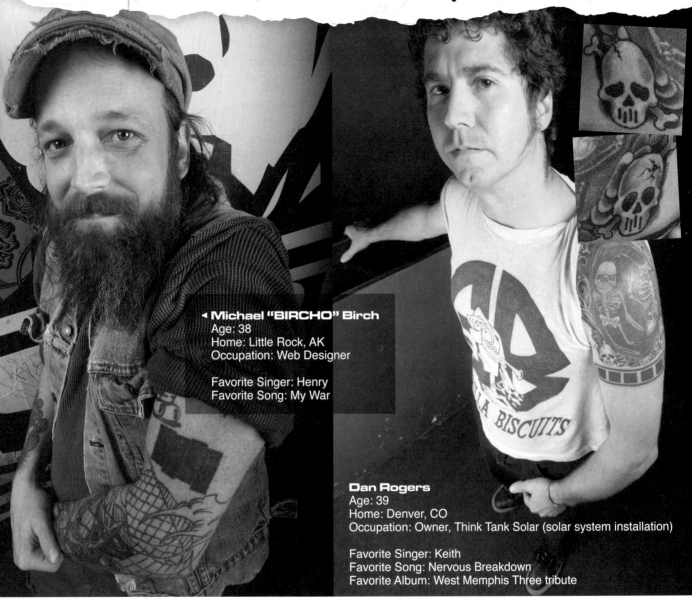

"My mother raised me. When I was fourteen, she married a very abusive man. Listening to Black Flag in my bedroom got me through every day of it. They were like a blanket that I could just pull over me. I've built my life on the music and message of Black Flag. Thank you, Black Flag."-M.B.

"The Bars represent an era: the time when I started to rebel against everything and began to find myself."-D.R.

◄ **Michael "BIRCHO" Birch**
Age: 38
Home: Little Rock, AK
Occupation: Web Designer

Favorite Singer: Henry
Favorite Song: My War

Dan Rogers
Age: 39
Home: Denver, CO
Occupation: Owner, Think Tank Solar (solar system installation)

Favorite Singer: Keith
Favorite Song: Nervous Breakdown
Favorite Album: West Memphis Three tribute

While words like "Sex Pistols," "The Clash," or even "Minor Threat" did cut to the heart of what people didn't understand about Punk Rock, The Bars were always much easier to draw. They looked more than a little bit like the number "four," if you were counting by fives in that scratch-number method most common on board games and games played where scores were tallied on the black board. When I tried to explain my little "four" to the public as anything but the count of "four," I'd get some really funny looks. At least at that level, if I was looking for a profound effect, The Bars were kind of a harmless visual.

If anything was going to get attention, SEX PISTOLS scrawled across the ass of my ripped Lee jeans was going to do it. Unfortunately, most Americans are not familiar with anarchism, its connection to the waving black flag, or its mysterious connection to the

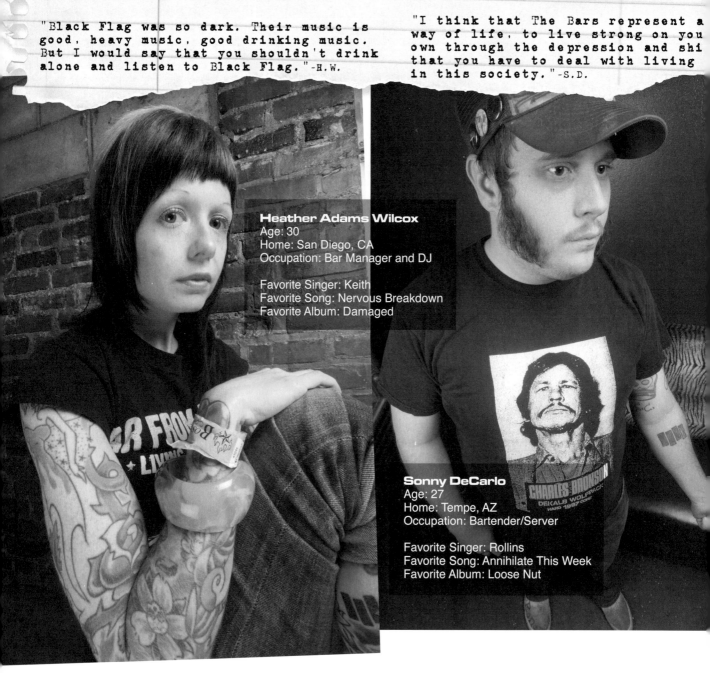

Heather Adams Wilcox
Age: 30
Home: San Diego, CA
Occupation: Bar Manager and DJ

Favorite Singer: Keith
Favorite Song: Nervous Breakdown
Favorite Album: Damaged

Sonny DeCarlo
Age: 27
Home: Tempe, AZ
Occupation: Bartender/Server

Favorite Singer: Rollins
Favorite Song: Annihilate This Week
Favorite Album: Loose Nut

number "four," so for a while I avoided trying to explain The Bars. It was just too complicated. After my long and frequently over-explained answer, I ended up looking more like a freakish philosopher than a member of a Punk Rock death squad. Long explanations do not scare people, I learned. They just make you look kind of smart and a little bit too deep for others' likings.

Among other Punk Rockers, though, The Bars were the venom. Between any two Punks passing by one another on the street, The Bars were instantly recognizable, and they conveyed a significant threat. Much like some bullyish Metal-head brandishing the pinky-and-forefinger horns, and in his/her deepest growl screaming "*Slayer*," The Bars had exactly the same effect between Punks back then, and even today. Had Black Flag been some wimpy-assed band, I just don't think that the effect would have been as solid, but Black Flag was down-and-dirty tough for that era of music. Very few bands, even bands in the scene, could touch the music that they were making.

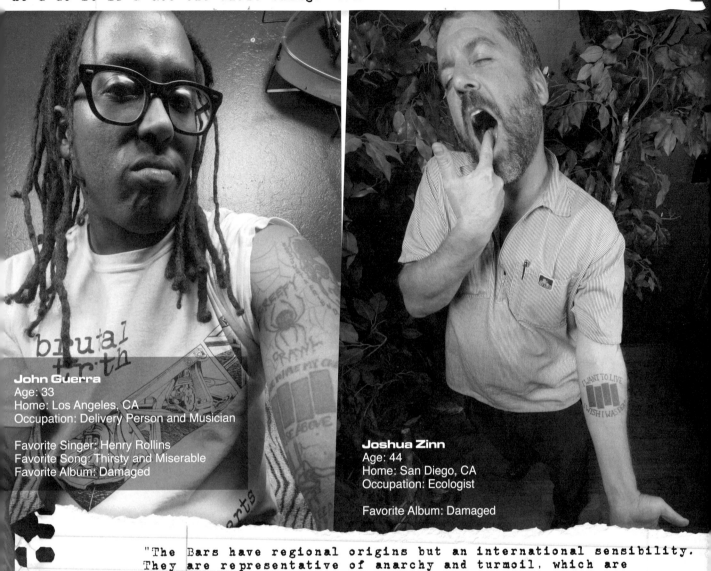

John Guerra
Age: 33
Home: Los Angeles, CA
Occupation: Delivery Person and Musician

Favorite Singer: Henry Rollins
Favorite Song: Thirsty and Miserable
Favorite Album: Damaged

Joshua Zinn
Age: 44
Home: San Diego, CA
Occupation: Ecologist

Favorite Album: Damaged

Sure, other bands helped create the mythos of the early years, but this one little symbol is the quintessential visual, like hieroglyphics speaking to Punks that know the code. In terms of my own tattoo of The Bars, I cannot imagine any other band symbol that I would want on me. No other band did so much to make Punk Rock a threat here as Black Flag. So, for me, this one single tattoo speaks volumes both to my own personal history and my history as a Punk Rocker living in this messed-up world. I've never regretted having it. By the time my Black Flag tattoo was inked into my skin, I had been around the Punk Rock scene for quite a few years. My true arrival in 1983 allotted me almost three full years to see Black Flag live before they would be condemned to death, but something happened.

My first Black Flag record happened to be the *Jealous Again* EP, with Ron Reyes, called Chavo Pederast on the cover, singing his little spleen out. Oddly enough, Reyes was hollering about being a "White Minority," when, technically, he was a Puerto Rican.

"I grew up in Portland, Oregon and participated in its very small Punk/New Wave scene circa 1979-1985. Like certain Portlanders of that era, I was profoundly influenced by a record store manager named Joe Carducci. Joe ran Renaissance Records, which at the time was the only place we could get independently-released vinyl. He didn't stay long in Portland, and went on to work at SST Records during its heyday, but Carducci's spirit, aesthetic, and attitude were like that first taste of alcohol to me and other impressionable Portland music kids. My Black Flag bars tattoo is as much, perhaps more, a tribute to Joe Carducci, his contributions to my life, and to what I perceive as the SST work ethic, as it is to the members and music of Black Flag."-T.S.

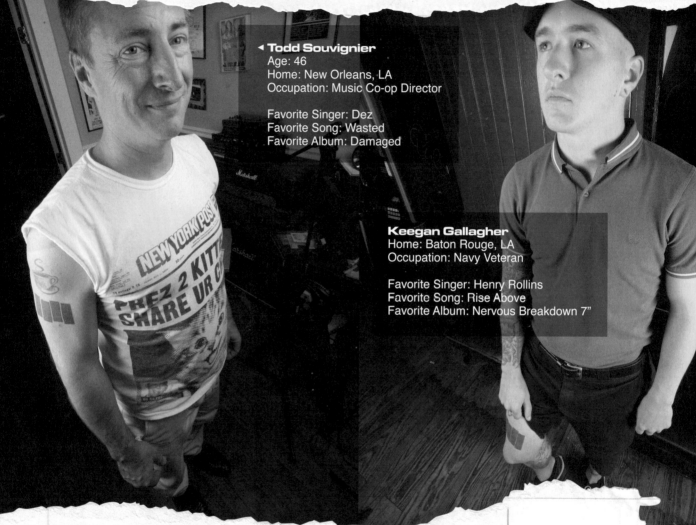

◄ **Todd Souvignier**
Age: 46
Home: New Orleans, LA
Occupation: Music Co-op Director

Favorite Singer: Dez
Favorite Song: Wasted
Favorite Album: Damaged

Keegan Gallagher
Home: Baton Rouge, LA
Occupation: Navy Veteran

Favorite Singer: Henry Rollins
Favorite Song: Rise Above
Favorite Album: Nervous Breakdown 7"

"Black Flag definitely was the biggest inspiration for me to get into Punk Rock, stay in Punk Rock, and play Punk Rock music."-K.G.

One's first Black Flag record usually determined a favorite singer. Reyes was the front man I've always associated with Black Flag since he sang my sorry ass to sleep many a depressing night as a teenager. Reyes was the voice of reason in my world gone mad. Luckily for me, in researching this book, I properly thanked him for his influence.

By my very first big Punk Rock show, I had amassed a smell gem of a collection of early releases by the Circle Jerks, Minor Threat, the Misfits, Social Distortion, Youth Brigade, and, of course, a thing or two by Black Flag. Then the bomb dropped. Not that I really knew anything at all about Black Flag's internal problems, but when *My War* dropped

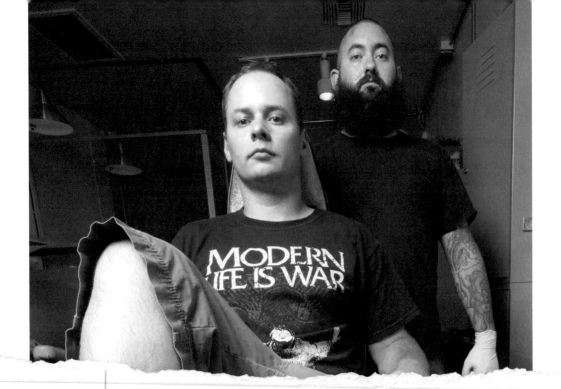

"The Bars are about courage, to be willing to take the hard route in life if that is what feels right to you, and to pave your own way in the world."-B.W.

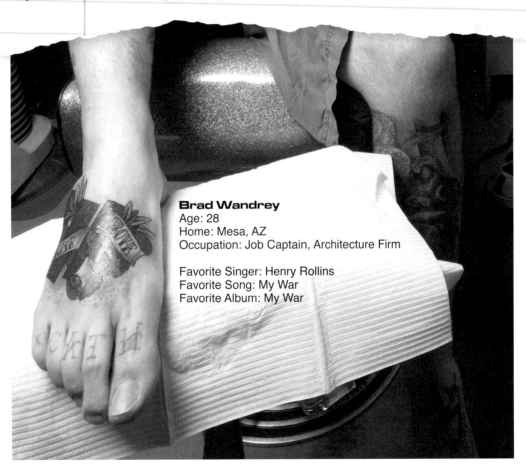

Brad Wandrey
Age: 28
Home: Mesa, AZ
Occupation: Job Captain, Architecture Firm

Favorite Singer: Henry Rollins
Favorite Song: My War
Favorite Album: My War

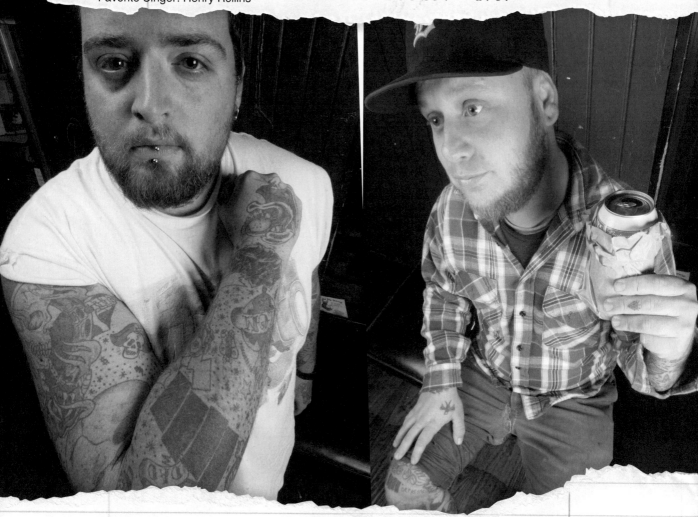

▼ **T.J. Coburn**
Age: 23
Home: Denham Spring, LA
Occupation: Sandwich Artist

Favorite Singer: Henry Rollins

"I got The Bars because of everything that they stand for: everything that Black Flag gave to the scene, to the whole Punk Rock scene, the whole Hardcore scene."-T.C.

"The Bars are the one tattoo that any person can get to show everybody that you are a Punk Rocker forever."-J.G.

Jeff Gerhart ▲
Age: 32
Home: New Orleans, LA
Occupation: Pizza Deliverer

Favorite Singer: Keith Morris
Favorite Song: Clocked In
Favorite Album: Everything Went Black

the band no longer featured Ron Reyes and his manic vocal assault. His singing spot had been taken over by Henry Rollins. I had no idea what was going on, even though I probably did hear *Damaged* tucked in there somewhere, so I wasn't at all prepared for what I was hearing. In fact, looking back, had I somehow gotten ahold of *Damaged*, Rollins's first trial as Black Flag's singer in residence, I probably wouldn't have been so upset, since *Damaged* kind of went on to be my favorite Black Flag release.

It was all so confusing to me. Black Flag with Reyes and these other guys named Greg, Chuck, and Robo morphed into Black Flag with Henry and these other guys named Greg, Dale, and Bill, yet the band didn't break up, change its name, or undergo drama

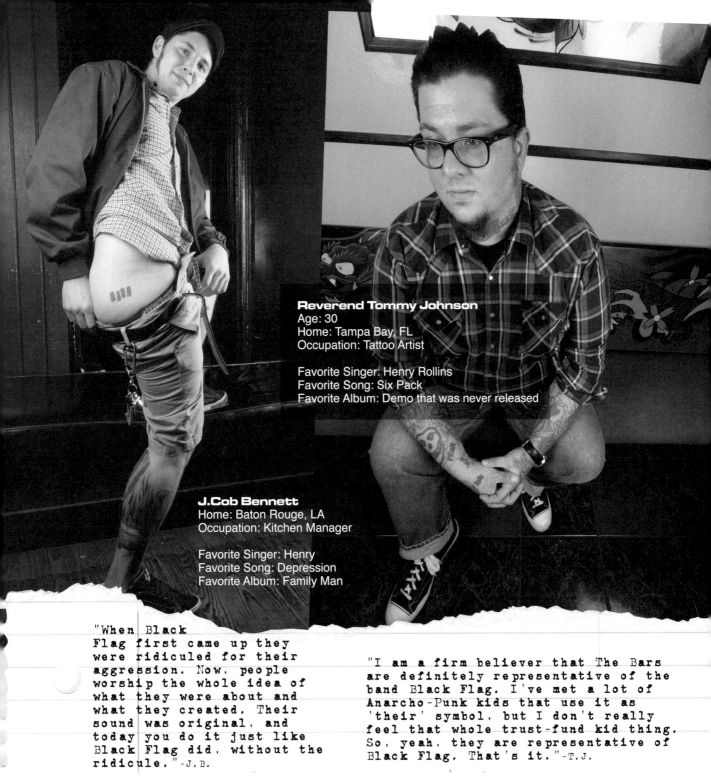

Reverend Tommy Johnson
Age: 30
Home: Tampa Bay, FL
Occupation: Tattoo Artist

Favorite Singer: Henry Rollins
Favorite Song: Six Pack
Favorite Album: Demo that was never released

J.Cob Bennett
Home: Baton Rouge, LA
Occupation: Kitchen Manager

Favorite Singer: Henry
Favorite Song: Depression
Favorite Album: Family Man

"When Black Flag first came up they were ridiculed for their aggression. Now, people worship the whole idea of what they were about and what they created. Their sound was original, and today you do it just like Black Flag did, without the ridicule." -J.B.

"I am a firm believer that The Bars are definitely representative of the band Black Flag. I've met a lot of Anarcho-Punk kids that use it as 'their' symbol, but I don't really feel that whole trust-fund kid thing. So, yeah, they are representative of Black Flag. That's it." -T.J.

consistent with massive line-up overhaul (thinking Aerosmith here). Instead, with this new line-up, only the music changed. That was all I could take at that very moment. Everything in my life was changing, and I wasn't cool with one of my favorite bands doing it too. I needed stability, and *My War* did not offer stability.

Where once I felt in unison with everything Ron was saying and eventually felt a total kinship to Henry screaming on *Damaged*, I didn't feel much of anything for *My War*. If I found Side A tolerable, I found Side B unlistenable. Because it was Black Flag, I would

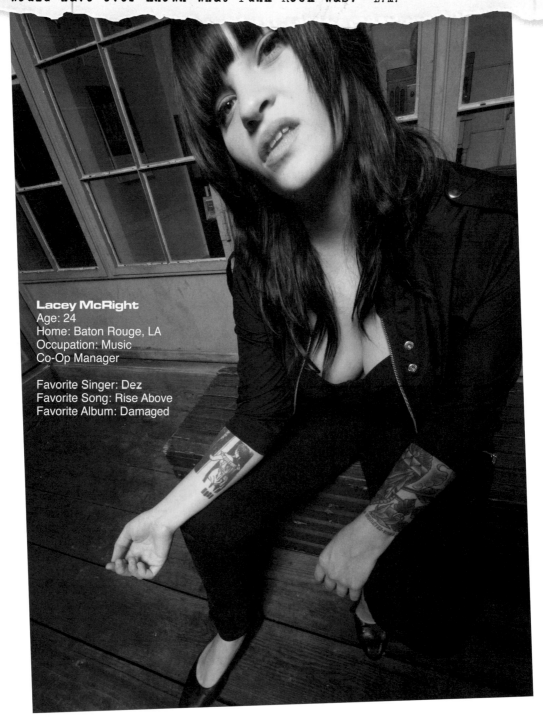

Lacey McRight
Age: 24
Home: Baton Rouge, LA
Occupation: Music
Co-Op Manager

Favorite Singer: Dez
Favorite Song: Rise Above
Favorite Album: Damaged

listen to Side A, and the title track made it on to a number of mixed tapes that I would make for my road trips and for my friends. However, nothing from Side B really made it onto anything at all. Black Flag was not helping matters much. Their songs formerly lashed out at authority, which I was kind of doing in my own way, but my love affair didn't weather their long songs of defeat and insecurity, total darkness and depression. Whereas the song "Depression" offered some hope in breaking free of depression's own grip on me, the song "Nothing Left Inside" had a feeling of giving up, no more

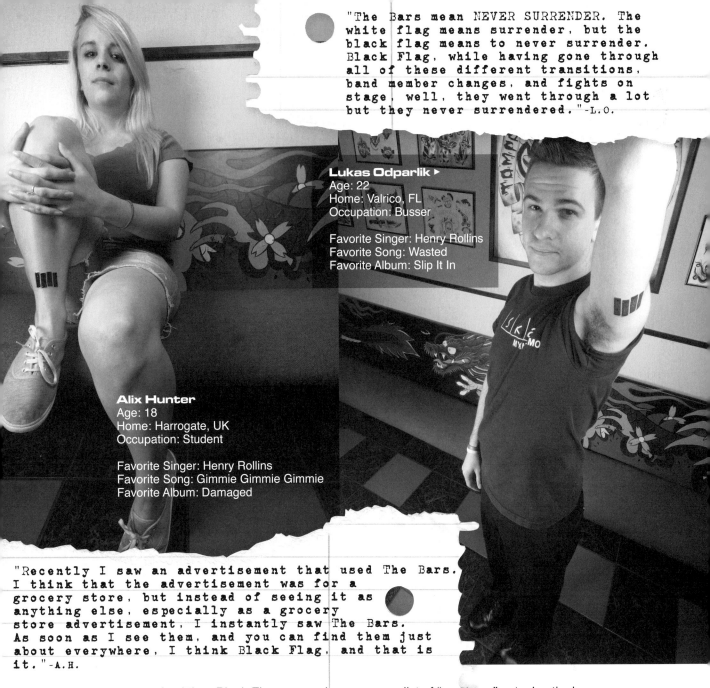

Lukas Odparlik ▶
Age: 22
Home: Valrico, FL
Occupation: Busser

Favorite Singer: Henry Rollins
Favorite Song: Wasted
Favorite Album: Slip It In

Alix Hunter
Age: 18
Home: Harrogate, UK
Occupation: Student

Favorite Singer: Henry Rollins
Favorite Song: Gimmie Gimmie Gimmie
Favorite Album: Damaged

energy, of quitting. Black Flag was no longer on my list of "must see" acts. I actively boycotted Black Flag and had a hard time listening to the old stuff for a while too.

The stark musical change wasn't the only thing keeping me disinterested in seeing the band. Reports from the Punk media and the grapevine fueled my fire. Stories of Black Flag touring with a posse of hard-to-listen-to SST bands and a monster sound system while denying local bands the chance to play with them made this Punk Rocker sour on this band appearing to outgrow the scene it helped to create. Upon exiting, Black Flag seemed to kick down the temple. I couldn't consider seeing this once amazing band if they were taking it upon themselves to mess things up so badly and turned its back on what I found so empowering. When I got into Punk Rock, I stopped giving my money to rock's idols and superstars, so why on earth was I going to give my money to a band that seemed to be aiming for rock's same goal? As a kid, I didn't really understand what I was seeing and hearing, but I was alert enough to know that I didn't like it.

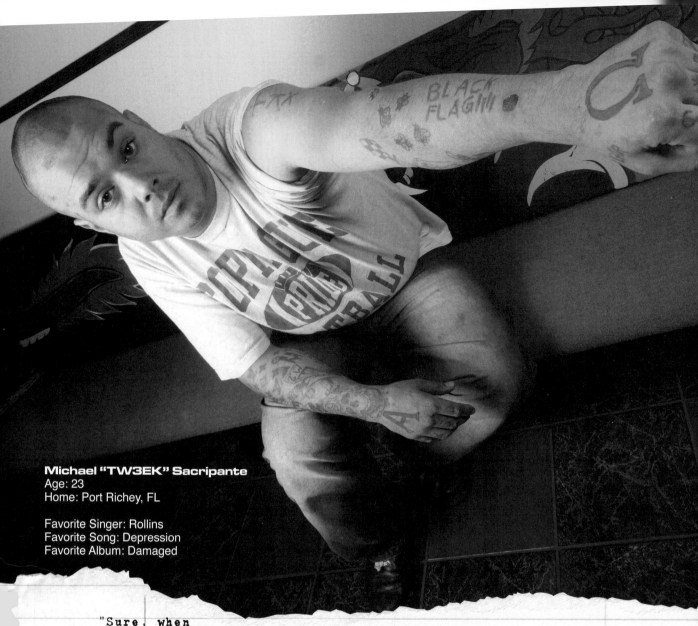

Michael "TW3EK" Sacripante
Age: 23
Home: Port Richey, FL

Favorite Singer: Rollins
Favorite Song: Depression
Favorite Album: Damaged

```
"Sure, when
I see The Bars I think 'Black Flag the band,' but I guess that they
also represent an entire movement of people that are not going to take
society's shit. They are not going to conform. They are going to do
what they want to do. They are part of a culture of people that stand
up for themselves."-M.S.
```

Figuring out that Black Flag was never going to be rock stars in the traditional sense of the title took me twenty years, but it only took me a few years following my boycott to feel the sting of regret, at least a little bit. By 1986, my first year in college, Black Flag broke up, and I never went to see them. At the time, I didn't give a damn, but a few years later I would start to give a small damn. Strangely, though, I don't regret the decision even today. My decision meant a lot to me back then, and I guess that after all these years I made the right one.

On my college radio show, I somehow figured out a way to only play what I'd considered "worthy" Black Flag songs, meaning those from Side A of *My War* and backwards. Occasionally, I would be told by the station manager to play something from *Slip It In* (which I later came to love), but I'd dismiss the tracks on-air and follow them with something from *Damaged*.

"People that know what The
Bars are, they just KNOW.
It doesn't matter what color
you are, what segment of
society you were born into,
if you have The Bars you
just get it. You greet each
other with a middle finger
rather than a hello."-J.B.

"Having the Black Flag Bars makes me
feel more connected to the scene I've
been into since I was nineteen. It's
kind of like a brotherhood, you know?
The Bars themselves represent a rich
history that shouldn't be lost. If
people stop caring about Punk Rock a
lot of groundbreaking cultural stuff
will all have been for nothing."-N.S.

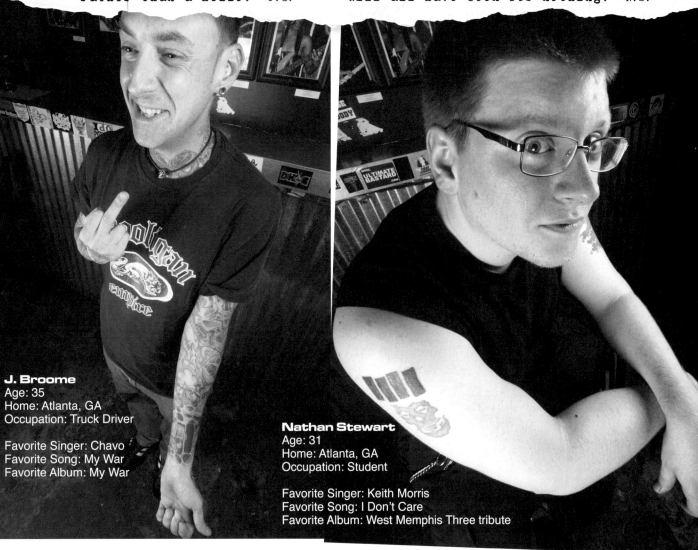

J. Broome
Age: 35
Home: Atlanta, GA
Occupation: Truck Driver

Favorite Singer: Chavo
Favorite Song: My War
Favorite Album: My War

Nathan Stewart
Age: 31
Home: Atlanta, GA
Occupation: Student

Favorite Singer: Keith Morris
Favorite Song: I Don't Care
Favorite Album: West Memphis Three tribute

Even though I thought I was taking the moral high road, I was passive aggressively getting in my two cents since the band that at one time fully charged my batteries decided to pull my plug. I felt deeply connected with Punk Rock in those days, but like most Hardcore Punks of the time, the bands, the shows, the ethic, and the movement defined us. The outside world was not a kind place to our tribe, and we found our place in the inner realm of Punk Rock culture. So, any attack against our music was an attack against the whole culture, and Black Flag seemed to cast the first stone. Ironically, in so many ways, the lyrics to *My War* tell the story of my own feelings towards the band that wrote and performed them. Even to this day, I chuckle at just how intensely I disliked Black Flag after that release.

By 1986, Black Flag had been reduced, in my eyes at least, to a handful of dismissible vinyl nuggets and exited the scene with very little fanfare. Even though I was kind of happy to see them go, I did feel a part of me die with them. In my Punk Rock life up to

Monika Iwanow
Age: 22
Home: Tampa, FL
Occupation: Student

Favorite Singer: Keith Morris
Favorite Song: My War
Favorite Album: My War

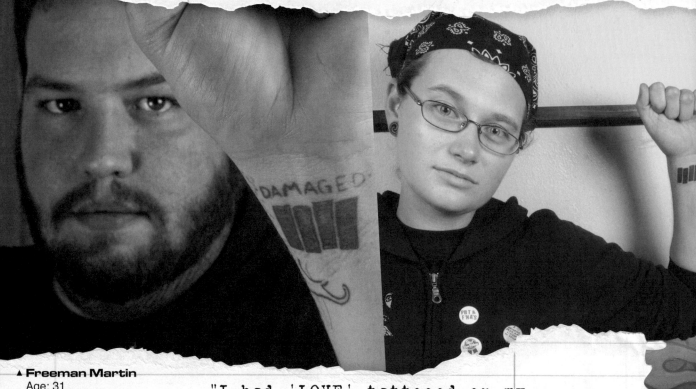

▲ **Freeman Martin**
Age: 31
Home: Richmond, VA
Occupation: Tattooist

Favorite Singer: Dez
Favorite Song: Depression
Favorite Album: First Four Years

that point, no other band left such a deep scar on me as they did. In my times of panic
and my times of insecurity, Black Flag spoke to me like the voice of a very big and a
very tough older brother. Sure, other bands helped ease the pain and the loneliness of
having stepped away from the mainstream on my own accord, but Black Flag was the
sound of a bodyguard. They were the band that made me feel that no matter how bad
things were, we were going to get through it together. In a small way, in 1986, I was
now once again on my own, though at first I had no idea Black Flag had decided to call
it quits. So, when I was doing my radio show, my little jabs and rabbit punches kept
rolling off my tongue like venom.

A few years later, I was attending a fairly large East Coast university and dating one of
the most influential Punk Rocker women I'd known in my life. I'd been a Punk Rocker
for about five or six years, and the scene I'd entered was all but gone. In its place there
were a lot of bands pieced together from older bands, like Dag Nasty and Fugazi, that
were both becoming East Coast favorites, but nothing really was striking a chord with
me like the music did when I first found my way into the culture. To make things worse,
I was hell-bent on finishing my degree and moving on in my life, so there was more
than just a small pang of depression lighting up inside of me.

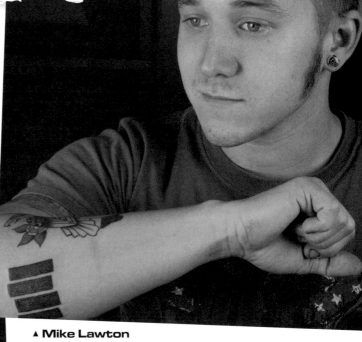

▲ **Mike Lawton**
Age: 21
Home: Palm Harbor, FL
Occupation: Welder/Fabricator

Favorite Singer: Henry Rollins
Favorite Song: Six Pack
Favorite Album: Damaged

▲ **Randy Kleinmernz**
Age: 21
Home: Tampa, FL
Occupation: Administrative Assistant

Favorite Singer: Keith Morris

"The first band I was in, when I was thirteen years old, was almost like a Black Flag worship band. We only had six songs, and three of them were Black Flag covers." -R. K.

I missed the early years, and I was feeling disconnected to a large degree from what was appearing on the culture's coming attractions, though I eventually embraced the new sounds with the same fervor of the early bands. I began revisiting my old records with increasing intensity, particularly interested in bands that seemed to lose their way simultaneously between the years of 1985 and 1986: Black Flag, SSD, DYS, Jerry's Kids, FU's, Circle Jerks, Agnostic Front, DRI, and so many others. While I wasn't exactly prone to being a nostalgic guy, I was curious, first, as to how these bands made it so far by playing basic three or four-chord thrash music and how they all chose to leap headfirst into a sort of dirge-like mix of Black Sabbath meets MC5 and AC/DC. I concluded that was the music those guys grew up on and dismissed when they became Punk Rock bands. They were doing what I was doing in 1988, so I made peace with the past. My girlfriend paid for me to get my Black Flag tattoo and that was my olive branch.

Driving to that shop with my copy of *My War* in my hands was suddenly empowering. While many of my close friends at the time (and who would not admit it now), teased

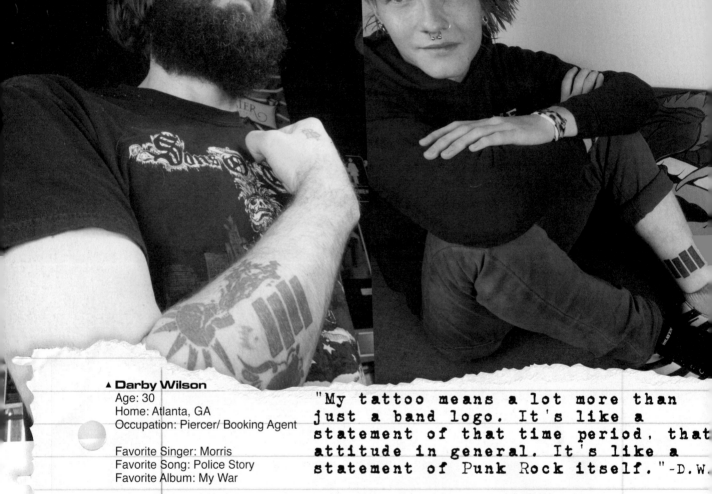

"Black Flag is more than just a band, they are an event. They helped create a whole DIY ethic that many bands still use. Ska bands, Metal, Hardcore, almost any band that isn't a huge corporate radio thing works with the ethic that Black Flag helped create." -J.B.

▼ Jullian Bowles
Age: 21
Home: Tampa, FL
Occupation: Fun-Haver (unemploye

Favorite Singer: Keith Morris
Favorite Song: Nervous Breakdown
Favorite Album: My War

▲ Darby Wilson
Age: 30
Home: Atlanta, GA
Occupation: Piercer/ Booking Agent

Favorite Singer: Morris
Favorite Song: Police Story
Favorite Album: My War

"My tattoo means a lot more than just a band logo. It's like a statement of that time period, that attitude in general. It's like a statement of Punk Rock itself." -D.W.

me about getting The Bars, or suggested that I get the words SOLD OUT somewhere in close proximity to The Bars. Eventually, they would make peace with the past and get them too. So, I was the only one in my crowd with the tattoo, and it would be that way for kind of a long time. The Bars were my way of saying I was unashamed to make a choice that others close to me back in high school thought was the greatest mistake of my life. The Bars were, and continue to be, a constant reminder that I chose the path least traveled, made it through, and successfully lived a life that only a handful ever really thought possible.

I am not going on record here to say that I lived the most awesome life ever. I am no Gandhi, or Elvis, or Chairman Mao, but given the path that was laid out before me in my tiny farm town in Pennsylvania, the steam provided to me by being part of the Punk

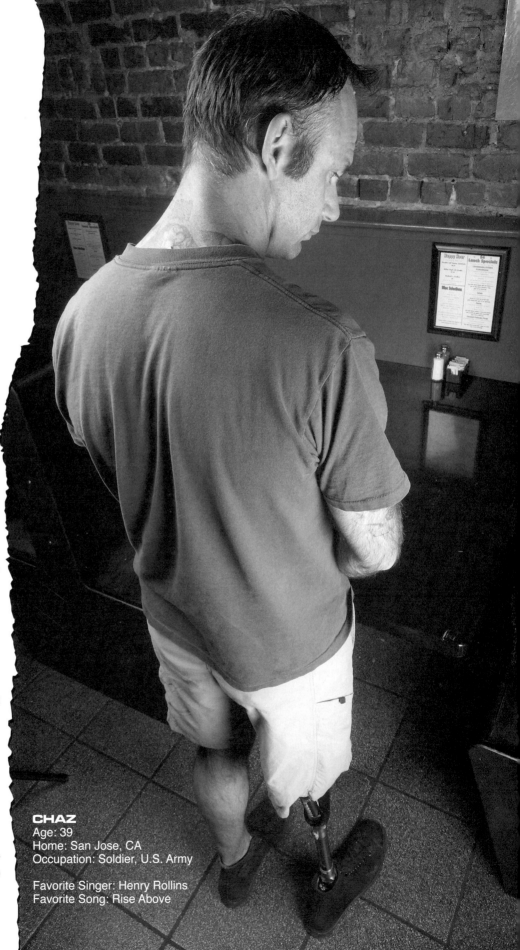

"I was a skateboarder since I could stand up. I pretty much wore Chuck Taylors since I was a little kid. I wanted The Bars most of my life, but I am from a military family. So when I told my dad that I wanted them he told me that if I got The Bars tattooed on my neck that I would be a target if/when I joined the Army. I joined the Army and got many tattoos over the years, but never The Bars. I got shot and lost my leg in Iraq in '05. My buddies told me that I died four times on the table before my condition stabilized. I was sent home after that.

At the beginning of my stay at Walter Reed Hospital in DC, the USO came to visit. It was all about timing. Henry Rollins was on that tour. It was odd to open my eyes after being in a coma for a while and, of all the people to be standing there, it was Henry Rollins. I told him where I was from, about when I'd seen Black Flag when I was seventeen, and about always wanting The Bars, and I think my story. He asked me now that I'd lost my leg what I wanted to do. I told him that I wanted to go back into combat with my buddies. He left the room and came back red-faced. I think that he was crying.

So, once I was out of the Army I decided to get the tattoo I'd been wanting to get all my life."-c.

CHAZ
Age: 39
Home: San Jose, CA
Occupation: Soldier, U.S. Army

Favorite Singer: Henry Rollins
Favorite Song: Rise Above

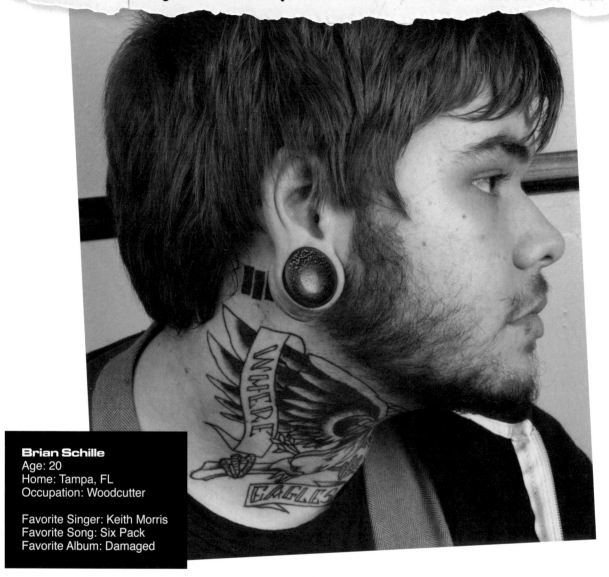

Brian Schille
Age: 20
Home: Tampa, FL
Occupation: Woodcutter

Favorite Singer: Keith Morris
Favorite Song: Six Pack
Favorite Album: Damaged

Rock culture redirected that path and gave it light and meaning. So, in retrospect, having The Bars permanently affixed on my skin is the least of what I can do to show my respect for my time served. Now that I am a scene drop-out, it is nice to reconnect with old-heads and new-heads alike. By displaying this little gem of a tattoo, I am never in need of company at a show. In fact, if I had a dime for every time I was called out while walking down the street by some other person with The Bars, or by somebody that can immediately identify with the image, you wouldn't have to pay for this book because I'd be rich enough to just give you a copy.

For a long time, I thought about my deep association with the Punk Rock underground and took it for granted. All of a sudden, one day an amazing alignment of strange and unforeseen circumstances placed me in a room with others of my tribe just as I was planning my own personal exit strategy, and *Barred for Life* was born as, more or less, a cruel joke regarding the overall poor quality of this tattoo on almost every person that has it.

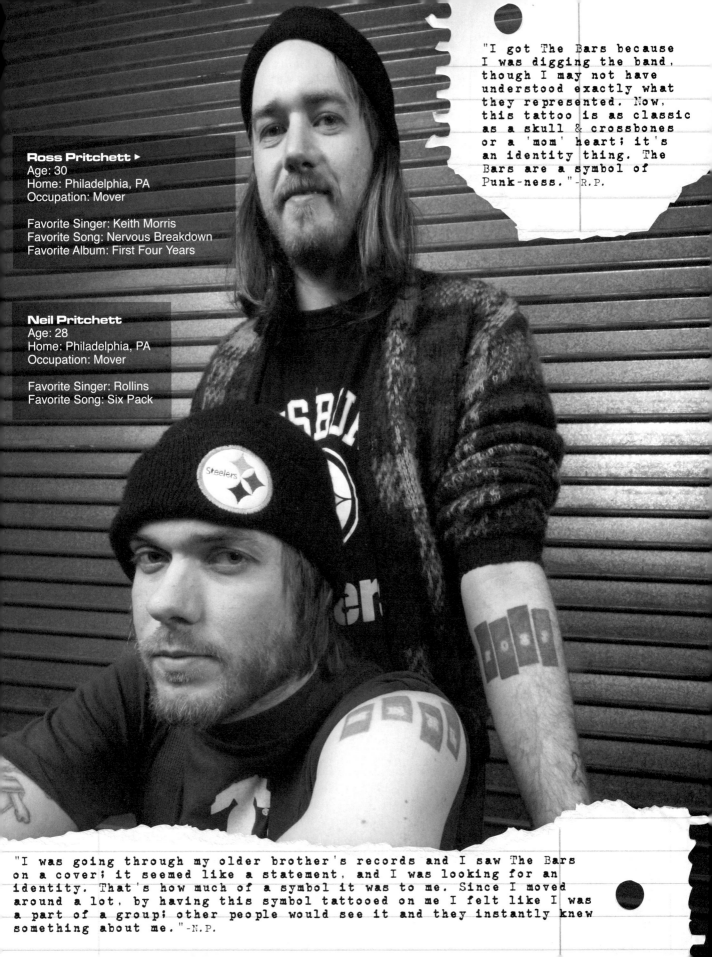

Ross Pritchett ▶
Age: 30
Home: Philadelphia, PA
Occupation: Mover

Favorite Singer: Keith Morris
Favorite Song: Nervous Breakdown
Favorite Album: First Four Years

Neil Pritchett
Age: 28
Home: Philadelphia, PA
Occupation: Mover

Favorite Singer: Rollins
Favorite Song: Six Pack

"I got The Bars because
I was digging the band,
though I may not have
understood exactly what
they represented. Now,
this tattoo is as classic
as a skull & crossbones
or a 'mom' heart; it's
an identity thing. The
Bars are a symbol of
Punk-ness."-R.P.

"I was going through my older brother's records and I saw The Bars
on a cover; it seemed like a statement, and I was looking for an
identity. That's how much of a symbol it was to me. Since I moved
around a lot, by having this symbol tattooed on me I felt like I was
a part of a group; other people would see it and they instantly knew
something about me."-N.P.

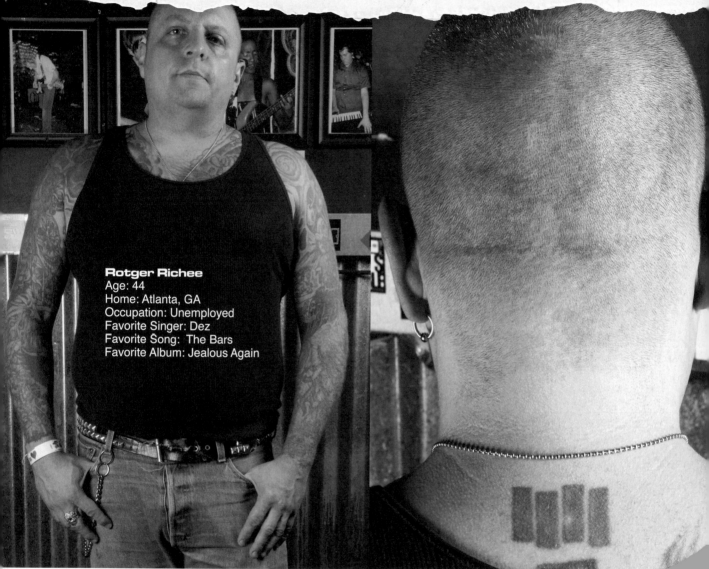

"Seeing Black Flag in 1983 in Atlanta changed my life forever. It's
why I'm still doing what I am doing, and why I am still here in the
Punk Rock scene. Early on I saw Kiss. From my seat they looked about
an inch tall. What a rip-off! My Black Flag experience showed me that
Rock 'n' Roll can be all in-your-face, and that totally changed my
life. Their music was about the emotions. Their music was therapy.
That's the thing I love about Punk Rock in general; it's the one
thing that WE have. It's OUR music. It's not the world's music." -R.R.

Rotger Richee
Age: 44
Home: Atlanta, GA
Occupation: Unemployed
Favorite Singer: Dez
Favorite Song: The Bars
Favorite Album: Jealous Again

YOUR BARS

For a *very* long time I was the only person, besides Henry, Dez, Kira, Bill, Chuck
Biscuits, and some other SST related names that I cannot remember, that I knew that
had The Bars tattooed on their skin, though I had heard reports that there were others.
Not that it really mattered, but at times I felt a sort of dread associated with having the
same tattoo as some other person.

Imagine being foolish enough to think that a piece of flash art hanging in your local
tattoo studio was somehow going to be unique in the world only to find out millions of
people have the same likeness of Yosemite Sam standing there with guns-a-blazin',
saying, "back off!" just like you might see on the mud flap of a monster truck. There is
that moment of dread when you might say, well, I was drunk, and it was a mistake and

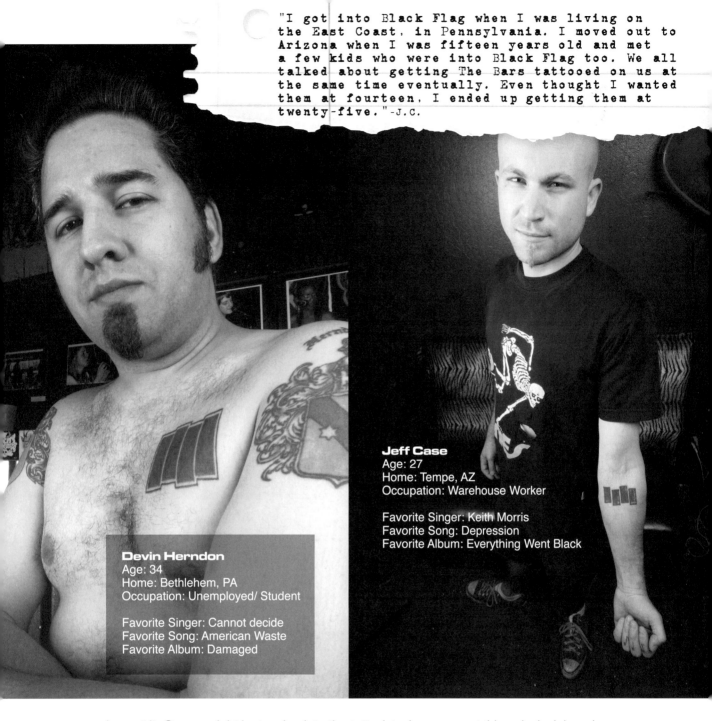

Devin Herndon
Age: 34
Home: Bethlehem, PA
Occupation: Unemployed/ Student

Favorite Singer: Cannot decide
Favorite Song: American Waste
Favorite Album: Damaged

Jeff Case
Age: 27
Home: Tempe, AZ
Occupation: Warehouse Worker

Favorite Singer: Keith Morris
Favorite Song: Depression
Favorite Album: Everything Went Black

lament it. Or you might just go back to the tattooist where you got this unlucky ink and ask him to ink these words below the tattoo, "Or I might just have to kill you like the last guy that laughed at me." I say, go for it.

One summer's day, I was driving home from my tattoo hinterland of Cincinnati, Ohio, where I spent a fair portion of my mid-twenties in graduate school. Having made friends with a well-respected tattooist named Mike Dorsey early in his career, we finally embarked on a huge chunk of my ribcage, of which I would drive the nine dreadful hours to be tattooed for three or four painful hours across some of the most sensitive tissue of the body, genitals notwithstanding, and then drive nine hours home again the next day. After this particular session of thick, rich, and black labyrinth-like outlines, I was off to stay at my friend's loft for the night before trekking back to Philadelphia.

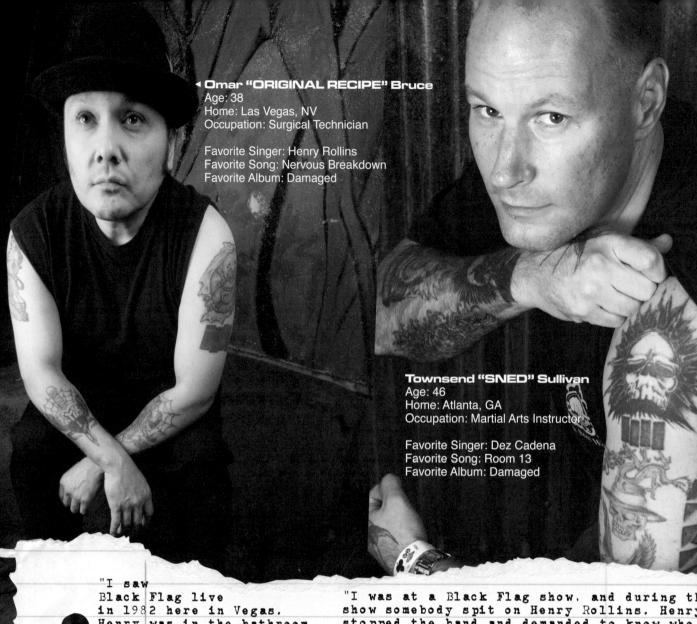

◄ Omar "ORIGINAL RECIPE" Bruce
Age: 38
Home: Las Vegas, NV
Occupation: Surgical Technician

Favorite Singer: Henry Rollins
Favorite Song: Nervous Breakdown
Favorite Album: Damaged

Townsend "SNED" Sullivan
Age: 46
Home: Atlanta, GA
Occupation: Martial Arts Instructor

Favorite Singer: Dez Cadena
Favorite Song: Room 13
Favorite Album: Damaged

"I saw
Black Flag live
in 1982 here in Vegas.
Henry was in the bathroom
just staring at the mirror
and pounding his chest,
getting entranced. Seeing
that as a kid was life-
changing." -O.B.

"I was at a Black Flag show, and during th
show somebody spit on Henry Rollins. Henry
stopped the band and demanded to know who
spit on him, saying, 'I am going to beat u
whoever spit on me after the show.' He tal
ed a lot of shit. After the show me and my
friend waited for him. He backed down—sai
that the threats were all just part of the
stage act." -T.S.

Waking up the next day to gray skies, rain, and some raw, painful ribs, I bid my host goodbye and headed north on Route 71, a road tough enough to navigate on a good day, but painful to navigate with the flip-flopping of the windshield wipers, the pouring rain, and a sack of really raw tattooed ribs. About halfway to Columbus, I started to fall asleep at the wheel repeatedly, often to be awakened when a semi-truck would pass me, splash me with a waterfall's worth of water, and blow my little truck so far off the roadside that I would run over that series of little bumps that makes a noise like all of the tires were shredding beneath the vehicle simultaneously.

Too proud to pull over and go to sleep under an overpass, I chugged on to Westerville, an eastern suburb of Columbus, Ohio, at a snail's pace, and decided to camp out on

"A lot of people say, 'If you weren't there, you don't know.' But I don't think that's necessarily true. I was born in '87 and Black Flag were ancient history when I started going to shows. My friends didn't listen to them, so I had to I find them on my own. I know that they're as relevant to me, now, as they've ever been to anyone else in the past."-J.C.

Joe Carey ▶
Age: 22
Home: Philadelphia, PA
Occupation: Student

Favorite Singer: Henry Rollins
Favorite Song: American Waste
Favorite Album: Nervous Breakdown 7"

Mathew Aldinger
Age: 23
Home: Hanover, PA
Occupation: Pizza Delivery Guy

Favorite Singer: Dez
Favorite Song: American Waste
Favorite Album: First Four Years

"You can relate to everybody that has The Bars. It's kind of a universal thing. If you're in the know, you know what it means. The Bars bring people together. You could be anywhere. I'm in a band and we could be on tour and someone says, 'Oh, you got The Bars? Me too!'"-M.A.

one of my favorite couches in the Midwest, which happened to be in the waiting room of a tattoo shop called Thrill Vulture, owned by another old Punk Rocker named Naomi. At the time, her apprentice was a friend of mine from the East affectionately called KEEF.

After making a round of greetings and showing off my bloody scar tissues to "oohs" and "aahs," KEEF asked if I had come there to make good on my promise to super-size my Bars like I'd been threatening to do for a while. I laughed, winced with the pain associated with dragging a dry shirt over a fresh tattoo, and said no. Laughing, trying desperately not to call me a pussy, KEEF, busy with his own client, stopped his drill, hiked up his pant leg, and showed me The Bars that had recently been inked onto his thigh.

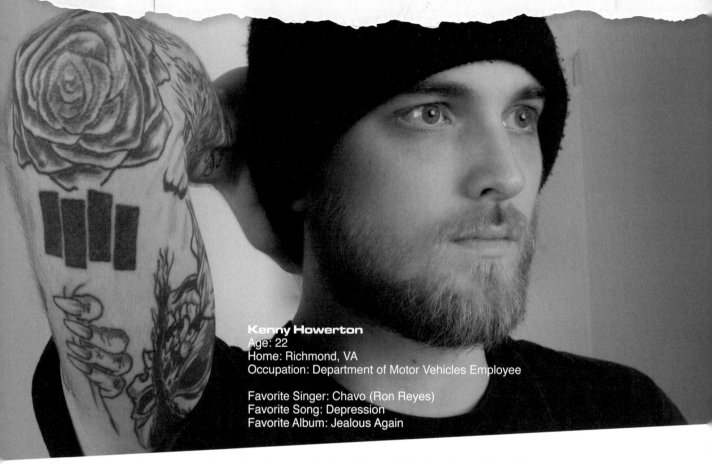

"When I see a tattoo of The Bars, of course I think of Black Flag. But I also know that that person probably felt the same as I did when I was growing up. You can just tell they're part of the Punk Rock culture. Black Flag were more than a band; they built an entire culture." -K.H.

Kenny Howerton
Age: 22
Home: Richmond, VA
Occupation: Department of Motor Vehicles Employee

Favorite Singer: Chavo (Ron Reyes)
Favorite Song: Depression
Favorite Album: Jealous Again

I was happy to no longer be the only fool, so Naomi hiked up her shirt to show me her Bars that came in the form of a blotchy, whited-out mass in an area generally regarded as "tramp stamp" territory: on her back just above her ass-crack, which can be seen mostly when bending over if you are wearing a shirt that is prone to riding up your back a bit. Usually, pieces here are wicked, say, like Celtic ropes or a bunch of hearts, or ironic sayings like "daddy's girl," but never (I know better now) The Bars.

So, now there were three of us, mine being the oldest, Naomi's being the gnarliest (an after-effect of nine months of stretching associated with carrying a child in her belly), and KEEF's was the only set really done professionally, sort of. We all rallied around the idea that no matter how well they are done, The Bars look poorly done almost immediately. The larger the bars, the more white blotches, blowout, or crooked line work. Honestly, after traveling halfway around the world to photograph people with this Punk Rock super tattoo, they all suck in their own little way: the tattoos all have blemishes almost as soon as they heal, which I think is pretty cool. If nothing else, no two sets of The Bars are the same, just like their owners.

Enter Matt Marsh. He entered the tattoo shop about an hour later. I don't remember why he was dropping by, but he wasn't there to be tattooed. Matt is a large dude and heavily tattooed. In his day, he would have been the guy that cleared the pit by sheer presence. Burly and obviously looking like an ass-kicking Punk Rocker, he was also gentle. No matter his disposition, upon entering the room, Naomi informed me, almost in a laugh, that Matt also had The Bars. Better yet, he had two sets of them tattooed on him.

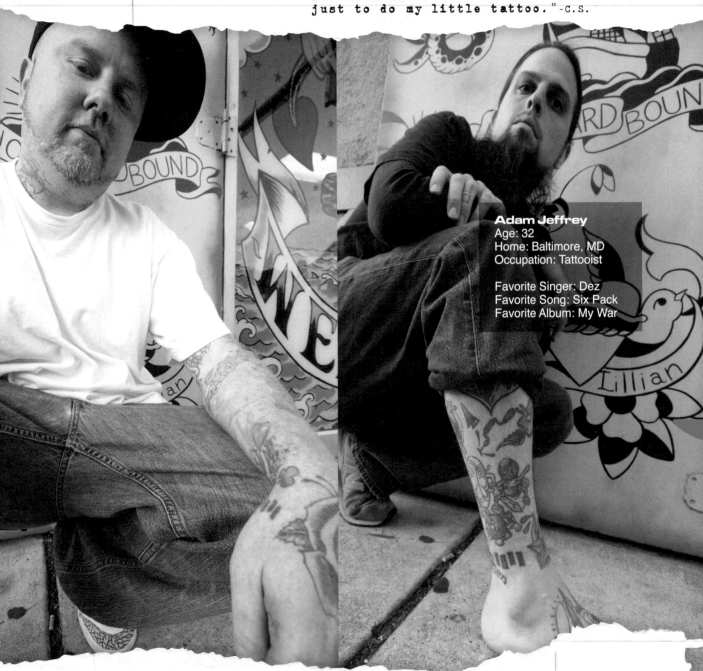

Christopher D. Smith
Age: 35
Home: College Park, MD
Occupation: Tattooist

Favorite Singer: Keith [Morris]
Favorite Album: Everything Went Black

"So I'd eaten four or five Xanax and I was listening to Black Flag. Somewhere in the haze I'd realized that I didn't have The Bars, and so I decided to get them the proper way. I made ink by hand and used a needle just like they do in jail. After I finished listening to Everything Went Black I listened to all my other Black Flag records, in order, while I was hand poking it. I think it took three or four records just to do my little tattoo."-c.s.

Adam Jeffrey
Age: 32
Home: Baltimore, MD
Occupation: Tattooist

Favorite Singer: Dez
Favorite Song: Six Pack
Favorite Album: My War

"I got my tattoo from Sean Brown (Dag Nasty, Swiz, Sweetbelly Freakdown) before he was an actual tattooist. I was really young and he probably shouldn't have given me a tattoo, but I made my skin available and he put them on me—backwards! It didn't really matter because I saw Sean as being the real deal part of the scene, and what better a symbol to have 'hacked' onto me than The Bars. Anyway, It was a very painful hour and a half of my life."-A.J.

"A year later, after our little meeting, I laid the groundwork to track down, smoke out, and meet each and every person with this intriguing little tattoo that would agree to talk to me."

Asking politely, Naomi asked Matt to show us his massively tattooed upper arm, and there were The Bars, in blue no less. As he hiked up the leg of his camo shorts, there was another smaller set in black. "I did these myself," he laughed. That was a first. Not that I had felt emasculated, but I did feel like his DIY bars kind of trumped my old-as-dirt bars, so we all spent the rest of the afternoon discussing the irony of being all there at the same time, and how this little cult should be documented. That was pretty much where the project began.

It took me a few hours while driving home to commit to such an asinine idea of somehow properly documenting this growing cult tattoo, but I did, and that is how *Barred for Life* was born. Eventually, I went back to Naomi to have my tiny little bars made into gigantic bars, but that was pretty much it. A year later, after our little meeting, I laid the groundwork to track down, smoke out, and meet each and every person with this intriguing little tattoo that would agree to talk to me. At that time, I figured a few hundred of them existed in the world, so on my little coast there must surely be a good smattering.

As I would go on to find out very quickly, we are in the midst of a profusion of people young-and-old getting this image tattooed on their skin for any of a number of reasons. It is weird.

Where there were just a handful of thirty-somethings in Thrill Vulture that day to witness a small but growing mass of people going under the needle, I don't think any of us could have predicted the sheer number of people that were wearing their Bars on their sleeves, so to speak, and how many of them couldn't wait to tell their story to whoever might listen. In such cases, I was the one listening. Hence, the book. ∎

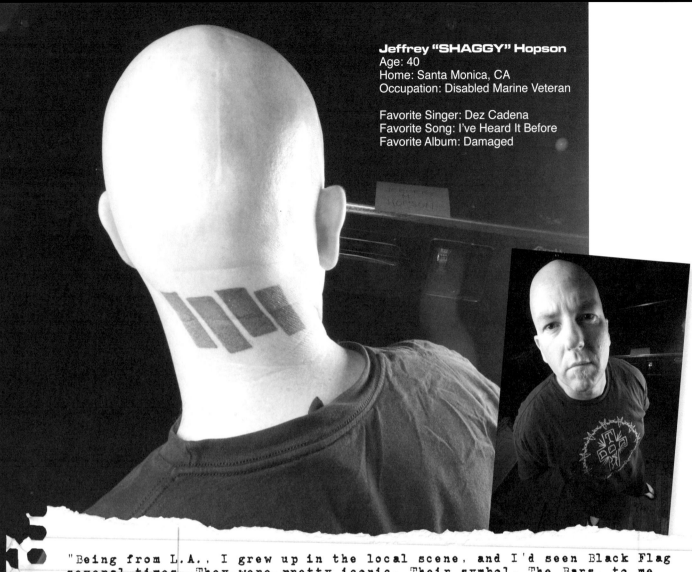

Jeffrey "SHAGGY" Hopson
Age: 40
Home: Santa Monica, CA
Occupation: Disabled Marine Veteran

Favorite Singer: Dez Cadena
Favorite Song: I've Heard It Before
Favorite Album: Damaged

"Being from L.A., I grew up in the local scene, and I'd seen Black Flag
several times. They were pretty iconic. Their symbol, The Bars, to me
it speaks about L.A., and the city's corruption at the time. No matter
which vocalist was singing the songs, the band to me is about life on
the streets of L.A."-J.H.

INTERVIEW

ANYTHING I DO, I DO IT ALL THE WAY.

KIRA ROESSLER

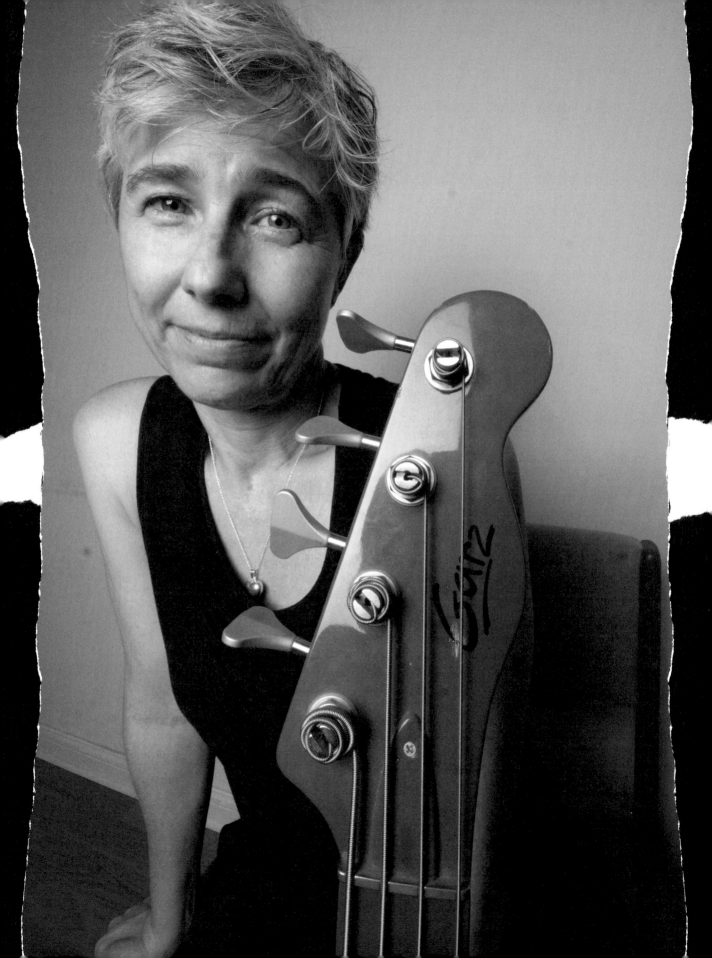

"There was no sleep. You had to just get in the van and drive. There were no role models. Nobody was doing it like Black Flag."

JUST TWO KIDS FROM THE BLACK HOLE

When I was fourteen, I was sort of a hippie chick for about six months. I had really long hair and wore bell-bottoms. When my mom moved away, my brother and I were able to create this sort of environment where, since we were living without parents, we could create this "crash pad." We were teenagers, and since most people get into that a little later, we were able to make this place where people could come and just crash. There wasn't a whole lot of authority. We got into a lot of trouble. It was more of a chaotic environment.

As that was happening, my brother began hanging out at Yumi High with a guy named Paul Bean, who later changed his name to Darby Crash. My brother knew these guys in high school, and they started a Punk Rock band. So, very early on, he came home with the "Forming" single and asked me what I thought. I was like, "Whoa, that is bad." We both played piano since we were very little, and I switched to bass because my brother had this Prog Rock band. I really wanted to become the bass player, but by the time I was good enough, he didn't have the band anymore.

Once my mom moved away, my older brother became my role model, so if he went to Hollywood to The Masque to see the Germs, I would tag along. When Darby cut his foot open during the show and needed to be taken to the hospital, I went to the hospital with them. I don't think I was committed. I had one foot in and one foot out because it was dangerous for a girl at that time. It wasn't hip or cool. People at my high school smacked me around due to how I dressed, so it was hard. For that reason, I was never sure I wanted to do it. My level of commitment grew very slowly.

Basically, I wanted to meet other musicians. Punk Rock was not Arena Rock, so I could go to a show and talk to the people and get into a band with somebody that wasn't my brother. I thought there might be some opportunities I'd never seen before or weren't available to me before, so I chopped all of my hair off to show my level of commitment, like, "Hey, I ain't that long-haired girl anymore!"

HOLLYWOOD VERSUS THE SOUTH BAY

Hollywood was sort of this super-small clique. Most places wouldn't let us scummy Punker types in. At some clubs, there was a "Punk Rock is fun" vibe, while at others there was a "Punk Rock is Bad" vibe. Hollywood was a microcosm. Some people from the South Bay were willing to steal a car just to come up here to see gigs. Though some people were cross-pollinating and attending the gigs, there was a kind of obvious separation.

Personally, I was afraid to go to [South Bay shows at] the Fleetwood because I was a little girl. It was really hard to watch the gigs because I got battered around. I definitely felt a little strange because it was really not friendly down there.

We [Hollywood Punks] were sleazebags. We were not living at home with mom, like kids from South Bay. Our lives were utter chaos. We lived in holes. There was nothing arty about us. They [South Bay Punks] still lived at home, got allowances, and put on stripes at night to go out and slam. We looked the same every day. I looked the same at night as I did when I was going to Hollywood High. I was the one getting my butt kicked, I was the one hunting in trash cans for food, and I was going to Hollywood High. I don't think they were doing that down South. In fact, they were copying us.

THE FLAG IS UNFURLED TO THE HOLLYWOOD GIRL

I met Ron [Reyes] at gigs in Hollywood, and then

KIRA

I saw Black Flag [with Ron singing] play. I also had a band with my brother called Twisted Roots, and we played down south a couple of times, and I saw a couple of the Black Flag guys down there. A very close friend of mine started dating Chuck Biscuits during that phase of the band. She started going to see them, so I starting hanging out with them around 1982. They weren't from Hollywood. I didn't have mom's car to get me there, but I would go to as many gigs as I could, and I was flat broke, so I would hang out with the bands and help people load in, then maybe one of them would help me get into the gig for free.

I dated Henry briefly, shortly after my friend started dating Chuck. Those were happy times for me, but things just didn't really work out with him. So, one day I got a call from Dez Cadena, who was starting a three-piece thing called the DC3, and he asked me if I wanted to play. He had just left Black Flag, which was Biscuits, Henry, and Dez on guitar, and he wanted to leave to do DC3. After I joined Dez's band for about three weeks, I got a call from Henry asking me to come down and play with Bill and Greg. I wasn't sure that if I quit DC3 there would be anything strange since Black Flag and DC3 shared a practice space. First, I practiced with DC3, and when Black Flag set up, I played with them as well. After Black Flag heard me play, they asked me to join.

At the time, I was going to UCLA and wanted to finish, so we spoke briefly about my school schedule, and I was in! There wasn't a lot of negotiation. Chuck [Dukowski] was still a friend [of mine]. Letting him go was miserable for them. Anytime that you have to fire someone, or tell them you don't want to play with them anymore, is difficult. It was a bit of a mystery. Henry didn't really have the musical sense to know what they were trying to achieve. It wasn't really intimidating, just sad. I've been kicked out of bands before, so I knew this was an emotional issue. They told me Chuck was going to manage Black Flag, so I felt the heat was on me.

Henry, very much the visual face of the band, was not necessarily a decision-maker and could not really assess whether it would be right to choose me as a bass player. The most intimidating thing for me was living up to this "mean" thing, and the good news was that I didn't have to be Dukowski. Greg wasn't looking for an imitation. Beyond that, I wanted Chuck to think what was happening was cool because he was still involved. Plus, having a girl in the band adds a new dimension too, like, "Are they soft now"?

When I committed to Black Flag, I told Dez I wasn't able to do both bands. Black Flag was my favorite band, so this wasn't an opportunity I could turn down. I did have a great idea for him—my brother could do a keyboard bass thing and be the third member. So, Paul joined the DC3 for quite some time, but eventually they got a bass player.

LIVING LIFE IN THE BELLY OF THE BLACK FLAG BEAST

Learning the songs and becoming Black Flag's bass player took me quite a while. There was a lot of office stuff, like answering mail. Bill Stevenson and I became pretty close and would grab some band mail and try to do some of the mundane stuff, since I would get off from school, take a bus from UCLA to South Bay with my books, come down to the office, and hang out or study before we practiced for five hours, which became an everyday ritual. If we didn't practice for that long, physically we wouldn't be able to play a lot harder live.

My first role was to fill in wherever possible. I was just "pitching in." Then when Bill left the band, a strange transition happened because I was expected to teach the new drummer all of the songs just three weeks before a four-month tour. Eventually, Anthony Martinez was selected, and I spent a lot of hours trying to get him into shape. Greg had other duties.

We toured with a PA in a big Ryder truck. Every show had a two-hour load in and load out. On our last tour, I suggested they let me do the promotional stuff because I wasn't going to be able to do a lot of the loading in and out. Bill always tried to handle most of that stuff, but I would jump in where I

could. So, I ended up doing a lot of driving and a lot of the promoter interface because I couldn't handle carrying all of the heavy speaker cabinets.

TAKING THE MY WAR SOUND SYSTEM TO THE KIDS

We carved out tour routes, spent four-month tours in a van and sleeping on people's floors, and carried our own PA every day. Do you know what this means time-wise? It means that you get out of clubs every night at four in the morning. There was no sleep. You had to just get in the van and drive. There were no role models. Nobody was doing it like Black Flag. For that time, we all just wanted the same thing, and we didn't care if you liked it or not. We just didn't care if you liked it. We wanted the people in the audience to be slammed up against the wall as hard as they could be. We wanted them to be slammed up against the wall in pain and agony and still digging it totally.

After the first tour, when we were promoting *My War* we would show up to a show playing to seven hundred people and there would be this piddly- shit PA. You wouldn't be able to hear Henry, and our amps were supposed to be propping us up by themselves. It was so depressing. The kids wanted to hear us play, and it sounded awful. We decided if we were going to play all of these small clubs all over the country, we needed to bring our own PA. We were trying to raise the quality of the sound. It was a fidelity issue. The low end had to be there. The high end had to be there, so you could hear Greg's guitar when he was playing a solo and hear Henry's voice cutting through.

INSCRIBING BLACK FLAG ON THE BODY

I realized just how hardcore they really were. They committed, worked harder, and were more serious than other bands. I got my tattoo in 1983 right after they asked me to be in the band. I got it by the same guy that gave Henry his, a guy named Rick Spellman. My tattoo meant, "Anything that I do I will do it all the way." I wanted a tattoo before I was in the band, but once I was in the band I knew that I had to go and get it. When I dated Henry, I sensed his emotional intertwinedness with Black Flag. It was almost like he didn't exist. He had given his self over to them and was not extricable from the band.

PARTNERSHIPS EVAPORATE

When Bill was kicked out, I was devastated because it was my most powerful relationship in the band. When I found out he wasn't going to be a part of it anymore, I felt a little bit uneasy because the longest tour was coming up, and I didn't have my closest friend going with me. Henry and I were always cordial, but when you think of friendships of being warm and fuzzy, that wasn't there with Henry. So, there wasn't going to be moral support coming from Henry, nor Greg, and Anthony I didn't know, so it was going to be a little more isolated. I felt a little lonelier going into that last tour, so there was a "shift."

We did an early photo shoot with Anthony right before we left, and I got dressed up. Henry made this off-of-the-cuff remark that it would be cool if I would get all done up for the entire tour. I said, "Just give me some money, and I'll do it." So, they gave me some money, and I bought all of this lace. After being a tomboy for so long, I created this new thing for the tour. I tried to go as far as I could towards something totally different, but it was distracting. I didn't have my moral support. When I was playing, I was trying to play well, not trying to look good. A lot of other female bass players were concerned with the way they looked, not how well they were playing. Greg and Henry certainly weren't worried about how they looked.

PUNK'S GENDER BARRIER

I felt like, "If you hate women, doesn't it kind of not make sense to have a woman in the band?" It seemed like a disconnect to me. There was some discomfort, and it wasn't like I was gonna ask, or gonna volunteer how I felt. I was in Black Flag, so I didn't want to make waves. I injured my hand and went to the emergency room. The doctor told me not to play for four to six weeks, and Black Flag knew that. But four days later, I was back at practice, so I had to learn physically to deal with it. We had commitments they could not break, and I

KIRA

couldn't be the weak link. But I was the weak link, and I just couldn't let on just how much it hurt. I was very much sidetracked by that.

After *Slip It In*, I was getting ready for tour, trying to get strong enough, and dealing with amps for the tour and vehicles. Being a woman, I have a smaller structure and physical limitations I just couldn't get past. That made me angry and irritable. Plus, Europe was angry. They were on a different timeline. Henry was a skinhead to them, and now Henry had long hair, and we had a girl in the band. Hüsker Dü was supposed to come with us, but they cancelled, so we had the Nig-Heist. So, having a girl and Henry's long hair pissed off fans. I was standing behind the amp for Nig-Heist, and some fans dropped beers on my head. I don't know if they would have done that if I were a boy.

If I said that I had to pull over and couldn't drive anymore, it was because I was a girl. If I was alone in the van with a man, there was supposedly sex involved. I would hear stories from home about my sexcapades. I would hear stories, especially on the last tour, that I was a busy girl. Perceptions and reality were pretty much skewed. I wasn't given the benefit of the doubt. Guys are cool if they do that kind of stuff, but I was supposed to have this sense of moral purity after traveling in a van with these guys. I just felt this weird difference in terms of how I was looked at in terms of my sexuality that didn't match how everybody was treated, or how everybody else was perceived, or what was really going on.

From a girl perspective, I could show no signs of weakness. I couldn't show that it was getting to me. I did, because it was, and you can ask anybody that was there whether I was a bitch or not. People like to throw that word around a lot, but Black Flag frayed me in ways. At times, I was less than 110 pounds. I couldn't sustain weight, but I could keep up with them. One thing they said about me is that I didn't show any weakness. There is a picture taken backstage of me sitting hunched over with Greg and Henry standing over me. It looks like some dramatic moment, but there is no doubt in my mind:

I was just in terrible pain with my hand, and we had to go back on stage for an encore. After the end of a set, I just wanted to shove my hand into a bucket of ice, but I couldn't because I wouldn't be able to go back and play the encore. I sucked it up and played a few more songs.

THE BEGINNING OF THE END

My concern about finishing school was a reservation about being totally consumed by Black Flag. After the 1985 tour, I was about to do my last quarter at UCLA and decided I wanted have this conversation with them about how, after finishing school, I could give myself over to them totally. Then I started hearing about them scheduling a tour while I was finishing my last quarter. We had finished the *Live '85* video and the *Who's Got the 10½?* record. I called Mike Watt, who worked at SST, and he told me they were scheduling a tour when I was still going to be in school. I was gonna be out of the band, I knew. There was no need to have this conversation with them.

I was committed to more than just the band. When I start something, I do it all the way. I was studying applied math, computers, and economics. It was called Economic Systems, and while I just wanted to study computers, there was a lot of upper-level math, so it was rigorously painful on the studying side. Imagine being dropped out of the van after finishing a tour and going straight to class. That is how close we cut it. I would still be all dirty from the tour, and the sorority girls would be like, "What the hell did these scumbags drop off at the door of UCLA?" Every time I'd enter class, I'd feel like I'd forgotten everything. My ears would be ringing. It was brutally hard and holding back the band. At the last gig, I cried. I knew that it was the last gig I would play with Black Flag. At an awkward meeting with Chuck at a restaurant down the street from the office, we talked about business, like the amp, and how we were going to break things off. That was it. There weren't fights, drama, or disagreements. I could have said, "Greg, if this was bothering you, why didn't you say something earlier?" It just wasn't his way to talk about it, try to fix it, or work it out. I was out. ∎

RECONNECTING TO PUNK ROCK ON MY OWN TERMS YEARS INTO THE FUTURE

"I just went for it, never looked back,

and had no idea that someday I would not be the only kid in my town adorned by The Bars."

TATTOOS OR RECORDS, AND BEYOND

At first, the joke made at Thrill Vulture on that rainy day showed all signs that this undertaking could be done in the form of a small zine-style publication. At first, I had planned to go with the original idea to highlight the fact that most of these tattoos were instantly flawed. Thinking differently later, I wanted to know why people that normally would laugh off any opportunity to get a tattoo that they knew others had gotten before them would go out and get them anyway. Knowing that this tattoo might end up looking crappy early on, due to bleed-over and blotching, I wanted to explore why people would place it prominently inside a well-crafted and colorful sleeve, or better yet, on a virgin acre of skin in plain sight.

Eventually, I'd stop asking such silly questions because it really didn't matter. Somewhere along the way it just seemed like a stupid idea to ask why or when. After all, I had it too. I didn't ask questions when I dragged my old Punk Rocker ass to that shop in Delaware. I just went for it, never looked back, and had no idea that some day I would not be the only kid in my town adorned by The Bars.

In this modern world in which everybody and their mother sports some tattoo coverage, people find it hard to believe there was ever a time when tattoos were not hip and fashionable. Whether you're sporting your baby's name on your neck, a cute little butterfly sitting on a brightly colored flower on your ass, some tasteless tramp stamp, or whether you are covered sleeve-to-shining-sleeve, this popular culture trend is new to most Americans. With all the hype, you'd think the average Joe had been getting ink forever.

Tattoos were relegated more-or-less to the world of motorcycle gangs, prison inmates, and drunken sailors, and only the gnarliest and the most destitute of the world's population seemed to get tattooed. Tattoos once received the same stigma as drug

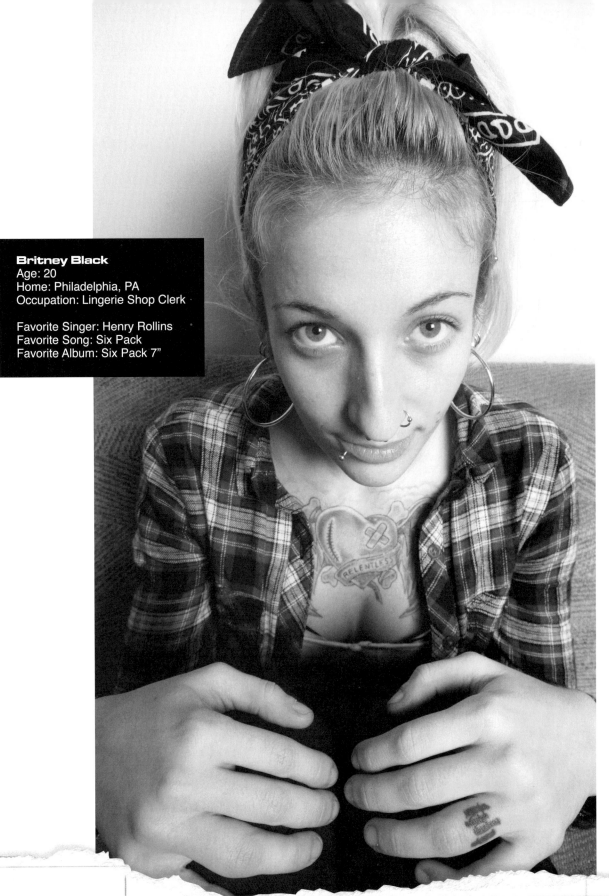

Britney Black
Age: 20
Home: Philadelphia, PA
Occupation: Lingerie Shop Clerk

Favorite Singer: Henry Rollins
Favorite Song: Six Pack
Favorite Album: Six Pack 7"

"I decided to have a bad tattoo covered with a tattoo of something meaningful, The Bars." -B.B.

"I played in Avail for about ten years. When I quit to play in Alabam
Thunderpussy it was a big change. I went from being in a successful
band playing to hundreds every night to playing to just a few friends
if we were lucky. People asked me why I quit and I said, 'It's just
more fun!' I got The Bars on a tour. Tour was going a little rough
and I was continually asked why I kept touring even through all the
trouble. Black Flag was an inspiration to me during those times. My
tattoo says 'Damaged 1991 - ' so when I stop touring I'll fill in th
date; but hopefully I'll never stop!" -E.L.

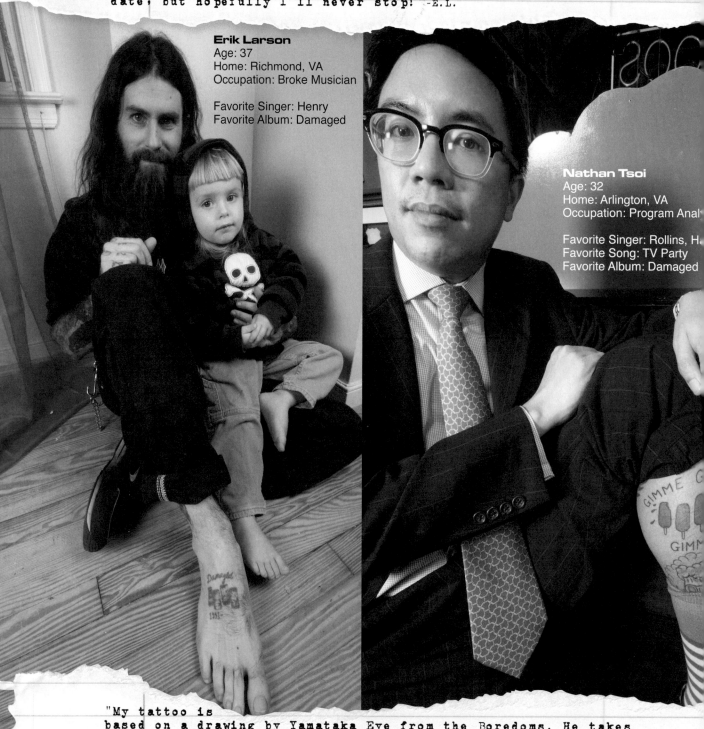

Erik Larson
Age: 37
Home: Richmond, VA
Occupation: Broke Musician

Favorite Singer: Henry
Favorite Album: Damaged

Nathan Tsoi
Age: 32
Home: Arlington, VA
Occupation: Program Anal

Favorite Singer: Rollins, H.
Favorite Song: TV Party
Favorite Album: Damaged

"My tattoo is
based on a drawing by Yamataka Eye from the Boredoms. He takes
classic Punk Rock bands and re-appropriates their logos. To me,
Black Flag is one band that can be seen as a pillar of American
Hardcore. They reach across decades and genres. There's something
so powerful about Black Flag to cause Yamataka to reconfigure the
image. I think it's a tribute. I added the 'Gimme Gimme Gimme' to
it because I like popsicles." -N.T.

▼ **Tom Allen**
Age: 38
Home: Baltimore, MD
Occupation: Carpenter

Favorite Singer: Keith Morris
Favorite Song: Gimmie Gimmie Gimmie
Favorite Album: Damaged

"I grew up skateboarding and listening to Black Flag. We had a boombox, and all that we did was listen to tapes and skate. We were living our own little Punk Rock skateboard lifestyle in Columbia, MD. I can remember that in the back of Hit Parader magazine, there was a small ad in the classified for a $3 or $4 tape sampler from SST records, and so I bought it. The tape had Black Flag, Saint Vitus, SWA, and some other bands, but Black Flag definitely made the biggest impression on me."-T.A.

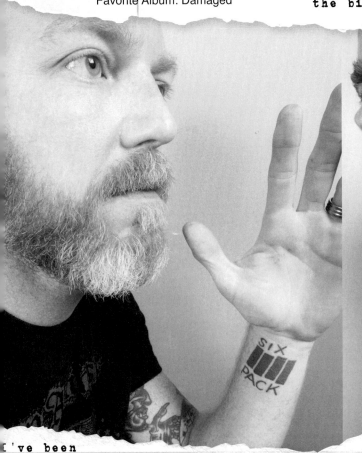

I've been in bands for fifteen years, experiencing varying degrees of success. One thing I've stuck to, and will always stick to, is to be in complete control of my band. You can do it yourself, and so there is no reason to allow somebody else take the reins. That goes for touring, agents, and managers. Black Flag was the antithesis of that, and that's Punk Rock!"-M.R.

Mike Riley ▶
Age: 33
Home: Baltimore, MD
Occupation: Printer, Binder

Favorite Singer: Keith
Favorite Song: American Waste
Favorite Album: Nervous Breakdown 7"

addiction, alcoholism, and child molestation. Mothers worldwide didn't just frown when their baby came home with ink, they cried their eyes out. If you were lucky, you would still have a place to live after the experience, but moms nationwide didn't really like tattoos. Unless your dad was a criminal, a gang member, or an unrepentant sailor, he didn't really like them either.

Plus, I was generally broke all of the time. On a good weekend, you could drive to a nearby town, see one or two shows, grab some grub at a crappy diner, and by the time that you got home, if everybody pitched in, you spent fifteen dollars tops. Even a

Armen Melekian
Age: 19
Home: San Francisco, CA
Occupation: Student

Favorite Singer: Hank Rollins
Favorite Song: TV Party
Favorite Album: Slip It In

"I've never met Henry Rollins but I have a big Henry Rollins complex. It would be a dream come true if he could perform at my wedding, my kid's birthday party, or something like that. Right now I'm trying to get him to speak at my college even though I very well might be one of only three or four people there to see him. I'd still be thrilled."-A.M.

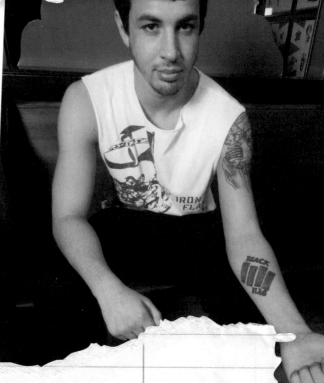

"Daddy didn't like Punk Rock, and he said I couldn't get a tattoo, but I did it anyway. I made my own tattoo machine with the motor from a toy, used stolen India Ink, and one day I gave myself The Bars in my bathroom. Black Flag was really DIY based and so I figured that since I was doing my own tattoo, why not use their logo?"-R.A.

▲ **Robby Adams**
Age: 22
Home: Centreville, VA
Occupation: X-Sport Fitness Employee

Favorite Singer: Dez
Favorite Song: Nervous Breakdown
Favorite Album: First Four Years

piss-poor tattoo would cost you fifty dollars. Even if you could come up with the money, you had to venture to a very unfriendly "tattoo parlor" in an unfriendly part of town, where you were going to be hammered on by an unfriendly person that didn't take kindly to Punk Rockers.

Back then, fifty dollars meant nearly a month's worth of Punk Rock awesomeness, while a new tattoo might get you kicked out of your house. At the very least your girlfriend or boyfriend's parents would forbid them from seeing you, so it was just a good idea to spend your money in the tried-and-true fashion of entertaining yourself by buying records and going to shows. For those reasons alone, tattoos seemed like a big waste of my time and energy, not to mention one might easily end up giving money to a person that was of the same breed as the dude in the pick-up truck that, as he drove past you, called you a Punk Rock faggot while his friend lobbed his half-full malt liquor bottle at your head. Not that all tattoo culture people were Punk haters, but you just never knew, so me and my friends lived for skateboards, records, and Punk Rock shows.

"The Bars represent brotherhood. Every Punk, every skin, especially from DC, definitely holds Black Flag in the utmost respect. The four black bars have become an iconic image, and are not just a band tattoo anymore. You don't have to be a Punk or a skin either. I even know some people who listen to The Grateful Dead who have The Bars. They're definitely a band that has brought a lot of people together from around the world."-L.M.

◄ Luke McHale
Age: 19
Home: Washington, DC
Occupation: Restaurant Manager

Favorite Singer: Rollins
Favorite Song: Rise Above
Favorite Album: Damaged

Kip Dawkins ►
Age: 45
Home: Monroe, NC
Occupation: Photographer

Favorite Singer: Henry Rollins
Favorite Song: Depression
Favorite Album: Damaged

"The Bars represent me finding my people. We were like a tribe. Together we are strong whereas before we felt weak and ostracized. I saw Black Flag five or six times and it was always an intense show. Henry was like a caged animal onstage. He would get this look in his eyes and it was almost scary. They didn't care if you were there. They were playing for themselves. They, like, invaded you. It was seriously the happiest time of my life."-K.D.

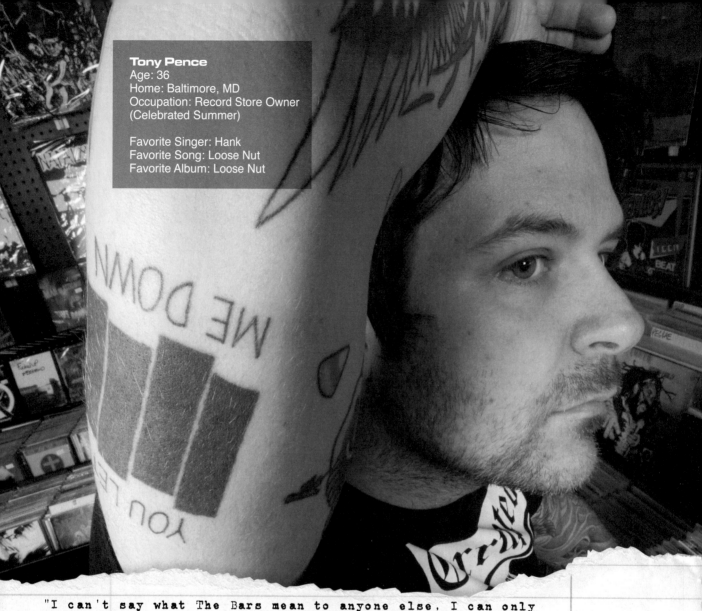

Tony Pence
Age: 36
Home: Baltimore, MD
Occupation: Record Store Owner
(Celebrated Summer)

Favorite Singer: Hank
Favorite Song: Loose Nut
Favorite Album: Loose Nut

"I can't say what The Bars mean to anyone else, I can only say what they mean to me. The Bars are like a Rorschach test. Whatever you think they mean is probably more representative of your personality than what The Bars actually mean." -T.P.

In my mind, tattoos started finding their way into the scene throughout the 1980s. I can recall watching the arms, and the back, of Henry Rollins, the most infamous (and admittedly rather scary) front man of Black Flag, fill up steadily over time. Rollins wasn't the only tattooed spectacle in Punk Rock at the time, and early images of bands like the Misfits and Agnostic Front showed so much ink that I started to feel like a pussy for having virgin skin. Truth be told, I really was chicken at that time, but eventually I would embrace tattoo culture as being a logical pathway for Punk Rockers, just as it had been for many other social outlier lifestyles in the past.

Just when I thought that nobody could be more tattooed than Rollins, along came the Cro-Mags, a New York band that appeared on the scene around 1985 that proved me totally wrong. Singer John Joseph and bass player Harley Flanagan were covered in ink. They took tattoos in Punk Rock culture to a new, unprecedented level—a level where I wanted to be, if I could just get my first tattoo. It would be a few more years

Anthony "Retro Skull-Duggery" Thornton
Age: 23
Home: Goole, England
Occupation: Listings Producer/Artist/Cartoonist

Favorite Singer: Rollins
Favorite Song: Jealous Again
Favorite Album: First Four Years

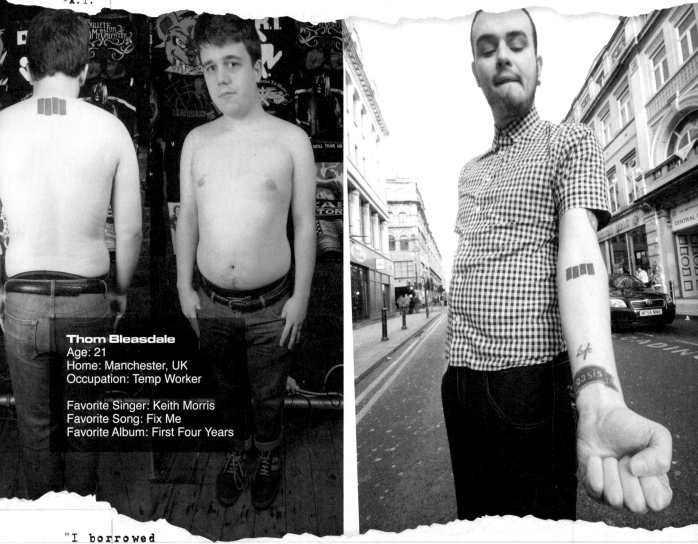

Thom Bleasdale
Age: 21
Home: Manchester, UK
Occupation: Temp Worker

Favorite Singer: Keith Morris
Favorite Song: Fix Me
Favorite Album: First Four Years

"I borrowed
the First Four Years album from the local library. It was raw and
furious, yet catchy and melodic. It was unlike anything I'd ever heard
before. I borrowed Damaged next, and for a while I didn't understand
the change of style. At some point I gave up caring and just fell in
love with it."-T.B.

before faces in the crowd just like me would start showing up on the scene with massive tattoo coverage, but around 1985 and 1986 you just started to see a lot of tattoos popping up at shows. They were never large tattoos, but then again the people with them had taken a leap that would only grow more and more in the following years.

Like so many of the people around me, my obsession with tattoo culture moved from randomly spaced, well-hidden, and little "distinct" pieces to larger bodies of work over a period of ten years. A decade later I was moving toward larger and larger pieces and was encouraged by the growing culture of Punk Rockers finding their way into the tattoo trades. Some were tattooists, and some were apprenticing, but after these people

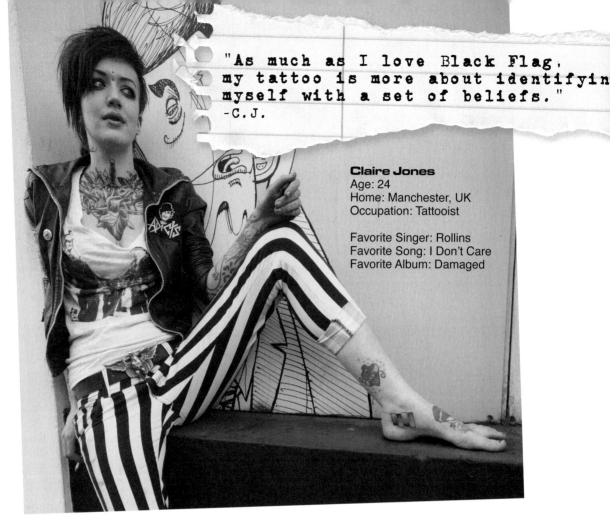

"As much as I love Black Flag, my tattoo is more about identifyin myself with a set of beliefs."
-C.J.

Claire Jones
Age: 24
Home: Manchester, UK
Occupation: Tattooist

Favorite Singer: Rollins
Favorite Song: I Don't Care
Favorite Album: Damaged

started running their own businesses I finally felt comfortable getting tattooed. Not that I wasn't a big fan of my first tattooist, The Butcher, who was a hulking and bearded biker, but his traditional methods and outrageous stories took some getting used to while sitting in his chair.

Until stumbling on to a coffee table book entitled *Punk*, I didn't realize how many of the early New York scenesters were tattooed. Those were some poor folks, some were drug addicts, yet they had some coverage. Then something happened. When Punk Rock was Americanized during the whole Hardcore era, tattoos disappeared for a while.

Maybe it was the baseline poverty of being a Hardcore kid, or the fact that the majority of the "kids" involved in the Hardcore scene were too young to get into tattoo shops, or whether there was an ideological snap in the twig that represented the "old" music and this "new" scene, tattoos just weren't a common thing. Personally, I was too young, too poor, and not all that interested. Most of my friends weren't as broke as me, but they weren't really all that interested in tattoos as well. Until I started making some money and finding shops that were Punk Rocker friendly, I had plenty of amazing sights and sounds to keep me out of tattoo shops and infinitely busy.

Now that I have more ink than my cute little curio pieces from the 1980s, it is not uncommon for kids half my age to have so much coverage that they are searching for bare skin on which to allow their apprenticing friend to practice his/her line work. If nothing, this change has been somewhat rapid and hugely revolutionary since old school tattoos, while finding a massive resurgence, are not really complex compared to

"I got into Black Flag at a time when I needed them the most. Before I got into them I was listening to music that encouraged me to wallow in my own self-loathing and depression, where as Black Flag encourages you to take all of the frustration you feel and actually do something positive with it."-J.O.

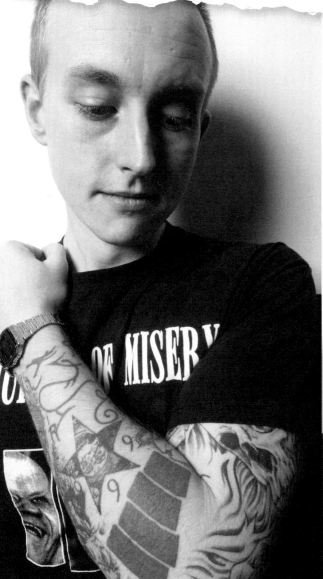

◄ James "Goatboy" Ollis
Age: 26
Home: Strood, Kent, UK
Occupation: Administration for British Red Cross

Favorite Singer: Rollins
Favorite Song: Depression
Favorite Album: Damaged

Jack Pitt ►
Age: 20
Home: Rayleigh, Essex, UK
Occupation: Student and Bar Worker

Favorite Singer: Rollins
Favorite Song: Black Coffee
Favorite Album: First Four Years

"The Bars were my first tattoo. To me they represent a certain aspect of the DIY lifestyle: that I am not only aware of certain issues, but I am actively committed to doing something about these issues."-J.P.

Jeff "JJ" Janiak ▶
Age: 33
Home: Stoke On Trent, UK
Occupation: Auto Painter and Musician

Favorite Singer: Rollins
Favorite Song: My War
Favorite Album: My War

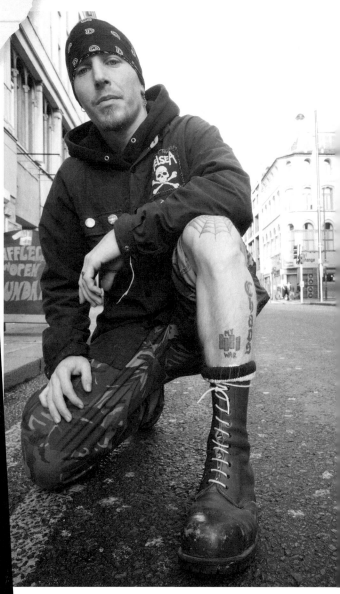

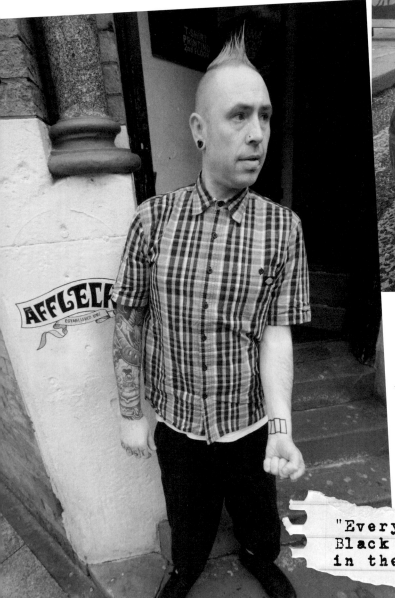

◀ Colin Thompson
Age: 38
Home: Manchester, UK
Occupation: Shop Manager, Piercer, and DJ

Favorite Singer: Rollins
Favorite Song: Six Pack
Favorite Album: Damaged

"I feel like The Bars have moved beyond just representing Black Flag and have almost become a fashion statement. In the 2000s, wearing the image is like wearing a CBGB's shirt and having never been there, or wearing a Ramones shirt and having never seen them."-J.W.

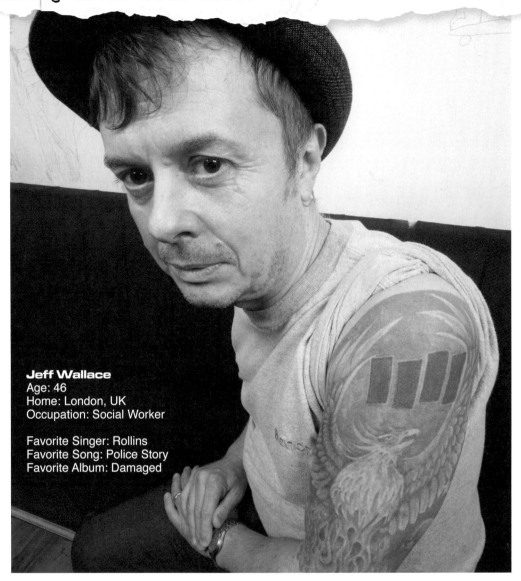

Jeff Wallace
Age: 46
Home: London, UK
Occupation: Social Worker

Favorite Singer: Rollins
Favorite Song: Police Story
Favorite Album: Damaged

a friend's work that has been studying past masters while finishing his degree in art school.

WHAT I LEARNED AFTER FIVE YEARS OF CHASING THE BARS AROUND THE WORLD

In a tattoo world, where the sky is the limit (just look at a tattoo magazine), it seems crazy, if not totally ironic, to walk into a shop and tell the tattooist you want four black rectangles tattooed somewhere that everybody can see it. Like the cute little bear holding a heart balloon or the a pod of dolphins swimming around a yin and yang symbol, some expressions in ink are better left hidden from plain site, but not The Bars. While many are found tucked just out of view, a great number have found their homes in plain view on wrists, throats, knuckles, behind ears, and dead center in the middle of massively complicated chest pieces. The wearers, who are quick to point out the

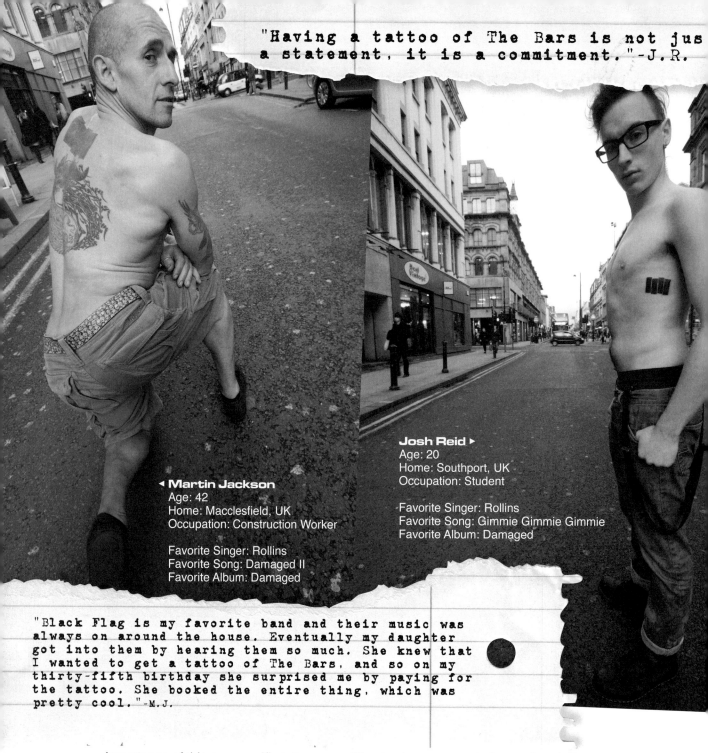

◄ Martin Jackson
Age: 42
Home: Macclesfield, UK
Occupation: Construction Worker

Favorite Singer: Rollins
Favorite Song: Damaged II
Favorite Album: Damaged

Josh Reid ►
Age: 20
Home: Southport, UK
Occupation: Student

Favorite Singer: Rollins
Favorite Song: Gimmie Gimmie Gimmie
Favorite Album: Damaged

"Black Flag is my favorite band and their music was always on around the house. Eventually my daughter got into them by hearing them so much. She knew that I wanted to get a tattoo of The Bars, and so on my thirty-fifth birthday she surprised me by paying for the tattoo. She booked the entire thing, which was pretty cool."-M.J.

importance of this one specific tattoo, are willing to place careers in jeopardy, relationships at stake, and reputations on the line in order push this loaded image.

While I cannot and will not speak for everyone in this book, the answer to the eternal question of "why?" always comes back to two things. In the first place, in a non-Punk context, The Bars are a nondescript entity, just four rectangles, and unless anything else is written nearby, might simply be mistaken for a barcode found on the back of a grocery item. Even when something is written in conjunction with The Bars—frequently a fragment from a Black Flag song or some piece of album art—the image remains obscure.

◄ Simon Frazer
Age: 32
Home: Blackburn, UK
Occupation: Record Store Employee

Favorite Singer: Henry Rollins
Favorite Song: TV Party
Favorite Album: My War

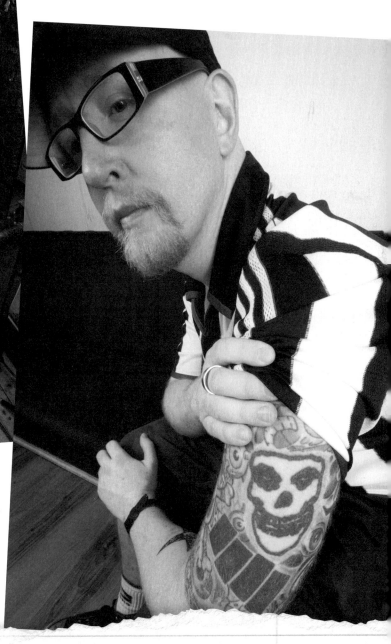

Jim Brown ►
Age: 31
Home: London, UK
Occupation: Secondary School English Teacher

Favorite Singer: Dez
Favorite Song: Gimmie Gimmie Gimmie
Favorite Album: Damaged

"For me The Bars don't so much represent Black Fl;
as much as they represent a lifestyle: a life of
standing up against the establishment."-J.B.

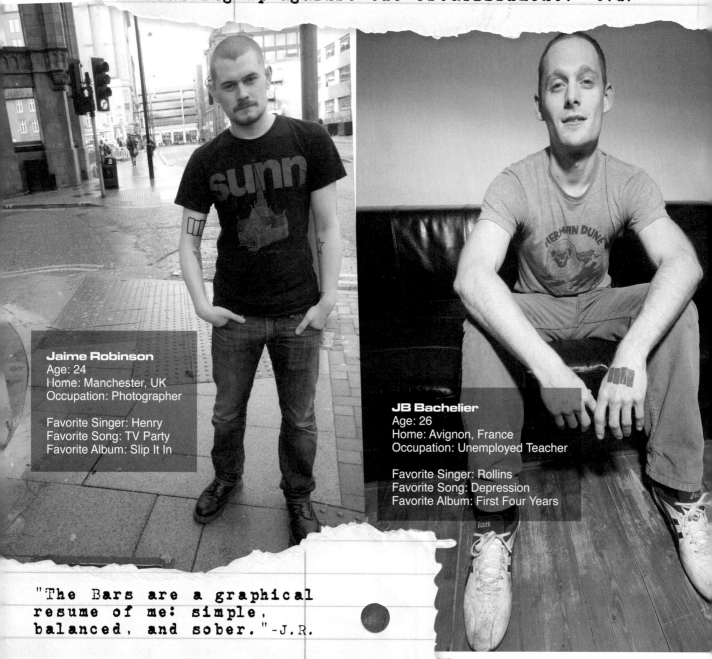

Jaime Robinson
Age: 24
Home: Manchester, UK
Occupation: Photographer

Favorite Singer: Henry
Favorite Song: TV Party
Favorite Album: Slip It In

JB Bachelier
Age: 26
Home: Avignon, France
Occupation: Unemployed Teacher

Favorite Singer: Rollins
Favorite Song: Depression
Favorite Album: First Four Years

"The Bars are a graphical
resume of me: simple,
balanced, and sober."-J.R.

On the other hand, contained inside each and every set of The Bars is a story that might take all night to tell, and it might sound more than similar to the story you've been reading all along. The Bars, whether directly connected to Black Flag, or connected more widely to one's engagement to Punk Rock, or simply a document of a turning point in one person's immediate life, represent something much greater than simple fandom. From what I gathered, The Bars were more a statement than an image. Frequently, the stories were deeper than anyone could have imagined prior.

The Bars are an immediate point of connection between any two people that "get it" independently, but probably do not know one another. As almost every person we

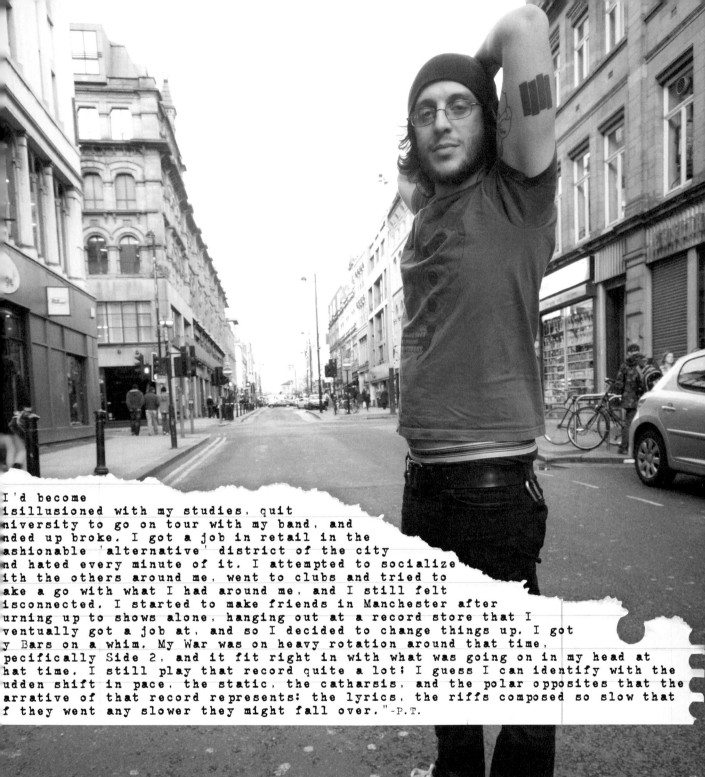

I'd become
isillusioned with my studies, quit
niversity to go on tour with my band, and
nded up broke. I got a job in retail in the
ashionable 'alternative' district of the city
nd hated every minute of it. I attempted to socialize
ith the others around me, went to clubs and tried to
ake a go with what I had around me, and I still felt
isconnected. I started to make friends in Manchester after
urning up to shows alone, hanging out at a record store that I
ventually got a job at, and so I decided to change things up. I got
y Bars on a whim. My War was on heavy rotation around that time,
pecifically Side 2, and it fit right in with what was going on in my head at
hat time. I still play that record quite a lot; I guess I can identify with the
udden shift in pace, the static, the catharsis, and the polar opposites that the
arrative of that record represents: the lyrics, the riffs composed so slow that
f they went any slower they might fall over."-P.T.

Phillip "TOZ" Torriero
Age: 30
Home: Burnlevy, Lancashire, UK
Occupation: Accounts

Favorite Singer: Henry Rollins
Favorite Song: I've Gotta Run
Favorite Album: My War

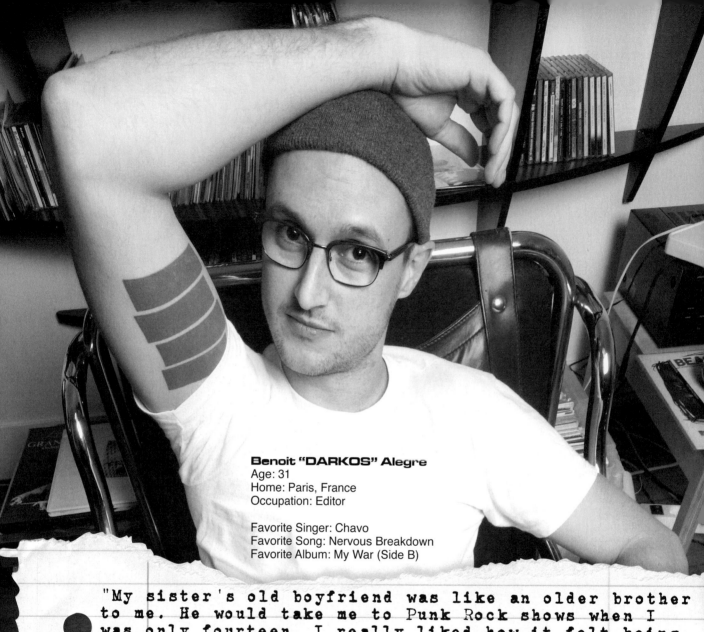

Benoit "DARKOS" Alegre
Age: 31
Home: Paris, France
Occupation: Editor

Favorite Singer: Chavo
Favorite Song: Nervous Breakdown
Favorite Album: My War (Side B)

"My sister's old boyfriend was like an older brother to me. He would take me to Punk Rock shows when I was only fourteen. I really liked how it felt being there at these shows. There was only the music and the pure energy." -B.A.

interviewed stated, "I might not know, and probably won't like, every other person that has The Bars, but at least I know that we have this shared experience." Frequently, the band to which this logo belongs is left out of this explanation. Upon first pass, The Bars are more akin to a symbol used to unite a scattered tribe in a very big and sometimes unknown world. Strangely, The Bars act secondarily as Black Flag's keynote symbol.

Stories emerge from people, supercharged with emotion, once considered another face in the crowd. The Bars, as proven in this long and complex research project, are an image that directly connects the freaks, geeks, and weirdos with (1) the point at which they found their Punk tribe, (2) the massive amount of shit that they took up to that point, and (3) how their involvement in the Punk Rock culture empowered them to step up their game and rise above being treated poorly at the hands of the cooler and better-off people. Every person in *Barred for Life* has a favorite era, a favorite singer, a favorite

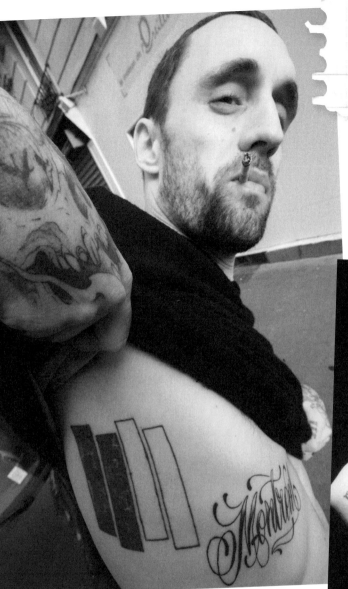

"I got The Bars tattooed on me when I was twenty-five years old by a friend. It was his first time tattooing and I let him tattoo me on my ribs using my machine. It may have been a mistake because it took a lot of time to make the tattoo, and it hurt enough that we stopped after finishing only two of them."-R.P.

◄ **Romain Pareja**
Age: 32
Home: Paris, France
Occupation: Tattooist

Favorite Singer: Keith Morris
Favorite Song: Six Pack
Favorite Album: Damaged

Antoine Laine-Pradines ►
Age: 21
Home: Lyon, France
Occupation: Student

Favorite Song: Rise Above
Favorite Album: Damaged

"There are many kids in the local Hardcore scene with The Bars tattooed on them. Sometimes it seems like everybody has that tattoo or a Black Flag shirt. The main character of my tattoo is a sheep. It represents a lot of kids in the Hardcore scene that do all of this for fashion, and so I thought that it might be funny to have a sheep wearing this symbol on his shirt. I see my tattoo as ironic, though, because I really like Black Flag too."-A.P.

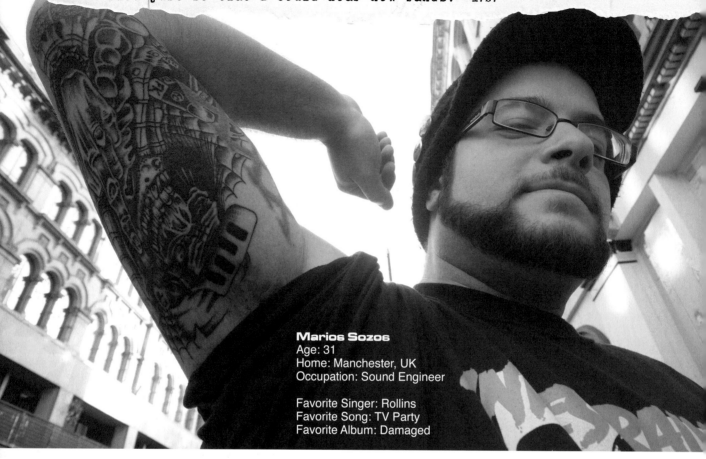

"The Bars remind me of when I was fourteen years old and living in Greece. There was a Punk Rock radio show that came on at midnight and played classic Punk music. The first song that I ever remember hearing on it was TV Party, and only later did I find out that it was by a band called Black Flag. Of course there was no Internet, so for a long time I would have to stay up every night and listen to that show just so that I could hear new bands." -M.S.

Marios Sozos
Age: 31
Home: Manchester, UK
Occupation: Sound Engineer

Favorite Singer: Rollins
Favorite Song: TV Party
Favorite Album: Damaged

album, a favorite song, or a favorite lineup, revealing their particular perspectives and forging their underground connections to each other.

From the very first interview for *Barred for Life* way back in 2007, the book was destined to bring together as much information from as many sources and from as many places in the world as possible. While the die was cast to use only photos and interviews conducted by the *Barred for Life* crew, hundreds more photos and testimonials flooded my computer from around the world. The United States, Canada, and a chunk of Europe were the best we could cover on our own dime, while Punks with The Bars were reported in Argentina, Ecuador, Brazil, Australia, Japan, Germany, Spain, and Poland. One eyewitness saw a cabana boy in Thailand with The Bars.

Finding The Bars in so many far-flung locations and Punk Rock representing a stronghold in many disparate places is extraordinary. From my days of reading *Maximumrocknroll* (Punk Rock's favorite magazine there for some time) from cover to cover, I knew that scenes existed all over the world. Many were easily as large as some of America's more impressive scenes. However, even with home-grown bands operating to keep these scenes flourishing, Black Flag ended up being the glue for the world's Hardcore Punk Rock culture, to the degree that Punk Rockers from as far away as the southern tip of South America asked for inclusion in *Barred for Life*.

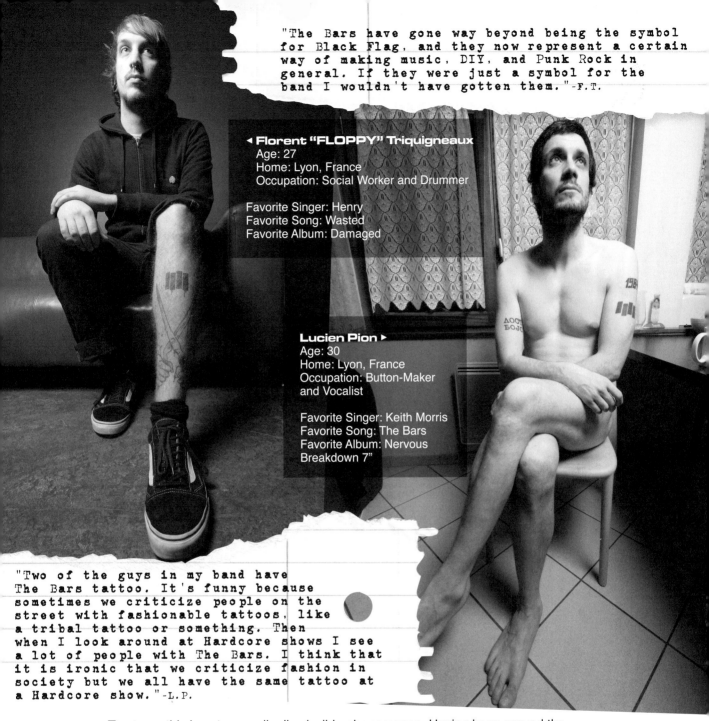

"The Bars have gone way beyond being the symbol for Black Flag, and they now represent a certain way of making music, DIY, and Punk Rock in general. If they were just a symbol for the band I wouldn't have gotten them."-F.T.

◄ **Florent "FLOPPY" Triquigneaux**
Age: 27
Home: Lyon, France
Occupation: Social Worker and Drummer

Favorite Singer: Henry
Favorite Song: Wasted
Favorite Album: Damaged

Lucien Pion ►
Age: 30
Home: Lyon, France
Occupation: Button-Maker and Vocalist

Favorite Singer: Keith Morris
Favorite Song: The Bars
Favorite Album: Nervous Breakdown 7"

"Two of the guys in my band have The Bars tattoo. It's funny because sometimes we criticize people on the street with fashionable tattoos, like a tribal tattoo or something. Then when I look around at Hardcore shows I see a lot of people with The Bars. I think that it is ironic that we criticize fashion in society but we all have the same tattoo at a Hardcore show."-L.P.

Trust me, this is not an easily dismissible phenomenon. Having been around the Hardcore Punk Rock scene for nearly three decades, very little has as much staying power as The Bars. I am still amazed. I cannot lie. I never expected things to move in this direction when I'd decided to accept my girlfriend's birthday gift and get them, nor would that have had any direct effect on my decision. When all of my individual bars seemed to melt into one another and form one big black glob on my ankle, the only thing I imagined doing was making them ten times as large.

In an early interview, I asked what advice this person would give to somebody who was thinking about covering up their tattoo. His answer was presented rather confidently, "You don't cover up The Bars. If anything, you make them bigger!" So it goes across the country and the world. The Bars are otherworldly. In wearing them, you don't really

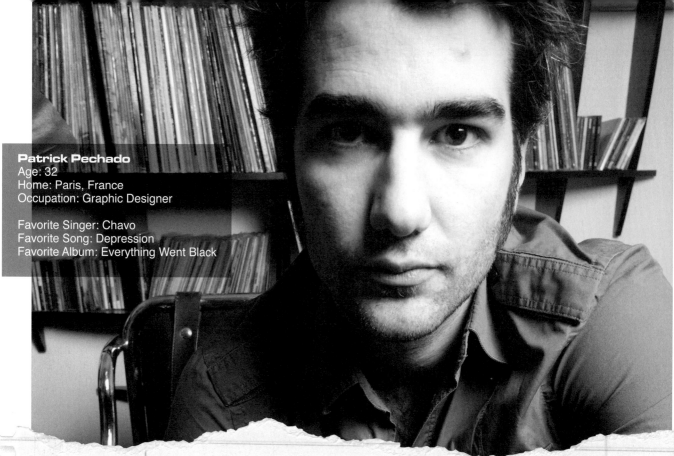

Patrick Pechado
Age: 32
Home: Paris, France
Occupation: Graphic Designer

Favorite Singer: Chavo
Favorite Song: Depression
Favorite Album: Everything Went Black

"I found The Bars so perfect and so inspiring, and so they helped me decide to become a Graphic Designer. When I design logos today I tell myself to try and create something just as strong as The Bars. I know that it is not possible, but I try." -P.P.

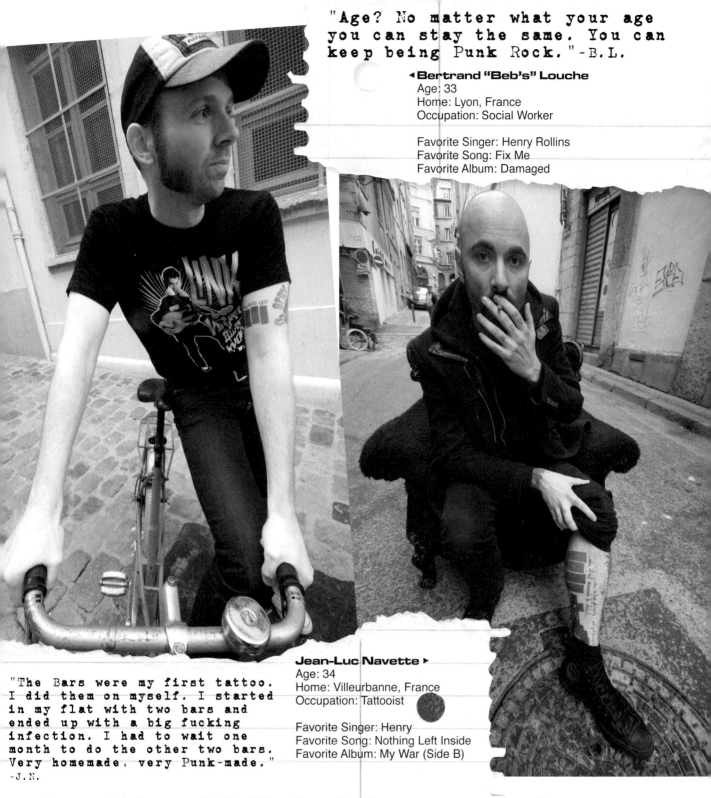

"Age? No matter what your age you can stay the same. You can keep being Punk Rock." -B.L.

◄ Bertrand "Beb's" Louche
Age: 33
Home: Lyon, France
Occupation: Social Worker

Favorite Singer: Henry Rollins
Favorite Song: Fix Me
Favorite Album: Damaged

"The Bars were my first tattoo. I did them on myself. I started in my flat with two bars and ended up with a big fucking infection. I had to wait one month to do the other two bars. Very homemade, very Punk-made." -J.N.

Jean-Luc Navette ►
Age: 34
Home: Villeurbanne, France
Occupation: Tattooist

Favorite Singer: Henry
Favorite Song: Nothing Left Inside
Favorite Album: My War (Side B)

jokingly say you like Black Flag. You confidently state you are part of something way more awesome than the world will ever truly understand.

SUBVERSIVE ACTS IN CONSERVATIVE WRAPS

I feel like I need to highlight a few examples of unique Black Flag tattoo stories. Upon making myself at home in the Paris-based home of my friend Patrick, in walks Jean-Baptiste Bachelier. Jean-Baptiste, studying to be a schoolteacher in southern

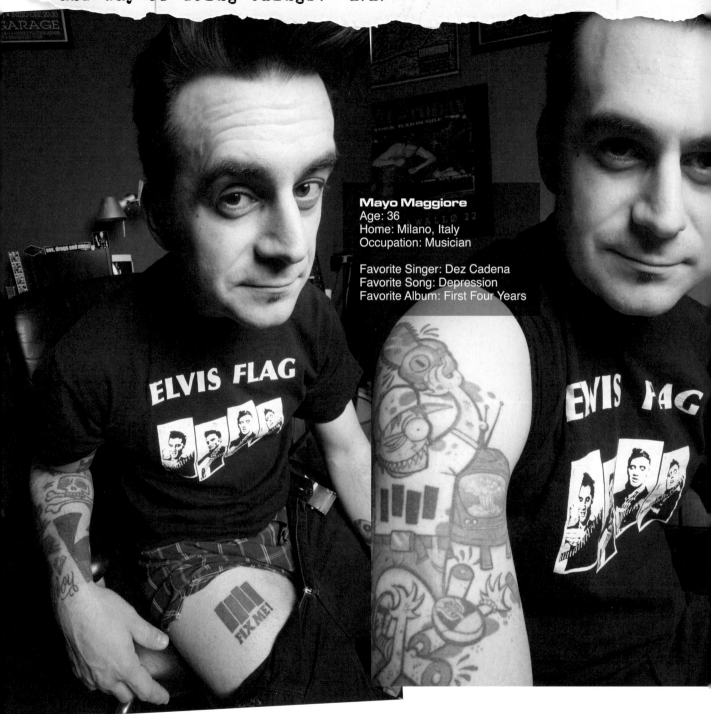

Mayo Maggiore
Age: 36
Home: Milano, Italy
Occupation: Musician

Favorite Singer: Dez Cadena
Favorite Song: Depression
Favorite Album: First Four Years

France, exposes to my camera the top of his left fist where The Bars steal most of the skin. Surely, he knows the risks of finding work in the conservative world of teaching with such a well-exposed Punk Rock tattoo. Luckily for him, as he tells me, nobody at the school where he substitute teaches knows what they are, so it really isn't such a big deal. Who could possibly have thought it possible to see The Bars thrive in a country that sees far fewer tattooed citizens, let alone very minimal connections to American Hardcore culture?

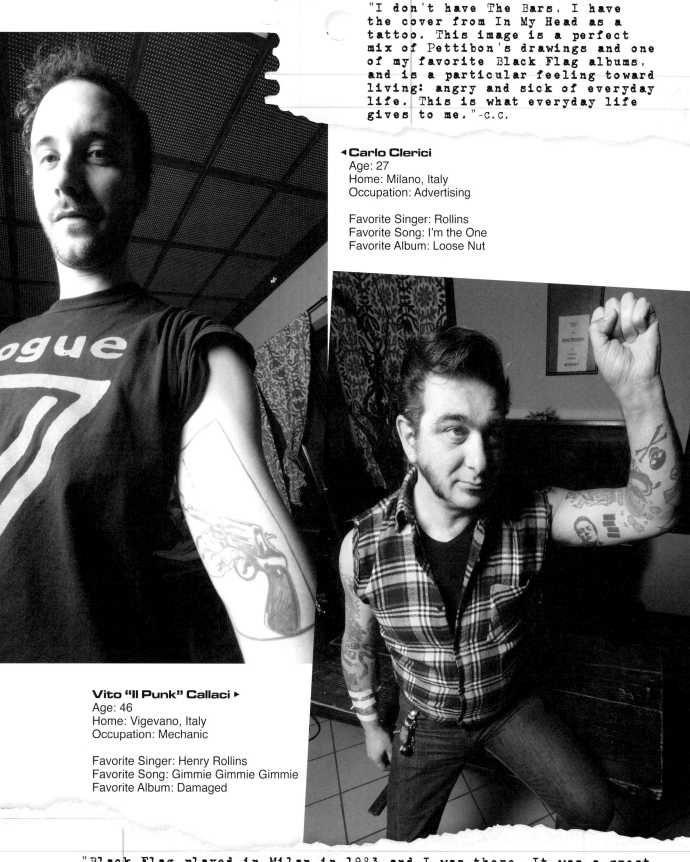

"I don't have The Bars, I have the cover from In My Head as a tattoo. This image is a perfect mix of Pettibon's drawings and one of my favorite Black Flag albums, and is a particular feeling toward living: angry and sick of everyday life. This is what everyday life gives to me."-c.c.

◄**Carlo Clerici**
Age: 27
Home: Milano, Italy
Occupation: Advertising

Favorite Singer: Rollins
Favorite Song: I'm the One
Favorite Album: Loose Nut

Vito "Il Punk" Callaci ►
Age: 46
Home: Vigevano, Italy
Occupation: Mechanic

Favorite Singer: Henry Rollins
Favorite Song: Gimmie Gimmie Gimmie
Favorite Album: Damaged

"Black Flag played in Milan in 1983 and I was there. It was a great show with a riot and police outside the venue. Back then all the Punk Rock shows cost 7,000 Lira, but this one was 8,000 Lira. So, the Punks started a riot to get the price down to 5,000 Lira so that they could get in."-v.c.

"Like the handshake of some secret society , The Bars can be jokingly placed in the most conservative of places."

Then there was Brad Wandary, formerly of Iowa and now living in Phoenix, Arizona. Making a living as an architect, this subversive individual designed an entire manufacturing complex in the likeness of The Bars. Unbeknownst to his clients, The Bars are now represented in concrete and steel. Unless any of the said clients were Punk Rockers before becoming captains of industry, only people inside Punk culture understand the effort. Like the handshake of some secret society, The Bars can be jokingly placed in the most conservative of places, thus making them a sort of insider graffiti, much like trail markings on a forest path.

Finally, it is just necessary to mention the dozen or so people, those I won't name by name (though I am sure they wouldn't really mind) that confided to me they were within a second of ending their own lives when Keith, Ron, Dez, or Henry suggested otherwise. Hence, Black Flag helped them divert a huge tragedy. One particular interview in Philadelphia found me leaning in for the hug after being floored by the story. I am sure many songs and poems have saved fed-up young people from ending their own lives, but having The Bars planted firmly on skin to celebrate the occasion is an awesome option. In lieu of suicide, The Bars renew life after a near-tragedy. Countries have their flags, gang members have their colors, and Hardcore Punk Rockers have The Bars and the music, which saved them.

With so many amazing examples of dedication, I had to follow the trail. While Jean-Baptiste is not the craziest example of this phenomenon, he is exemplary of why I found it so compelling as to resign a career, empty my bank account, ask friends to endure three months worth of slumming with me, and teach myself, on-the-fly, how to become an exemplary photographer on a project in which I took on too many responsibilities to be considered healthy. Somebody had to do it. So, with a number of amazingly dedicated accomplices, we did it. ■

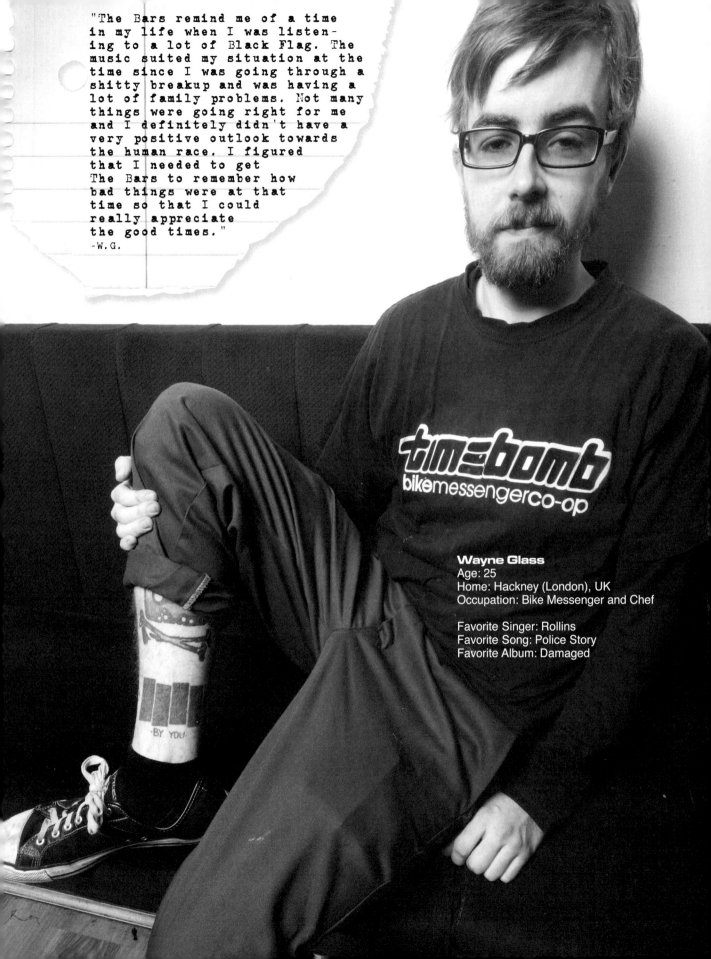

"The Bars remind me of a time in my life when I was listening to a lot of Black Flag. The music suited my situation at the time since I was going through a shitty breakup and was having a lot of family problems. Not many things were going right for me and I definitely didn't have a very positive outlook towards the human race. I figured that I needed to get The Bars to remember how bad things were at that time so that I could really appreciate the good times."
-W.G.

Wayne Glass
Age: 25
Home: Hackney (London), UK
Occupation: Bike Messenger and Chef

Favorite Singer: Rollins
Favorite Song: Police Story
Favorite Album: Damaged

INTERVIEW

I HADN'T HEARD A NOTE
OF PUNK ROCK BEFORE
I GOT INTO IT.

EDWARD
COLVER

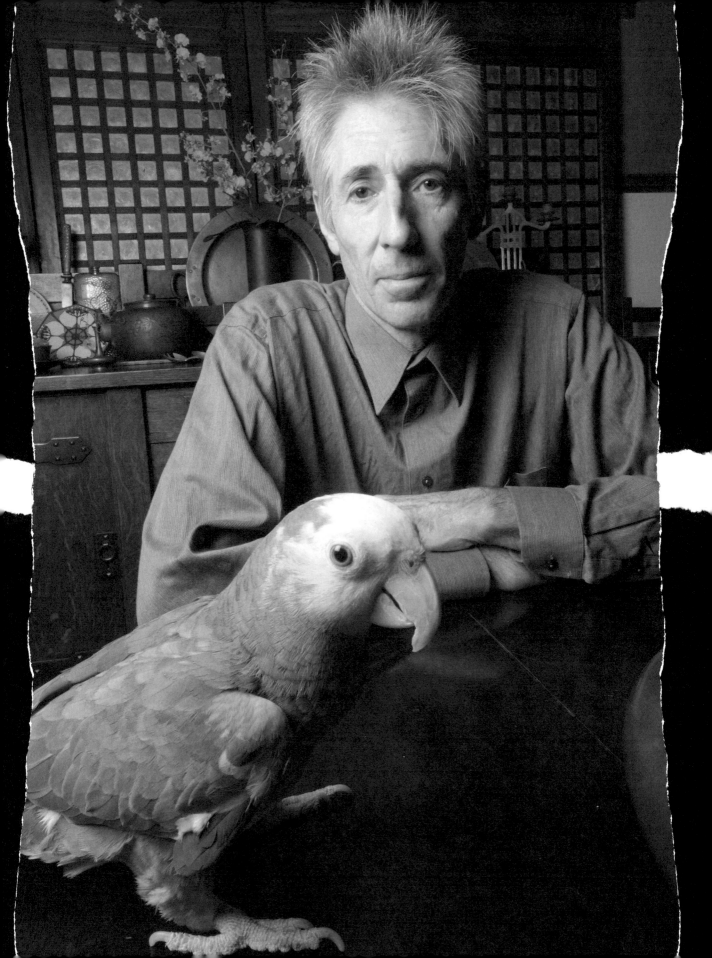

"After about three years, the scene kind of bubbled, boiled, and turned into something huge. At a Black Flag show at the Olympic, three thousand people were there, and I thought, 'Wow, this is a little bit different.'"

EDWARD

I WAS A TEENAGE AVANT-GARDIST

Art was always an interest of mine. As for Punk Rock, back when I used to watch television I saw a news report about a club called the Hong Kong Café in downtown L.A., so I thought I would go and check it out. I started going all of the time to see bands like Fear, X, and the Bags. This was early in 1978 and '79, and three months later I had a photo of Johanna Went, a performance artist with a pair of mannequin legs on her head, published from a show there, so I ran with that. That particular show got shut down. Fear was performing too, and they (Fear's audience) tore the place apart. They really fucked the place up.

I hadn't heard a note of Punk Rock before I got into it. I liked Iggy Pop, who was the predecessor. As a kid, I listened to a lot of avant-garde classical and electronic music from the 1940s, '50s, '60s, and '70s. It changed my life, just like the Punk scene did. When I was eighteen, I heard John Cage, Edgard Varèse, Karlheinz Stockhausen, and then my life took a big turn right there. I think that the last big thing that I went to was the Newport Pop Festival in 1969 or 1970, an awful outdoor festival. Somebody covered "Nights in White Satin" for twenty minutes, and that was it.

CONFESSIONS OF A CALIFORNIA HARDCORE CHRONICLER

The Punk scene was just a tiny nucleus, like two or three hundred kids making up the entire scene. It wasn't getting publicity, so it was a totally underground thing at that time. Many people in the early L.A. Punk scene were involved in the art scene. There were a lot of Art-Punk bands. They weren't the most interesting bands, but it was new, raw, and had energy. There was no bullshit, no backstage passes and crap like that. If somebody asked me if I was into New Wave, I'd say, "Hell no, I'm into Punk Rock." I always liked to say that.

Punk Rock was totally new, real, vital, primal, and raw—what rock'n'roll should be about. I lived twenty-five miles out of town too. I fell asleep standing up one day at work because I'd been out

shooting bands all night and shooting pictures in alleyways in downtown L.A. on skid row and then drove home. I'd get home at three in the morning, go to sleep, wake up, and do it all over again the next night. If it weren't for the dots in the road waking me up, I'd have probably died on my way home because I was constantly falling asleep at the wheel.

Black Flag was one of the first bands that I saw in late 1978 or early 1979. They were playing up in Hollywood. Fear and Dead Kennedys were really great too. While all of those bands were in the same genre, they had their own thing going on. Black Flag was just a tight, good, and hard band. They were real strong and intense, more than most bands.

After about three years, the scene kind of bubbled, boiled, and turned into something huge. At a Black Flag show at the Olympic, three thousand people were there, and I thought, "Wow, this is a little bit different."

For a long time, I was out at least five nights a week shooting photographs. It was like a five-year party, in essence, since I shot two or three nights a week in those days. I went to at least one thousand Punk Rock shows in that period, and sometimes two shows in a night. The Circle Jerks might be playing somewhere, and Fear another, and I'd go to catch them both. If somebody went to a Punk Rock show, I was there. Even if they didn't know me personally, I was there. So, being everywhere afforded me a little bit of space in the pit, so I wouldn't get messed with. Even if people didn't know my name, they knew that I was there for a reason. People would approach me and say, "I see you everywhere. Who are you?"

A lot of people I've known forever, but I never knew their names back then. I am still shocked that the bands are still historically significant. I sensed they might be significant back then, but it really surprises me that Punk has been absorbed into popular culture. Seeing it co-opted is strange, but there are far worse things that could have happened.

RECORD SLEEVES:
THE ICONOGRAPHY OF THE
NEW GENERATION OF PUNK ROCK

I shot Circle Jerks' *Group Sex* album, the first TSOL, the first Christian Death, and the Wasted Youth covers, so Black Flag just pulled me aside and asked me to shoot the photos for the *Damaged* LP. Black Flag wanted to do a picture of Henry hitting a mirror, so I came up with a way to execute it.

I got a mirror and covered the back with duct tape. I turned it over and hit it once with a hammer. Then I cleaned it up, set it up the shot, then made blood out of a mixture of red India ink, instant coffee, and dish soap for consistency. It looked fucking perfect. I shot it in color, and in a few of the shots Henry's eyes are glowing red. They didn't use any of those shots because they said that Henry "looks demented." I said that the album was called *Damaged*. . . . A lot of people didn't really get it and thought the photograph was too abstract.

I like one of the outtakes of the *Damaged* record cover a lot, a profile shot with Henry punching the mirror. It's not the picture that is on the cover. It ended up as a design on a T-shirt. I've lost most of what I shot for *Damaged*, and I believe SST lost the original too. I haven't seen most of that stuff for fifteen years.

I like the photo I took of myself holding a gun backwards, which was supposed to be used in the *Damaged* album liner notes but never made it, so I gave it to the band Channel 3, which they used for one of their record covers. The guy from Posh Boy claims to own it since it was used for a work for hire, but the photo was shot for Black Flag, and I gave him permission to use it for his record. It was a self-portrait used in the book *Hardcore California*. I will use it if I want to use it. Posh Boy can go and fuck himself.

A lot of people thought the *Group Sex* photo was great and asked me to shoot photographs for their albums. Around 1982 or '83, I started working with

> ## "If somebody asked me if I was into New Wave, I'd say, 'Hell no, I'm into Punk Rock.' I always liked to say that."

IRS Records and did that horrible *Wild in the Streets* album cover, which I am embarrassed about to this day. The art director dropped the band members into the photo in black and white just to separate them from the crowd, but they look like they were from another picture. It was kind of weird.

THEY HATE US, WE HATE THEM: THE HARDCORE RIOTS

From my impression, the big stink with the LAPD was fueled by stuff like the image of the [Police Story drawing with the] policeman with the gun in his mouth and the "make me come faggot" thing written beside it. That image was on flyers, and I am sure that the cops saw them. It wasn't hard for them to follow the flyers to where the band was playing and just show up.

If one cop car would drive by a show, nothing would happen. If a car, or two cars, would pull up to the show and stop, there would always be a riot. The kids would always throw something at them if they stopped. Were the cops provoking the riots? I don't know. Were they following Black Flag and trying to shut their shows down because there was this back-and-forth? Well, it seemed like it went on for a year or two.

If the cops showed up to a show with a lot of force, the riots would last five, maybe ten minutes. They'd bust the kids and chase them out, and it would be over pretty quickly. They never really lasted that long and didn't really carry into the neighborhoods, usually.

Shooting the riots was a dangerous environment, but I never really felt threatened. I was having too much fun and being careful. Most photos I shot with available light because they were at night and taken from a distance. Since I wasn't using a flash, I didn't really bring that kind of attention to myself. I'd anticipate them, then I'd go out to take pictures. The one where they blocked off Sunset Blvd. was a Black Flag show. They blocked off the sidewalk, so I walked down the sidewalk and shot the marquee with their name on it with the cop car sitting in front.

AND THEN IT WAS OVER: LEAVING THE PIT BEHIND

Once all of the thrash bands started up, I just couldn't tolerate it anymore. It was sloppy, messy, and they were spouting the same old anarchy sort of stuff. There just wasn't anything to that later period stuff, just a fast, repetitive, and nervous sort of music. I remained friends with all of the people in the scene, but I just stopped going to shows and didn't really follow those bands. I really liked the earlier music, and I am not embarrassed by my involvement in the least, but I just didn't like the scene after all of those thrash bands took over. I just lost interest by that time.

I liked working with Punk bands because they were so animated and fun. I look back on it now, and I don't have any idea how I ended up where I did.

EDWARD

I totally pulled that one out of a hat. So many times I see pictures that I took and wonder, "How did I do that?" Mostly, it was about focusing on something or somebody while they were in motion, and somehow the shots came out.

I'd done like eighty record jackets between 1979 and '83 and photographed every fucking band, so what else was I going to do? I wanted to make a living, and I wasn't making a living shooting the Punk stuff. I enjoyed photography because it was an applied art, so I wanted to get some paying jobs. When I did the *Wild in the Streets* cover, I started working with IRS. In 1984, I stopped shooting Punk Rock entirely. I started working for IRS records shooting photos for *The Cutting Edge* show, shooting Wall of Voodoo, REM, and Lords of the New Church. I liked all of those bands too and started working with the *L.A. Weekly* and the *L.A. Reader*.

I'M NOT ALONE: FELLOW TRAVELERS IN PUNK GRAPHIC ARTS

Raymond Pettibon set the tone for the whole style of Black Flag. He is one of the few people that really set a style to, or added anything to, the whole Punk Rock thing from the art world. He was, and still is, an astute social commentator. He was like the fifth (or sometimes the sixth) member of Black Flag in terms of being inseparable from the band's aesthetic. I've often said that the Black Flag logo that Pettibon did (and some say he borrowed it from Impulse Records), the red cross, and the swastika, are some of the strongest designs ever made. They are beautiful and work well visually, even though Hitler really fucked up the swastika's meaning.

Shawn Kerri, who drew the Circle Jerks' skanker, was pretty important. She did a lot of other stuff, like the Germs logo where the skull is tearing through that circle. Mad Marc Rude did a lot of stuff too, but Pettibon's stuff was ubiquitous.

STARTING FROM SCRATCH: SHOOTING FROM THE FINE-ART GUT

I had some art influences, but really the only photographic stuff I'd seen prior to taking photos myself were like those of Diane Arbus, but I never wanted to copy anything. I've started paying much more attention to photographers, but I've always been more interested in fine-art approaches to photography. I had a sense of composition that most photographers don't even think about. One night I was on the roof of my old building, and this woman was shooting pictures with a panoramic camera. I was like, "Can I take a photo with your camera?" I took a vertical shot where the sky went from blue to pink to orange, and the city was placed at the bottom of the shot. I could tell that she was like, "I never thought of that."

My friend Bob Seideman did the Blind Faith album, the one with the prepubescent girl and the chrome airplane, which is a really amazing icon and memorable composite image of an ugly red-headed girl with freckles holding a chrome airplane, with green grass and bright blue skies juxtaposed.

Many photographers like to keep details in the white or in the black, but I was always like "fuck that." Most of my photos are contrasting black and whites with only one shade of gray in between. I overdevelop, overexpose, kick the contrast up, and print. I don't print my own any more. I printed a stack of photos that could reach the moon, so I am over that. ∎

"Were the cops provoking the riots? I don't know. Were they following Black Flag and trying to shut their shows down because there was this back-and-forth?"

SCENE NUMBER NINE
GET IN THE SEDAN

"A few early missions involved live tattooings at houses of friends which led us to other people in other cities with The Bars."

MY LAST TOUR EVER —TRUST ME

Barred for Life, then, could have easily been some little magazine with contributions sent in from around the world. It would have made my life a hell of a lot easier, honestly, but that wasn't the way my crew and I saw things panning out.

In the first place, two professional photographers, both of whom stem from Punk Rock and tattoo culture, jumped on board. Soon after, another friend, a graphic designer by trade, climbed onto the project. Finally, a chance encounter with a fellow Punk Rock Aquarian, an author and editor himself, placed him right into the mix within a week of our being introduced.

Early on in the evolution of the project, we went town-to-town, house-to-house, in search of The Bars. A few early missions involved live tattooings at houses of friends, which led us to other people in other cities with The Bars. Inside a few weeks, we were traveling to other towns, replicating the process. We made it easy on everybody by making things hardest on ourselves. Eventually, we'd return to Columbus to collect all of the fine people that were present on the day that *Barred for Life* was born. So, in very little time, we'd covered Philadelphia, Washington D.C., and New York City on the East Coast, and Columbus, Ohio to the west.

While interesting and exciting, at that pace, a hundred years would pass before we had approached anything amounting to a book-sized effort. So, we mothballed the project while I came up with a plan that would eventually become a full-blown tour of the U.S., Canada, and much of Europe. Due to rapid networking on social network sites, such as MySpace and Facebook, and on-line Punk Rock-oriented chat rooms and bulletin boards, a tour shaped up well. As much as I take issue with the "good" stemming from our new Internet obsession, I was a slave to its charms.

"I've been playing and listening to Hardcore music since I was thirteen
years old. Once Punk exploded I didn't like the scene—Rome's scene and
what was coming out of America—anymore and so I moved into Rap music.
I had a great time doing Rap music. After some time, and lots of
success, I realized that I wasn't in my world at all. I was Hardcore,
and most of the people that I related to had The Bars tattooed on them.
So, I came back to Rome and had The Bars tattooed on me. It was as sort
of surrendering to my roots."-P.M.

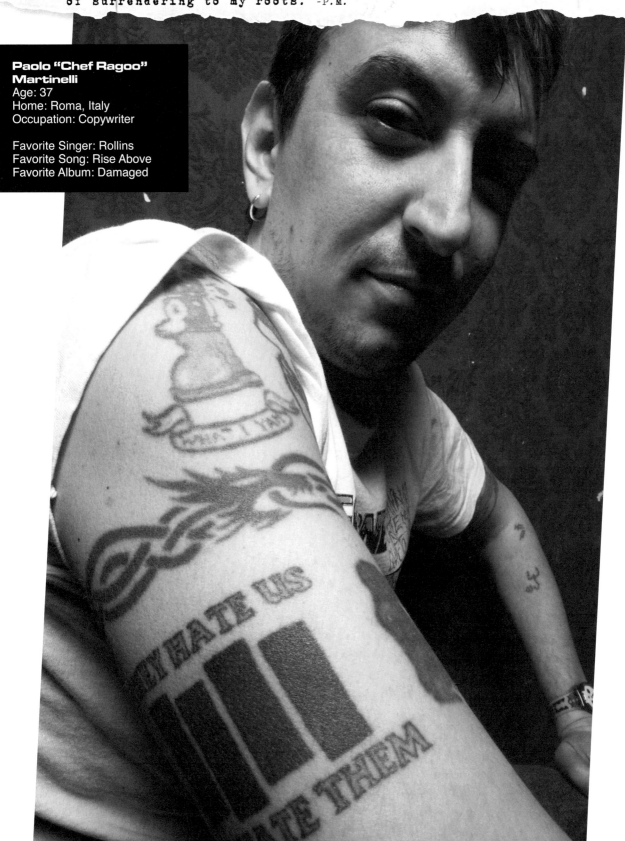

Paolo "Chef Ragoo"
Martinelli
Age: 37
Home: Roma, Italy
Occupation: Copywriter

Favorite Singer: Rollins
Favorite Song: Rise Above
Favorite Album: Damaged

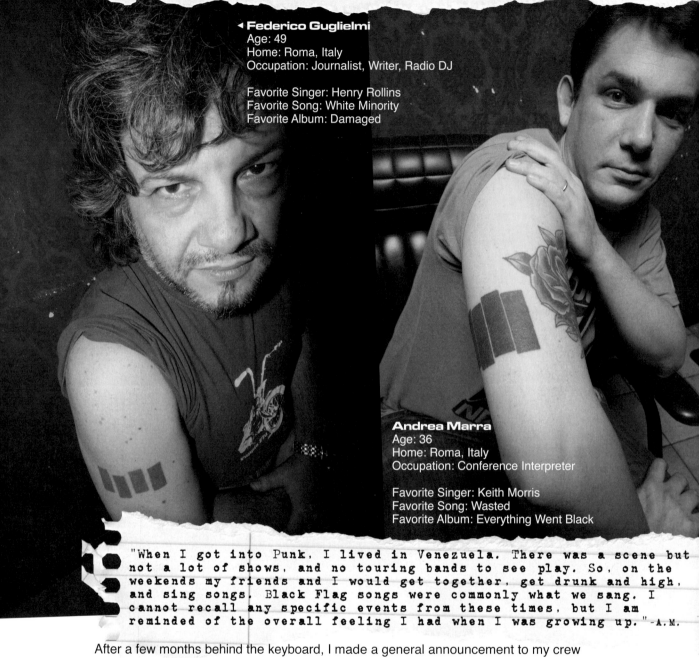

◄ **Federico Guglielmi**
Age: 49
Home: Roma, Italy
Occupation: Journalist, Writer, Radio DJ

Favorite Singer: Henry Rollins
Favorite Song: White Minority
Favorite Album: Damaged

Andrea Marra
Age: 36
Home: Roma, Italy
Occupation: Conference Interpreter

Favorite Singer: Keith Morris
Favorite Song: Wasted
Favorite Album: Everything Went Black

"When I got into Punk, I lived in Venezuela. There was a scene but
not a lot of shows, and no touring bands to see play. So, on the
weekends my friends and I would get together, get drunk and high,
and sing songs. Black Flag songs were commonly what we sang. I
cannot recall any specific events from these times, but I am
reminded of the overall feeling I had when I was growing up."-A.M.

After a few months behind the keyboard, I made a general announcement to my crew
that a full-blown three-month-long tour was solidly booked and would be happening
later in the year. My crew mumbled in unison: they could do pieces, parts, or very little
of it, which led me to dig a bit deeper to find a solution. In the end, to preserve the
cohesion of the book, I built the tour around a hand full of dedicated travelers that could
serve as interviewers and photo assistants, while I became the project's new full-time
photographer. Not that I wanted to grab any glory from Jared, who by that time had
provided the visual standard, but I couldn't find anybody that could take off of work,
school, or life for three full months to follow me on this crazy trail on their own dime. In
the end, necessity won. Had it not been for the sanity of my dedicated and unemployed
Austrian friend, Stefan, I am not sure that I would have made it around the world.

▼ Marco "Neuch" Dapino

Age: 28
Home: Milano, Italy
Occupation: Photographer

Favorite Singer: Rollins
Favorite Song: Wasted
Favorite Album: Damaged

"Graphically, The Bars are a good symbol. I think that they synthesize the essence of what Punk is." -M.D.

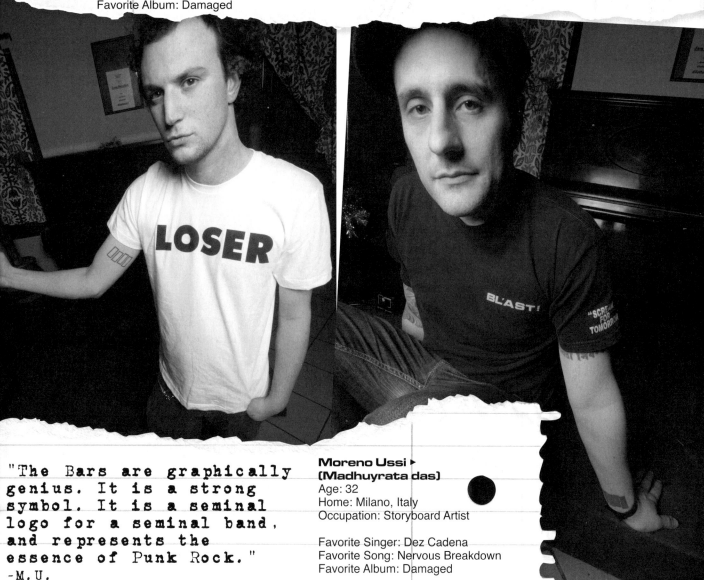

"The Bars are graphically genius. It is a strong symbol. It is a seminal logo for a seminal band, and represents the essence of Punk Rock." -M.U.

Moreno Ussi ▶ (Madhuyrata das)

Age: 32
Home: Milano, Italy
Occupation: Storyboard Artist

Favorite Singer: Dez Cadena
Favorite Song: Nervous Breakdown
Favorite Album: Damaged

Spending two full months cooped up in a tiny white Hyundai sedan, we never came to blows.

Three months from start to finish, starting in Philadelphia and finishing up in Roma, Italy, I got solid proof: The Bars have become the biggest symbol in Punk Rock. New Punk Rock music has made it to the stadium, something that should have never happened, but that was never the point. Punk Rock was to be a place for freaks, geeks, and losers just like me. What was once a very dingy safe haven for the uber-smart and the uber-dumb alike found its way to the tour circuit and the big time. For a jaded fuck like me, on my travels I found where the heart of Punk Rock lives, which is not in the stadium or on big record labels but in the basement shows with people doing it for themselves, expecting little in return for huge efforts.

"...allowing geeky kids, just like me, to rise above what is considered 'normal' and create something amazing."

Due to the speed at which this logo has been finding its way onto the skin of younger and younger kids, you can be sure within a few years it will be one of the most contrived visuals in the history of this culture. For now, I feel like this book nicely captures the essence of those who want a nice-and-cozy pure Punk Rock pasture to return to upon retirement. Looking forward, I don't care if Punk Rock lives or dies, in all honesty.

What I do want to see, however, is something new, engaging, and equally, or even more awesome, entering the cultural picture allowing geeky kids, just like me, to rise above what is considered "normal" and create something amazing. About thirty years after breaking free of the status quo for teenagers, navigating my way into the crazy world of Punk Rock, and making it to my first big-city Punk Rock show, I must have lived a hundred lives. Like most of the people that have come and gone into and out of my life, I still find those that seek to escape everyday confinement have much better stories to tell. Whether straight-edge, train-hopper, or an anarchist, the basic fabric of the stories speaks to the richness of a life fully lived and to adventures yet to be undertaken.

Laying on the exact same couch here in Italy where I found myself all but defeated at the end of the 2009 tour, as if by some sort of magic, I am finding a new voice and a new enthusiasm for discussing this phenomenon. While I am pretty sure that my "Punk Rock" life is now being exchanged for something new and exciting in its own right, it would be a foolish enterprise to think I could walk out without making my contribution. My book is dedicated mostly to the voices of those generally stricken from the record of this "band and show" culture, those that spend every day of their lives living on the fringe that are rarely photographed and almost never interviewed but obviously have something amazing to contribute.

To all of you who are pictured herein, and to all of you I could not connect with, maybe because you lived so far away, I am in your debt. You, and all of that great music of course, are the reasons that Punk Rock was just so much fun. Hopefully, it still is to you. You rock. ∎

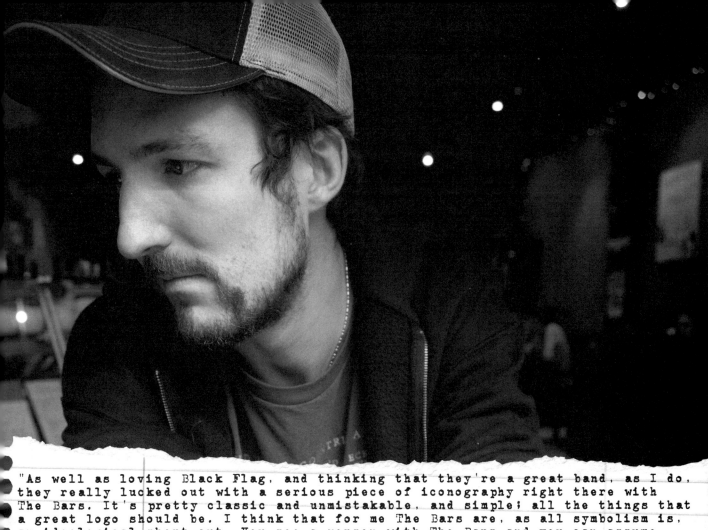

"As well as loving Black Flag, and thinking that they're a great band, as I do, they really lucked out with a serious piece of iconography right there with The Bars. It's pretty classic and unmistakable, and simple; all the things that a great logo should be. I think that for me The Bars are, as all symbolism is, an ideological short-cut. You see a person with The Bars and you can assume certain things about their approach in music and their taste in music."-F.T.

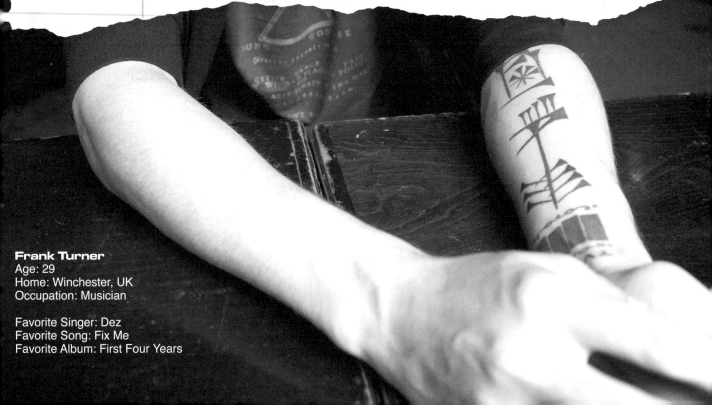

Frank Turner
Age: 29
Home: Winchester, UK
Occupation: Musician

Favorite Singer: Dez
Favorite Song: Fix Me
Favorite Album: First Four Years

Spray Paint the Walls
The Story of Black Flag
Stevie Chick
$19.95 * Paperback * 432 pages

Black Flag were the pioneers of American Hardcore, and this is their blood-spattered story.

Formed in Hermosa Beach, California in 1978, for eight brutal years they made and played brilliant, ugly, no-holds-barred music on a self-appointed touring circuit of America's clubs, squats and community halls. They fought with everybody: the police, the record industry and even their own fans. They toured overseas on pennies a day and did it in beat-up trucks and vans.

Spray Paint the Walls tells Black Flag's story from the inside, drawing on exclusive interviews with the group's members, their contemporaries, and the bands they inspired. It's the story of Henry Rollins, and his journey from fan to iconic frontman. And it's the story of Greg Ginn, who turned his electronics company into one of the world's most influential independent record labels while leading Black Flag from punk's three-chord frenzy into heavy metal and free-jazz. Featuring over 30 photos of the band from Glen E. Friedman, Edward Colver, and others.

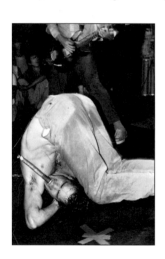
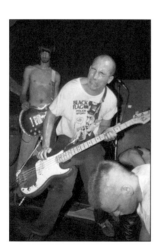
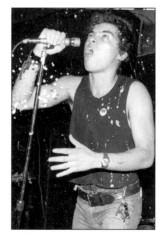
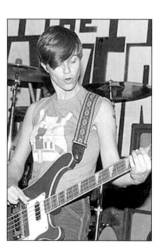

"Neither Greg Ginn nor Henry Rollins sat for interviews but their voices are included from earlier interviews, and more importantly Chuck Dukowski spoke to Chick—a first I believe. The story, laid out from the band's earliest practices in 1976 to its end ten years later, makes a far more dramatic book than the usual shelf-fillers with their stretch to make the empty stories of various chart-toppers sound exciting and crucial and against the odds."
—Joe Carducci, formerly of SST Records

"Chick's well-researched and readable book immerses the reader in Black Flag's world, recreating the violent yet creative atmosphere of the early Hardcore scene through new interviews with the band and their peers."
—Mat Croft, *Record Collector*

Left of the Dial
Conversations with Punk Icons
David Ensminger
$20.00 * Paperback * 320 pages

Left of the Dial features interviews by musical journalist, folklorist, educator, and musician David Ensminger with leading figures of the punk underground, Ian MacKaye (Minor Threat/Fugazi), Jello Biafra (Dead Kennedys), Dave Dictor (MDC), and many more. Ensminger probes the legacy of punk's sometimes fuzzy political ideology, its ongoing DIY traditions, its rupture of cultural social norms, its progressive media ecology, its transgenerational and transnational appeal, its pursuit of social justice, its hybrid musical nuances, and its sometimes ambivalent responses to queer identities, race relations, and its own history. Passionate, far-reaching, and fresh, these conversations illuminate punk's oral history with candor and humor.

Rather than focus on discographies and rehashed gig memories, the interviews aim to unveil the secret history of punk and hardcore ideologies and values, as understood by the performers. In addition, Ensminger has culled key graphics from his massive punk flyer collection to celebrate the visual history of the bands represented. The book also features rare photographs shot by Houston-based photographer Ben Desoto during the heyday of punk and hardcore, which capture the movement's raw gusto, gritty physicality, and resilient determination.

Interviews include Peter Case (The Nerves, Plimsouls), The Damned, The Dils, El Vez, UK Subs, The Deaf Club (an oral history of the landmark San Francisco club), Agent Orange, Angry Samoans, Ian MacKaye (Minor Threat, Fugazi), Jello Biafra (Dead Kennedys), Gary Floyd (The Dicks), Mike Watt (Minutemen), Youth Brigade, Kira Roessler (Black Flag), TSOL, Circle Jerks, Beefeater, Really Red, Vic Bondi (Articles of Faith), Frontier Records, MDC, and Strike Anywhere.

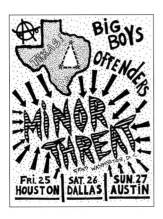
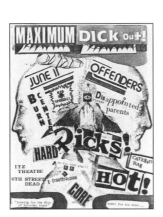
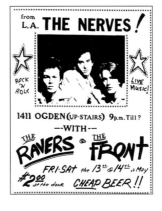

"David is one of the rare scene insiders who also has a depth of knowledge of the social and political context for the punk and hardcore moment. His love for the scene and understanding of its importance is unique, well-researched, and valuable."
—Vic Bondi, Articles of Faith

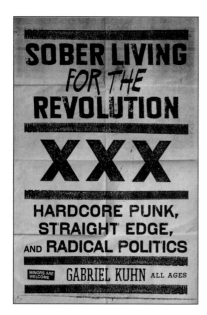

Sober Living for the Revolution
Hardcore Punk, Straight Edge And Radical Politics
Edited by Gabriel Kuhn
$22.95 * Paperback * 304 pages

Straight edge has persisted as a drug-free, hardcore punk subculture for 25 years. Its political legacy, however, remains ambiguous—often associated with self-righteous macho posturing and conservative puritanism. While certain elements of straight edge culture feed into such perception, the movement's political history is far more complex.

Since straight edge's origins in Washington, D.C. in the early 1980s, it has been linked to radical thought and action by countless individuals, bands, and entire scenes worldwide. *Sober Living for the Revolution* traces this history.

It includes contributions—in the form of in-depth interviews, essays, and manifestos—by numerous artists and activists connected to straight edge, from Ian MacKaye (Minor Threat/Fugazi) and Mark Andersen (*Dance of Days*/Positive Force DC) to Dennis Lyxzén (Refused/The (International) Noise Conspiracy) and Andy Hurley (Racetraitor/Fall Out Boy), from bands such as ManLiftingBanner and Point of No Return to feminist and queer initiatives, from radical collectives like CrimethInc. and Alpine Anarchist Productions to the Emancypunx project and many others dedicated as much to sober living as to the fight for a better world.

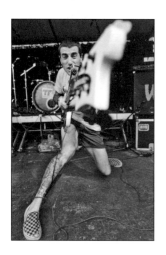
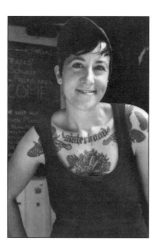
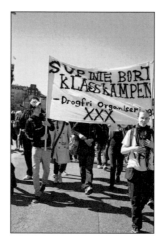

"Perhaps the greatest reason I am still committed to sXe is an unfailing belief that sXe is more than music, that it can be a force of change. I believe in the power of sXe as a bridge to social change, as an opportunity to create a more just and sustainable world."
—Ross Haenfler, Professor of Sociology at the University of Mississippi, author of *Straight Edge: Clean-Living Youth, Hardcore Punk, and Social Change*

Punk Rock
An Oral History
John Robb * Foreword by Henry Rollins
$19.95 * Paperback * 584 pages

With its own fashion, culture, and chaotic energy, punk rock boasted a do-it-yourself ethos that allowed anyone to take part. Vibrant and volatile, the punk scene left an extraordinary legacy of music and cultural change. John Robb talks to many of those who cultivated the movement, such as John Lydon, Lemmy, Siouxsie Sioux, Mick Jones, Chrissie Hynde, Malcolm McLaren, Henry Rollins, and Glen Matlock, weaving together their accounts to create a raw and unprecedented oral history of UK punk. All the main players are here: from The Clash to Crass, from The Sex Pistols to the Stranglers, from the UK Subs to Buzzcocks—over 150 interviews capture the excitement of the most thrilling wave of rock 'n' roll pop culture ever. Ranging from its widely debated roots in the late 1960s to its enduring influence on the bands, fashion, and culture of today, this history brings to life the energy and the anarchy as no other book has done.

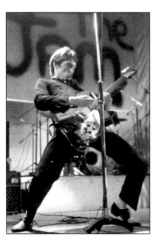
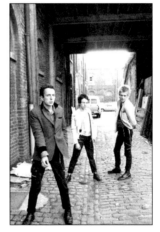
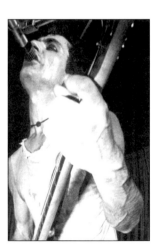

"Its unique brand of energy helps make it a riot all its own."
—*Harp Magazine*

"John Robb is a great writer...and he is supremely qualified in my opinion to talk about punk rock."
—Mick Jones, The Clash

"John Robb is as punk rock as The Clash."
—Alan McGee

About PM Press

politics • culture • art • fiction • music • film

PM Press was founded at the end of 2007 by a small collection of folks with decades of publishing, media, and organizing experience. PM Press co-conspirators have published and distributed hundreds of books, pamphlets, CDs, and DVDs. Members of PM have founded enduring book fairs, spearheaded victorious tenant organizing campaigns, and worked closely with bookstores, academic conferences, and even rock bands to deliver political and challenging ideas to all walks of life. We're old enough to know what we're doing and young enough to know what's at stake.

We seek to create radical and stimulating fiction and nonfiction books, pamphlets, t-shirts, visual and audio materials to entertain, educate, and inspire you. We aim to distribute these through every available channel with every available technology, whether that means you are seeing anarchist classics at our bookfair stalls; reading our latest vegan cookbook at the café; downloading geeky fiction e-books; or digging new music and timely videos from our website.

Contact us for direct ordering and questions about all PM Press releases, as well as manuscript submissions, review copy requests, foreign rights sales, author interviews, to book an author for an event, and to have PM Press attend your bookfair:

PM Press • PO Box 23912 • Oakland, CA 94623
510-658-3906 • info@pmpress.org

Buy books and stay on top of what we are doing at:

www.pmpress.org

FOPM MONTHLY SUBSCRIPTION PROGRAM

These are indisputably momentous times—the financial system is melting down globally and the Empire is stumbling. Now more than ever there is a vital need for radical ideas.

In the five years since its founding—and on a mere shoestring—PM Press has risen to the formidable challenge of publishing and distributing knowledge and entertainment for the struggles ahead. With over 200 releases to date, we have published an impressive and stimulating array of literature, art, music, politics, and culture. Using every available medium, we've succeeded in connecting those hungry for ideas and information to those putting them into practice.

Friends of PM allows you to directly help impact, amplify, and revitalize the discourse and actions of radical writers, filmmakers, and artists. It provides us with a stable foundation from which we can build upon our early successes and provides a much-needed subsidy for the materials that can't necessarily pay their own way. You can help make that happen—and receive every new title automatically delivered to your door once a month—by joining as a Friend of PM Press. And, we'll throw in a free T-Shirt when you sign up.

Here are your options:
- $25 a month: Get all books and pamphlets plus 50% discount on all webstore purchases
- $40 a month: Get all PM Press releases (including CDs and DVDs) plus 50% discount on all webstore purchases
- $100 a month: Superstar—Everything plus PM merchandise, free downloads, and 50% discount on all webstore purchases

For those who can't afford $25 or more a month, we're introducing *Sustainer Rates* at $15, $10 and $5. Sustainers get a free PM Press t-shirt and a 50% discount on all purchases from our website.

Your Visa or Mastercard will be billed once a month, until you tell us to stop. Or until our efforts succeed in bringing the revolution around. Or the financial meltdown of Capital makes plastic redundant. Whichever comes first.